GIFTS FOR THE GODS

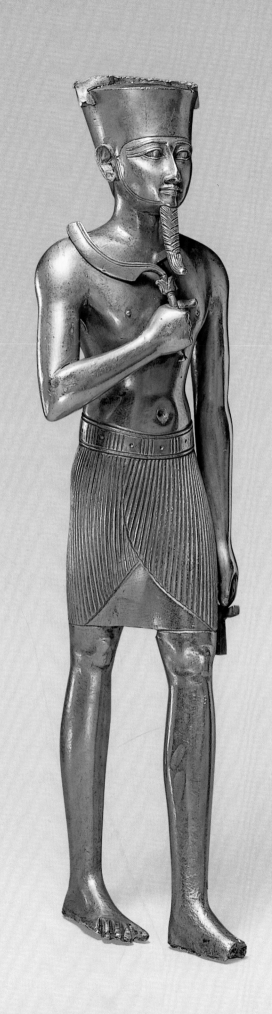

GIFTS FOR THE GODS
IMAGES FROM EGYPTIAN TEMPLES

Edited by Marsha Hill

with Deborah Schorsch, Technical Editor

The Metropolitan Museum of Art, New York

Yale University Press, New Haven and London

This volume is published in conjunction with the exhibition
"Gifts for the Gods: Images from Egyptian Temples,"
held at The Metropolitan Museum of Art, New York, from
October 16, 2007, to February 18, 2008.

The exhibition is made possible by **ORASCⓍM**
HOTELS & DEVELOPMENT

It is supported by an indemnity from the
Federal Council on the Arts and the Humanities.

The catalogue is made possible by The Adelaide Milton
de Groot Fund, in memory of the de Groot and Hawley families.

Additional support is provided by the Lila Acheson Wallace Fund.

Published by The Metropolitan Museum of Art, New York

John P. O'Neill, *Publisher and Editor in Chief*
Dale Tucker, *Senior Editor*
Antony Drobinski, *Designer*
Paula M. Torres, *Production Manager*
Philomena Mariani, *Bibliographic Editor*
Cathy Dorsey, *Indexer*

Typeset in Nofret and Trajan
Printed on 150 gsm Lumisilk
Color separations by Professional Graphics, Inc., Rockville, Illinois
Printed and bound by CS Graphics PTE Ltd., Singapore

Library of Congress Cataloging-in-Publication Data

Gifts for the gods : images from Egyptian temples / Marsha Hill, editor ;
Deborah Schorsch, technical editor.
 p. cm.
 Catalog of an exhibition held at the Metropolitan Museum of Art,
New York, Oct. 16, 2007–Feb. 18, 2008.
 Includes bibliographical references and index.
 ISBN 978-1-58839-231-2 (Metropolitan Museum of Art : hc)—
ISBN 978-0-300-12408-8 (Yale University Press : hc) 1. Sculpture,
Egyptian—Exhibitions. 2. Sculpture, Ancient—Egypt—Exhibitions.
3. Metal sculpture—Egypt—Exhibitions. 4. Statues—Egypt—
Exhibitions. 5. Temples—Egypt—Exhibitions. I. Hill, Marsha, 1949–
II. Schorsch, Deborah. III. Metropolitan Museum of Art (New York, N.Y.)
NB75.G54 2007
732'.80747471—dc22 2007030150

Jacket illustration: Detail of *Fragment from* Menit *of Harsiese*
(cat. no. 33)
Frontispiece: *Amun* (cat. no. 19)

CONTENTS

SPONSOR'S STATEMENT

Orascom Hotels & Development is proud to be the principal sponsor of "Gifts for the Gods: Images from Egyptian Temples." This ground-breaking exhibition explores the rich civilization and culture of Egypt through the intimate metal statuary that filled its ancient temples.

At Orascom Hotels & Development (OHD), our motto is "Building Better Towns," and in that light we are committed to upholding the highest standards in everything we do for our customers, shareholders, associates, and communities. With a land bank of more than 118 million square meters, OHD is a global town developer that specializes in planning, building, and operating integrated, self-sufficient leisure and residential towns around the world, complete with top-quality hotels, emerald golf courses, marinas, groomed beaches, and fully integrated amenities and services. The crossroad icon in the OHD logo, which derives from the Egyptian hieroglyph for "town," represents our vision to develop Orascom towns worldwide.

OHD's flagship project, El Gouna, a complete resort town on the coast of the Red Sea, began as a simple real estate project and evolved into a fully self-sufficient town with a strong infrastructure and established reputation. The success of El Gouna served as a business model for OHD as we expanded our operations internationally and broadened the scope of our development. The company is now active in Egypt, Oman, Jordan, United Arab Emirates, Switzerland, Mauritius, and Morocco, with plans to enter additional countries, and with active partnerships with the best contractors and the best international hotel operators in the world.

In supporting this exhibition, OHD hopes that all visitors to The Metropolitan Museum of Art will be rewarded with an appreciation of Egypt's rich cultural traditions and a new understanding of this ancient civilization.

Samih Sawiris
Chairman and Chief Executive Officer
www.orascomhd.com

DIRECTOR'S FOREWORD

Among the unmatched finds that entered collections of Egyptian art in the nineteenth century were a number of remarkable large bronzes whose intricate ornamentation and euphonious names—Takushit, Pedubaste, Karomama—conveyed then, as they still do, something of the atmosphere of ancient Egyptian temple rituals. For many decades the allure of these intimate works has been overshadowed by the impact of the overwhelming mass of stone statuary from tombs and from the more public parts of Egyptian temples; it has also been obscured by the inherent difficulties in studying metal statuary. "Gifts for the Gods: Images from Egyptian Temples" draws on recent scholarly advances as well as the discovery in the last decades of a number of intact temple caches to present the first comprehensive picture of the art and significance of Egyptian metal statuary, the quintessential artistic expression of the temple. In so doing, the exhibition and its accompanying catalogue rely on the distinctive splendor of this art to bring into focus hitherto inadequately appreciated aspects of Egypt's art and culture. In the presence of these images of gods and pious individuals, the temples themselves emerge as crucibles in which influences came together and regularly replenished the society's art and beliefs. Especially arresting are the statues from the first third of the first millennium B.C., including large, decorated bronzes not found in American collections. This splendid statuary reveals the artistic and technical accomplishment of the temple workshops and underscores the appeal of an era whose conventional, somewhat prosaic name, the Third Intermediate Period, belies its great cultural and artistic fecundity.

Thanks and admiration are due to curator Marsha Hill, who conceived and organized the exhibition, and to her colleague in the study of Egyptian metal sculpture, conservator Deborah Schorsch; they were partners in the editing of this catalogue. Their collaboration, and similar instances of cooperation at other museums to which the loans and essays in this catalogue bear ample testimony, reflect the crucial role of the museum in bringing a rich set of expertise to the study of works of art.

The Metropolitan Museum of Art extends profound and heartfelt thanks to the many institutions that contributed loans to this exhibition, and to their respective directors. From Greece, we received seminal treasures of ancient Egyptian statuary that have never before been lent, and which constitute the first Egyptian loans ever made by the National Archaeological Museum, Athens, to the Metropolitan Museum. On this auspicious occasion, we must state our particular gratitude to Dr. George Voulgarakis, Minister of Culture; Dr. Paraskevi Vassilopoulou, General Director, General Directorate of Antiquities and Cultural Heritage; Mrs. Maria Pandou, Director, Directorate of Museums, Exhibitions, and Educational Programs; Mrs. Suzanna Choulia-Kapeloni, Directorate for Museums, Exhibitions, and Educational Programs, Hellenic Ministry of Culture; and Dr. Nikolaos Kaltsas, Director of the National Archaeological Museum, who is a friend to everyone at this institution. In Egypt, the Supreme Council of Antiquities and its Secretary General, Dr. Zahi Hawass, with customary and continuing generosity, agreed to lend rare works to the exhibition from the Egyptian Museum, Cairo. Dr. Wafaa El-Saddik, Director of the museum and a close colleague, provided crucial support in obtaining loan agreements. Many other museums in Europe and America have graciously lent their own significant works to the exhibition, for which we are truly grateful.

We are delighted to share the exhibition with the Fondation Pierre Gianadda, Martigny, Switzerland, and Mr. Léonard Gianadda is, once again, a most welcome partner.

Particular mention should be made here of the efforts of two individuals at the Metropolitan Museum. The foresight of Mahrukh Tarapor, Director of International Affairs in the Museum's Geneva office and Associate Director for Exhibitions, was instrumental in forging new understandings and partnerships that made a focused consideration such as "Gifts for the Gods" a reality. Special thanks also go to Dorothea Arnold, Lila Acheson Wallace Chairman, Department of Egyptian Art, for her receptiveness and support of new initiatives.

I would like to express special thanks to Mr. Samih Sawiris, Chairman and CEO, Orascom Hotels & Development, for his generous support of this exhibition. The catalogue is made possible by The Adelaide Milton de Groot Fund, in memory of the de Groot and Hawley families. Additional support is provided by the Lila Acheson Wallace Fund. We are also grateful to the Federal Council on the Arts and Humanities for its support through the Federal Indemnity Program.

Philippe de Montebello
Director
The Metropolitan Museum of Art, New York

ACKNOWLEDGMENTS

Over the long period of development of this exhibition and its accompanying catalogue, we have accrued considerable debts to many colleagues and friends. The following acknowledgments make amply clear how much cooperation we requested and received. In that respect, our first thanks go to Philippe de Montebello, Director of The Metropolitan Museum of Art, who gave his consent to the project because of its promise to advance the study of ancient art, and despite the fact that its realization was sure to prove difficult and time-consuming.

In Greece, we received much valued assistance from the Hellenic Ministry of Culture, Athens, as noted in the foreword to this volume. Here we would like to underscore and express our appreciation for the special interest and involvement of Nikolaos Kaltsas, Director of the National Archaeological Museum, Athens, who made possible loans of remarkable works from the museum's renowned collection of Egyptian art. We would also like to acknowledge the help of our other colleagues in the National Archaeological Museum: Eleni Papazoglou, Curator in Charge of the Prehistoric, Anatolian, and Egyptian collections, who adroitly overcame every seeming obstacle, and Eleni Tourna, Curator of the Egyptian collection, who has been a most welcoming colleague for many years and who sought out crucial new information about several important statues. We would also like to thank Maria Viglaki-Sofianou, Archaeologist in Charge of the Vathy Museum, Samos, who made the important objects in that collection available for photography.

In Egypt, the friendship of Zahi Hawass, Secretary General of the Supreme Council of Antiquities, to this Museum and to Egyptian art studies in general cannot be sufficiently acknowledged. Likewise, the careful attention of Wafaa El-Saddik, Director of the Egyptian Museum, Cairo, guaranteed that arrangements proceeded smoothly. Their willingness to make available unique objects from the unsurpassed resources of the Egyptian Museum proved invaluable in helping us to illuminate otherwise undocumented aspects of metal statuary.

We would like to extend our profound appreciation to the museums that loaned works of art to the exhibition. All of these institutions hold pieces that are landmarks for the study of metal statuary, and at many of them seminal studies of metal statuary have been produced or are currently underway. This significant aspect of the project will find its best acknowledgment in a thorough perusal of the catalogue or in the scholarly events planned in conjunction with the exhibition. Here we would like to recognize the direct and generous assistance of our many valued colleagues in obtaining loans, studying objects, and pursuing technical examinations. In Europe: Department of Antiquities, Nicosia, Cyprus: Pavlos Flourentzos and Despina Pilides; Ny Carlsberg Glyptotek, Copenhagen: Mogens Jørgensen and Rebecca Hast; Ägyptisches Museum und Papyrussammlung, Staatliche Museen zu Berlin: Dietrich Wildung, Olivia Zorn, Frank Marohn, and, at the Rathgen-Forschungslabor, Josef Riederer, who provided us with unpublished analyses; Roemer- und Pelizaeus-Museum, Hildesheim: Katja Lembke and Bettina Schmitz; Rijksmuseum van Oudheden, Leiden, Netherlands: Wim Weijland and Maarten Raven; Museu Calouste Gulbenkian, Lisbon: João Castel-Branco Pereira, Maria Rosa Figueiredo, and Rui Xavier; Musée du Louvre, Paris: Henri Loyrette, Christiane Ziegler (former head of the Department of Egyptian Antiquities), and Élisabeth Delange, who pursued innumerable points of art-historical, archival, and technical interest that have greatly enriched the exhibition; British Museum, London: Neil MacGregor, W. V. Davies, John H. Taylor, Claire Messenger, and Paul Craddock (formerly in the Department of Conservation, Documentation and Science). In the United States: The Walters Art Museum, Baltimore: Gary Vikan, Regine Schulz, Terry Drayman-Weisser, and Jennifer Giaccai; Brooklyn Museum: Arnold Lehman, Richard Fazzini (former Chairman of the Department of Egyptian, Classical, and Ancient Middle Eastern Art), Edna R. Russmann, Madeleine Cody, Ellen Pearlstein (formerly in the Department of Conservation), Lisa Bruno, and Tina March; University of Pennsylvania Museum of Archaeology and Anthropology, Philadelphia: David Silverman and Jennifer Wegner. Special note should be made of the continuing generosity of Dietrich Wildung, Director of the Ägyptisches Museum, who has on many occasions facilitated the editors' studies and examinations of the objects borrowed for this exhibition. We would also like to thank João Castel-Branco Pereira and Maria Rosa Figueiredo at the Museu Calouste Gulbenkian for their willingness to loan their important statue as a mark of friendship to this institution and for their support of our thorough study of that work.

Professor Harry Smith and Sue Davies of Cambridge, England, have for many years shared information with the editors of this volume about the Egypt Exploration Society's excavations at the Saqqara Sacred Animal Necropolis, and Sue Davies has written a most welcome contribution to the catalogue. Patricia Spencer, Secretary General of the Society, assisted with permissions, and Caroline Middleton helped to obtain plans. More recently, contact with Michel Wuttmann, Laurent Coulon, and Florence Gombert of

the Institut Français d'Archéologie Orientale, Cairo, has been most fruitful and resulted in their valuable contribution, for which Nadine Cherpion helped to obtain photographs.

Professor Herman De Meulenaere, Director of the Association Égyptologique Reine Élisabeth, Brussels, provided inscriptional insights that have been incorporated in the catalogue. Barbara Mendoza sent us an early copy of her dissertation on bronze priests. Hermann Kienast, former Director of the Deutsches Archäologisches Institut, Athens, gave strategic advice, and Sylvia Diebner, of the Deutsches Archäologisches Institut, Rome, helped to identify photographs there. Our former colleague James P. Allen, now of Brown University, provided every kind of linguistic assistance—readings, spelling guidance (although any remaining errors are our own), computer hieroglyphic drawings—in addition to our many discussions over the years. We also benefited from the photographic skills of Biri Fay in Cairo. Mortimer Lebigre, of mortimeralex.com, created a digital photomontage of Takushit that made possible a register-by-register and magnified study of the statue's figural decoration and inscriptions. Julia Jarrett drew the facsimile of the inscription on catalogue number 32. Will Schenck provided the original drawings of catalogue numbers 21 and 57, which have been reused here.

We are, of course, indebted to many of our colleagues at The Metropolitan Museum of Art for their invaluable help during the gestation of the exhibition. Mahrukh Tarapor, Director for International Affairs in the Museum's Geneva office and Associate Director for Exhibitions, sustained the project with her own commitment; without her will and efforts, the exhibition could not have been realized in its present form. Martha Deese, Senior Administrator for Exhibitions and International Affairs, was also always helpful. Herb Moskowitz in the Registrar's office and Linda Sylling, Manager of Special Exhibitions, Installations, and Design, closely followed and guided the development of the exhibition. Dan Kershaw created the handsome design for the exhibition in New York and extended it, with adaptations, to Martigny. The intimate color photographs of works of art in the Museum's collection were made by Oi-Cheong Lee of The Photograph Studio. In the Editorial Department, we are grateful to John O'Neill, Publisher and Editor in Chief, for his support and advice. Dale Tucker, our editor, shaped this elegant catalogue along with Paula Torres, who managed its production, and Tony Drobinski, who created its responsive and appealing design. The bibliography was edited by Philomena Mariani. Alexandra Kotsaki, Conservator in the National Archaeological Museum, Athens, translated the entries of Eleni Tourna. The Watson Library and its staff have been a wonderful resource, helping to obtain many publications and articles needed for our work, and Wojtek Batycki in Information Systems and Technology made special arrangements to facilitate work on the catalogue.

Finally, many colleagues in our respective departments must be acknowledged and thanked. Dorothea Arnold, Lila Acheson Wallace Chairman, Department of Egyptian Art, fostered this project in every imaginable way

and committed a good deal of her personal energies to its fruition. She and other members of the department have assisted us not only through the example of their own work but in discussions, obtaining books, and moving objects; we thank Susan Allen, Dieter Arnold, William Barrette, Miriam Blieka, Don Fortenberry, Dennis Kelly, Adela Oppenheim, Diana Craig Patch, Catharine Roehrig, Isidore Salerno, Isabel Stuenkel, and Victoria Southwell. In the Sherman Fairchild Center for Objects Conservation, thanks are due to Lawrence Becker, Conservator-in-Charge, Ann Heywood, and Richard E. Stone; in the Department of Scientific Research, we are grateful to James H. Frantz for initiating the technical study of Egyptian metalwork in the Metropolitan Museum and for his continuing contributions, and to Mark T. Wypyski for carrying out SEM/EDS analyses of statuary in the Metropolitan's collection and in many other collections crucial to our understanding of this material.

Marsha Hill
Curator
Department of Egyptian Art

Deborah Schorsch
Conservator
Sherman Fairchild Center for Objects Conservation

Contributors to the Catalogue

Laurent Coulon
Egyptologist, Institut Français d'Archéologie Orientale, Cairo

Sue Davies
Sacred Animal Necropolis Project, Upwood-Huntingdon, United Kingdom

Élisabeth Delange
Conservateur en chef, Département des Antiquités Égyptiennes, Musée du Louvre, Paris

Richard Fazzini (RF)
Curator Emeritus, Egyptian, Classical, and Ancient Middle Eastern Art, Brooklyn Museum, New York

Florence Gombert
Conservateur, Palais des Beaux-Arts de Lille, France

Marsha Hill (MH)
Curator, Department of Egyptian Art, The Metropolitan Museum of Art, New York

Adela Oppenheim (AO)
Associate Curator, Department of Egyptian Art, The Metropolitan Museum of Art, New York

Diana Craig Patch (DCP)
Assistant Curator, Department of Egyptian Art, The Metropolitan Museum of Art, New York

Maarten Raven (MR)
Curator, Egyptian Department, Rijksmuseum van Oudheden, Leiden, Netherlands

Edna R. Russmann (ERR)
Curator, Department of Egyptian, Classical, and Ancient Middle Eastern Art, Brooklyn Museum, New York

Deborah Schorsch (DS)
Conservator, Sherman Fairchild Center for Objects Conservation, The Metropolitan Museum of Art, New York

John H. Taylor (JHT)
Assistant Keeper, Department of Ancient Egypt and Sudan, British Museum, London

Eleni Tourna (ET)
Curator of the Egyptian Collection, Department of Prehistoric, Egyptian and Oriental Antiquities, National Archaeological Museum, Athens

Maria Viglaki–Sofianou (MV–S)
Archaeologist, Samos, Greece

Michel Wuttmann
Archaeologist, Institut Français d'Archéologie Orientale, Cairo

Lenders to the Exhibition

CYPRUS
Nicosia, Cyprus Museum

DENMARK
Copenhagen, Ny Carlsberg Glyptotek

EGYPT
Cairo, Egyptian Museum

FRANCE
Paris, Musée du Louvre

GERMANY
Berlin, Ägyptisches Museum und Papyrussammlung,
Staatliche Museen zu Berlin
Hildesheim, Roemer- und Pelizaeus-Museum

GREECE
Athens, National Archaeological Museum
Samos, Archaeological Museum, Vathy

NETHERLANDS
Leiden, Rijksmuseum van Oudheden

PORTUGAL
Lisbon, Museu Calouste Gulbenkian

UNITED KINGDOM
London, The Trustees of the British Museum

UNITED STATES
Baltimore, The Walters Art Museum
New York, Brooklyn Museum
New York, The Metropolitan Museum of Art
Philadelphia, University of Pennsylvania Museum of
Archaeology and Anthropology

Note to the Reader

The catalogue comprises sixty-seven objects (see "Works in the Exhibition," pp. 201–13), some of which are discussed in separate entries; these discussions and their accompanying illustrations are cross-referenced by catalogue and page number (e.g., cat. no. 7; pp. 18–21). All other illustrations, including those of art works in the exhibition but not discussed in separate entries, are cross-referenced by catalogue and figure number (e.g., cat. no. 1; figs. 4, 5).

The ancient Egyptian chronology used in this volume reflects dates currently used by the Metropolitan Museum's Department of Egyptian Art.

In the headings of catalogue entries, dimensions are abbreviated as follows: height (H.), width (W.), depth (D.), length (L.), diameter (Diam.), and thickness (Th.).

All source references are cited in abbreviated form. Complete citations will be found in the bibliography.

For a discussion of the technical terminology used in this volume, see the essay "The Manufacture of Metal Statuary" by Deborah Schorsch, pp. 189–99. For glossaries of commonly used names and terms in Egyptian art, see, for example, Do. Arnold et al. 1999 and Roehrig 2005.

Following standard Egyptological practice, square brackets in translations indicate losses in the original, and parentheses mark modern additions, interpolations, and commentary.

GIFTS FOR THE GODS

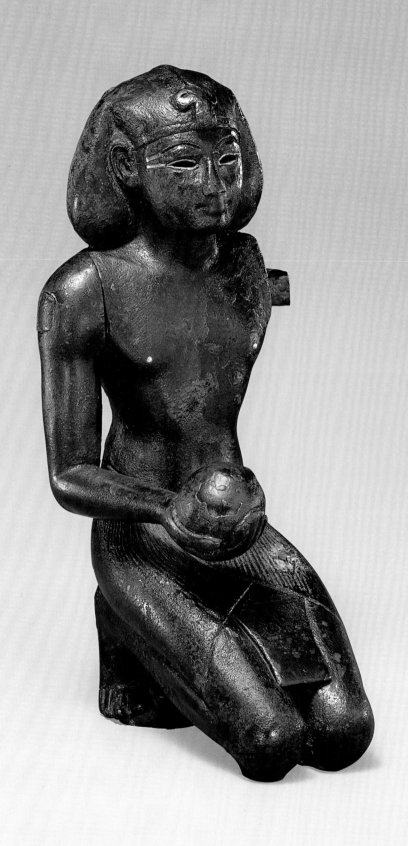

ART AND INFLUENCE IN TEMPLE IMAGES

Marsha Hill

As for the gods and goddesses who are in this land, their hearts are joyful;
the lords of shrines are rejoicing, the shores are shouting praise, and exultation
pervades the [entire] land now that good [plans] have come to pass.[1]

The ancient Egyptians throughout their long history created fine objects, including statuary, in gold, silver, and copper.[2] The intertwined economic and aesthetic values of these lustrous metals, along with the symbolic values they attracted, were basic to the close association between such materials and the gods and their temples. When we view and study metal statuary, we thus are gazing into the fascinating world in which the Egyptians interacted with their gods: from the rites conducted within inner sanctuaries of temples both great and small, to the worship practices, processions, and festivals held in open temple courts and throughout the countryside. The intimacy of the image of the great monarch Senwosret I prostrate before the gods (cat. no. 1; figs. 4, 5) or of the conqueror Thutmose III kneeling to serve as a kind of guardian to a sacred image (cat. no. 8; fig. 1), as well as the vulnerability expressed in the hundreds of small deity figures piously wrapped in linen and laid into the earth (fig. 77): in each case we are reminded of the role these small statues played in religious performances and of the beliefs that were invested in them.

The ritual atmosphere of temples and other places of worship encouraged certain sculptural and decorative values in metal statuary—such as transportability, readability, and the evocation of movement and color—that the use of metal as a medium facilitated and that differ somewhat from the values historically associated with stone statuary, the more familiar artistic achievement of ancient Egypt.[3] Metal statuary is distinctive not only because its most characteristic use—as "actors" in temple rituals—differed from that of stone statuary, but also because its places of production[4]— for metal statuary these were probably, but not necessarily always, temple workshops—were by no means fully integrated with those of stone sculpture. As a result divergent influences acted on the production of metal statuary, providing scholars and enthusiasts of ancient Egypt with a vantage point from which diverse aspects of ancient Egyptian art and society come into view. A study of copper–alloy statuettes of kneeling kings, for example,

Fig. 1. *King Thutmose III*
(cat. no. 8)

• 3

has drawn attention to certain facial styles, costume elements, and iconographic details that often vary markedly from contemporaneous stone statuary. This is true not only for periods of political disintegration and instability, including the so-called Third Intermediate Period (ca. 1070–664 B.C.), when one might expect such disjunctions to occur, but also during more cohesive eras such as the Late Period (664–332 B.C.) and afterward. Instead, there are often observable links between metal statuary and temple relief narratives, a relationship that can be attributed to the fact that reliefs, like metal statuary, were concerned with temple rituals. Another likely factor in this close association is the degree of overlap in the places where reliefs and metal statuary were produced.[5]

The extent to which disjunctions between metal and stone statuary found expression in a given era would have depended on many factors, including the political environment. The identification of such disjunctions from the periods of Egyptian history antedating the first millennium B.C. is complex, however, mainly because there are fewer metal statues preserved from this time. In the Eighteenth and Nineteenth Dynasties a series of royal metal portraits was produced that is remarkable for its strong *conformity* to images in stone, yet even in these works it is possible to isolate details, such as a strongly slanted belt line (fig. 87), that appear in royal metal temple sculpture a generation before they do in stone.[6] Looking at metal statuary from the pre-Thutmoside periods, we can sometimes suspect that the use of metal was linked to specific characteristics of the owner, in effect imparting what might be described as a personal dimension to the statuary. For instance, the conjunction of a specific medium (cupreous metals) and a specific stylistic element (a rare hairstyle) in a few statuettes dating to the late Second Intermediate Period and early Eighteenth Dynasty could indicate that a particular set of persons had special access to the material.[7] These considerations are indicative, first, of how strongly our views of Egyptian art and society have been formed by the study of stone statuary and, second, of how these views are shifted by explorations of metal statuary.[8]

Obstacles to a greater understanding of metal statuary remain, of course, many of them tied to the very aspects of the work that constitute part of its unique character and special appeal to those who study Egyptian art. The large numbers of such pieces produced in the Late Period, for example, testify to some major religious phenomenon, but they also present dating issues stemming from having been used for long periods in temples before being cleared away and buried in caches of sacred material (fig. 76). Likewise, the susceptibility of metal statuary to a wide variety of influences resulted in a high degree of particularity among these works, and as a consequence they often resist historical organization and analysis. Nonetheless, in the last few decades a framework for a history of metal statuary has been elaborated, and new insights have been gained through museum-based studies and other scholarly inquiries into focused groups of objects.[9] The presentation of this exhibition at this time, therefore, seems particularly

appropriate. Although there are still large gaps in our knowledge as well as many open questions, a better-informed appreciation of metal statuary is now possible. At the same time, these new understandings, it is hoped, will suggest subjects and strategies for future investigations.

The exhibition "Gifts for the Gods" and this catalogue both concentrate on anthropomorphic statuary because these works benefit most from the tools of stylistic analysis developed for the study of Egyptian art. The essays and other discussions that follow pursue several objectives: to bring attention to continuities of development in metal statuary and to address some of the ways its development may have been integrated within specific artistic and social structures; to examine and appreciate the apogee of artistry in metal reached during the Third Intermediate Period; and to observe closely the clues afforded by extant examples of small temple statuary regarding the original meanings of such works. Part of this exhibition's contribution to our knowledge of Egyptian metal statuary will be the care that has been taken to provide technical descriptions that are as precise, detailed, and consistent in terminology as possible—crucial considerations for a field of sculptural studies in which accurate information about manufacture and material is inextricably linked to an appreciation of the artistry and history of the medium.

1. From the "Restoration Inscription of Tutankhamun," trans. from Murnane 1995, p. 214.
2. For a detailed description and discussion of these metals, see the essay by Deborah Schorsch in this volume.
3. See, for example, discussion of the statue of Pedubaste (cat. no. 21), pp. 90–91.
4. Pichot et al. 2006 and similar studies are important undertakings on the topic of chains of production.
5. See discussions of catalogue numbers 43 and 44, pp. 117–20, and 46, pp. 137–39.
6. See discussion of catalogue number 8, p. 26.
7. See discussion of catalogue number 7, pp. 18–21.
8. This is also one of the reasons why metal statuary is better served by period definitions that follow socioreligious changes more closely than political history: for example, the continuation from the Middle Kingdom through the pre-Thutmoside New Kingdom, or the inclusion of the Kushite Period with the Third Intermediate Period.
9. See especially Ziegler 1987, 1996; Bianchi 1990; Giumlia-Mair 1997; Vassilika 1997; Aubert and Aubert 2001; and Hill 2004. For Third Intermediate Period bronzes, see the studies referred to in the essay "Heights of Artistry" in this volume.

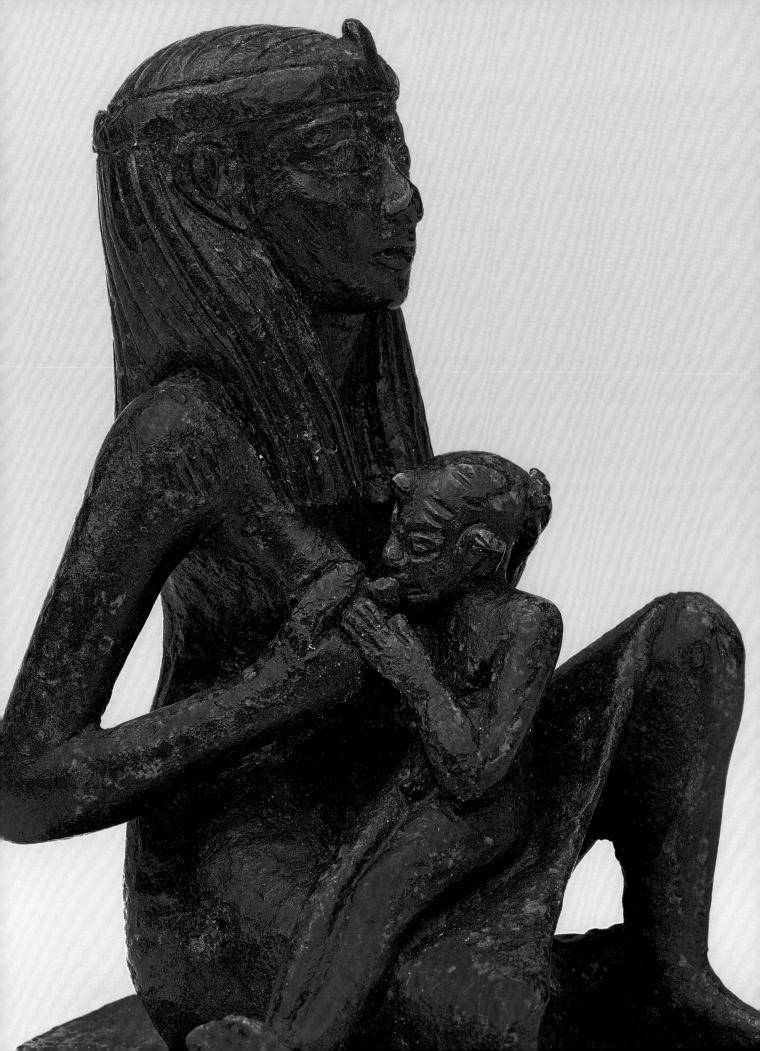

CHARTING METAL STATUARY: THE ARCHAIC PERIOD THROUGH THE PRE-THUTMOSIDE NEW KINGDOM (ca. 3100–1479 B.C.)

Marsha Hill

Those who were fortunate enough to view the exhibition "Art of the First Cities" at the Metropolitan Museum in 2003 will recall seeing impressive examples of metallurgy from the ancient Near East dating to the late fourth and third millennia B.C. Magnificent and complex castings, from depictions of rulers to figural temple equipment, are among the most famed ancient Near Eastern art works from those eras, which precede and are contemporary with the Egyptian Archaic Period (ca. 3100–2649 B.C.) and Old Kingdom (ca. 2649–2100 B.C.). Metal statuary was produced in Egypt beginning about the end of the Archaic Period, but technologically it was less advanced. Although precise connections between the two regions cannot be traced, it is likely that Egypt gradually acquired from the Near East technologies that had long been practiced there.[1]

Various sources allow us to eke out a history of metal statuary even in these early periods and to observe how cultural and religious tendencies within Egypt influenced the development of this work. On the whole what we know about metal statuary from the Archaic through the pre-Thutmoside periods is sparse, riddled with lacunae and the particular biases of preservation and historical sources, and, therefore, difficult to accept as fully representative. The overall profile presented by this evidence may, nevertheless, reflect some truths. Some scholars have proposed, for example, that originally royal support of local deity cults was neither ubiquitous nor continuous, and that local cults only gradually attained the status of state cults, along with the richly endowed treasuries—including metal statuary—that this status conveyed. No doubt this process was largely complete by the New Kingdom, when many local temples also functioned as state cults.[2] It is possible, then, that broad shifts in political and social organization during the pre-Thutmoside periods underlie the gradually increasing numbers of metal statues that seem to have been produced over this long span of time as well as the progressive emergence of different types of statuary.

Fig. 2. Detail of
*Princess Sobeknakht
Nursing Her Son*
(cat. no. 2)

The ancient annals of kings from the First through the Fifth Dynasties (ca. 3100–2323 B.C.) record as notable events the creation of certain statues of kings in copper, electrum, and gold. The earliest of these, judging from its name, "High-is-Khasekhemwy," was a large copper statue of that Second Dynasty monarch (r. ca. 2676–2649 B.C.). Similarly, the creation of an electrum statue of the god Ihy is noted in the Fifth Dynasty under the pharaoh Neferirkare (r. ca. 2446–2438 B.C.).[3] In addition to these recorded works, three examples are actually preserved, having been discovered where they were deposited beneath the floor of a temple at Hierakonpolis, in southern Egypt; the temple was either the main shrine of the god Horus or a "ka-temple" of the pharaoh Pepi I of the Sixth Dynasty (r. ca. 2289–2255 B.C.).[4] These sculptures include two large, striding royal statues made of hammered and riveted unalloyed copper; the larger one depicts Pepi I, while the smaller one represents, if not the same king, then a near contemporary, who originally had a falcon behind his head. The third work discovered at Hierakonpolis is an apparent cult statue of a crouching falcon (fig. 3), whose head is made of thick gold sheet raised by hammering; the head was attached with nails to the body, which is made of hammered and riveted sheets of unalloyed copper over wood.

The excavations at Hierakonpolis, conducted in 1897, were inadequately recorded, and yet archaeological context, even under the best circumstances, is usually insufficient to determine the dates for such works, which inhabited a sanctuary for an indefinite period of time before being reverently buried beneath a temple floor. It is no wonder, then, that the date of the unusual falcon image has been the subject of much debate, which is itself instructive because it draws attention to the fact that temple images were subject to alteration again and again during their "lifetimes." One point that has seemed to argue against an early date for the falcon is that originally a small statuette of a king (now lost) was located beneath the bird's beak, an arrangement known only in works from the New Kingdom. Recent restoration and technical study of the statue has now identified three phases in the "life" of the falcon image, however: first, as a wood image covered with painted gesso; second, a "metalizing" stage during which construction techniques closely related to those used to make the Pepi figure were employed to cover the older wood image with copper sheet and, possibly, the head with gold sheet, if the latter work had not already been added during the previous stage; and third, the addition of the crown. From this investigation, it appears likely that the Hierakonpolis cult statue was created essentially during the Old Kingdom.[5] While the now-missing king was added at an unknown point in the object's history, there is no reason to unduly extend that time frame; archaeological evaluation suggests the statues were deposited beneath the floor of the temple at the end of their use life, just before a rebuilding phase in the early Middle Kingdom.[6] This, then, is an

Fig. 3. Drawing illustrating phases of construction of *Cult Statue of a Falcon*, 6th Dynasty (ca. 2323–2150 B.C.), from Hierakonpolis. Statue: H. approx. 55–60 cm. Egyptian Museum, Cairo (CG 52701/14717). Drawing by J. Ribbeck

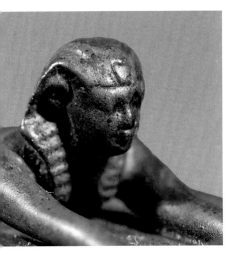

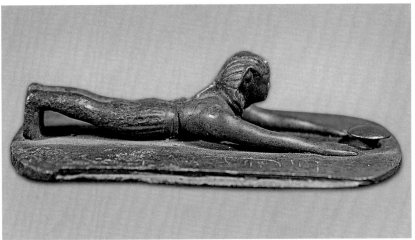

Figs. 4, 5. *Censer Lid with Prostrate King Senwosret* (cat. no. 1), with detail of face at left

instance in which metal cult and ritual statuary apparently introduced a sculptural type (a king beneath the chin of a deity) that appeared in stone statuary only some six centuries later: early evidence of how temple ritual statuary and monumental statuary occupied different, if overlapping, spheres.

The few extant records from the First Intermediate Period (ca. 2100–2040 B.C.) and the Middle Kingdom (ca. 2040–1650 B.C.) include mentions of wood statues of gods and gilded wood statues of royalty; we also know that metal equipment and statuary embellishments (if not necessarily metal statuary itself) were employed in the great processional dramas of the Osiris cult at Abydos during the annual festival, when the statue of Osiris was made to journey from his temple to his tomb amid enactments of his legends.[7] There are, in addition to those records, notable examples of actual metal statues of kings, gods, and high officials preserved from the Twelfth and Thirteenth Dynasties (ca. 1981–1650 B.C.). A copper-alloy censer (cat. no. 1; figs. 4, 5) found in a secondary context (no longer in any relation to its original place of use) at Deir el-Ballas—a site north of Thebes with an early New Kingdom palace—is topped by a small, fully prostrate figure of a king identified in an inscription as "Senwosret." Judging from the monarch's features and other datable details of treatment, he is Senwosret I (r. ca. 1961–1917 B.C.). The censer is the earliest surviving example of a royal metal statue that is also identifiable as a ritual statue: that is, a statue posed and proportioned so that it could be moved about to enact rituals before, or otherwise accompany, a cult statue, which we understand to have been generally small in size. The prostrate pose appears here in a metal temple statue dating to the Twelfth Dynasty, whereas in stone statuary it is not seen until the Eighteenth Dynasty.[8]

One important group of works from the late Middle Kingdom—probably a deposit from a temple in the Fayum area of Egypt—ranges in date from as early as the reign of Amenemhat III (ca. 1859–1813 B.C.) to about the mid-Thirteenth Dynasty (ca. 1725 B.C.).[9] It includes impressive statues of royalty and high officials as well as a figure of the god Sobek in crocodile form.

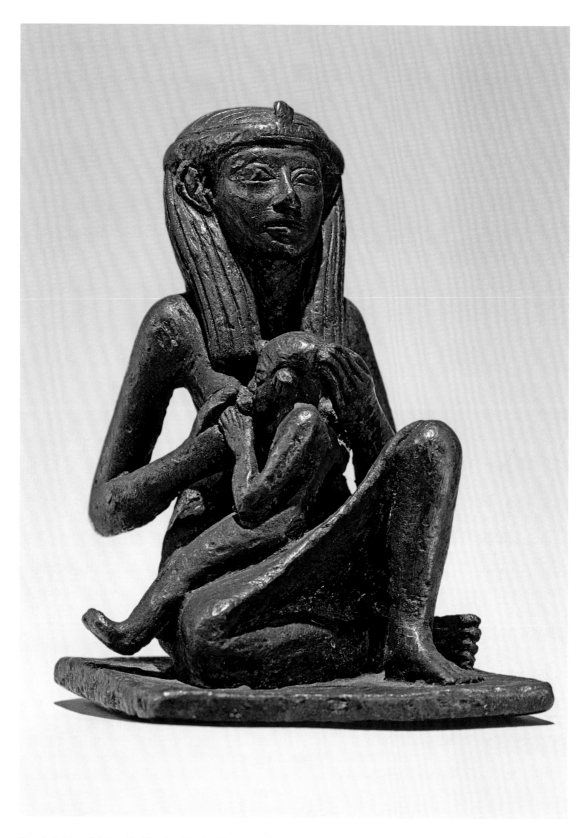

Fig. 6. *Princess Sobeknakht Nursing Her Son* (cat. no. 2)

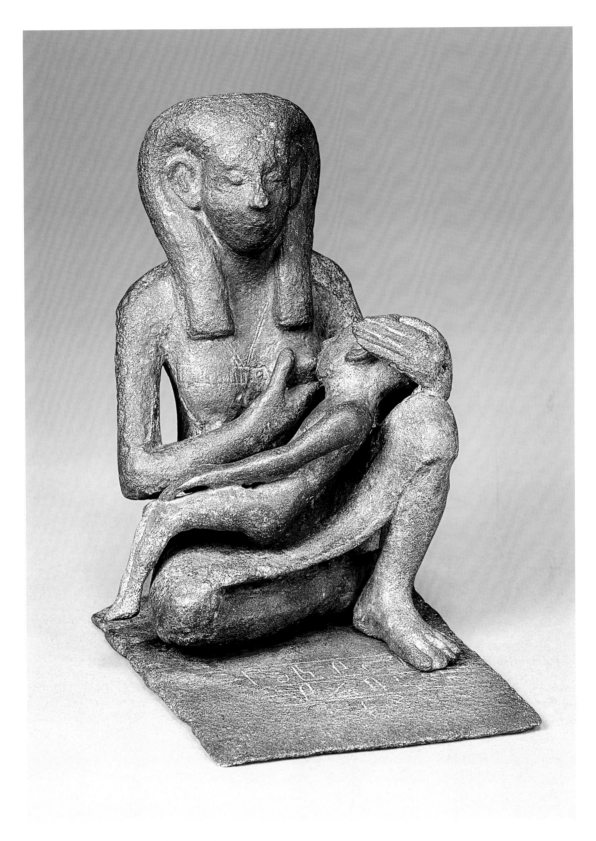

Fig. 7. *Isis Nursing Horus* (?) (cat. no. 3)

Made from various cupreous metals, the statues in the Fayum group provide evidence of such sophisticated metalworking techniques as hollow casting, complex alloying, and decoration using precious metals. A kneeling king in the group and the figure of Sobek are, respectively, among the early examples in metal of ritual performance statuary and of statues of gods.

Two arsenical-copper statuettes depicting women squatting and nursing infants (cat. nos. 2, 3; figs. 6, 7) are likewise datable to this era. The subject of a recent study,[10] these two works exemplify many of the difficulties typical of early metal temple statuary and its disjunctions with the broader statuary corpus. The squatting and nursing pose has a reasonably continuous history among informal statuettes of unnamed, ostensibly low-status women from the Old Kingdom through at least the mid–Eighteenth Dynasty.[11] Yet catalogue number 2, which can be dated on stylistic grounds to the mid- to late Thirteenth Dynasty (ca. 1750–1650 B.C.), bears an inscription indicating that the figure depicts a royal woman named "Sobeknakht." Catalogue number 3, datable stylistically to the late Middle Kingdom (ca. 1878–1650 B.C.), is inscribed with a text that, as reconstructed, seems to suggest the figure depicts the goddess Isis nursing her son, Horus: "Recitation by Isis, the goddess…her son Horus: 'We have come to protect (?) the Queen….'" This text is related to the inscriptions on magic "knives" and similar objects from the Middle Kingdom that functioned as implements in magical practices; such implements were embellished with the figures of genii and deities who served to safeguard childbirth and children and, by extension, the newly dead. Both of the nursing statuettes may have served a related purpose. They were likely donated to a temple, although some type of palace shrine or other location cannot be ruled out, to invoke the protection of a god for a royal mother and/or her child.

The pose of the statuette of Isis and Horus (cat. no. 3), with its clear connections to informal statuary, points to the possibility that the poses of other early temple statuary, including cult statuary, might well have emerged from traditions other than the central royal tradition known to us. Yet because so little evidence is preserved, this is a difficult argument to make. Some scholars have questioned the identification of the statue as Isis nursing Horus since the earliest statue complete enough to be unambiguously identified as such dates to the eighth century B.C. and is in the well-known enthroned pose.[12] If we are correct in maintaining that catalogue number 3 is indeed a representation of Isis suckling Horus, the chronological and representational gap between this work and the eighth-century examples can be attributed to the shifting complex of religious ideas and representational norms in ancient Egypt over the centuries. For instance, we can observe that in the late Middle Kingdom—when ideas of magical protection seem to have preoccupied all levels of Egyptian society and permeated every aspect of life—an informal mode of representation was adopted for an image of a royal mother and child so that the queen could

partake in the powerful prophylactic forces inherent in that iconography, which originally was conceived for womankind as a whole. We can imagine that this same mode also served at that moment, possibly for the first time, to represent Isis nursing Horus in order to invoke the great goddess's protective intervention on behalf of a royal mother and child. It is also possible, of course, that the statuette of Isis belongs to a representational tradition of the goddess that is now lost to us.

The advent of the New Kingdom (ca. 1550–1070 B.C.) witnessed the consolidation of certain politico-religious hierarchies, and with them the strong assertion of formal representational conventions for elite figures. The relative rarity of New Kingdom images of goddesses nursing their own children cannot be easily evaluated, since cult and temple images of deities remain largely unknown from this period. However, in certain relief contexts, and in continuation of long-standing tradition, goddesses were occasionally represented as nursing a royal child or king. Moreover, the role of high-status women as royal nurses was certainly significant at this time, as documented in many statues from the Eighteenth Dynasty (ca. 1550–1295 B.C.). Yet very seldom do works from the New Kingdom or thereafter show goddesses, royal nurses, or high-status women informally squatting or attentively fulfilling their maternal roles.[13] Beginning in the Third Intermediate Period or perhaps slightly earlier, other changes in religious practice manifested themselves, including a more overt acknowledgment of the importance of women and female divinities in both state and religious contexts, and an intensified identification of the king with the divine child, especially Horus.[14] In this atmosphere, the image of Isis suckling Horus reemerged in a formal mode and thereafter became emblematic in that form.

Images such as the falcon from Hierakonpolis or the Isis and Horus sculpture retain the imprint of the local traditions that are characteristic of the pre–New Kingdom era. The affinity felt for these local gods is poignantly evoked by the late Middle Kingdom stela of Horemkhauef in the Metropolitan Museum (35.7.55). The stela's owner, an overseer of priests at Hierakonpolis, was sent to the capital of Egypt, in the north at Lisht, to bring back a new image for the temple. In the inscription, he says:

> *Horus Who Avenged His Father assigned me to the capital [on a mission] to get Horus of Hierakonpolis and his mother, Isis, justified, having put me in charge of a boat and crew because he knew me as an official functional for his temple and watchful over what has been entrusted to him. Then I went downstream in good order and took Horus of Hierakonpolis in my arms, along with his mother, that goddess, from the Goods Office of Lisht in the presence of the king himself.*[15]

In addition to royal and temple statuary made of cupreous metal, we know of more than forty cupreous-metal statuettes of nonroyal individuals—mostly men, ranging in height from about 10 to slightly more than 30 centimeters—likely made from about the late Old Kingdom or First Intermediate Period through the pre-Thutmoside Eighteenth Dynasty

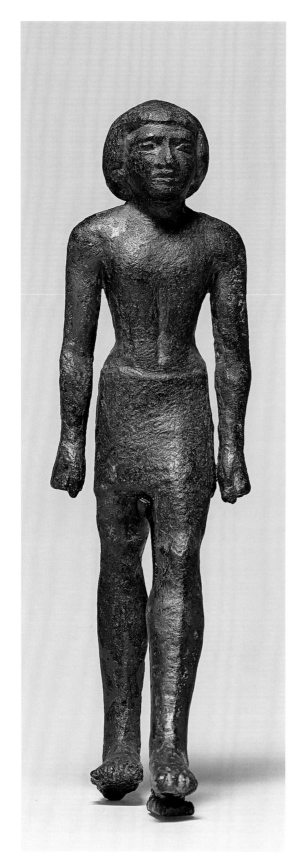

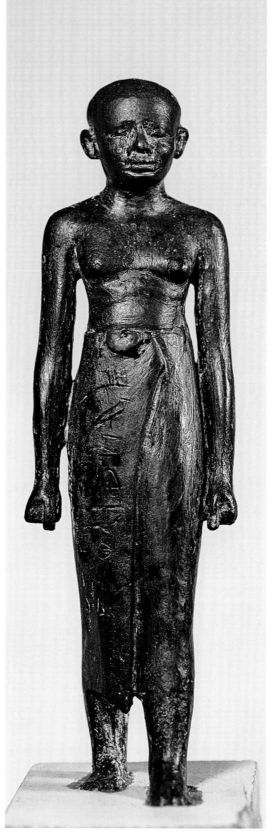

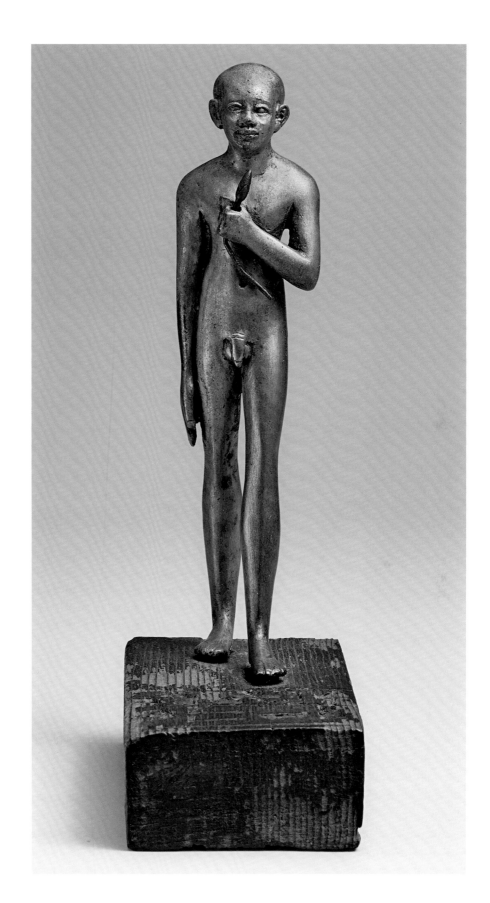

Figs. 8–10. Left to right: *Striding Man* (cat. no. 4); *Treasurer Nakht* (cat. no. 5); *Amenemhab with Lotus* (cat. no. 6)

(ca. 2323–1479 B.C.).[16] A few of these statuettes are artistically complex sculptures of high-status persons associated with the late Middle Kingdom Fayum group mentioned above, but most are less ambitious works; they depict persons whose social status is, perhaps, relatively insignificant. The range of sculptural types within the group is generally similar to that of wood statues; like most other nonroyal statuary from the period, these metal examples were intended to serve funerary purposes. One of them (cat. no. 4; fig. 8) represents a relatively early type; the man's bag wig is angled back to reveal the earlobes, a style first observed in wood statuary dating to the end of the reign of Pepi II (ca. 2152 B.C.) or slightly later, and which probably persisted into the reign of Senwosret I (ca. 1961–1917 B.C.).[17] The statuette of Nakht (cat. no. 5; fig. 9) was found in 1892 at Meir, where the owner was a treasurer, probably in some regional capacity.[18] It is datable to the second half of the Twelfth Dynasty (ca. 1887–1802 B.C.) based on the treatment of the torso, particularly the prominent breasts, and certain elements of dress, including the relatively low placement of the upper edge of his wrapped garment.[19] The statuette has no tangs; a clump of wax that once surrounded the statuette—removed sometime before 1925 by Georges Daressy, a curator in the Egyptian Museum, Cairo—probably indicates that the statuette once lay alongside the mummy in the coffin, as was often the case with small statuary in these periods.

Several of the male statuettes in this group likely date to about the Seventeenth Dynasty through the early Eighteenth Dynasty (ca. 1550–1479 B.C.), before the political centralization and the strongly cohesive style characteristic of the reigns of Hatshepsut and Thutmose III became dominant. The slight, childlike nude bronze figure of Amenemhab (cat. no. 6; fig. 10) holds a silver lotus bud. Dedicated by Amenemhab's father, Djehuti, the statuette, along with one of Amenemhab's brother, was found at Thebes in the coffin of a woman who might have been the boys' mother. As a figure holding a lotus bud or blossom, it is among the earliest examples of this New Kingdom type.[20] In the later New Kingdom, such figures appear on stelae associated with a form of the ancestor cult (which worshipped ancestors as intercessors) linked to the sun god; in that context, the lotus would have been associated with both rebirth and Re.[21] The statuette of Hepu (cat. no. 7; pp. 18–21) is distinguished by its hairstyle, which is unusual in that it was almost certainly meant to represent natural hair—that is, neither a wig nor some other elaborately shaped coiffure normally worn by elite persons, whose modes of dress are those most often seen in statuary. The so-called natural style, found on several figures from the period, evidently enjoyed a certain amount of popularity during the early Eighteenth Dynasty, possibly a sign that it was associated with the newly acquired status of a specific social or demographic group that wore its hair in a natural manner; soldiers, for example, kept their hair long for protection. It is also possible that, for a complex of reasons, there was a fashion at the time founded on a greater general acceptance for natural hair. The fact that a number of non-

royal cupreous–metal statuettes have this distinctive hairstyle but also vary in terms of technical execution raises an intriguing if ultimately unanswerable question as to whether the style is linked to a particular demographic—perhaps a specific occupation, as noted above—that had an inclination for, or preferential access to, cupreous alloys.

1. See, e.g., Aruz 2003, p. 210; see also Michael Müller-Karpe in Eckmann and Shafik 2005, pp. 1–8.

2. Kemp 2006, pp. 112–13, cited in Lorton 1999, p. 124.

3. Sethe 1914, pp. 233–35; Roccati 1982, pp. 39–41, 45, 50–51. Baud and Dobrev (1995, pp. 32–40) note what could be mentions of statues of kings and gods in the annals of the Sixth Dynasty, but this is uncertain given the lacunae in the annals. Posener-Kriéger (1976, esp. pp. 52–55, 544–65) discusses royal and divine figures and their rituals and festivals that are described in the Abusir papyri from Neferirkare's funerary temple. For relevant points related to new finds at Abusir by Miroslav Verner, see Posener-Kriéger 1997.

4. Eckmann and Shafik 2005; Hill 2004, pp. 7–9, nn. 3–9.

5. Eckmann and Shafik 2005, pp. 65–69.

6. Ibid., pp. 12–15, esp. n. 9.

7. For royal and divine cult images offered in royal and divine temples, see Altenmüller and Moussa 1991; see also Borchardt 1899, p. 96; Quirke 1997, pp. 31–32; and Lichtheim 1973, pp. 123–25. For physical remains of wood statuary, see Di. Arnold 1992, including a possible figure of the Nile god Hapy from the offering hall of Senwosret I's mortuary temple (pp. 80–82, pls. 96–100a); see also his mention of Middle Kingdom wood figures found in the mortuary temple of Pepi II (ibid.). For wood ritual figures found in a deposit at the Imhotep mastaba, see Do. Arnold forthcoming.

8. A depiction of a statue of Thutmose IV and an actual statuette of Amenhotep III are known; see Fischer 1956. Large statues of Akhenaten are documented among the fragments at the Metropolitan Museum from the dump of the Amarna Great Temple (e.g., 21.9.441); see Hill forthcoming (b).

9. For a summary of the group and bibliography, see Hill 2004, pp. 11–16.

10. Romano 1992. In general, studies of catalogue objects are cited in the checklist of works in the exhibition unless, as here, they address a topic of broader significance for metal statuary.

11. Roehrig 1996, pp. 16–19.

12. On the emergence of the canonical Isis and Horus type, see M. Müller 1984–85, pp. 213–22.

13. Roehrig 1996, pp. 16–19; Roehrig 2005, pp. 112–13. For an Eighteenth Dynasty statue of a nurse from Saqqara (Egyptian Museum, Cairo, JE 91301), see Hastings 1997, pp. 9–11 (comments by C. Roehrig), pls. x–xii; for images of nonelite individuals (e.g., figure vases) from the Eighteenth Dynasty, see Roehrig 2005, pp. 233–41.

14. See, e.g., Fazzini 2002, esp. pp. 355–60.

15. Translation by James P. Allen.

16. For recent lists, see Hill 2004, pp. 9–10, 17; Hill forthcoming (a); Mendoza 2004; and Lilyquist 2007.

17. See Harvey 2001, wig type W7a, p. 16, fig. 1b. For this wig style on a Theban figure of Wah (MMA, 20.3.210), see Roehrig 2002, p. 9, fig. 4, p. 14; there is also an example of the style on a figure in a model boat from Lisht (MMA, 24.9) dating to the reign of Senwosret I (ca. 1961–1917 B.C.).

18. Grajetzki 2001, p. 79.

19. Compare this statue to wood examples from Meir (MMA, 10.176.58–61), which are datable to the reign of Senwosret II (ca. 1887–1878 B.C.) but whose modeling suggests perhaps a slightly earlier phase; Dorothea Arnold, personal communication. See also Fay 2003, pp. 19–20.

20. Statuettes from the period of figures holding lotus buds or blossoms include a limestone statuette of Taweret (MMA, 26.7.1404; see Roehrig 2005, p. 40) and a wood figure of a man (Museo Egizio, Turin, 3101; see Donadoni Roveri 1986b, p. 146). Figures holding lotus blossoms certainly occur earlier in reliefs and in at least one wood statue (as noted to me by Dorothea Arnold; see the figure of Meketre on a riverboat in the Metropolitan Museum [20.3.1]).

21. Schulman 1986, p. 307.

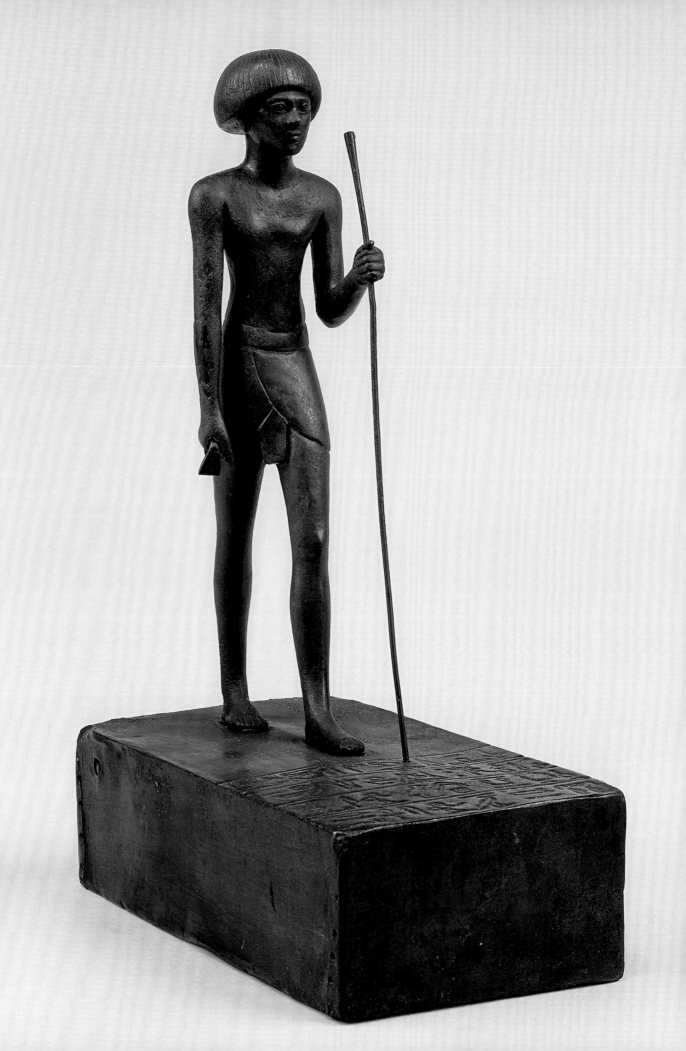

Hepu

New Kingdom, early 18th Dynasty (ca. 1550–1479 B.C.)
Copper alloy, solid cast, with hammered staff; silver/electrum (?)[1] attribute in right hand;
hammered copper-alloy sheet over wood base
H. of statuette above base 14.5 cm (5 ¾ in.); base: H. 3.8 cm (1 ½ in.), W. 6.7 cm (2 ⅝ in.),
D. 12.7 cm (5 in.)
National Archaeological Museum, Athens (3365)
[cat. no. 7]

Provenance: unknown; Zizinia collection; acquired by Ioannis Demetriou in
Alexandria; donated with his collection in 1880[2]

Selected References: von Bissing 1913, pp. 239–42, 250–52; Roeder 1956, §366a;
Tzachou-Alexandri 1995, p. 111, no. 1; Málek 1999, no. 801-426-035; Cladaki-Manoli
et al. 2002, p. 35, no. II.9; Hill forthcoming (a)

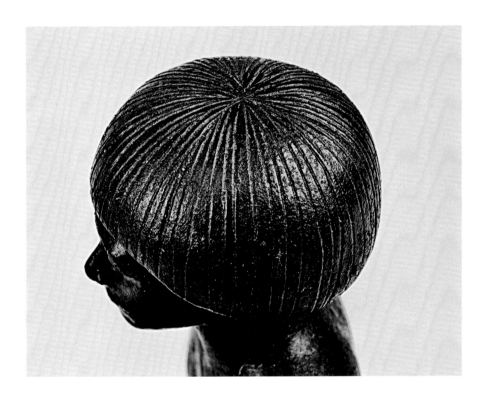

Despite its small size, this exceptionally refined statuette of a male figure is considered a masterwork of the early Eighteenth Dynasty (ca. 1550–1479 B.C.), a period, according to William C. Hayes, when "[Egypt's] rapidly growing prosperity and the accompanying rise in her standards of taste were no longer confined to certain privileged classes, but were shared to a great extent by her people as a whole."[3] Indeed, this shift is possibly reflected in some aspects of the statuette. The hairstyle, for example, whose delicate details are carefully delineated, is represented as thick and short, in what we would call a "bowl cut." Shortest in the front, it gradually gets longer toward the ears, covering them down to the lobe, and is slightly longer at the back of the head. According to a forthcoming study by Marsha Hill, this style was intended to represent natural hair, as opposed to the wigs associated with the elite. This manner of wearing the hair may have become acceptable as a fashion at this time, when emerging classes of craftsmen, musicians, soldiers, and high-society servants,

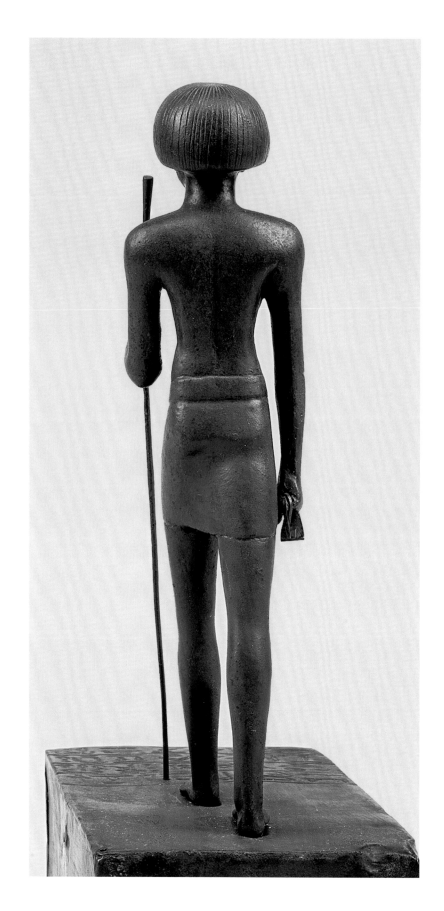

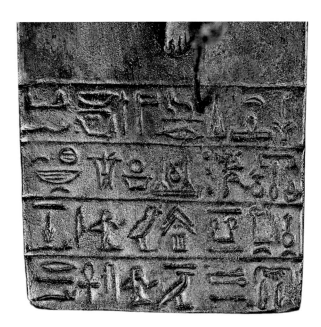

Inscription on top of base

whether they were Egyptians or foreigners (Asiatics or Nubians), presumably wore their hair in the "natural" style associated with their background. That people chose to depict themselves wearing it can likely be attributed to the prominence and popularity of one such group, the soldier class, who at the beginning of the Eighteenth Dynasty had helped bring about the withdrawal from Egypt of the Hyksos: Asiatic rulers who had held sway over a large part of the country from Avaris, their capital in the Delta.

The statuette stands on a rectangular wood base, which is clad in thin, hammered copper–alloy sheet held in place by small nails, some of which are still present. Folds in the sheet are apparent along the four vertical corners of the base. The statuette is attached to the base with two tangs. Two large nails or pegs on the right and left sides of the base align with the feet, indicating that they run through the tangs inside the base and thus provide additional stability.

The figure advances his left foot in a striding motion. His small face has plastically indicated eyes and eyebrows and a pronounced brow ridge and cheekbones. The nose has wide wings, and the small mouth is unsmiling, with only slight indications of a lower lip. The chin is somewhat narrow and receding. The body of the statuette is

sensitively carved and seems to depict a youthful figure; the torso is smooth and the modeling of the chest is well balanced. The hands and feet are similarly long and slim, with smooth curves. The left tibia (shinbone) is indicated by a sharp ridge along the length of the shin, the knees by slight pinches. A deep groove on the back of the torso marks the backbone, while the buttocks are small with angular contours.

Hepu is wearing a short, unpleated *shendyt* kilt, with its characteristic center tab, and a belt. With his left hand he grasps a staff; in his right fist he carries an object (possibly made of silver) that resembles an implement—a spatula or a scraper, perhaps—more than it does the handkerchief usually carried in the hands of such statues. The inscription on the base (above) is a typical Middle Kingdom funerary formula (*hetep-di-nesut*): "a royal offering of Osiris for the *ka* of the deceased, Hepu, by his brother, the goldsmith Tchenena, so that his name lives." The high quality of the craftsmanship might suggest the piece was executed through connections of the deceased's brother.

ET

1. Von Bissing 1913, p. 241, n. 1.
2. The work arrived with the last shipments of the Demetriou collection.
3. Hayes 1990, vol. 2, pp. 59–61.

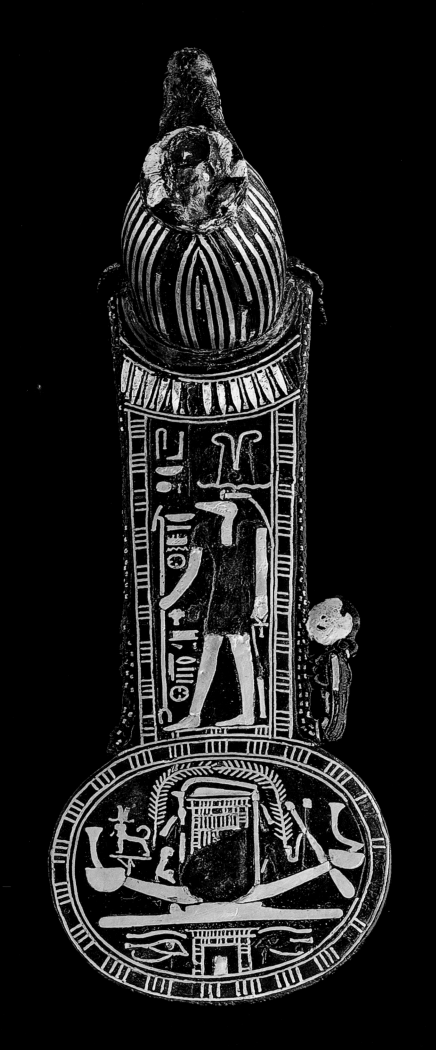

SHIFTING GROUND: THE NEW KINGDOM FROM THE REIGN OF THUTMOSE III (ca. 1479–1070 B.C.)

Marsha Hill

Recent studies of technological changes in the cultures around the Mediterranean have noted the apparent widespread availability of metals there by the Late Bronze Age, a period roughly corresponding to the Egyptian New Kingdom (ca. 1550–1070 B.C.). There also seems to have been a dramatic increase in the volume of metal in circulation and a growing tendency for metal to circulate outside official (e.g., state-controlled) channels.[1] It is reasonable to expect that Egypt would reflect the same developments. Analyses of Egyptian cupreous metals have, at least thus far, been insufficient to answer questions about the particular situation there regarding copper and bronze, but systematic observations suggest that the use of silver, much of it probably imported, increased during the New Kingdom.[2] Although this trend did not necessarily have a direct impact on statuary, New Kingdom texts, paintings, and reliefs—notably reliefs from the temples of Seti I (r. ca. 1294–1279 B.C.) at Abydos and of Ramesses III (r. ca. 1184–1153 B.C.) at Medinet Habu—detail rich accumulations of temple treasuries, including metal statuary of gods and kings.[3] This picture is borne out by a list of temple benefactions from Ramesses III, including for the Theban area alone 2,756 sacred images for whose manufacture the pharaoh committed more than 3,650 pounds each of gold and silver, roughly the same quantity of precious stones, and more than 22,426 pounds of black copper, copper, lead, and tin.[4] A few tomb illustrations of workshops likewise suggest a busy atmosphere of production, and recent archaeological work at Piramesse, the Ramesside royal city in the eastern Delta, has even brought to light impressive installations used to manufacture bronze military equipment.[5]

The number of preserved metal statuettes from the New Kingdom is sometimes seen as incommensurate with this picture, however, and, puzzlingly, it could be argued that these works reflect a diminished technological capacity compared to the sophisticated examples of metalwork known from the late Middle Kingdom. To explain this discrepancy, scholars have often proposed that metal statuary from the New Kingdom was melted

Fig. 11. View of top of Menit *Inscribed for Sobek-Re* (cat. no. 16)

• 23

down for reuse, as was the case with weapons and utilitarian items. In specific historical circumstances some precious- and cupreous-metal statuary may well have been melted down,[6] and limited reconfigurations of some sacred materials within temples cannot be ruled out,[7] but, generally speaking, it is unlikely that the sanctioned conversion of metal statuary to profane uses was a regular occurrence. There is ample evidence indicating that the ancient Egyptians revered such statuettes as sacred in and of themselves,[8] in keeping with their long-standing tradition of consigning real resources to the spiritual world. As we shall see, shifts in funerary practices, rather than the recycling of metal resources, can be identified as the likely reason for the diminished profile of nonroyal metal statuary as a class of object. Moreover, we do have, in fact, numerous examples of cupreous-metal royal statuary (cat. nos. 8–10; figs. 1, 12, 14) as well as royal and nonroyal shawabtis (cat. no. 11; figs. 15, 16) from the New Kingdom, not to mention the wealth of gold and gilded-wood figures from the tomb of Tutankhamun. Close evaluation also allows the identification of other New Kingdom examples of large royal statuary (cat. no. 12; pp. 32–33) as well as examples of divine statuary, such as the large unalloyed-copper statue of Seth (cat. no. 13; pp. 34–37).[9]

Religion in ancient Egypt had many aspects. Best known to us through countless relief representations is what might be referred to as the state religion, in which the king and the gods were linked, like a son to parents, in a cycle of offerings and care that ensured the functioning and well-being of the world. The king and the gods were represented as the only actors in this exclusive performance, which was conducted in a shrine within the recesses of the temple. Yet at festival times, barques carrying the image of a deity emerged from the inner recesses of temples to travel out among the populace, providing opportunities for all persons, regardless of social status, to attend the passage of the god's image in order to rejoice in the divine presence. In the late New Kingdom, it becomes clear that through such processions festival attendees could themselves receive oracles and other divine indications: part of the emergence of a variety of modes whereby a wider population attained access to the gods.[10]

A testament to the role of royal metal ritual statuary in maintaining these cycles is a group of small statuettes of kings who seem to be offering either *nu* pots or small figures of the goddess Maat.[11] The *nu* pot is the classical form of the essential offering to the gods; indeed, an arm offering a *nu* pot forms the hieroglyph meaning "to offer." Maat represents "the way things ought to be," or proper order. These offerings, along with the later addition of the *wedjat* eye offering (which signified the entirety of all offerings), constituted the gifts that represented all others: the epitome of the offerings that had to pass between the king and the gods.[12] The earliest known example in the group (cat. no. 8; fig. 1) is a "black bronze" statuette of Thutmose III (r. ca. 1479–1425 B.C.).[13] There is a marked agreement between this king's facial features and those found in stone depictions of Thutmose III,

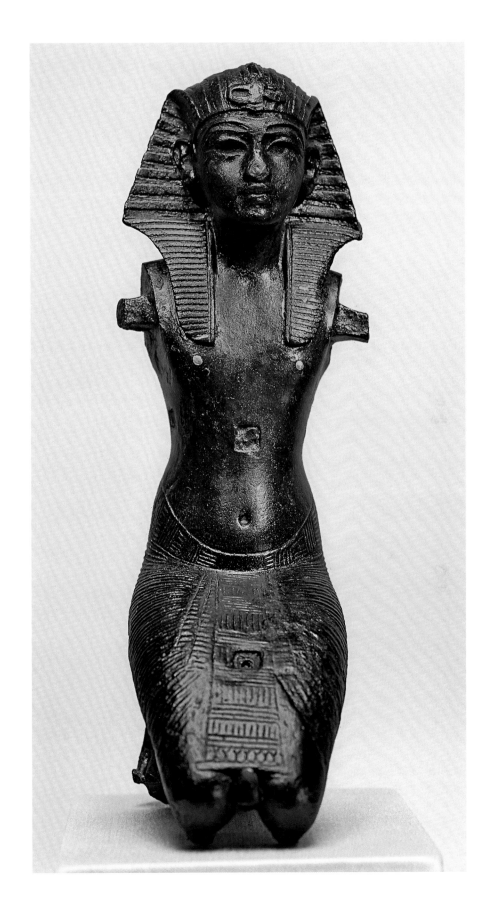

Fig. 12. *Kneeling King (Probably Tutankhamun)* (cat. no. 9)

including his characteristic Adam's apple. Conversely, a detail such as the treatment of the belt line, which narrows considerably from back to front (fig. 87), anticipates a mode adopted in stone statuary only with the reign of Amenhotep III (ca. 1390–1352 B.C.).[14] The reign of Thutmose III coincided with a period when the public and processional functions of the cult of Amun at Thebes were subject to considerable elaboration, including, for example, the peopling of the decks of processional barques with small royal ritual statuary (fig. 13). It is possible that this statue was used in such a context, where it would have helped to preserve the protective cultic atmosphere around the vulnerable divine image. Small royal statuary was not restricted to use on processional equipment, however; from relief depictions of temple cults and the record of the temple endowments of Ramesses III, we know that such statues were featured in many ritual contexts and in temples throughout the country.[15]

Like the statuette of Thutmose III, catalogue number 9 (fig. 12), a finely modeled statuette of a king, is a so-called black bronze. Traces of precious-metal detailing remain on the king's *nemes* headdress, his nipples, and, perhaps, his kilt. The eyes seem to have been lined with cupreous-metal sheet and inlaid; the eyebrows were also inlaid. The identification of this monarch as Tutankhamun (r. ca. 1336–1327 B.C.) is virtually certain despite the highly complex period of royal succession following the death of Akhenaten (r. ca. 1352–1336 B.C.; as Amenhotep IV, r. ca. 1352–1349) and the concomitant difficulties of parsing royal portraiture from that time. The statuette's distinctive features—the broad cheeks, slightly pointed chin, and furrows at the corners of the mouth—coordinate very closely with other images indisputably identified as Tutankhamun's. It is possible that the statuette was created as part of Tutankhamun's reparations of rich divine

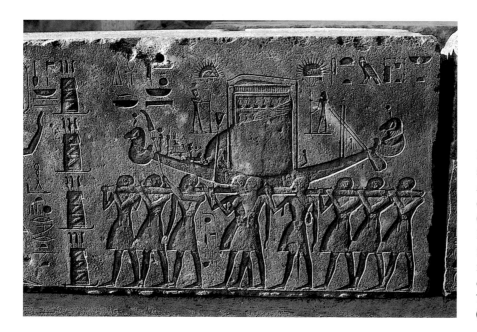

Fig. 13. Processional barque of Amun depicted on block from the Chapelle Rouge, Karnak, Thebes. 18th Dynasty, primarily joint reign of Hatshepsut and Thutmose III (ca. 1473–1458 B.C.)

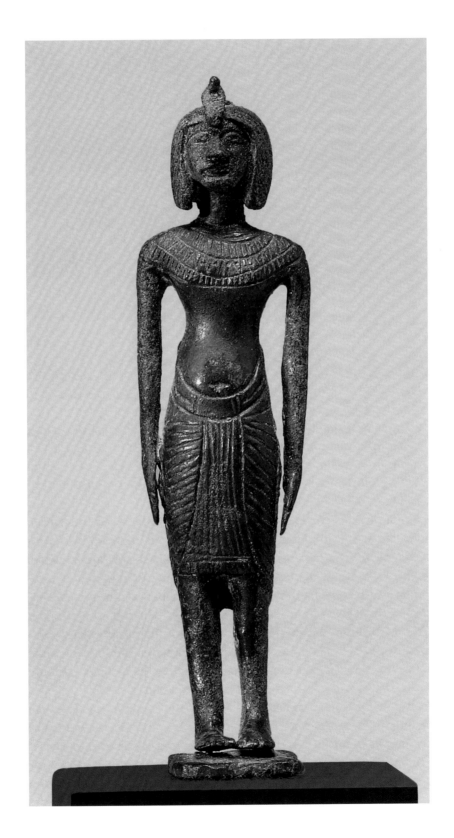

Fig. 14. *Standing Amarna King* (cat. no. 10)

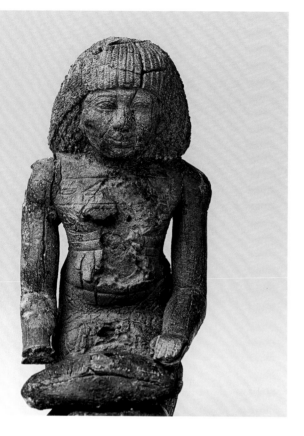

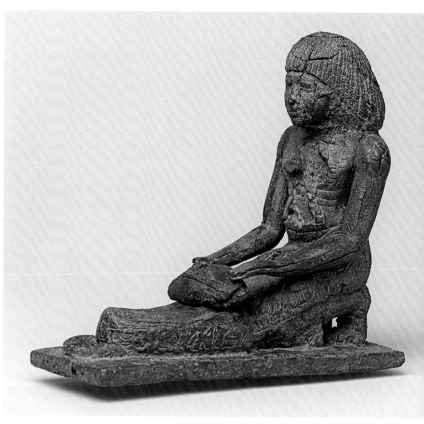

Figs. 15, 16.
Shawabti of Siese
(cat. no. 11), with
detail of face and
torso at left

statuary and enlarged barque equipment, along with property and sup-
plies, to the temples and gods deprived of support during the Amarna
period, when Akhenaten gave his entire devotion to the sun disk, or Aten.
The king's restoration inscription, quoted in part as the epigraph to the first
essay in this volume (p. 3), records the rejoicing this renewed attention
engendered among the gods and the people. It bears reiteration here for
the picture it offers of the deep-seated identification between the people
and their gods in New Kingdom Egypt: "As for the gods and goddesses who
are in this land, their hearts are joyful; the lords of the shrines are rejoicing,
the shores [i.e., the people lining the shores] are shouting praise, and exulta-
tion pervades the [entire] land now that good [plans] have come to pass."

Another small royal figure (cat. no. 10; fig. 14), which has been in the
Walters Art Museum, Baltimore, since 1927, is indisputably datable to
the Amarna period because of its so-called Amarna navel. The statuette is the
same figure traced by Egyptologist Ludwig Borchardt to the Medinet el-Gurab
find of 1904–5, which, if it was indeed the discrete find that Borchardt believed
it was, also included the famous wood head of the aged Queen Tiye, wife
of Amenhotep III and mother of Akhenaten (Ägyptisches Museum und
Papyrussammlung, Berlin, 21834), along with other objects related to Amen-
hotep III and his family.[16] The Gurab find and the archaeology of the site,
both recently reevaluated, are probably best understood as evidence for a
cult of the deceased Amenhotep III.[17] Interestingly, the range in the quality

of workmanship of the objects associated with the find suggests that some of the pieces, including this royal statuette, were produced in workshops peripheral to the most sophisticated ones, whether these were local temple workshops or other types accessible to a wider community wishing to make donations to a specific sacred place or deity.[18] Another, perhaps slightly later structure at Medinet el-Gurab that has been associated with a cult of the deceased Thutmose III has certain features that can be described as private chapels: worship and gathering places that served the needs of a local community.[19] A royal figure like the Walters statue would seem to correlate well to such a context; it represents a descendant of Amenhotep III, who would presumably have been the focus of cult practice in such a chapel, and it is made in metal, a material often associated with ritual statuary. My earlier proposal that the statue can be compared to small figures of Tutankhamun topping the gold and silver staffs from his tomb has proved to be incorrect, however, since the socket on the bottom of the figure's base is not ancient,[20] leaving the precise manner of this statue's display and use a mystery.

The number of examples of nonroyal statuettes in poses and stances typical for use in burials diminishes greatly in the New Kingdom, and metal statuary is no exception, reflecting a general shift in funerary practices away from the deposition of statuary in tombs.[21] Although the shawabti (a funerary servitor who performed labor for the deceased in the afterlife) was by no means the equivalent of formal tomb statuary, these figures were creatively elaborated during this period, and a certain number of cupreous-metal shawabtis exist of nonroyal and even some royal individuals. These include an unusual shawabti of Siese (cat. no. 11; figs. 15, 16), an important official who can be dated to the reigns of Thutmose IV (ca. 1400–1390 B.C.) and, possibly, Amenhotep III. This shawabti type, which depicts a figure kneeling at a millstone grinding grain, may have been influenced by Old Kingdom serving statuettes, which had been rediscovered in the course of continuing use during the New Kingdom of the Memphite burial grounds.[22] Yet men never grind grain in Old Kingdom depictions, and the elegant attire and delicate grasp of the shawabti figure are totally inappropriate for what in reality was backbreaking work.

Catalogue number 14 (fig. 17), a small bronze of an elaborately wigged and kilted man kneeling with his hands raised in a worshipping gesture, is datable to the late New Kingdom (late Nineteenth or Twentieth Dynasty, ca. 1250–1070 B.C.) based on a combination of stylistic traits (especially the face, wig, and garment) and technical features (the tangs). It is the earliest convincingly datable small metal statue of a nonroyal man in a temple or ritual pose.[23] The type becomes familiar during the first millennium B.C., but most statuettes in the genre display the shaved head, flowing garments, and other accoutrements that, from the New Kingdom onward, were associated with priests. Some of these later works could, theoretically, date to the New Kingdom as well, but the persistence of priest-related features across such a long period of time makes dating such works difficult, especially

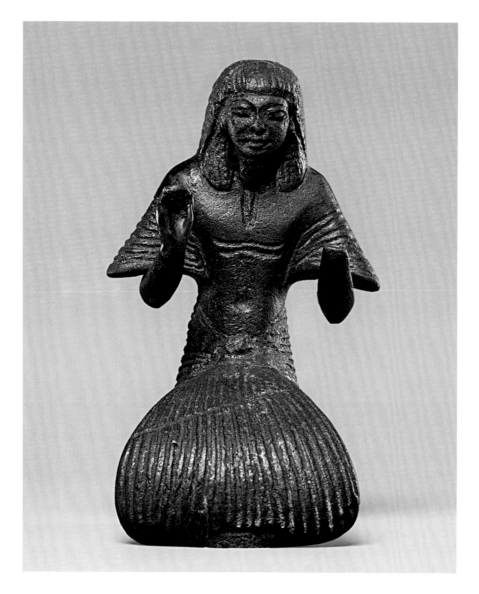

Fig. 17. *Kneeling Official* (cat. no. 14)

in the absence of a better understanding of the evolution of social factors and decorum that might have influenced their creation and placement in temples.[24]

These small nonroyal figures represent only one aspect of the difficulties scholars face when dating certain works owing to the lasting popularity of Thutmoside and early Ramesside stylistic features throughout the Third Intermediate Period. For metal statuary, one promising area of study that could help to identify distinctions among such works is the careful mapping of technological phases,[25] including observable shifts in the compositions of luxury alloys, as proposed by Élisabeth Delange (see her essay in this volume). More generally, an increased understanding of Ramesside and especially late Ramesside art, areas that remain particularly thorny for scholars, is needed to supplement advances in our comprehension of the complex art from the Third Intermediate Period.

1. Sherratt and Sherratt 2001, p. 29; Stós-Gale 2001, pp. 203–4, 207.

2. Deborah Schorsch, personal communication, based on her database documenting the use of gold and silver in ancient Egypt.

3. See Robins 2005 for references to some of this rich source material; see also Grandet 1994–99.

4. Grandet 1994–99, vol. 1 (pp. 75, 236, 252), discusses these Theban benefactions, which are given as 18,252 deben of gold and silver (in the New Kingdom five deben equaled roughly 1 pound); 18,244 deben of precious stones; 112,132 deben of black copper, copper, lead, and tin; 328 pieces of pine; and 4,515 pieces of persea wood.

5. For workshop scenes, see, for example, Ogden 2000, pp. 150, 155. For a brief introduction to the work at Piramesse, see ibid., pp. 155–57.

6. Jansen-Winkeln 1995.

7. In Greek sanctuaries, small precious-metal donations were periodically recorded in inventories but were then combined and melted down to cast more significant offerings; Van Straten 1992, pp. 273–74.

8. See the chapter "Lives of the Statuary" in this volume.

9. For other examples, see the studies referred to in the essay "Art and Influence in Temple Images" in this volume, n. 9. Add to these a post–Amarna figure of Amun in the Walters Art Museum, Baltimore (54.401), as noted by Peter Lacovara in Freed et al. 1999, p. 274.

10. Baines (2006) presents, as a sort of corrective, a skeptical assessment of public performance. For questions that were addressed to the gods during the New Kingdom in the hopes of obtaining oracular decrees, see Valbelle and Husson 1998. See also Černý 1962, which presents a basic overview of the question.

11. This is true to the extent that the state of preservation of the statues has allowed us to ascertain what, exactly, they seem to be offering.

12. Regarding the statuettes, see Hill 2004, pp. 16–21; regarding the offerings (including references), see ibid., pp. 124–25; Tefnin 1979, pp. 74–78; Teeter 1997, p. 78; and Englund 1987, p. 57.

13. As discussed elsewhere in this volume, the term "black bronze" is used conventionally to refer to an alloy of copper, tin, and gold that was treated chemically to achieve a contrasting, dusky background suitable for precious-metal inlay. See the essay in this volume by Élisabeth Delange, in which she discusses catalogue numbers 8, 9, 15, and 16, as well as the essay by Deborah Schorsch.

14. The belt line does seem to appear somewhat earlier in reliefs, so there is a possibility that this feature is a manifestation of the relationship between temple reliefs and metal works that can be observed in the Saite Period. This relationship is likely attributable to the locations of the workshops where such statues were made (in temples) and the ritual function they shared with the reliefs.

15. Hill 2004, pp. 136–39; Grandet 1994–99, vol. 2, pp. 28–29, n. 128.

16. Borchardt 1911, p. 16.

17. Do. Arnold 1996, pp. 27–28, 34–35.

18. Kozloff et al. 1992, pp. 211–12; Kemp 1995, pp. 35–36.

19. Bomann 1991, pp. 83–84.

20. Steindorff (1946, p. 47) cites the acquisition date incorrectly as 1907; since the piece was acquired only in 1927 (after the discovery of Tutankhamun's tomb in 1922), my earlier reasoning turns out to be invalid. I am grateful to Regine Schulz, Terry Drayman-Weisser, Jennifer Giaccai, and Deborah Schorsch for their careful examination of the statue, which definitively determined that the socket is a modern feature.

21. Stuart Tyson Smith 1992.

22. Schneider 1977, vol. 1, p. 23.

23. Relevant to the question of ritual and temple contexts for metal nonroyal statuary is a group of metal statues of nude women (some datable to the Thutmoside period) that form the handles of caryatid mirrors, suggesting some unusual context of use; see, e.g., Lilyquist 2007.

24. For a catalogue of metal statues depicting priests, see Mendoza 2006. The differences between nonroyal and royal statuary are suggested by their respective repertoires of hand positions and "offerings," which only partly overlap, and by the fact that ancient groupings incorporating priests were not always dismantled at the time of burial, as was the case with groups containing major types of royal figures; see the essay "Lives of the Statuary" in this volume.

25. For example, catalogue number 28 might have been a candidate for an earlier date, but certain technological features of the work indicate that it dates to well within the first millennium B.C.; see discussion by Deborah Schorsch, pp. 192–93.

Fragment of a Wig

New Kingdom, late 18th–19th Dynasty (ca. 1350–1186 B.C.)
Copper alloy, hollow cast
H. 8 cm (3⅛ in.), W. 16 cm (6¼ in.), Th. 0.7 cm (¼ in.)
Cyprus Museum, Nicosia (Enkomi Fr. Ex. Inv. No. 126, 1960)
[cat. no. 12]

Provenance: Cyprus, Enkomi, quartier 3E

Selected References: Courtois 1984, p. 35, no. 311, pl. I:3, fig. 9:2; Cenival 1986;
Courtois et al. 1986, p. 68, pl. 18, no. 10; Karageorghis 1986, pp. 46–51

This cluster of curls, identified by Jean-Louis de Cenival as a fragment of a so-called Nubian wig, dates most likely to the Amarna period, when this hairstyle was fashionable for men and women of all social classes, or to the later Eighteenth or Nineteenth Dynasty (see fig. 18). Such wigs were perhaps revived in the Third Intermediate Period for archaizing works, but the Late Cypriot context of the fragment's unusual findspot at Enkomi,[1] an ancient port in eastern Cyprus, precludes a date after the New Kingdom. Taking into account the wig's style and high quality, the metallurgical history of Cyprus, and textual sources found at Amarna[2]—and in spite of copper-ore provenance data[3]—it is unthinkable that the statue from which this piece derives was produced anywhere other than Egypt. The fragment offers, therefore, a tantalizing glimpse into the production of large-scale metal statuary in the New Kingdom.

The curls were carefully modeled in high relief onto a sheet of wax that formed the walls of the head and then articulated with pronounced undercuts and scoring. Cenival, citing parallels among the fragmentary wigs of faience, stone, and wood found at Amarna, hypothesized that the fragment comes from the head of a composite statue, whose complete height he estimated to be between 1.2 and 1.5 meters, or considerably taller than Egyptian cast statuary preserved even from the subsequent Third Intermediate Period.[4]

Such a statue would have been considerably larger than surviving examples of New Kingdom statuary (see, for example, cat. nos. 6–9), which in turn are smaller than cupreous-alloy works that survive from the late Middle Kingdom.[5] A round perforation partially preserved in the outline of the fragment, however, probably accommodated a core support, a measure superfluous if the work had been only a wig. The quality of the execution is superior to that of many large works from the Third Intermediate Period, such as Osirid and female figures in the British Museum (cat. no. 25; pp. 95–97).[6] The existence of such a work, taking into account the many dissimilarities in quality, ambition, and manufacture among works produced in Egypt over several millennia, suggests perhaps knowledge that was periodically abandoned and revived and also points to the existence of regional centers where different types of works were produced using variations on established techniques.

In ancient times Cyprus exported copper along trade routes extending throughout the Mediterranean, but its own metal industry, particularly in terms of nonutilitarian works, was still in its infancy in the Late Bronze Age. Only between about 1330 and 1150 B.C. (Late Cypriot IIC–IIIA) was the lost-wax process or even cupreous metals first used for ritual products and figurative representations, functions previously served by stone and terracotta.[7]

The discovery of this single figural fragment, which appears to have been broken and flattened in antiquity, among so many finds at Enkomi relating to metal production, suggests that the metal itself was being recycled, but it is unlikely that the figure was brought to Cyprus for that purpose, even though its original function there cannot be deduced. This accomplished and ambitious casting of a human figure, and other smaller but also fine examples of hollow casts of Egyptian manufacture or inspiration,[8] may well have demonstrated to Cypriot consumers, and to workers in the nascent Cypriot metal industry, the possibilities offered by lost-wax hollow casting.[9]

D S

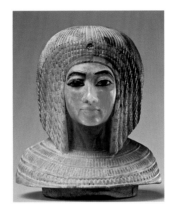

Fig. 18. *Head of a Royal Woman on Lid of Canopic Jar*, 18th Dynasty, reign of Akhenaten (ca. 1352–1336 B.C.). Travertine with stone and glass inlays, H. 18.2 cm. The Metropolitan Museum of Art (30.8.54)

1. The end of Late Cypriot III (1220–1075 B.C.) serves as a *terminus ante quem* for its deposition (Courtois et al. 1986, p. 8) and not as the date of its manufacture.
2. See Moran 1992, pp. 104–13, letters 33–40, for correspondence sent to Akhenaten or his successors over a period of about ten years (p. 104, n. 1) referring to gifts and requests for gifts given or received by the king of Alasia, thought to be Cyprus or a region of Cyprus. Numerous finds excavated on Cyprus still require close scrutiny in order to determine if they are imports from Egypt, Egyptianizing works from the Levant, or of local origin.
3. Lead isotope analysis to establish the origin of the metal itself, undertaken by Zofia Stós and Noel Gale, was described in Karageorghis 1986 (pp. 49–51) as inconclusive, partly as a result of the lack of reference data for Egyptian sources and artifacts; analyses conducted more recently of copper-alloy objects excavated at Amarna (Stós-Gale et al. 1995) identified Lavrio (Attica) as one of two major sources for the copper. Lead isotope ratios for the Enkomi wig fragment matched those of a second, then unknown source that also provided metal used on Cyprus. The place of origin of

the ore was described as Malatya (southeast Anatolia) in Stós-Gale and Gale 1994 (pp. 92–122, 210–16, 214, no. F1552), now localized to the Bolkardağ area in the Taurus Mountains based on isotopic values published in Sayre et al. 2001, pp. 112–15, and Hirao et al. 1995 (Stós, 11 December 2006, e-mail communication), although Crete is also a possible source (Stós-Gale 2001).
4. Cenival cites the height of the largest metal figure in the Louvre as 83 centimeters; in fact, the Louvre's striding falcon-headed god found with the figure of Seth (cat. no. 13) is 95.5 centimeters in height. Even so, there is a marked difference in scale.
5. Hill 2004, pp. 11–16.
6. For Osirid figures in the British Museum, see Taylor et al. 1998; for female figures in various collections, see Delange et al. 1998.
7. Schorsch and Hendrix 2003a, pp. 54–55; some ambitious examples of Cypriot cupreous cast metalwork found at Enkomi are illustrated in Courtois et al. 1986, pl. 18.
8. South et al. 1989, p. 26, pls. I, IX, X.
9. Schorsch and Hendrix 2003b.

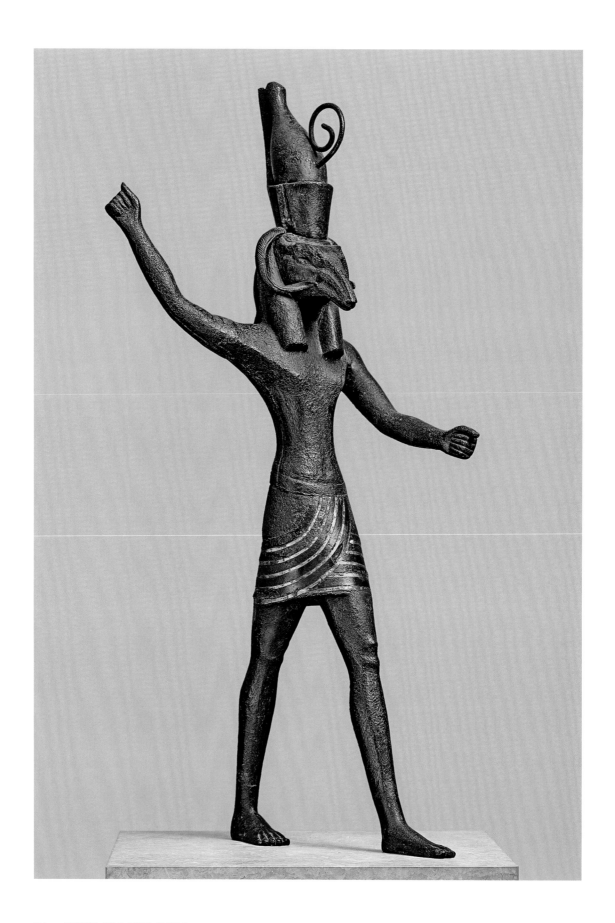

Seth

New Kingdom, 19th–20th Dynasty (ca. 1295–1070 B.C.)
Unalloyed copper, solid cast, with separate right arm; auriferous-silver and copper-alloy inlay;
partially clad with gold sheet; altered in antiquity by removal of ears and addition of ram
horns and crown with lituus; feet with lower legs, right horn, and reattachment of right arm
are 19th-century restorations[1]
H. as restored 67.7 cm (26 ⅝ in.), W. 35 cm (13 ¾ in.), D. 30 cm (11 ¾ in.)
Ny Carlsberg Glyptotek, Copenhagen (AEIN 614)
[cat. no. 13]

Provenance: unknown, said to be from Saqqara;[2] Posno collection; Hoffmann collection; Jacobsen collection; acquired in 1899

Selected References: Roeder 1956, §§61Ab, 62b, 63a, 64c, 65a,e, 98; Porter and Moss 1978, p. 870; Jørgensen 1998, pp. 340–41, no. 144; Schorsch forthcoming

Altered in antiquity by the removal of its upright ears and the addition of horns, this statue retains the characteristic drooping snout of the fabulous *seth*-animal. The resulting representation has traditionally been ascribed to Khnum, but the god Amun is more likely.[3] The transformation of Seth probably relates to changing political conditions. Associated with foreign gods such as Reshef and Baal and with foreign lands, Seth was favored by the Hyksos kings ruling from Avaris during the Second Intermediate Period and attained his greatest prominence under the Ramessides, who originated in the eastern Delta. Thereafter, the god and his foreign compatriots fell from grace. After the Twentieth Dynasty, the temples of Seth declined, images of the god were no longer produced, and the use of his name in royal and private personal names ceased. Although Herman te Velde has suggested that this shift from adoration to demonization—including the actual destruction of existing representations of Seth—occurred much later, in the Twenty-fifth Dynasty,[4] the erasure of the god's name and image is attested as early as the reign of Osorkon II (ca. 874–850 B.C.).[5]

Elongated and top-heavy, the solid figure was cast integrally with its right arm;[6] the left arm is separate (see fig. 88) and held tightly in a mortise in the shoulder by a small metal wedge. The hollow fists offer no evidence of what they carried. Although Seth's stance is also not readily identifiable, it is similar to the positions of gods and kings when they are shown smiting while holding pris-

oners or when they are represented as warriors holding shields. As in some other New Kingdom representations of Seth,[7] the figure wears a double crown, which was cast separately from the body and is held in place with a loose tenon (see fig. 88), an unusual solution that suggests the crown is a later reattachment or addition, though certainly made while the figure was still intended to represent Seth because of the space reserved for the prominent ears. The odd recessed area on the god's forehead appears to be part of the ancient reworking of the figure: the brow was cut back, while some metal was reserved and articulated in relief to serve as the "root" for the separately cast horns.

The figure is porous (see fig. 88), not surprisingly, since it is relatively large and was cast from unalloyed copper. The latter feature is intriguing; bronze was used for figural statuary in the late Middle Kingdom, if not earlier, so the possibility exists that an older formulation was intentionally chosen.[8] With this in mind, a gilded arsenical-copper figure of a foreign smiting god in the Roemer- und Pelizaeus-Museum, Hildesheim (RPM 46), is doubly significant.[9] Like Seth, he wears a long kilt made from a wrapped length of cloth with stripes indicated with precious-metal inlay. The Hildesheim god has on his right leg one of the two corners of the wrapped cloth also seen on the outside of Seth's thighs, where they fall below the garment's lower edge (see p. 36). These appendages are different in form and unrelated in function to tassels known from representations of west Asiatic nomads called

Detail of kilt

Shasu by the Egyptians, which were often worn by Baal/Reshef, or by Seth in the form of Reshef or Baal, on Ramesside royal or private stelae.[10] On the Copenhagen Seth, the silver stripes alternate with inlays of cupreous metals that differ in color from the statue itself, with a large inlay placed into the recessed area above the first silvery strip. Much, if not all, of the rest of the figure was covered with thick gold sheet, which is retained on the crown where it is crimped in the recesses originally hidden by the ears. Channels extending up the sides of the torso and below the arms, on the wig, and on the backs of the legs confirm that these parts were also covered with precious metal. DS

1. Gamma radiographs of the figure were taken at Force Technology, Brøndby, Denmark, in February 2006, and metal samples removed from various components were analyzed using EDS/WDS/SEM in the Sherman Fairchild Center for Objects Conservation in September 2006. We thank Gunnar Nygaard-Petersen, who carried out the radiography.
2. Stern (1883, pp. 285–86) refers to the recovery of this piece with seven others near Saqqara, including figures of Bepeshes, an anonymous private man, and a falcon-headed god, all now in the Louvre (E 7693, E 7692, E 7705). See also Yoyotte 1958, p. 82, nn. 4, 5; Zivie-Coche 1991, pp. 270–71.
3. Vandier 1969, p. 193.
4. Te Velde 2001, p. 270.
5. Sourouzian 2006; Montet 1947, pl. IV.
6. The right arm broke off at some point and was reattached in the nineteenth century, apparently in its original position.
7. For example, a steatite figure of Seth accompanied by Nephthys in the Louvre (E 3374), dated to the time of Ramesses II (r. ca. 1279–1213 B.C.), is wearing a double crown with uraeus and a wig; illustrated in Klaus Ohlhafer, "Statue: Seth mit Nephthys," in Petschel and Falck 2004, pp. 19–20, no. 6.
8. See discussion of the chronological introduction of alloys in "The Manufacture of Metal Statuary," pp. 190–92.
9. The height of that figure is 21.7 centimeters; see Roeder 1937, §26, pl. 2h–k (as New Kingdom, which is likely); Bettina Schmitz, "Statuette des Gottes Reschef," in Petschel and Falck 2004, p. 179, no. 170 (as Third Intermediate Period). Results of atomic absorption analysis appear in Riederer 1984, p. 6, no. 6.
10. See Te Velde 1977, pl. XI, for a royal stela from Qantir, and Cornelius 1994 for numerous private stelae. The motif visible on the right leg of a Baal-Zaphon figure on a limestone stela found at Ras Shamra (Musée du Louvre, Paris, AO 15775) represents a pendant corner of the deity's striped garment; Cornelius 1994, pp. 135–42 (described as a tassel), pl. 32, BR1. Interestingly, Eggler (2006, p. 1/8), who does perceive the difference, refers to Baal-Zaphon's clothing as "Egyptian garb."

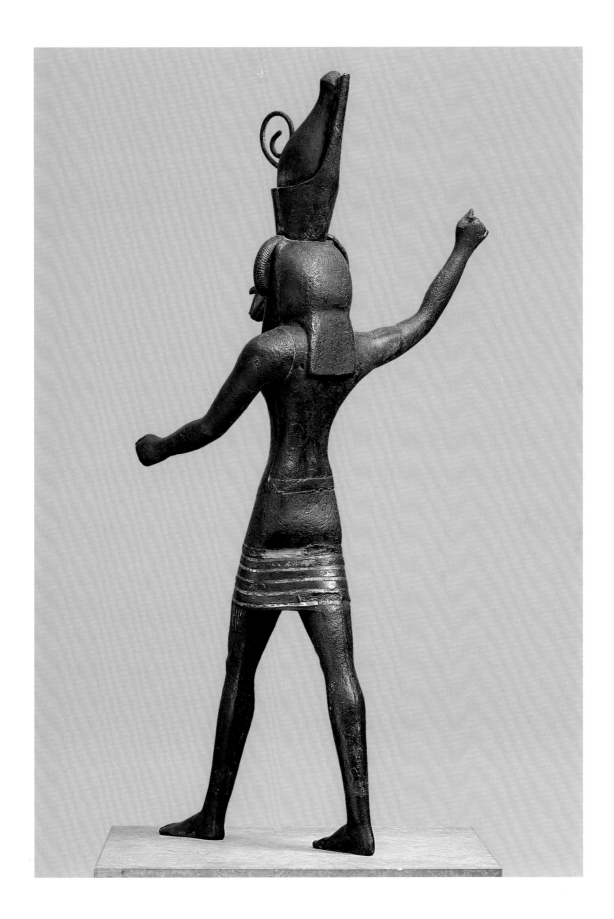

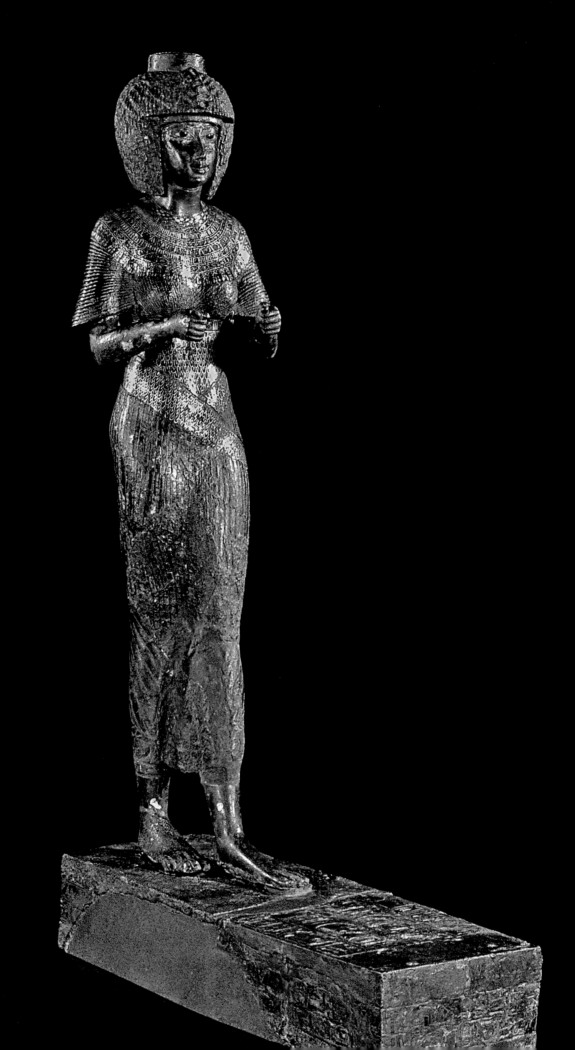

THE COMPLEXITY OF ALLOYS: NEW DISCOVERIES ABOUT CERTAIN "BRONZES" IN THE LOUVRE

Élisabeth Delange

The collection of bronzes in the Musée du Louvre's Department of Egyptian Antiquities includes landmark works of art that are renowned for their extraordinary technical accomplishment as much as for their storied provenances. Although these sculptures are well known to devotees of pharaonic art and are frequently illustrated, their descriptions, at least from a material point of view, are often inexact because they have not been studied sufficiently in this regard. This essay discusses a number of remarkable Egyptian bronzes in the Louvre that, after recent analyses using the most scientifically advanced means available, have revealed new and unsuspected horizons. The results of these studies, including the revelation of alloys more diverse and complex than ever before expected, require modifications of many long-accepted opinions and, in turn, lead us toward a refined visual comprehension of these precious objects.

One area in which significant progress has recently been made at the Louvre is the study of metal polychromy that is no longer perceptible to the human eye.[1] Most ancient metal objects appear quite differently today than they did when they were originally created: a result of the inevitable alteration of metals over time and, often, of the damaging treatments they suffered after rediscovery, both of which can mask their initial brilliance to the point of transforming or even inverting color relationships. Original nuances of color intended by the artisans can, nonetheless, sometimes be deduced by recognizing the diverse compositions of alloys employed on a given object. In addition, recent discoveries have revealed how specific alloy compositions permitted the creation, through chemical processes, of certain patinas, which added further hues and even greater nuance. "Black bronze" (and "black copper"), cupreous alloys containing small amounts of gold and silver, enabled the creation of black patinas that gleam like hematite[2] as well as other artificial surface colorations ranging from true black to deep blue, and from brown to red and dark gray.[3]

The statue of Karomama (fig. 19) is a remarkable testament to what Egyptian bronze-workers could achieve.[4] Here the Divine Adoratress and God's Wife of Amun, as she was titled, who lived in Thebes under the reigns of Osorkon II and Takelot II of the Twenty-second Dynasty (ninth

Fig. 19. *God's Wife of Amun Karomama*, 22nd Dynasty, mid-9th century B.C., from Karnak, Thebes. H. with base 59.5 cm. Musée du Louvre, Paris (N 500)

century B.C.), is depicted in a walking pose, with her extended hands shaking sistra (now missing) to distract and calm Amun. The statue was assembled from elements cast separately using the lost-wax method in a range of alloys. The base contains a high percentage of tin (12.6), which imparts a yellow color; originally it would have contrasted with the figure, which has a higher percentage of copper and, thus, would have had a pinker tone. The *wesekh* collar spread over the shoulders and upper chest is not a separate element but was cast with the body. One might imagine that this surface originally was patinated (in some yet to be discovered manner) to contrast with the rich floral decoration worked out over its surface in inlays of four different alloys, from relatively pure gold (the petals) to pale electrum[5] (the sepals) to copper-rich gold (for the brown tips and the collar's counterweight). The result would have been a visually sophisticated program of embellishment designed to shimmer and to alternate in color. The plumes of the vulture that encircle the statue's pleated dress are likewise formed from small cells that were first covered entirely with gold and then inlaid with fine scales of a copper-gold alloy that have a dark gray surface;[6] almost all of these are missing today. It is difficult to recapture the subtle interplay of all this decoration: the delicate modulations of the collar; the dark wings of the vulture, each feather delineated by precious metal; the brilliance of the flesh covered in gold leaf.

Originally the bronze substrate of the statue of Karomama was largely hidden by gilding and inlay. On the base, though, the bronze surface, with its inherent coloration, would have been apparent, and against it the ebony-colored inlaid inscriptions would have stood out. Some of the inscriptions, which are black bronze, are lost; others were partially scraped away by early restorers owing to a misunderstanding of the black surfaces. The seven gold-containing alloys, some precious metal and others cupreous, that have been identified on this statue testify to the palette of coloristic nuance known to the bronze-workers of the epoch. Yet despite our awareness of these different alloys, and even knowing that they were employed to achieve distinct tones, the ultimate effect of this can only be partly imagined, since some of the alloys may also have been treated in order to create an artificial patina that is now lost.

This remarkable technical feat—this jewel "full of charm," as she is described in the inscription—was commissioned by Karomama's Chief Steward, Ahtefnakht. By virtue of his status as a God's Father, Ahtefnakht would have approached the statue of the god Amun during rites in the temple alongside the woman whose name he sought to perpetuate through the creation of this statue; the figure itself was intended to be exhibited in the prow of the processional barque of Amun. In his capacity as Overseer of the Treasury, Ahtefnakht had access to precious metals. The parallels between his offices and the ritual and artistic emphases of the statue constitute a kind of "signature" that allows us to identify Ahtefnakht as the master behind this work, since technical masterworks were conceived in the temple by priests and innovative artists working jointly.

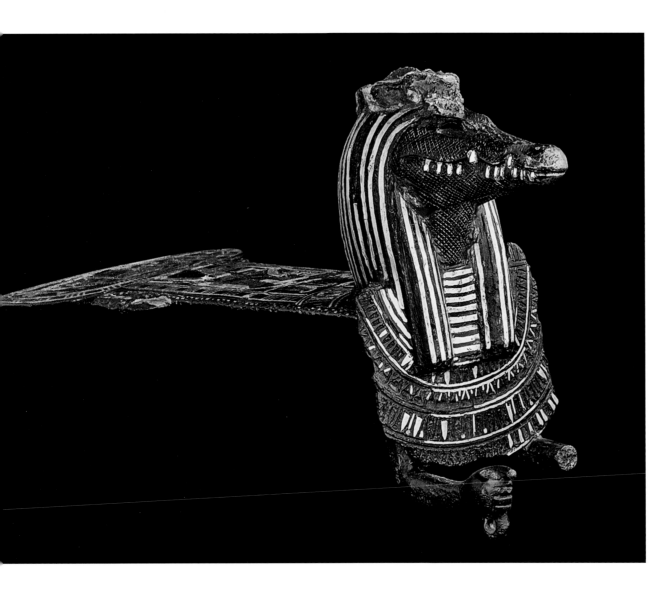

Fig. 20. View of
front of Menit
Inscribed for Sobek-Re
(cat. no. 16)

As with Karomama, the recognition that a work exhibits polychromy often proceeds from the identification of the alloy black bronze. This material was so precious in the eyes of the Egyptians that lists of offerings often mention it following the most noble metals, gold and silver, and before bronze or copper.[7] Indeed, a growing number of objects in the Louvre can be recognized as black bronze. Whereas on the statue of Karomama the metal was cut into small pieces and used as a material for inlay, it was also employed as the basic metal for luxury objects, as seen in four examples from various epochs that testify to the role of such exceptional pieces in relation to a divine statue.[8] One is a distinctively shaped collar counter-weight (*menit*) with the head of a crocodile, which served the cult of the god Sobek (cat. no. 16; figs. 11, 20).[9] The scene represented on the roundel[10] suggests the object was used in connection with the divine processional barque of the god, who is described in the inscription on the *menit* as "Sobek-Re, lord of Sumenu who resides in Imiotru," locales in the region

of Gebelein.[11] On the occasion of processions between these two places of veneration—the Isle of Imiotru is separated from Sumenu by a branch of the Nile—a priest would have performed the ritual gesture of presenting the *menit* to the divine image.

Although the hybrid form of the crocodile *menit* is uncommon on this type of liturgical object, the iconography of the decoration follows a classic formula. The reptile's collar is composed of a series of simple pendants and is devoid of the complex floral decoration of the Karomama figure and exotic motifs such as those seen on the *menit* of Harsiese (cat. no. 33; pp. 104–5). A preference for tradition and a relative decorative sobriety are demonstrated by numerous other details: the frieze demarcating the two tableaux; the austere attitude of the half-man, half-animal Sobek; the divine barque, suggested by its most basic constituent parts; and the uraeus cobra, whose scaled body slides discreetly along the edges of the *menit*. These stylistic characteristics suggest a date during the principal period of occupation of the site of Sumenu in the New Kingdom, from the Amenhoteps (mid-Eighteenth Dynasty) through the Ramessides (Twentieth Dynasty).[12] The substrate metal is black bronze containing 5 percent gold, 3 percent silver, and a small amount of tin: a formulation that could be patinated to serve as a dark canvas for the precious-metal inlays. The latter were made of various alloys, chosen according to their specific location on the object, including auriferous silver for the crocodile's teeth, electrum for other details, and gold leaf for the god's flesh.

A miniature double aegis (figs. 21, 22), like the crocodile *menit*, may have served as a piece of equipment for a god's portable barque; it may also have been placed as a symbolic object near the chapel for the god's sacred image.[13] A discreet inscription on the back names the priest Nebiunu and his high offices: "opener of the two leaves of the door of the sky," "the one who knows the mysteries of heaven, of the earth, and of the sky"—that is, the officiant who admits sunlight into the sanctuary in order to illuminate the barque and the divine statue. These important titles, held by other members of the Theban high clergy,[14] indicate a date in the Third Intermediate Period, about 1000 B.C. J. F. Champollion (1790–1832), the decipherer of hieroglyphs, brought the aegis back from his voyage in Egypt,[15] so we can hypothesize that it was found in the course of the excavations he undertook at Karnak, when, according to the report of his companion Nestor L'Hôte, "in some sorts of four-walled cells [came to light] a quantity of precious objects and those beautiful bronzes so desired in collections."[16] The highly original, twinned aegis has two heads, two separate collars, and a counterweight ornamented with a cascade of amulets and symbols, including the head of Hathor and the figure of Horus resting on the hieroglyphs for "all," stabilized on *djed* pillars and the papyrus sign. The metal of the counterweight is classifiable within the family of artificially patinated cupreous alloys; it contains 6.5 percent tin, with an addition of 3 percent silver and 1 percent gold, a relationship of precious metals inverse to that

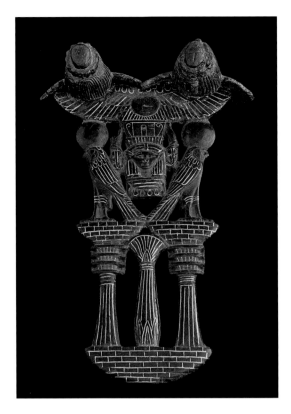

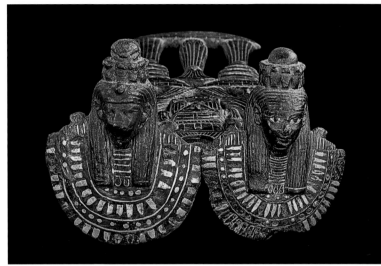

Figs. 21, 22. View of
top (*left*) and front
(*right*) of *Double Aegis
of Nebiunu*. H. 10.2 cm,
W. 6.8 cm. Musée
du Louvre, Paris
(N 4302)

of the crocodile *menit*. The two divine faces, one of which retains its finely executed features, are differentiated by the inlays in their collars, the gold of the first contrasting with the paler auriferous silver (55.17 percent silver and 40.31 percent gold) of the second. Coupled by mechanical means, the two elements may have been intended to allude to the respective brilliance of the sun and the moon, thus guaranteeing the efficacy of the rites of illumination for which Nebiunu was responsible.

Two small sphinxes in the Louvre that were cited in 1966 by John Cooney, the pioneering observer of black bronze,[17] as possible examples of the genre have, in fact, proved to belong to that class of alloy. These two works, like the cult instruments discussed above, bring us into the most hidden zones of the temple, where cult objects were housed when they were not being exhibited in processions. The sphinx of King Siamun (r. ca. 978–959 B.C.; fig. 23) has human arms that present a table of offerings bearing foodstuffs and one of his royal names; his royal names also appear on the animal's hindquarters.[18] The inlaid decoration visible on the back of the animal includes the king's *wesekh* collar, the tail of his *nemes* headdress in relief, the mane of the lion, and the wings of the royal falcon, creating a mesh of decoration that entirely covers the body. The sphinx is hollow cast, with tangs that indicate the height of the base upon which it once rested. In its offering attitude and small size, the piece can be compared to the small sphinxes visible on the decks of processional barques as depicted in New Kingdom reliefs at Karnak. These barque shrines, sent forth on festival

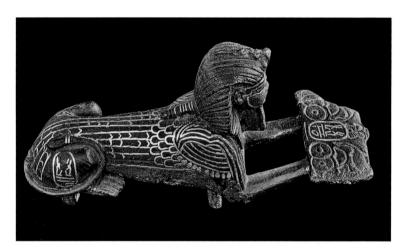

Fig. 23. *Sphinx of King Siamun*, 21st Dynasty (r. ca. 978–959 B.C.). L. 10.3 cm. Musée du Louvre, Paris (E 3914)

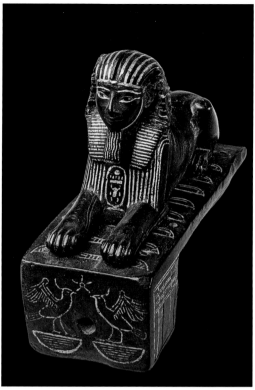

occasions, were equipped with liturgical gear and treated as miniature temples in which the actions of the cult were perpetuated by the ritual figures of the king, the high priest par excellence. This context helps to explain the composition of the alloy: an impure copper to which was added about 1.5 percent silver and 0.13 percent gold, sufficient to give the sphinx "divine flesh"—according to mythology the bodies of gods were made of precious metals and thus were inalterable for eternity—and to create a dark patinated surface against which the network of decoration shone.

The second sphinx, inscribed on the chest with the cartouche of Menkheperre (fig. 24), rests upon a distinctive square-shaped base, whose sliding channel indicates the piece was originally part of a locking mechanism.[19] Even at such a small scale, the precise casting reveals features attributable to Thutmose III (r. ca. 1479–1425 B.C.), including the profile of the nose, the shape of the eyes, and the wide mouth. Such precision, combined with the fact that the piece is made of a precious alloy, suggests the sphinx was intended for a divine chapel. It is sometimes dated to the era of the High Priest Menkheperre (fl. 1045–992 B.C.) of the Twenty-first Dynasty,[20] who occasionally styled himself a king; some art of that period, moreover, was inspired by the style of Thutmose III. The inlay underscoring the forceful lines of the sphinx and the age-old royal iconography are quite traditional; the sphinx crushes the Nine Bows, symbols of foreign lands, and dominates the *rekhyt* birds that represent "all the people" of Egypt. There is a discernibly different spirit to this decorative program compared to that

Fig. 24. *Sphinx of Menkheperre*, assigned to 18th Dynasty, reign of Thutmose III (ca. 1479–1425 B.C.). L. 8.9 cm. Musée du Louvre, Paris (E 10897)

of Siamun's sphinx, whose mass of symbols overlay one other and partially mask the body of the lion. In that respect Siamun's sphinx exhibits the disjunction between sculptural form and decoration found in some works from the Third Intermediate Period, along with the tendency, as seen in the double aegis discussed above, for multiple motifs to fill any voids.

The composition of the alloy used for Menkheperre's sphinx and its base—a black bronze containing 5 percent tin, 7 percent gold, and 1 percent silver—is notably different from that of Siamun's sphinx, particularly in its high gold content. It is rare to find analogies of alloys even among contemporary statuettes, so the similarity between the composition of Menkheperre's sphinx and that of the statue of Thutmose III in the Metropolitan Museum (cat. no. 8; fig. 1), which contains 4.3 percent tin, 6.1 percent gold, and 0.4 percent silver, is all the more interesting.[21] Given the comparable stylistic criteria of the two works, such as the related physiognomies, this unusual similarity between two bronze formulations would seem to increase the likelihood that these works are chronologically apposite, and that the technological profile they present could be considered a marker for the fifteenth century B.C.

From these examples, it would appear that the percentage of added gold in bronze alloys attributed to the New Kingdom is elevated compared to bronze alloys from the Third Intermediate Period, an observation that seems to accord with other recently conducted analyses of New Kingdom works.[22] In addition, some general tendencies in the formulation of artificially patinated bronzes can be noted in certain works from the Third Intermediate Period: in particular, that the overall content of precious metals diminishes, and that some alloys contain gold and silver in inverse proportions to New Kingdom alloys.[23]

Although scholars might wish to elucidate some linear evolution of bronze casting through the millennia, to what degree can technique and alloy composition accurately be attributed to a specific period? The question is most pressing for works that have no equivalents in terms of style or subject and whose proposed dates oscillate between two attributions. In attempting to put forward an answer, we must remember that the limited number of bronzes preserved from the second millennium (comprising the Middle and New Kingdoms) hardly signifies that advanced metalworking technologies were not employed; this is simply a result of lacunae in the material record, since the bronzes that do survive from the period demonstrate the adroit use of such technologies.

To illustrate this problem, let us examine a work of exceptional quality that is often attributed to the Third Intermediate Period: a statuette of a nude royal or divine child who is depicted in a seated posture, with a uraeus[24] (now broken) on his forehead (cat. no. 15; fig. 25).[25] The figure is remarkable for the naturalness of its pose and for the absence of the crowns and attributes that typically bedeck first millennium figures of child-gods.[26] The position of the head, which is turned to the figure's proper right at a

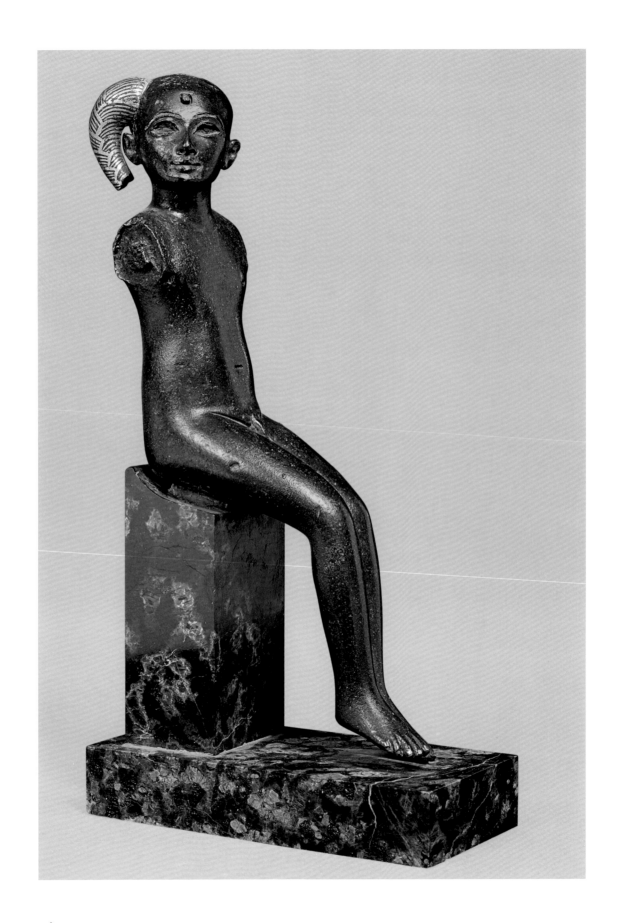

three-quarter angle, with the face slightly raised, indicates that the child must have originally been placed on the knees of a goddess or queen. His shaved head retains the sidelock worn by children, which is represented as though tightly plaited, judging from the rhythm of the minute inlays, and is missing its bottom curl. A number of stylistic traits suggest the work was made in or about the Amarna period, at the end of the Eighteenth Dynasty: the proportions of the body; the shape of the skull; the softness of the volumes, which slide from one to another without marked transitions; the thick waist; the asymmetry of the feet; and the roundness of the face, with its large almond-shaped eyes and finely rimmed eyelids. Yet clear markers of the Amarna style, such as horizontal lines on the neck, perforation of the earlobes, and the characteristic fan-shaped navel, are absent. In these respects, the child—perhaps a king, perhaps a god—resembles the figure of Tutankhamun as the god Ihy from the king's tomb (Egyptian Museum, Cairo, JE 60731), which, like this figure, has a small nose rounded at the tip.[27] The anatomical characteristics of the child also evoke those of a kneeling king in the University of Pennsylvania Museum of Archaeology and Anthropology, Philadephia (cat. no. 9; fig. 12), that has been attributed to Tutankhamun,[28] although the fleshy, smiling mouth of the child is more reminiscent of the young, sweet faces of the Ramesside family. For these reasons, we propose a date for the child between the end of the Eighteenth Dynasty and the early Nineteenth Dynasty.

The child is solid cast except for the head, which is partially hollow to accommodate the sidelock. The missing arms were made separately and attached with tenons, with the join masked by a thin rim projecting from the shoulders, a type of finishing sometimes seen in fine statuary.[29] The refinement of the figure includes its otherwise unattested binary alloy of three parts copper and one part gold, an unusual composition in terms of both the high proportion of gold and the absence of any other element, even at trace levels. The porosity of the statuette, visible in a radiograph, testifies to the experimental nature of this alloy. As noted above, the child can be compared on stylistic grounds to the statue of Tutankhamun in Philadelphia (cat. no. 9), but the alloys of the two works are not comparable, since the Philadelphia Tutankhamun figure is a typical black bronze containing 4.7 percent gold and 0.75 percent silver. The lock of the Louvre statue does, however, precisely fit the conventional definition of black bronze; it is made of a patinated alloy of copper, tin, lead, and gold.[30] With its dark flesh[31] and formerly inlaid eyes, the child is a unique work in the repertoire of cupreous-metal figurines. The presence of gold, albeit "hidden" beneath the dark patina, imbued this child-king with all of the divine qualities with which he was associated.

The presence of gold in many of the bronzes discussed in this brief consideration points to what originally must have been a sophisticated program of subtly contrasting polychromy. Some of the metals, by virtue of their somber patinas, were no doubt deliberately chosen to exalt the decoration

Fig. 25. *Royal or Divine Child* (cat. no. 15)

of these works of art, which during worship came into contact with the divine realm. In addition, technical study of black bronzes in the Louvre has revealed potential historical markers and patterns that can, perhaps, be ascribed to historical trends or to the existence of standardized metal alloys. As in the case of the child discussed above, some precious objects lie outside the norms for such works, as we know them, and remain subject to reflection; they may yet inflect and refine our understanding of the evolution of Egyptian metalworking technologies. These pieces reveal the extraordinary ability and knowledge of Egyptian metalworkers, who knew the precise qualities of the metals they worked with, and who manipulated them to achieve specific effects that were, in turn, appropriate to the function of the objects.

1. Several campaigns of analyses were undertaken at the Centre de Recherche et de Restauration des Musées de France (C2RMF) under the leadership of Marc Aucouturier; results were obtained by François Mathis, Benoît Mille, and Dominique Robcis. I would like to acknowledge all of them as full partners in this introductory presentation.

2. For black bronze, see, for example, Craddock and Giumlia-Mair 1993, Giumlia-Mair 1996. [*Technical editor's note:* The term "black bronze" is a modern convention that derives from a reading of the ancient Egyptian term *ḥmty km,*" which has been convincingly correlated to the appearance of certain cupreous-metal works preserved from antiquity. Strictly speaking neither an alloy nor a type of alloy, black bronze refers to a cupreous metal that has been chemically treated to produce a black surface patina. The process was carried out on alloys containing a small intentional addition of gold, and it is the inclusion of the gold atoms in the matrix of the artificially induced layer of cuprite that produces the distinctive color. For this essay, "black bronze" has been extended to include other cupreous alloys displaying a broad range of tonalities that may have been obtained using the same or similar patination processes. These technological possibilities are suggested not only by the striking polychromatic decoration seen on many of the works themselves, but by our knowledge of traditional Japanese metalworking practices from which our understanding of black bronze proceeds. See also the essay "The Manufacture of Metal Statuary" in this volume.]

3. La Niece et al. 2002; Aucouturier et al. 2004.

4. See Aucouturier et al. 2004; Delange et al. 2005.

5. The term "electrum" can refer to an alloy of gold and silver that contains 25 percent or more of silver; see Ogden 2000, p. 162. This catalogue follows a different definition, based on Pliny; see the essay "The Manufacture of Metal Statuary" by Deborah Schorsch in this volume.

6. The quills contain approximately 60 percent copper, 38 percent gold, and 2 percent silver.

7. Giumlia–Mair and Quirke 1997.

8. The sistrum of Henettawy (Musée du Louvre, Paris, E 11201), a piece of cult paraphernalia, is a black bronze, but the box of Shepenwepet (E 10814) is not; study of these objects is ongoing.

9. See Mathis et al. 2007; Mathis 2005.

10. A *menit* in the Kestner-Museum, Hannover (1950.131), shows a barque with figures on the reverse and not on the face; Leclant 1961b, pl. II; *In Pharaos Grab* 2006, pp. 120–21, entry by Christian Loeben, to whom I am most grateful for kindly communicating the reference.

11. On Imiotru, see Montet 1961, pp. 52–53, and Bucher 1928, pp. 41–42.

12. Sauneron 1968; Bakry 1971. It is interesting to note the title of Sobekmose at Gebelein: "Overseer of the Two Houses of Gold and Silver"; see Porter and Moss 1937, p. 161.

13. See Ziegler 1993, no. 37, fig. 12; Mathis et al. 2007.

14. For other Theban clergy with these titles, see, for example, the coffins of Amenhotep in the Louvre (E 13028, E 13030, E 13041; see Niwinski 1988, p. 164, no. 329) and the coffin of Djedhoriuefankh in the Vatican (25012.2.1, 25012.2.2; see Gasse 1996, pp. 44–65, nos. 3, 4). On the title itself, see, for example, Legrain 1917, pp. 22–23.

15. Ziegler 1993, no. 37, fig. 12.

16. Harlé and Lefebvre 1993, p. 255, letter dated March 18, 1829; Manuscrits Bibliothèque Nationale, Naf 20395, f. 140.

17. See Cooney 1966, p. 45: "The earliest surviving object in this medium known to me is the splendid bronze sphinx inlaid in gold and inscribed for Tuthmosis III now in the Louvre"; ". . . other objects in the Louvre must at least be mentioned as important examples of black bronze,

among them . . . a sphinx inscribed for King Sa-amen"

18. See *Tanis* 1987, p. 164, no. 42. Analyses of the base alloy, precious-metal inlays, and patination layers are published in Mathis et al. 2007.

19. See Laboury 1998, pp. 310–12, no. C 123. Analyses of the base alloy and precious-metal inlays are published in Mathis et al. 2007.

20. Hill 2004, p. 153.

21. Hill and Schorsch 1997, p. 12, n. 38.

22. Ibid., pp. 16–17, nn. 38–40.

23. The latter is not the case with the sistrum of Henettawy (see n. 8 above), an inlaid plaque in the form of an Isis knot in the Louvre (E 4358) (results forthcoming), or the figurine of Ptah in the British Museum (EA 27363).

24. It could also be the tenon of a uraeus.

25. See Mathis et al. 2007.

26. See, however, Roeder 1937, §75, for a similar example in the Roemer- und Pelizaeus-Museum, Hildesheim (1741).

27. Desroches-Noblecourt 1967, no. 37. The childlike face can also be compared to other small statuary of this period, such as the statue of Tjay in the Louvre (E 11555).

28. Silverman 1997, p. 101, no. 27, entry by Marsha Hill.

29. The right arm retains a trace of the projecting rim. Such a rim is attested, for example, on an ivory figure of a woman from the Middle Kingdom (Musée du Louvre, Paris, E 14697).

30. This conclusion is based on an analysis of the patina; sampling of the substrate metal was not possible.

31. The patina of the figure, perhaps as the result of an early intervention to improve the appearance of the surface, contains the copper chlorides nantokite and paratacamite as well as some copper sulfides.

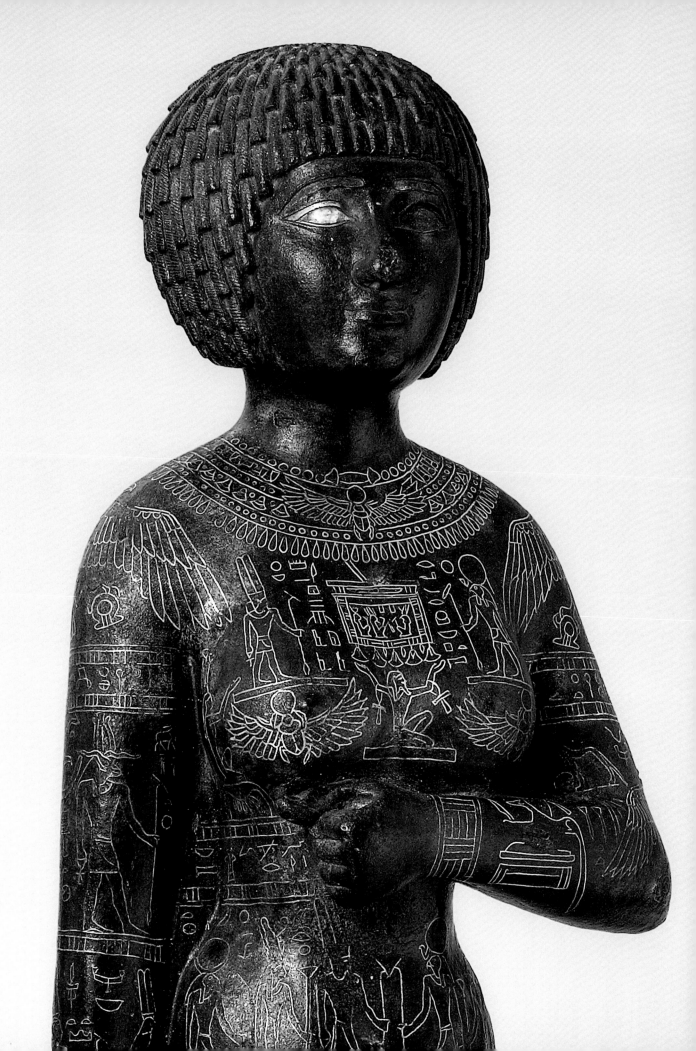

HEIGHTS OF ARTISTRY: THE THIRD INTERMEDIATE PERIOD (ca. 1070–664 B.C.)

Marsha Hill

The Third Intermediate Period of Egyptian history was marked by a progressive diffusion of power associated with the ascendance of ruling classes that had strong ties to Libyan tribal groups long settled in the country. The complicated governing relations of this era are organized traditionally as the Twenty-first through the Twenty-fourth Dynasty (ca. 1070–712 B.C.); toward the end of the period, Nubian Kushites ruled Egypt as the Twenty-fifth Dynasty (ca. 747–664 B.C.). As central, unifying authority diminished, the temples functioned as arenas in which reconfigurations of political strength were expressed. One illustration of this was the new prominence of the institution of the God's Wife of Amun at Thebes: female relatives of the kings ruling from the north who were symbolically married to the god Amun, and whose resulting religious and political status allowed them to act as virtual rulers of the south in the king's stead. In a related development, the mythology of divine kingship began to acquire new dimensions; the king came to be equated with the divine child of certain important deities, and the child himself was regarded as an avatar of the rising sun.[1] This complex interplay of religious, political, and social factors found expression in gifts to temples of equipment and metal statuary of unsurpassed artistry and innovation, such as those recorded as gifts from Osorkon I (r. ca. 924–889 B.C.), whose own statue (cat. no. 17; pp. 82–83) is just one preserved example of such benefactions.[2] Another notable trend is the participation of nonroyal individuals in donation practices, which becomes increasingly visible in the material record (cat. no. 18; fig. 60).

Precious-metal and cupreous-alloy statues of gods (cat. nos. 18–20), kings and chiefs (cat. nos. 17, 21–24), high-ranking women associated with the temples (cat. nos. 25–27), and officials or priests (cat. nos. 28–32)—many depicted enacting ritual roles—constitute the most important art works preserved from the Third Intermediate Period. Some of these sculptures, all remarkable artistic and technical achievements, reach impressive size, such as the figure of a woman probably from Karnak (cat. no. 25; pp. 95–97).

Fig. 26. Detail of *Takushit* (cat. no. 27; see pp. 98–103)

Others evoke movement in a way not normally associated with Egyptian art. Whether through torsion, as seen in the figure of Pedubaste (cat. no. 21; pp. 90–91), the transfer of weight from the back to the front foot, demonstrated by the figure of Takushit (cat. no. 27; pp. 98–103), or the physical urgency of a leaning pose, exemplified by the figure of Pami (cat. no. 22; figs. 28, 29), these statues effectively convey the temple environment of ritual performance.

Recent studies have revealed the surprising extent and subtlety of the coloristic use of metals during this period: the shimmer of different tones on the figure of the God's Wife of Amun Karomama, for example (fig. 19); the visual animation achieved through design and color juxtaposition on the menit of Harsiese (cat. no. 33; pp. 104–5); and, on the apron of Pedubaste, the way the patterning and color of the metal inlay seem to reinforce the figure's physical motion.[3] Even the moonlike glow of Pami is possibly an intentional effect of the artist's use of a heavily leaded copper alloy.[4] Metalworking feats of this sort attest to a high level of metallurgical expertise and experimentation that seems unprecedented in ancient Egypt. In addition, the surfaces of many statues bear figural decoration whose affinities and meanings provide important new perspectives on the remarkable religious and artistic convergences of the era (see the essay by John H. Taylor in this volume). The relationship of such heights of artistry to the broader aesthetic of the period demands a much more detailed investigation than is possible in this exhibition catalogue; even so, the works presented here illuminate the artistic accomplishment of this misnamed era.

Numerous examples of divine statuary survive from the Third Intermediate Period, datable based on either their inscriptions or styles. The most well known is the gold figure of Amun (cat. no. 19; pp. 84–89). Since being correctly attributed to the Third Intermediate Period by Cyril Aldred, the statuette has come to characterize one major aspect of the period's style: namely, the way such works reveal the influence of portraits of major New Kingdom pharaohs such as Thutmose III and Ramesses II but, at the same time, usually differ perceptibly in terms of general affect and modeling, particularly of the torso. In this figure, the tripartite stylization of the torso, along with the god's serious expression, suggests a somewhat later date (probably in the early eighth century B.C.) than that originally proposed by Aldred.[5]

Divine statues from the Third Intermediate Period antedate the most prolific period of metal statuary production, when images became widespread and thus relatively standardized, and as a result some of these present unfamiliar iconographic elements. The copper-alloy figure of Nefertem (cat. no. 20; fig. 27), which was refitted in antiquity with a headdress of Montu, is one such example; it was made during a period, ending about the mid-eighth century B.C., when Thutmoside and early Ramesside artistic styles still exerted a strong influence. The statue wears a corselet uncharacteristic of Nefertem as he came to be represented in subsequent centuries,

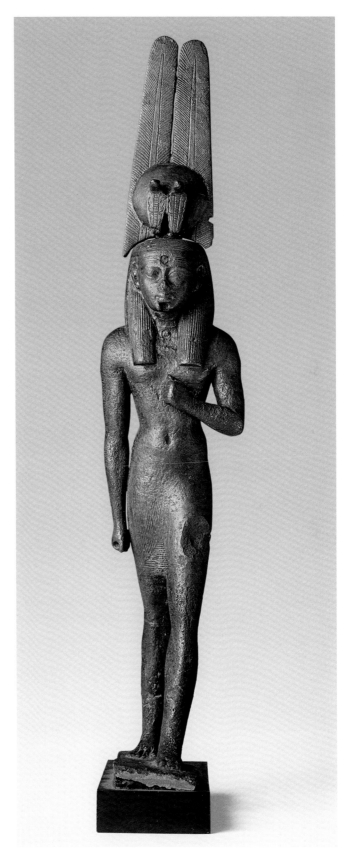

Fig. 27. *Nefertem*
with Headdress of
Montu (cat. no. 20)

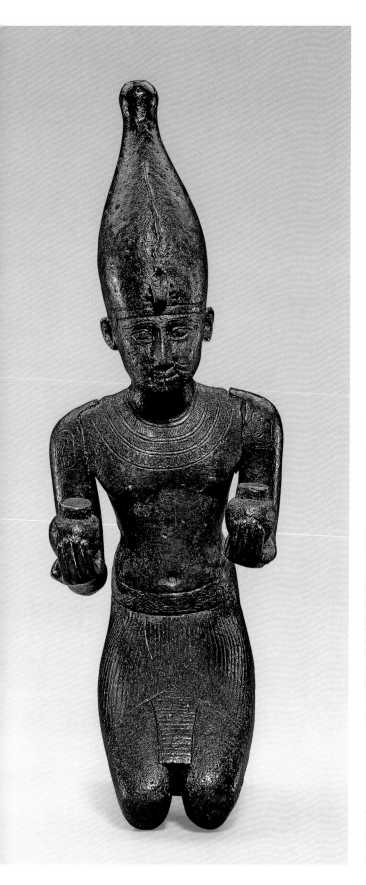

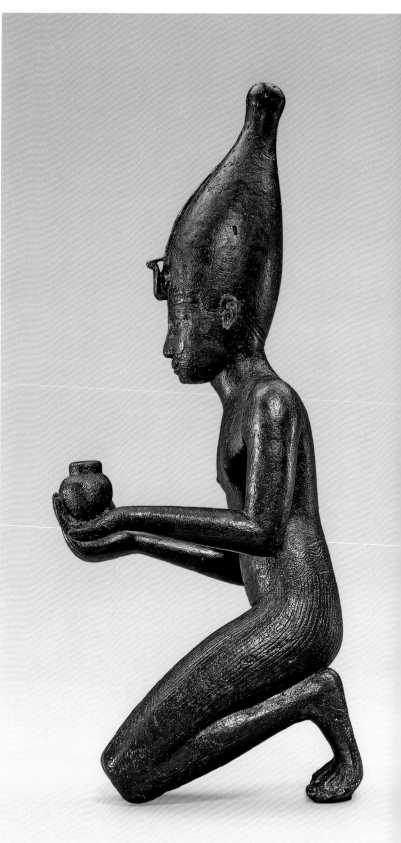

a feature that may have contributed to what was apparently the subsequent reinterpretation of the statue as the god Montu.

Royal kneeling figures, of which Pami (cat. no. 22) is one of the most impressive examples, are particularly numerous from the eighth century B.C., as are barque accoutrements (cat. nos. 34 [pp. 106–7], 35 [fig. 65]), probably a reflection of renewed attention being paid by rulers to religious practice in reaction to the increasing political atomization of the epoch. Generally these royal statuettes display the stylistic range characteristic of the Third Intermediate Period, although with the ascendance of the Kushite rulers (ca. 747–664 B.C.) this range gradually narrows; what emerges is a clear affinity for the Old Kingdom figural style, which was visible then in examples still standing at Memphis and probably elsewhere in the north. The proliferation of kneeling metal kings, in addition to certain textual evidence, underscores what was likely the Kushite rulers' intense religiosity. A statue of a Kushite monarch (cat. no. 23; pp. 92–94) is the largest known metal example of a kneeling king, whose original regalia, including distinctive double uraei and a necklace with ram head amulets, were erased in antiquity for political reasons.

The greatly increased significance of the role of women in the temple is one of the most distinctive phenomena of the Third Intermediate Period. The best-known example of this, as noted above, was the institution of the God's Wife of Amun at Karnak. Other elite women were members of colleges that served in the temple; this structure of female staff, found in other temples throughout Egypt, persisted as an important element into the Saite Period. The women who came to occupy key temple roles were represented in a remarkable body of large metal statuary, of which the famous figure of the God's Wife of Amun Karomama (fig. 19) is one of the foremost examples.[6] According to an inscription, the statue of Karomama stood on the portable barque of Amun. Other statues of women likely served similar ritual roles; the hands of catalogue number 25, for example, are posed as if to offer Maat (the figure of the goddess is now missing), an essentially royal offering associated with the role of a God's Wife. The statue of Takushit, judging from the import of her decoration (see comments by John H. Taylor in this volume, pp. 78–80), also played a ritual role.

There was a long tradition in Egypt of depicting divine or quasi-divine/royal female figures such as Karomama wearing feather or net-patterned garments suggestive of their mythical aspect. The decoration of the likely figure of a God's Wife (cat. no. 25) is no longer ascertainable, and as John H. Taylor clearly shows in his essay, Takushit's decoration mimics that of naoi and reliefs, not feathers or net patterning. Still, that tradition probably influenced the tailoring of Takushit's exceptional decoration to the form of a garment. The statue was cast with metal connecting the arms and body, an unusual feature for metal sculpture; the lavish decoration covering the surface of the body continues over these connective areas. This overall decorative program, along with the strong visual coherence and

Figs. 28, 29. *King Pami Kneeling and Offering* Nu *Pots* (cat. no. 22)

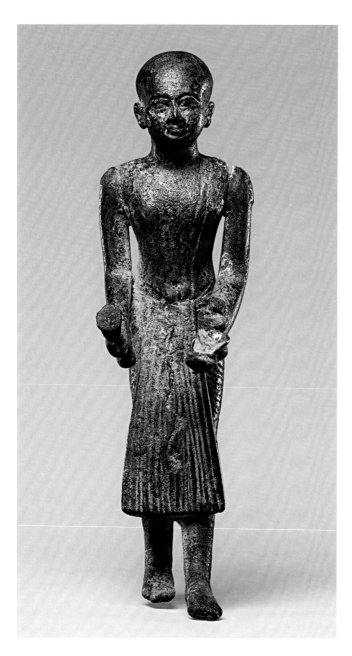

Fig. 30. *Priest*
(cat. no. 28)

surface tension of the embellishment, conveys the impression that Takushit is wearing a garment decorated with registers of figures, yet the treatment of the negative space between the right arm and the body is inconsistent with the indication of the volume of a textile.[7] When not in ritual use, figures such as Takushit and Karomama probably stood in chapels in the temple. After the deaths of the individuals they depicted, they may also have served as funerary images, as indicated by the inscriptions and some of the imagery on their bodies.

It is more difficult to draw generalized conclusions about statues of male nonroyal figures. Small examples are preserved from the Third

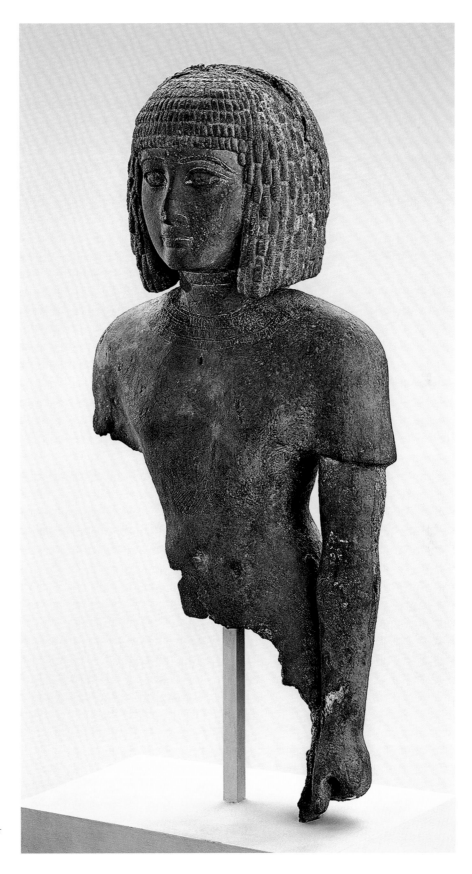

Fig. 31. *Upper Part of
a Man* (cat. no. 29)

Intermediate Period, and they continued to be made in later eras; some of these are preserved in groupings with gods. Large nonroyal male figures date from the Third Intermediate Period to the Saite Period and, as a group, are somewhat more diverse in type. Among these, judging from those whose names and titles are known, are statues of rulers' sons, high officials, and priests.[8] Catalogue number 29 (figs. 31, 36), a finely modeled torso with sweet, sedate facial features, can be dated to the Twenty-second to the Twenty-fourth Dynasty (ca. 945–712 B.C.). The inscriptions on the figure are missing, so there are no indications of the man's identity or office, but his wig and costume follow Ramesside style. In contrast, many other male figures both large and small display the shaved head, garments (such as leopard skins), and, occasionally, cultic paraphernalia (cat. no. 28; fig. 30) generally associated with priestly functions. Although priestly roles had indeed proliferated in the Third Intermediate Period, inscriptions on statues do not always confirm that the individual represented actually served in such a capacity. The decision to have oneself represented in a priestly style possibly depended to some degree on personal preference. Certainly the complex stylistic profile of stone sculpture from the eighth through at least the mid-seventh century B.C. testifies to a complicated mixture of influences that affected representational decisions in this proximate era.[9]

The figure of Khonsumeh (cat. no. 30; figs. 32, 45–47), whose enlarged, elongated, and shaved head dominates his small face, wears a long, pleated sash kilt and a plain shirt with elaborate sleeves. Together, these features exemplify the priestly style that first flourished in reliefs and paintings during the Ramesside period and that remained highly influential through-out the Third Intermediate Period in depictions of individuals in temple roles. A number of details suggest a relatively early date for this statuette, including the large bright eyes with a crease in the lid and the added figur-al elements, which have parallels in works from the tenth and ninth cen-turies B.C.[10] This figure is thus likely the earliest of the priestly-style figures discussed here. Khonsumeh is described in an inscription on the front of the statue as a "God's Father of Khonsu," and he wears an image of this god as a pendant. On the sides of the statue are representations of Pasherienese, a "God's Father of Atum." The title "God's Father" has a complicated history; by the Ramesside period it had probably come to signify a priestly rank below that of "prophet," but in the Third Intermediate Period, when, as noted above, priestly titles proliferated and shifted somewhat in meaning, the exact significance of the title is difficult to pinpoint.[11]

The statue of Padiamun (cat. no. 31; figs. 33, 35) strides forward with his left arm raised, as if to grasp a staff or, perhaps, a cult instrument.[12] Over his sleeved shirt he wears a pectoral depicting Amun, rather than Ptah, between figures of Ptah's consort and son, Sekhmet and Nefertem. This unusual configuration, along with the pairings of gods on the front of Padiamun's kilt—on the left, Amun, Mut, Khonsu, and Isis, and on the right, Ptah, Sekhmet, Nefertem, and Nephthys—could suggest that the statue was

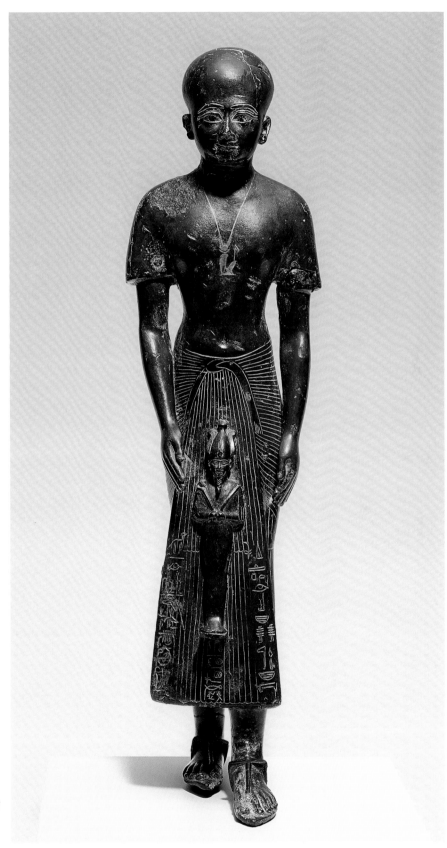

Fig. 32. *God's Father of Khonsu, Khonsumeh* (cat. no. 30)

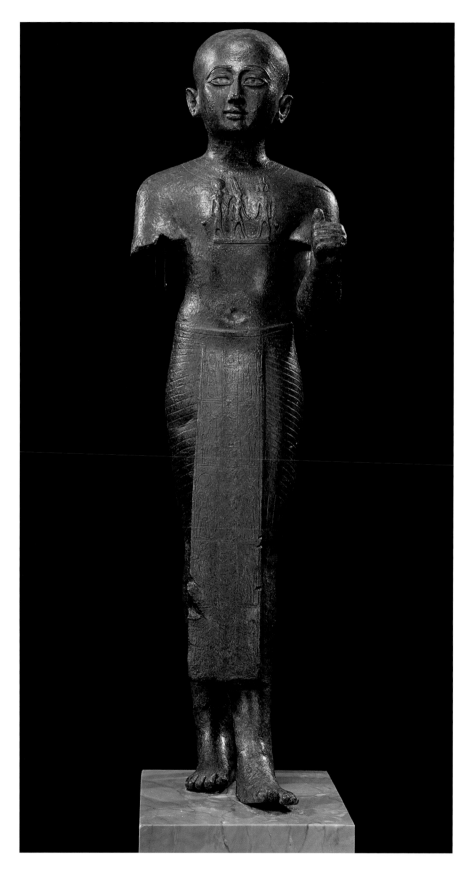

Fig. 33. *Padiamun*
(cat. no. 31)

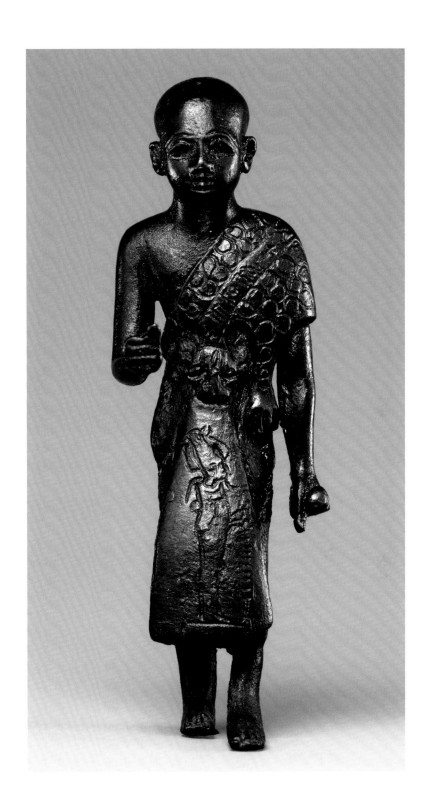

Fig. 34. *Statuette of
a Man Holding a
Document Case or
Papyrus* (cat. no. 32)

created for a temple in Memphis, where various cults of Amun were associated with those of Ptah.[13] This would accord with the reputed provenance of the statue. The statue names Wedjahor as Padiamun's father and Haremakhbit as his son. The father's name became popular in the Saite Period, but it is attested earlier, in the Third Intermediate Period, from the reign of Sheshonq V (ca. 767–730 B.C.).[14] There are strong echoes of the Thutmoside and Ramesside styles in Padiamun's heart-shaped face and his small, smiling mouth, not to mention the large earring holes. Given that the influence of this highly resilient mode is evident in some substantial relief-decorated constructions at Tanis that date to as late as Sheshonq's reign, this statue should probably be placed in the same period.[15]

Catalogue number 32 (fig. 34) depicts a male figure whose name (...Haty...) and titles are inscribed on a banderole across the leopard skin he wears over his chest and left shoulder. He is described as a "God's Father, Beloved of the God," a title that seems to be a revival as an honorific of an older type of title that originally conveyed proximity to the king; it was used extensively during the Third Intermediate Period. It has been suggested that the presence on the banderole of the titles and name of the subject, rather than those of the king, may be characteristic of the Kushite or very early Saite Period (mid-eighth to mid-seventh century B.C.).[16] If true, this would agree with the stylistic traits—broad neck, round skull, and small chin—linking this figure to that era.

A number of remarkable examples of Egyptian metalwork dating to the Third Intermediate Period were excavated at the Heraion (sanctuary of Hera) on the Greek island of Samos. Beginning in the eighth century B.C., offerings from around the Mediterranean were brought to this sanctuary, where it appears they were placed either near the great altar or in small shrines in the temenos (sacred precinct). A statuette of the goddess Neith (cat. no. 37; pp. 108–9) displays the so-called realistic features found in Egyptian works dating to the Kushite and early Saite periods—that is, marked features that convey age or some appearance other than that of idealized youth. A male figure excavated at Samos (cat. no. 38; pp. 110–13) can be assigned to the same era on stylistic grounds. Whether these statues were carried to Samos by Egyptians or by Greeks, who are reputed to have served as mercenaries in Egypt during the reign of Psamtik I (664–610 B.C.), they arrived on the island sometime before about 575 B.C., when they were buried in conjunction with a new phase of construction of the Heraion.[17] Pausanias, a second-century A.D. Greek geographer, traveler, and writer, attributed the first casting of Greek bronzes to artists known to have been working at Samos in the sixth century B.C. If, in his statement, Pausanias is referring to the casting of large bronzes in Greece, as has been suggested, then it is quite possible that this development was in some way influenced by the presence at the Heraion of these large Egyptian metal statues.[18]

1. See Fazzini 1988, pp. 8–14. Regarding the birth house, or *mammisi* (the temple structure characteristic of the new attention being paid to the divine child), see Di. Arnold 1999, pp. 285–88.

2. For inventories in texts and reliefs of divine statuary in first millennium B.C. temples, see Zivie-Coche 1991, pp. 233–35; Cauville 1987, pp. 73–74 (and notes). Spencer 2006 (pp. 19–38) is an important examination of the meaning of such evidence.

3. For a discussion of the statue of Karomama, see the essay by Élisabeth Delange in this volume. For coloristic uses, see also the remarks by Deborah Schorsch in this volume, pp. 191–92, 195–97.

4. For remarks on the statue of Pami, see the essay by Deborah Schorsch in this volume, p. 191.

5. Hill 2004, pp. 32–34; Hill and Schorsch 2005, pp. 182–83.

6. The basic studies of these figures are: Raven 1993; Delange et al. 1998; Taylor et al. 1998. According to Delange, the latest known example dates to the time of Amasis (r. 570–526 B.C.).

7. Although there is little evidence to indicate that actual garments were decorated this way in ancient Egypt, given the statue's accomplished artistry those involved in its creation must have entertained that conceit. The meager evidence for figural ornamentation of garments, none of which specifically refers to decoration that, like Takushit's, mimics temple scenes, includes references in Herodotus (III, 47, noted by Riefstahl 1944, pp. 45–46) to figurally decorated linen corselets or breastplates being given by Amasis to the Spartans and to Athena of Lindos (the relevant Greek words are *thōrax* and *zōon*), and references in the Demotic cycle (texts from the Greco-Roman period) to decorated garments being donned for war by the hero Pami; see Hoffmann 1996, pp. 271–84. For ornamental and/or symbolic decoration on Kushite and Meroitic royal textiles, including spread-winged birds on the shoulders, from as early as the late third century B.C., see Török 1990, figs. 13, 27, 41, 42. Archaic Greek textiles with registers of figures have been noted; see Barber 1991, pp. 358–65.

8. These include a statue of the son of a chief of the Ma (Musée du Louvre, Paris, E 7693; see Ziegler 1996, pp. 34–35) and one of a governor of Upper Egypt (British Museum, London, EA 14466; see Russmann 2001, pp. 238–39, no. 130). Although the latter is depicted in a priestly style, his titles do not refer to any priestly office; for a discussion of this problem, see Hill and Schorsch 2005, p. 181.

9. Russmann 2001, pp. 40–45.

10. For a discussion of the figural elements, see the essay by John H. Taylor in this volume.

11. Kees 1961, pp. 121–25.

12. In January 2007 Élisabeth Delange located the figure's missing arm in a provincial museum; the arm has been reattached to the statue for this exhibition.

13. Guermeur 2005, pp. 9–71, esp. 22–31, and personal communication from Guermeur pertaining to the cults of Amun.

14. For the father's name, see Malinine et al. 1968, vol. 1, pp. 25–28, nos. 26, 27; pp. 33–34, no. 34 (as Hor-wedja); pp. 65–66, no. 76 (as Wedjahor).

15. For illustrations, see Montet 1966, pl. LVII, 117; LVIII, 118; LXVIII, 227. See commentary in Fazzini 1997, p. 115 and n. 22.

16. Winter 1971, p. 153.

17. Weitz 2005, p. 134.

18. Kyrieleis 1990.

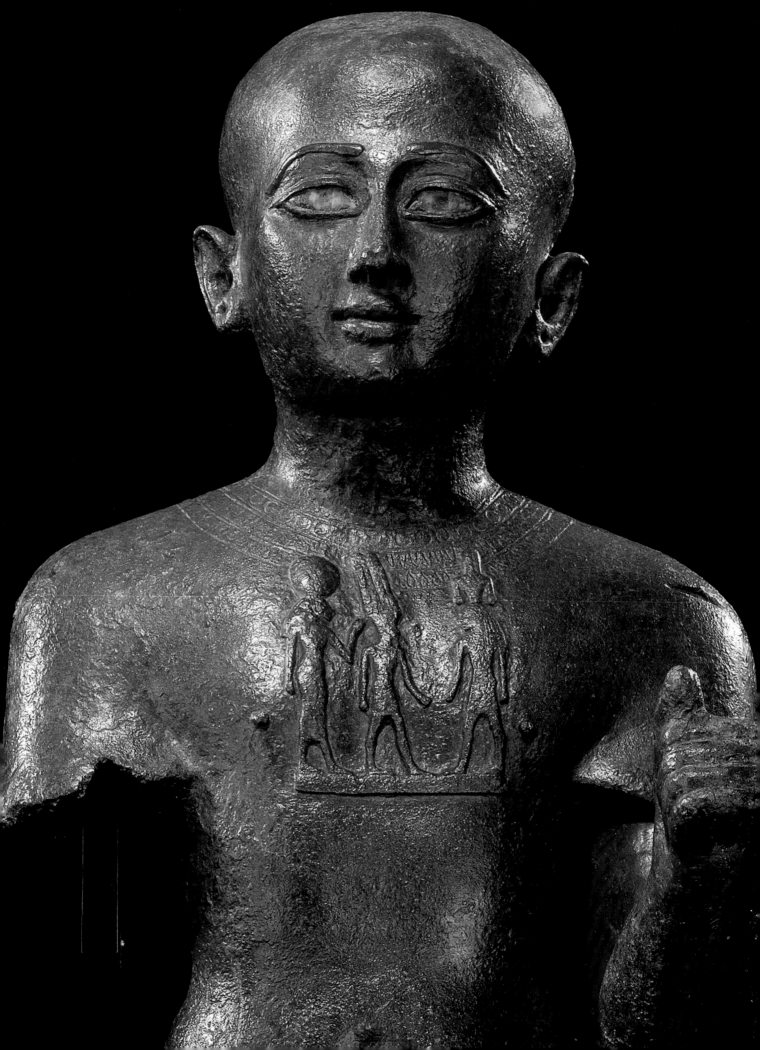

FIGURAL SURFACE DECORATION ON BRONZE STATUARY OF THE THIRD INTERMEDIATE PERIOD

John H. Taylor

Recent studies have highlighted the previously unsuspected degree to which Egyptian copper–alloy works were artificially colored through manipulation of the specific composition and chemical treatment of alloys or by surface pigmentation.[1] These treatments are now often difficult to detect owing to deterioration, inappropriate cleaning, or modern repatination. Much better preserved are the decorations consisting of designs either cast in raised relief or sunk into the surface of the body metal. The latter were often inlaid with stone, glass, faience, and metals, both precious and non-precious, to produce a brilliantly polychrome effect. The decorative elements produced using these methods include costume details and inscriptions, but it is figural decoration on body surfaces that is among the most characteristic features of metal statuary from the Third Intermediate Period.

The statues that bear figural decoration are a diverse group; they represent kings, God's Wives of Amun and other high–status women, as well as nonroyal persons. Few are dated by inscription, but those that are span a period of at least three hundred years, from the reign of Osorkon I (ca. 924–889 B.C.) to that of Necho II (610–595 B.C.). They vary in pose, quality of craftsmanship, and size, ranging in height from less than 15 to more than 80 centimeters. Details of costume are routinely emphasized on the surface, and the name of the owner is often displayed. Many of the sculptures also bear images of divinities, from a small isolated figure of Osiris to a highly complex program of deities and texts arranged in formal registers. No single interpretation can account for the significance and function of all these examples of figural decoration. This essay simply attempts to outline the main categories of such decoration, to draw attention to affinities between the metal statues on which it appears and other classes of artifact, and to pose some questions that might lead toward a greater understanding of the phenomenon of figural surface iconography.

Most of the figures depict deities or divine emblems. The manner in which they are arranged on the body surfaces falls into three broad categories:

Fig. 35. Detail of
Padiamun (cat. no. 31)

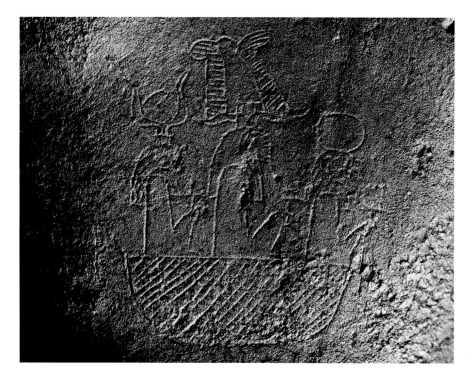

Fig. 36. Detail of
triad on chest of
Upper Part of a Man
(cat. no. 29)

isolated figures or emblems without frames (or borderlines); multifigure
groups framed like vignettes or wall scenes; and multigroup compositions
with figures arranged in registers. Some statues have more than one type
of decoration; of these, the most striking example is the statuette of Khon-
sumeh (cat. no. 30; figs. 45–47), which is adorned with figures both in iso-
lation and in groups. The subject is also depicted wearing an image of
Khonsu as a pendant around his neck, presumably to express his devotion
to the god. This is not the only instance on a metal statue in which a divine
image is depicted as an item of dress; triads of deities in sunken or raised
relief on the statue of an unidentified man said to come from Giza
(cat. no. 29; fig. 36) and on a statue of a priest named Padiamun (cat. no. 31;
fig. 35) may perhaps be understood to represent elaborate pectorals.[2]

The Role of Figural Surface Decoration
The application of images of deities directly to the bodies of statues is par-
ticularly characteristic of Egyptian sculpture from the first millennium B.C.[3]
and is found frequently on stone statuary as well as metal sculpture. The
reason for this practice is not explicitly stated in any inscription. In general,
however, the basic function of any human or divine image in ancient Egypt
was to act as a receptacle for the nonphysical aspect of the individual rep-
resented, enabling him or her to be present at, and to participate in, reli-
gious ceremonies or cult activities.[4] This role applied to both two- and
three-dimensional representations. By extension, the image was a conduit,
or means of access, to the person or thing represented. Placing a depiction
of Osiris on the body of a priest's statue gave that priest direct contact with

Osiris himself for purposes of adoration, petition, or personal identification. A single image on a statue might thus make possible a direct, one-to-one relationship with a god. A cult setting might be invoked still more strongly when groups of figures participating in a ritual (for example, the presentation of offerings) were depicted on the surface of a monument such as a statue. The image would ensure the eternal repetition of the ritual acts, by which the owner of the monument might benefit.[5] More extensive figural scenes, with groups of deities in registers, as on the statue of Takushit in Athens (cat. no. 27; pp. 98–103), were perhaps inspired by the decoration of temple walls; in the case of Takushit the iconography seems to have played a somewhat different role, which will be discussed later in this essay.

The statues of the Third Intermediate Period that have divine images on the body surface are part of a long iconographic tradition. Their immediate precursors are a few statues of the Ramesside period on which such figures appear,[6] but the custom can be traced back much further in the sphere of funerary art. It is on coffins that the function of such images and their role in association with the body can be most closely elucidated. The assemblages of images and texts on the surface of a coffin placed the occupant at the center of a microcosm—a model of the universe—in which he or she could experience rebirth. The occupant of the coffin was thus situated among the gods, a notion fundamentally similar to that which underlies the depiction of divine figures on statues, although the iconography on coffins realizes an altogether more far-reaching relationship between the human and the divine. In their totality, the images on coffin surfaces defined the sacred space in which resurrection would take place. They could also act individually as media through which the things depicted were made accessible to the occupant. The images on earlier (late Old Kingdom to Middle Kingdom) rectangular coffins were predominantly of commodities that the deceased would need in the afterlife. The presence of deities around the occupant was at first alluded to only by their names written on the sides of the coffin, but from the Middle Kingdom on the figures of such deities began to be added as well. The development of this trend in the New Kingdom led to the depiction of a series of divinities around the mummy. The vignette of spell 151 of the Book of the Dead provides a kind of blueprint for this concept, showing deities stationed around the bier in the tomb. The same deities were painted or carved on the coffin or sarcophagus.

A crucial step forward in figural decoration was taken in the Eighteenth Dynasty, when anthropoid coffins largely displaced rectangular ones as the preferred type. The anthropoid coffin, closely identified with the mummy of the deceased, was treated as the outer surface of the transfigured body. As an eternal image, its magical functions overlapped with those of statues. In the Eighteenth Dynasty the decorative program of rectangular coffins was transferred to the anthropoid coffin, thus bringing images of divinities into direct contact with the exterior of the human form. In this new setting, the divine figures continued to lend protection to the occupant of the coffin

while also giving the deceased personal access to divine attributes by virtue of their proximity to his or her mummy.

Throughout the New Kingdom and the Third Intermediate Period, the decoration of anthropoid coffins became greatly elaborated by the inclusion of more images of deities, to which were added divine emblems, vignettes from the Book of the Dead and other mortuary compositions, and, often, group scenes depicting interaction between the deceased and deities (particularly Osiris and Re-Harakhti). These images were arranged in rectangular frames and strips and were also located as more or less isolated elements on the surface of the coffin.

During the first millennium B.C., the religious functions of anthropoid coffins and statues converged. Between about 1100 and 700 B.C., the coffins underwent a rich iconographic development that culminated in the adoption of design elements appropriated from statuary, such as the back pillar and plinth.[7] During the same period, tomb statues became progressively rarer as the focus of the elite mortuary cult, and there was a corresponding rise in the practice of installing statues of private individuals in cult temples. The temple statue enabled the owner to share in the god's offerings and in his cyclical revival by means of the daily ritual; it also took the place of the tomb figure, as the cult of the dead came to be centered less at the burial place and more at the temple.[8] It is perhaps no coincidence that, at the time temple statues assumed a stronger role in the mortuary cult, surface decoration began to be applied to them on a more regular basis.

The most favored type of stone sculpture in this period was the block statue, whose surfaces were often adorned with designs taken from funerary and temple iconography. There is a particular focus on the gods Osiris and Sokar, who are frequently represented by their respective emblems,

Fig. 37. Detail of *henu* barque of Sokar on *Block Statue of Hor*, 23rd Dynasty, reign of Osorkon III (ca. 787–759 B.C.). Graywacke, H. 31 cm. Ägyptisches Museum und Papyrussammlung, Staatliche Museen zu Berlin (17272)

Fig. 38. *Cartonnage of Djedmaatiuesankh*, 22nd Dynasty (ca. 945–712 B.C.), from Deir el-Bahri, Thebes. Cartonnage, paint, and gold leaf, L. 154.7 cm. Royal Ontario Museum, Toronto (910.10)

the Abydos fetish and the *henu* barque (fig. 37).[9] The same motifs appear often on coffins of the same period, particularly those of the Twenty-second Dynasty (see discussion below). These images expressed the perpetuation of the cycle of creation, which, it was desired, would occur both in the temple and in the tomb (fig. 38). Some of the same designs, arranged in a similar manner, occur on metal statuary, which has prompted the suggestion that such works fulfilled a mortuary function in addition to their role in temple ritual.[10]

The following sections consider the main categories of figural surface decoration on the metal sculptures concerned.

Isolated Figures
On a number of statues one or more figures are depicted on the body, isolated and without frames. The most common design is a standing figure of Osiris in his familiar mummiform guise, arms crossed or with hands opposed, and usually grasping the crook and flail scepters.[11] A single standing figure of this type is seen on the right shoulder of the statue of Meresamun (Ägyptisches Museum und Papyrussammlung, Berlin, 32321). Similar figures appear on the right breast of Bepeshes (Musée du Louvre, Paris, E 7693) and Khonsuirdis (British Museum, London, EA 14466), and on the back of the right breast of Ihat (Ephesus Museum, Selçuk, Turkey, 1965). An image of Osiris in gold leaf is also located at the throat of a female figure in the British Museum (EA 54388).

Comparable "floating" figures can be found on several stone temple statues. Among the most striking are examples from the Twenty-second Dynasty: Osiris on the chest of Harakhbit (Egyptian Museum, Cairo, CG 42214);[12] Amun on the chest and Osiris on the kilt of Sheshonq (Egyptian Museum, Cairo, CG 42194);[13] Osiris, Isis, Nephthys, and Herishef as a ram on the dress of Shebensopdet (Egyptian Museum, Cairo, CG 42228);[14] and Amun, Re–Harakhti, and Ptah on the block statue of Nimlot (fig. 39).[15] Previous discussions of the meaning of such figures and of the inscriptions on the bodies of the statues have focused on the possibility that they might represent tattoos, body markings, or embroideries on clothing,[16] but these views lack supporting evidence and fail to take into account the broader context in which such images occur. Edna Russmann sees these figures as expressions of piety,[17] and there is certainly reason to think that in some cases the gods depicted held special significance for the person on whose statue they appear. In the Twenty–sixth Dynasty, for example, Pakharkhonsu, priest of Montu and Iunyt, had figures of those deities carved on the breast of his statue (Egyptian Museum, Cairo, JE 37860).[18] A more specific function of the figures, however, was probably to act as a medium through which the owner could approach the gods for mortuary cult purposes. This is made explicit on the block statue of Nimlot, where each figure is accompanied by an invocation to provide benefits for the statue's owner.

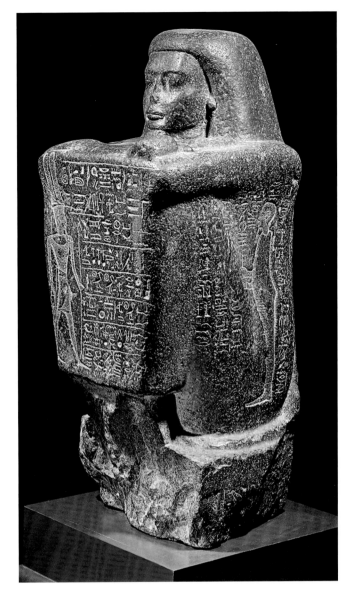

Fig. 39. *Block Statue of Nimlot*, 22nd Dynasty, second half of 10th century B.C. Granodiorite, H. 77.5 cm. Kunsthistorisches Museum, Vienna (ÄOS 5791)

The Osiris figure at the throat of the female statue in the British Museum (EA 54388) perhaps had a slightly different function.[19] Necklace-pendants in the form of Osiris are occasionally depicted on block statues,[20] but in this case no suspension chain is visible. In fact, the closest parallels to this example are found on anthropoid coffins and cartonnage mummy cases, where the space between the lappets of the wig is often occupied by a small divine image. Of these, Maat and the *benu* bird are the most frequent, occasionally appearing together (see fig. 38),[21] but Osiris and the Abydos fetish are also attested in this context.[22] These images began to appear on coffins in the Twenty-second Dynasty and fell out of the iconographic repertoire during the Twenty-fifth Dynasty.[23] They sometimes occur on the outer, or intermediary, coffins of a set, but they are found most frequently on the innermost cases of cartonnage, the envelope that represented the outer surface

of the transfigured body. They were probably intended to act as amuletic figures, and it is significant that they are depicted at the throat, one of the most vulnerable parts of the body, where actual amulets were predominantly situated. On some cartonnage cases the motif is applied in gold leaf, prompting a comparison with sheet-gold amulets that were placed within the wrappings of high-status mummies.[24] All of these motifs have strong funerary connotations—the Maat figures alluded to passage through judgment, while the *benu* bird possessed regenerative significance and was associated with the heart of the deceased. A figure of Osiris in the same context, whether on a coffin or a metal statue, could have served to identify the owner with the god, so that he or she, like Osiris, could undergo resurrection.

Isolated figures on metal statues may have fulfilled both of the functions mentioned above: as marks of devotion to a deity, and as amuletic devices to endow the wearer with the protection or attributes of that deity. A parallel with amulets may also be seen in the small size of most of the isolated deity figures, some of which were depicted on very small statuettes. An image of Osiris on the back of a small kneeling figure of a priest in the Fitzwilliam Museum, Cambridge (E.11.1937), part of a votive group, was probably protective in function; its position on the priest's back recalls the common expression *s3 h3.f*, or "protection around/behind him."[25]

On some metal sculptures several figures appear on the body, usually in a symmetrical arrangement but, as before, without frames. One of the earliest examples is the small statue of Osorkon I from Tell el-Yahudiya (cat. no. 17; pp. 82–83). The body of the king bears his name in cartouches; they are accompanied by images of Thoth in the form of an ibis, a goddess and a falcon-headed deity, and a vulture spreading its wings across the back. The statuette is clearly a temple piece, as indicated by the offering pose of the king and the selection of deities represented. Isolated deity figures also appear on the shoulders of the bronze statue of Khonsumeh in Berlin (cat. no. 30; fig. 47); since these figures represent forms of Amun, a temple rather than a funerary significance seems to predominate.

On other metal statues the images and emblems again invite comparison with the iconography of coffins. An unpublished standing male statuette from Thebes (British Museum, London, EA 2290) has symmetrical pairs of Osiris figures on the front and back of the breast; those on the front flank an Abydos fetish. The fetish is a major element of coffin design from the Twenty-second to the Twenty-fifth Dynasty, when it stood for Osiris and occupied a focal position in the center of the coffin lid or cartonnage mummy case (see fig. 38).[26] The fetish also appears on the front of another metal sculpture: a statue of a woman, probably a God's Wife of Amun (Musée du Louvre, Paris, N 3390). A small figure of Osiris on the right shoulder indicates the statue had a decorative program that incorporated several images, but too much of the surface is lost to reconstruct the design in its entirety.

Perhaps the most striking example of a metal statue with multiple images of divinities is a representation of an unidentified high-ranking

woman now in the Ägyptisches Museum und Papyrussammlung, Berlin (cat. no. 26). The *henu* barque of Sokar appears on the front of her torso and the Abydos fetish of Osiris in the middle of her back (figs. 40, 41). Osiris is depicted in human form on each thigh and on the right calf (figs. 42–44). As noted above, the pairing of the *henu* barque and the fetish of Osiris is found on several temple block statues of private persons dating from the Twenty-second to the Twenty-fifth Dynasty (see fig. 37). On some of the stone statues, interaction with the deities is shown—the deceased making offering to or adoring the divine emblems—but on the Berlin figure the barque and fetish are depicted in isolation, and they appear in the same manner on many coffins and cartonnage mummy cases.[27] The juxtaposition of the *henu* barque and the fetish (or an alternative Osirian emblem such as the *djed*) occurs on coffins as early as the beginning of the Twenty-second Dynasty (see fig. 38) and continued into the Twenty-fifth Dynasty. The barque then declined in prominence and seems to have been superseded by depictions of Sokar as a falcon or by the falcon-headed, anthropomorphic Ptah-Sokar-Osiris. The *henu* barque seems also to have disappeared from the iconography of stone statuary, and thus its presence on the Berlin woman may suggest that this piece does not postdate the Twenty-fifth Dynasty. Indeed, a date in the Kushite Period is most likely, since the iconography of the Abydos fetish is of a type that came into vogue on coffins in the later Third Intermediate Period.[28]

The precise positioning of divine images on statues calls for comment. The torso appears to have been the most favored location; while it naturally offered the largest field for decoration, there may have been additional, religious reasons why it was preferred. The positioning of deity figures on or near the shoulders of both stone and metal sculptures recalls how divine images or the names of gods were drawn on the human body as part of magical practices.[29] (At least one funerary text recommends that divine figures be drawn on the shoulders of a human image.[30]) Although we cannot necessarily infer from this practice that the figures depicted on metal statues represent such drawings, this parallel may help to explain the positions of some of them, since the upper torso was an important part of the body. Other examples are more difficult to explain. Why do two Osiris figures appear on the hips of the Berlin female figure (cat. no. 26), for example, and why is the symmetry of the design broken by the addition of a third Osiris on the back of her right calf? (This asymmetry is also manifested on the statues of Meresamun, Bepeshes, Khonsuirdis, and Ihat in the off-center position of single Osiris figures.) Equally puzzling is the reason for the craftsman's selection of the back of the thighs on the female statue in the British Museum (EA 43372) as the place to depict a confronted pair of mummiform deities (probably Osiris); in this case, however, the heavy corrosion still covering much of the surface may conceal additional images.

The statue of Khonsumeh (cat. no. 30), as mentioned above, has paired deity figures on the upper arms. These images are linear, but on the skirt of the statue are two images, cast in high relief, of a man named Pasherienese,

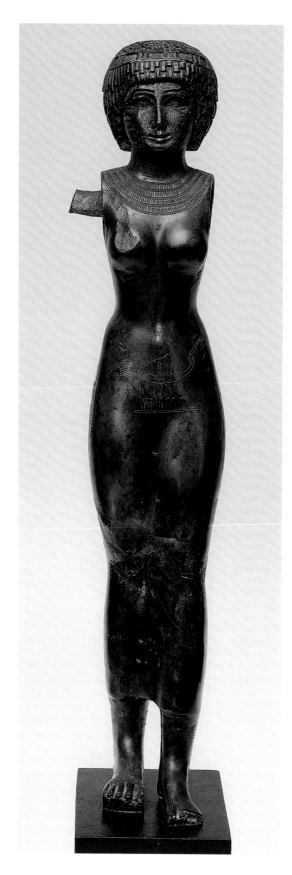

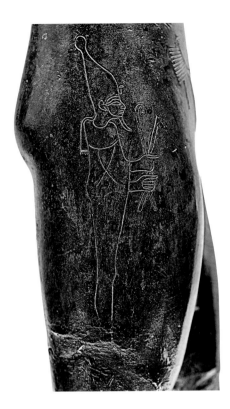

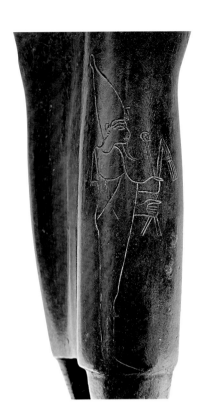

Opposite: Figs. 40, 41. Front and back views of *Statue of a Woman* (cat. no. 26), showing *henu* barque of Sokar and Abydos fetish, respectively

Top: Figs. 42–44. Details of *Statue of a Woman* (cat. no. 26), showing Osiris figures on left thigh, right thigh, and back of right thigh

probably a relative of Khonsumeh, making offerings (figs. 45, 46). These images reflect a long-standing tradition, dating to the late Old Kingdom, of depicting family members on the sides of a private statue. In the Third Intermediate Period such figures sometimes appeared on stone statues,[31] but that of Khonsumeh is the only known example in metal. The function of the male figures is clearly distinguished from those of divinities both by their offering pose and by the plastic modeling, which lends them an almost three-dimensional quality.

Figures in Formal Groups

Another category of decoration comprises figures arranged in well-defined groups. These scenes are usually, but not always, in frames, which have the effect of emphasizing the formal character of the depiction and the close relationship between the figures. The divine triads on the breasts of the male statue allegedly from Giza (cat. no. 29; fig. 36) and the statue of Padiamun (cat. no. 31; fig. 35) have already been mentioned; there the primary purpose of the triads may have been to represent items of jewelry, but the deities doubtless also carried significance particular to the owner of the statue. Padiamun's statue also has a series of divine figures on the front of the skirt; they are placed inside frames in symmetrical pairs, with the apron treated as though it were the surface of a wall or coffin. No interaction with the gods is depicted in the individual scenes, but the pose of the priest himself is one of offering, so perhaps this group can be interpreted as representing a perpetuation of the act of making offerings to all the gods depicted.

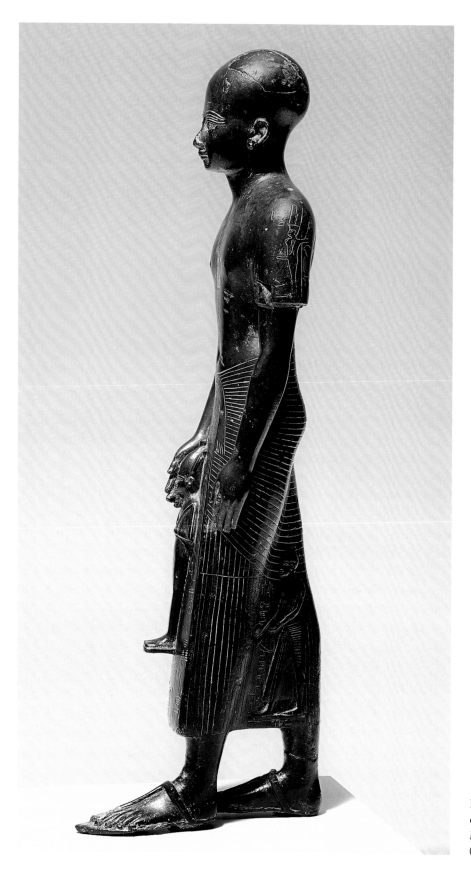

Fig. 45. Side view
of *God's Father of
Khonsu, Khonsumeh*
(cat. no. 30)

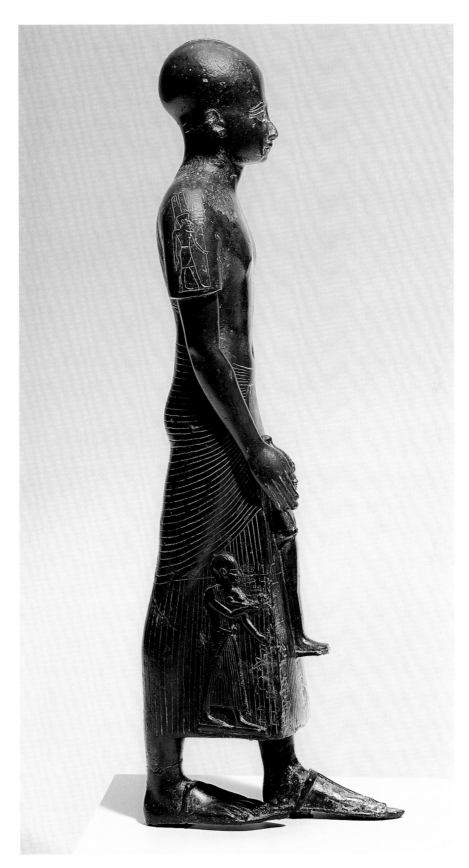

Fig. 46. Side view of *God's Father of Khonsu, Khonsumeh* (cat. no. 30)

Equally formal is the framed scene on the back of the statue of Khonsumeh (fig. 47), which shows the deities Osiris, Horus, and Isis. While this group evokes the funerary domain, the separate figures of Amun-Re and Amenemopet on the upper arms point to a temple role for the statue, as suggested above, and this is further emphasized by the three-dimensional image of Osiris that Khonsumeh presents. Was this figure perhaps installed, like similar stone statues, in a temple court or colonnade to function continuously as a focus for offerings to the spirit of Khonsumeh? Or was its role closer to that of the statues of the God's Wives, and as such was it intended to be placed near the cult image on the processional barque on festal occasions?

The torso of the large statue of King Pedubaste (cat. no. 21; pp. 90–91) is adorned with two confronted triads of deities (see fig. 48). Despite the loss of the upper portions of the figures, one group can probably be identified with some confidence as Osiris, Isis, and Horus, but the identities of the other figures are lost, and the context of the images cannot be reconstructed from the portion that remains.[32]

Program of Scenes in Registers
The most extreme example of a formal arrangement of divine figures on the surface of a metal statue is the figure of Takushit (cat. no. 27; pp. 98–103). Takushit was a daughter of the Great Chief of the Ma Akanosh of Sebennytos, whose recent identification as Akanosh "B" (rather than

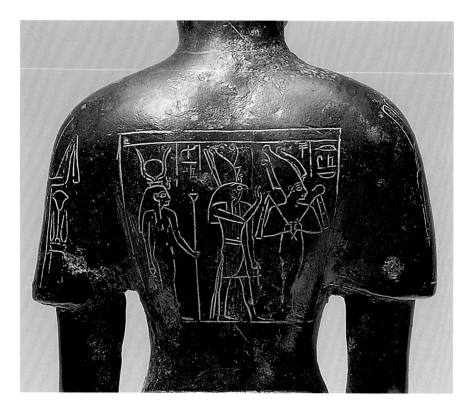

Fig. 47. Detail of *God's Father of Khonsu, Khonsumeh* (cat. no. 30), showing triad on upper back

Akanosh "A," his grandfather) pushes the date of the statue to the end of the Twenty-fifth Dynasty, making it one of the latest considered here.[33] A large percentage of the surface area is covered with images of deities in registers, which bear no relation to the forms of the body underneath. This arrangement recalls the images on the walls of temples and on naoi, where groups of divine images re-create cult topography or cosmogony, particularly with reference to local deities.[34] Such associations certainly seem to underlie much of the iconography on Takushit's statue, since many of the deities depicted are characteristic of the eastern Delta area (specifically Behbeit el-Hagar, close to Sebennytos) from which the owner evidently originated. How should the decoration be interpreted? Since Takushit's scenes depict no king or other dedicator interacting with the gods, the reciprocal relationship between pharaoh and deity may not have been of primary importance. It has been suggested that metal statues of kneeling kings and standing God's Wives would have been mounted on the processional barque of the deity, and that through them the important protective environment of the temple shrine or sanctuary might have been re-created in the more vulnerable situation outside the temple, when the god was carried in procession.[35] If the statue of Takushit was used in this context, then it perhaps represents another means of mobilizing the environment of the shrine or naos by applying the wall decoration typical of a shrine to the body of a figure that could be placed before the cult image.

Despite the strong overtones of temple iconography, the statue of Takushit also has associations with the funerary sphere. The most notable manifestation of this is the *djed* pillar, whose location on the back recalls the iconography of contemporary anthropoid coffins, where this motif often occupies the same position.[36] The inscription identifying the owner of this statue as the "Osiris" Takushit seems to indicate that at least one aspect of its function was to serve as the focus of a funerary cult.[37] There is thus perhaps a continuation of the dual function (cult and mortuary) of temple statues discussed above. The parallel development of statue and coffin iconography may also be reflected here; anthropoid coffins from the Twenty-fifth and Twenty-sixth Dynasties reveal an increased preference for

small-scale images of deities arranged in horizontal registers, in a manner similar to that of the designs on Takushit's statue.[38]

Conclusions

It appears likely that the primary function of figural decoration on metal statues was to create a conduit between the earthly and the divine. The statue, like the tomb and the coffin, acted as the threshold to the divine realm, and it permitted communication in both directions. The divine images on the surface provided benefits in the form of the protection of the gods depicted (sometimes in the manner of amulets) and close identification with divinity, which was believed to bring about the rebirth of the deceased. Such images also allowed the owners of the statues to petition the gods for offerings and to participate in cult activities in both temple and tomb. The more complex decoration on certain statues, such as that on the figure of Takushit, perhaps perpetuated the sacred environment that housed the cult image of the deity and thus ensured the appropriate degree of protection for it even when it was outside the precincts of the temple.

The specific reason why these images were placed directly on the bodies of statues remains elusive, but perhaps an explanation should be sought in the gradually changing conception of the human body as both an eternal image and a focus for interaction between the earthly and the divine spheres. It can be argued that, as the first millennium B.C. progressed, the body came to be regarded increasingly as an important vehicle for carrying divine iconography. While this trend is most noticeable on anthropoid coffins—where the exterior, covered with divine images, acts as the outer surface of the mummy—it is also apparent in the surface figural decoration of stone and metal statuary. The idea that divine images on the body itself held especially strong power found its most explicit expression in the healing statues of the Late Period; the pieces discussed above may in some sense be considered their ancestors.

1. La Niece et al. 2002; Hill and Schorsch 2005, pp. 176–78, nn. 79–82.
2. Hill and Schorsch 2005, p. 180.
3. Russmann 1989, p. 159.
4. Robins 1997, p. 12.
5. Ibid.
6. Schulz 1992, vol. 2, pls. 8a, 38, 41, 50c, 74a, 75a, 83a, 90, 115c, 116, 119c, 129b.
7. Taylor 2001, p. 236.
8. Fazzini 1988, pp. 21–22; Robins 1997, p. 206.
9. Jansen-Winkeln 1985, vol. 2, pls. 30–33, 49–53; Jansen-Winkeln 2001, vol. 2, pls. 18, 19; Jansen-Winkeln 2004, pl. XVI.
10. Hill and Schorsch 2005, p. 180.
11. For this design, see ibid., pp. 180–81.
12. See Jansen-Winkeln 1985, vol. 2, pls. 22, 23; Radwan 2005, p. 218, fig. 11.
13. See Robins 1997, p. 207, fig. 249. This statue was usurped, but there is no doubt that the divine figures were added when the piece was recarved for Sheshonq.
14. See Jansen-Winkeln 1985, vol. 2, pls. 37–40; Robins 1997, p. 207, fig. 248.
15. See Seipel 1992, pp. 370–73. Figures of goddesses also appear prominently on the arms of the statue of Shebensopdet, but there they function as hieroglyphic signs, writing the divine elements in the lady's name and in her title of Singer of Bastet.
16. Keimer 1948, pp. 47–53, 64–67; Pinch 1994, pp. 70–71, fig. 35.
17. Russmann 1989, p. 145.
18. See El-Toukhy 2005.
19. Hill and Schorsch 2005, pp. 180–81, n. 119.
20. Jansen-Winkeln 2001, vol. 2, pls. 11, 14.
21. Taylor 2001, figs. 171–72; see, e.g., John H. Taylor in D'Auria et al. 1988, pp. 169–70.
22. For Osiris, see cartonnage cases in the Kunsthistorisches Museum, Vienna (8641; see Seipel 1989, vol. 1, p. 299, no. 471) and the Ashmolean Museum, Oxford (1969.493; unpublished). For the Abydos fetish, see a coffin in the British Museum (EA 24906; see Andrews 1984, p. 45, fig. 49).
23. John H. Taylor in Raven et al. 1998, p. 20.
24. See, e.g., Jean Yoyotte in *Tanis* 1987, pp. 250–52, nos. 87, 88.
25. Insley 1979, pl. XXX, 2.
26. For examples, see Taylor 2003, figs. 45, 46, 48, 49, 53, 60–62, 65.
27. Examples include cartonnage cases and coffins in the Brooklyn Museum (34.1223; see Fazzini 1988, pl. XLVI, 1); the Rijksmuseum van Oudheden, Leiden (Inv. L.XII.3 [M 36]); and the British Museum (EA 6659; see Taylor 2003, figs. 46, 53).
28. In the New Kingdom and the Twenty-first Dynasty the fetish was represented in profile, with frontal uraeus serpents and a rear streamer projecting beyond the outline of the object; the double plumes were often tilted slightly backward. During the course of the Twenty-second Dynasty a frontal view of the fetish came into use; the plumes were vertical, the uraei were located centrally, and the rear streamer was either omitted or replaced by strips of cloth attached symmetrically to each side of the pole. This iconography is found chiefly on coffins and cartonnage mummy cases from the Twenty-second to the Twenty-sixth Dynasty; it was perhaps developed specifically for use in this context, since the fetish usually occupied a focal position in the central axis of the design. On stone statuary, both the "profile" and "frontal" views of the fetish remained current at least as late as the Twenty-sixth Dynasty.
29. Pinch 1994, pp. 70–71.
30. Rubric to spell 165 in the Book of the Dead; see Allen 1974, p. 161.
31. Jacquet-Gordon 1964–65.
32. Hill and Schorsch 2005, pp. 178–79.
33. Perdu 2004, pp. 97–99, 103.
34. Spencer 2006, p. 19.
35. Hill 2004, p. 139.
36. Hill and Schorsch 2005, p. 180.
37. Ibid.
38. Taylor 2003, p. 118.

King Osorkon I

Third Intermediate Period, 22nd Dynasty, reign of Osorkon I (ca. 924–889 B.C.)
Bronze, hollow cast, with separate solid-cast arms; precious-metal inlay and leaf
H. 14 cm (5 ½ in.), W. 3.8 cm (1 ½ in.), D. 9.2 cm (3 ⅝ in.)
Brooklyn Museum, New York; Charles Edwin Wilbour Fund (57.92)
[cat. no. 17]

Provenance: from Shibin el-Qanatir, near Tell el-Yahudiya (a dependency of Heliopolis); Lanzone collection, by 1875; Lehman collection; acquired in 1957

Selected References: Porter and Moss 1934, p. 58; Hill 2004, pp. 154–55, no. 10, with earlier references; Hill and Schorsch 2005, pp. 179, 192, n. 110

From an inscription at Bubastis, an important city in the eastern Delta, we know that Osorkon I was responsible for handsome gifts of gold and silver furnishings to major Egyptian temples. This striding image of the king, it has been suggested, could be an illustration of the possibly high quality of that otherwise lost workmanship.[1] The figure was hollow cast, and its surface is mainly dark, but because of its specific composition we cannot call it a "black bronze," nor can we be sure of its original color unless it is that represented by the silvery brown surface on the inner left leg.[2]

Osorkon wears a *khat* headdress, and his lower left arm projects to hold a ritual *nu* jar. Traces of precious-metal leaf remain on the jar and headdress, and precious-metal inlays of two different hues adorn the pleats of his kilt and belt. Inlays also color cartouches on his chest, kilt, and left shoulder; the image on his back of Nekhbet, goddess of Upper Egypt, as a vulture with spread wings holding *shen*-rings, symbols of eternity (right); and the three figures on his abdomen. The latter are a falcon-headed deity wearing a double crown and holding a *was* scepter, an ibis on a standard, and a human-headed goddess holding a papyrus scepter and wearing a partially preserved wig surmounted by cow horns and a sun disk. It is reasonable to identify the gods as Re (or Re-Harakhti) and Thoth, respectively, but the identity of the goddess remains uncertain.

The Third Intermediate Period witnessed the evolution of a style influenced by both Thutmoside art and art of the Nineteenth Dynasty that was itself influenced by Thutmoside art.[3] This image of Osorkon is an example of that style, but it exhibits

Detail of back, showing Nekhbet as a vulture

a more svelte figure than later works of the Libyan period, which often have heavier upper bodies and lower waists.[4] One such copper-alloy statuette, only recently published, is an image of Amun commissioned by Tefnakht of Sais.[5]

R F

1. Kitchen 1986, p. 303.
2. As suggested in 1989 by former Brooklyn Museum conservator Jane Carpenter.
3. Fazzini 1996.
4. See Hill 2004, pp. 26, 29–30, 34–36, on what she terms stylistic Phase C. See also Fazzini 2002.
5. Guermeur 2005, pp. 119–20, with reference to Del Francia 2000.

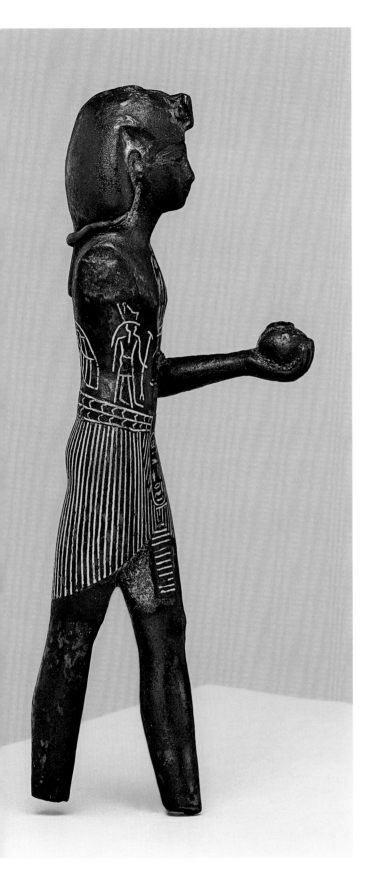
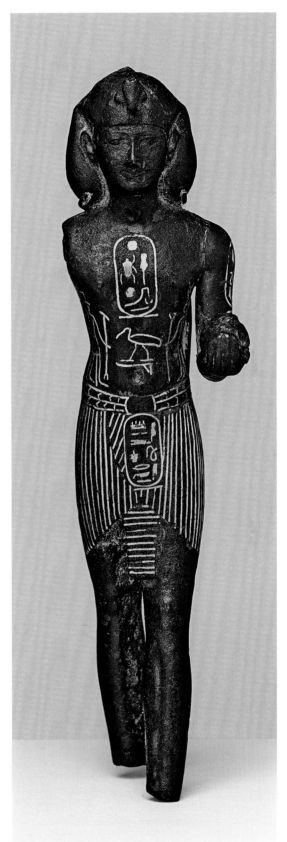

Amun

Third Intermediate Period, early 8th century (ca. 800–770 B.C.)[1]
Gold, solid cast, with separate solid-cast arms and beard;[2] separate tripartite loop, attributes,
feather crown, and sun disk (loop, crown, and disk mostly lost); separate precious-metal base
(lost)
H. 17.5 cm (6 ⅞ in.), W. 4.7 cm (1 ⅞ in.), D. 5.8 cm (2 ¼ in.)
The Metropolitan Museum of Art, New York; Purchase, Edward S. Harkness Gift, 1926 (26.7.1412)
[cat. no. 19]

Provenance: unknown; acquired by Howard Carter, 1917; acquired with the
Carnarvon collection in 1926

Selected References: Aldred 1956; Hill 2004, pp. 33–34; Hill and Schorsch 2005,
pp. 182–84

In ancient times this striding figure of the god Amun, with its feather crown and base still intact,[3] would have measured 24 centimeters or more in height; as such it is the only surviving gold figure of its size from Egypt. The statue has the remains of a tripartite loop on top of its head (see p. 88), and in a separate commentary below it is considered in relation to a group of precious-metal representations of deities with loops, a number of which are inscribed as temple offerings.[4]

Copper-alloy figures of Amun, which are preserved in abundance, provide not only typological parallels for this extraordinary work but also insight into its manufacture, which reflects traditions of working in precious metals as well as practices associated with cast cupreous-metal statuary. The figure, including the torso, head (excluding the beard), and legs, was cast solid, but with separately cast solid arms, an arrangement often employed for copper-alloy statuary. On the gold Amun, however, the arms are joined with a gold-silver-copper-alloy solder, whereas on cupreous-metal examples the attachment is mechanical. Amun's attributes—the scepter, *ankh*, and feather crown—and the tripartite loop on top of his cap were each constructed separately from many small gold elements. The *ankh* alone consists of seven pieces: five rods and two bosses. The rods were shaped by hammering, with traces of solder visible where they join and are covered by the bosses on the front and back; the bosses, too, were soldered in place. The open ends of the ring were fitted into the god's hand and soldered. On copper-alloy statuary, loops, where present, were always cast integrally with the figure.

Hammered gold sheet forms the feather headdress, with its separate sun disk and ten thin strips defining the edges and spines of the plumes in front and back. The strips were probably attached to the feathers using the so-called granulation technique or by fusing, joining methods used exclusively on precious metal. On copper-alloy Amun figures of this size and larger, the feathers were usually made separately, and if so they were invariably cast and attached mechanically.

Amun's beard, cast separately, was soldered to the god's chin and also to a separately manufactured square-section rod (below), which in turn is attached to his chest. While the manufacture of Amun's attributes and headdress from hammered components joined by metallurgical means is consistent with goldsmithing practices, this rod, which serves no practical purpose, points to the use as a

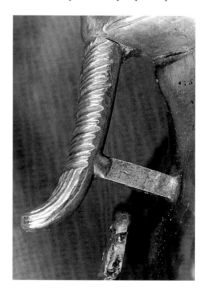

*Detail of beard
and rod, showing
solder joins and
scored details*

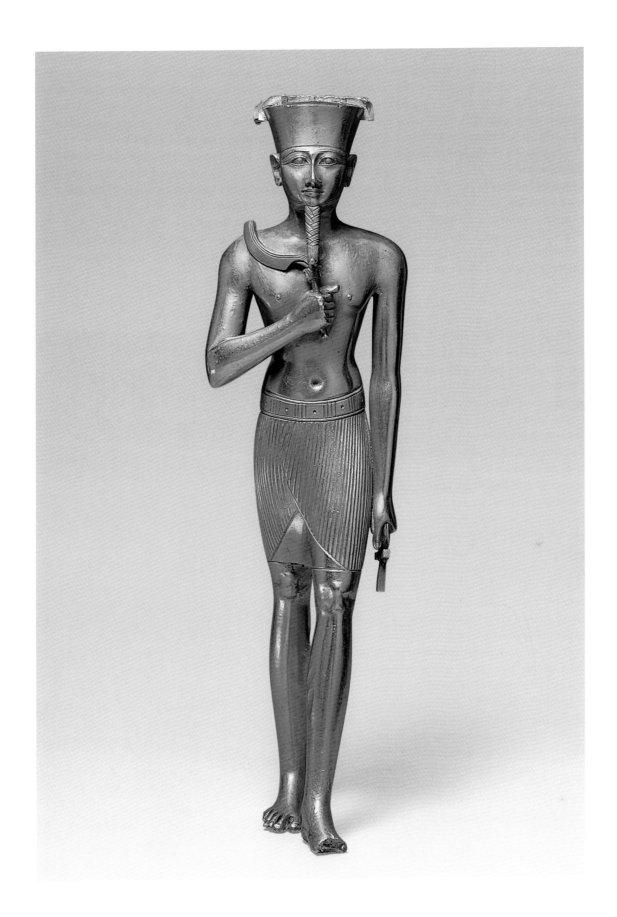

prototype of an unfinished, cast copper–alloy figure on which a gate, extending from the neck, allowed the molten metal to flow into an integrally cast beard.[5] Typically the gate would have been removed after casting.[6] Copper–alloy figures of Amun as well as other deities often had separately cast beards, but these were then mechanically attached, probably also using some adhesive, with a tang extending into the chin. A similar prototype with a vestigial gate may explain a redundant tang hole seemingly intended for the attachment of a separately cast beard onto the throat of the Nefertem/Montu figure in the Rijksmuseum van Oudheden, Leiden (cat. no. 20; fig. 27).

On cast bronze or hammered-bronze sheet of appreciable thickness, it is difficult to introduce surface details without resorting to steel tools, which, as a rule, were not used in Egypt until well into the first millennium B.C. For this reason, surface detail on copper–alloy statuary was generally cut into the wax model. Gold is a far softer metal, and on the surface of the Amun figure details seen on the beard, the kilt, and elsewhere were scored directly onto the metal surface itself (see p. 84).

One noteworthy aspect of the gold Amun figure is its monochromaticity, a trait shared by the Saite Period silver female figure (cat. no. 40; pp. 130–35).[7] Egyptian metalwork was often quite colorful, with precious and cupreous metals, sometimes artificially patinated,[8] used in combination and embellished with stone, glass, and faience inlays. In terms of bronze statuary, this tendency was indulged on the grandest scale during the Third Intermediate Period, on works such as the statues of Pedubaste (cat. no. 21; pp. 90–91) and Takushit (cat. no. 27; pp. 98–103), but it is also seen on figures that are smaller or later in date, such as the Metropolitan Museum's Bes-image (cat. no. 50; fig. 86). Silver figures—for example, the statue of Amun in the British Museum (EA 60006)—were often partially gilded and also decorated with nonmetallic inlays. The silver falcon-headed god in the Miho Museum, Shigaraki, Japan,[9] which formerly was entirely gilded and therefore appeared to be gold, has rock crystal eyes and lapis lazuli stripes in his *nemes*; on the gold triad of Osorkon II in the Louvre (E 6204), the hair of Isis and Horus was inlaid and colored stones were incorporated into the pedestal and base.[10]

The yellow surface of the Amun figure contrasts strongly in color with the pale interior, seen where a plug has fallen out of a large casting flaw on the left leg, a visual difference that corresponds to dissimilar elemental compositions; indeed, the silver-rich interior alloy is just short, in terms of silver content, of being electrum.[11] Intentional surface enrichment of gold–silver alloys in an ancient Egyptian context has never been demonstrated, and, as viewed in a scanning electron microscope, the island and tunnel morphology of the figure's exterior surfaces,[12] undisturbed by burnishing, suggests that the process, while extreme, was unintentional and occurred during burial. If this is the case, then the surface of the gold Amun was originally a paler, silvery color.

DS

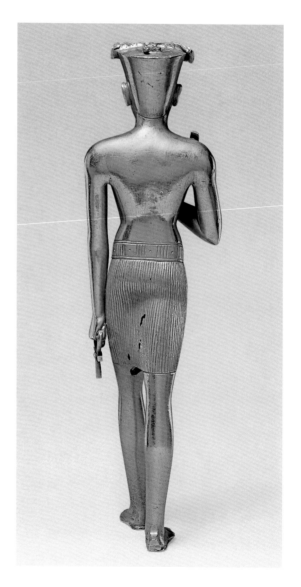

1. Hill 2004, pp. 32–34.
2. Gamma radiographs of the figure were taken at JANX, Piscataway, New Jersey, in 2002; EDS/SEM analyses were conducted in the Sherman Fairchild Center for Object Conservation in 2002.
3. The feet had no tangs, and the presence of solder on their undersides suggests that the base was probably gold, possibly silver; it is likely to have resembled the base of the silver statue of Nefertem in the Ägyptisches Museum und Papyrussammlung, Berlin (cat. no. 51).
4. Perdu 2003. See also the discussion of the statuette of Nefertem (cat. no. 51), pp. 143–46.
5. See, for example, although they are later in date, several cupreous-metal alloy figures of Amun in the Ägyptisches

Museum und Papyrussammlung, Berlin (2441; see Roeder 1956, §54e, pl. 8a–c), and the British Museum, London (EA 65581; see Leclant 1961a, p. 88, figs. 7, 8).
6. Hill and Schorsch 2005, pp. 170–71.
7. Becker et al. 1994, p. 51.
8. Giumlia-Mair and Craddock 1993; Delange 1998; Schorsch 2001; La Niece et al. 2002.
9. Catharine H. Roehrig, "Cult Figure of a Falcon-Headed Deity," in *Shumei Family Collection* 1996, pp. 4–7, no. 2.
10. Stierlin and Ziegler 1987, figs. 107–10.
11. See the essay "The Manufacture of Metal Statuary" in this volume.
12. Forty 1979.

Loops and Metal Statuary

We know of a number of precious-metal divine statuettes that are datable to the Third Intermediate Period or slightly later, that have loops like the one on the top of this statuette of Amun, and, significantly, that also have preserved inscriptions indicating they were intended as donations (royal and nonroyal) for use in the temple.[1] (As noted above, Amun's base, and any inscription it may have had, are now missing.) Among these works, the gold triad of Osiris, Isis, and Horus (Musée du Louvre, Paris, E 6204) that bears the names of Osorkon II (r. ca. 874–850 B.C.) is, like the present figure of Amun, surprisingly large and, thus, heavy. Loops also occur on other silver and copper-alloy statuettes, in a range of sizes and types, from this period or later.[2] That loops are found on high-status temple statues larger than what might easily be termed either an amulet or a pendant needs to be accommodated within our understanding of this large metal statuary, yet the most obvious explanations are by no means always the right ones.

One could envision that such loops permitted what are relatively heavy and large statuettes (10 cm or taller) to be either attached to individuals connected with the cult or hung on divine statuary. There is scattered evidence that might support these explanations, particularly that statuary with loops might have been hung from the neck or otherwise suspended from a worship participant. This includes a few seventh-century copper-alloy and stone statues of women holding statuettes of a juvenile god at chest height;[3] a small copper-alloy

figure of a priest holding a large, outward-facing statuette of Osiris strapped to his chest, like a toddler in a modern baby carrier;[4] and relief depictions of Ptolemaic priests at Dendera carrying an important naos with straps that encircle their necks and then are tied to loops on the base of the naos.[5] In addition, Ptolemaic stone statues occasionally depict an official wearing a rather chunky three-dimensional image on a cord around the neck.[6] Figures of kings and queens of Meroe—as the late stage of the Kushite kingdom is named, after its capital on the White Nile north of Khartoum—wear heavy bead strings from which hang divine statuettes; similarly, the busts of gods on Meroitic so-called shield rings are adorned with small statuettes hanging from necklaces.[7] Although such scenarios, for reasons elaborated below, are difficult to support as general temple practice, they cannot be ruled out as explanations for the loops on this statuette of Amun and on the Osiris triad in the Louvre. The quality of the workmanship of these two statues, the valuable materials with which they were made, and their early date in terms of the "loop phenomenon" could be understood as manifestations of a very precise intent. Of course alternative functions for loops can also be imagined. They might have helped to secure statues to other sculptural elements, to ritual furniture (such as barques), or in groupings, either permanently or as part of a specific ritual.[8] It has also been suggested that metal votive statuary was hung from rings on temple walls.[9]

Detail showing top of head (remains of loop visible at bottom)

Yet there is much about the loops on metal statuary that warrants a good deal of caution before we accede to any generalized ideas about their function as a means of physical attachment. Certainly our powers of inference are limited by the fact that the form of these objects evolved over long stretches of time, and by the tendency of forms and practices associated with beliefs to themselves become sanctified in complex ways.[10] Examples of vestigial, nonusable loops raise the question of whether the two types (usable and nonusable) coexisted, or if there was a historical development from potentially functional to probably nonfunctional loops.[11] Knowing this would be crucial to our understanding of this element, but it is also a very difficult undertaking given the general dearth of dating and provenance studies of metal statuary.[12] At the same time, patterns in the types of statues that commonly display loops seem to demand investigation. Is the phenomenon actually related to metal statuary, for example? It could, in fact, concern a particular aspect of the god in question or of the god's representational history, as is possibly the case with Nefertem (see cat. no. 51; pp. 143–46).

MH

1. Perdu 2003.
2. Roeder 1956, §§601–3, 709. Perdu (2003, p. 165, n. 44) refers to an interesting silver chain in the Louvre (E 17255) from which are suspended four figures of Harpokrates (max. H. 11.5 cm).
3. Small bronze examples include works in the Brooklyn Museum (37.402E) and the Egyptian Museum, Cairo (JE 35107L); see Parlasca 1953, p. 130, n. 30, pl. 46 4. For a large granite statue of Queen Amanimalel (ca. 642–623 B.C.) holding such a figure, now in the Sudan National Museum, Khartoum (SNM 1845), see Wildung 1997, pp. 222–23.
4. G. Scott 1992, pp. 56–57, no. 30; his suggested date for this work (early in the Late Period) seems reasonable.
5. For line drawings of these, see Chassinat et al. 1934–2001, vol. 5/2, pl. 392, vol. 7/2, pls. 677, 689, vol. 8/2, pls. 767, 793. The inscriptions give these particular priests the names of the Four Sons of Horus. Other priests in the stairwell reliefs carry naoi with straps running beneath the object. In addition, a statue of Maat with an ibis, from Tuna el-Gebel (Egyptian Museum, Cairo, JE 71971), is fixed on its ancient wood base, which has such loops; Hornung and Bryan 2002, p. 189.
6. See, e.g., the statue of Teos wearing a figure of Horus of Mesen, from Tanis (Egyptian Museum, Cairo, CG 67904); see Zivie-Coche 2004, pp. 88–90, for comments about such statues.
7. See, for example, Priese 1993: for shield rings, pp. 31, 33, and for reliefs of Kandake Amanishaketo (late first century B.C.), illustrations on endpapers.
8. For an example of a loop structure used either as a hinge or for fastening, see the wings that envelop a statue of Isis with Osiris in the Museo Egizio, Turin (cat. 514); Donadoni Roveri 1989a, pp. 99–101. See also the essay by Sue Davies in this volume on the Sacred Animal Necropolis at North Saqqara.
9. Perdu 2003, p. 165. There is no good evidence for such a practice.
10. In Egyptian art, related questions—often impenetrable—regarding function, symbolic value, and representational tradition arise, for instance, with back pillars and the identity of objects held in fists.
11. For examples of nonfunctional loops, see a figure of Nefertem in the Metropolitan Museum (58.2.19) and the two large silver statuettes of Isis (H. of each 44 cm) from the Dendera treasure; the loop of one (Egyptian Museum, Cairo, JE 46582) is visible in Cauville 1987, pl. 19.
12. Loops integrated with streamers behind upright crowns appear on post–Saite Period royal ritual statuary (see Hill 2004, pp. 93, 98, 101–2), a development that could conceivably relate to the phenomenon of loops on divine statuary.

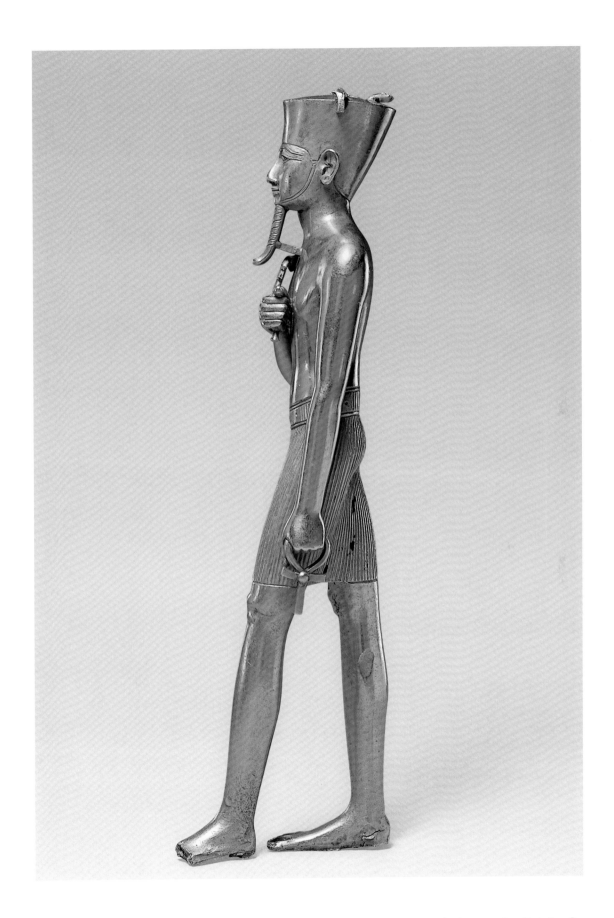

Torso of King Pedubaste

Third Intermediate Period, 23rd Dynasty, reign of Pedubaste (ca. 818–793 B.C.)
Bronze, hollow cast with multiple cavities and iron armature and core supports;
yellow- and red-gold inlay and gold leaf[1]
H. 27 cm (10⅝ in.), W. 14 (5½ in.), D. 17 cm (6¾ in.)
Museu Calouste Gulbenkian, Lisbon (52)
[cat. no. 21]

Provenance: unknown, possibly Tanis; Count Grigory Stroganoff collection,
Rome and Aachen, by 1880; acquired by Calouste Gulbenkian in 1921

Selected References: Hill and Schorsch 2005; Araújo 2006, pp. 98–99, no. 16

This torso, the only surviving portion of a sizable striding figure, is inscribed with the names of Pedubaste, a little-known ruler of the Twenty-third Dynasty. Abundantly inlaid with yellow and red gold and partially gilded, it belongs to a group of polychrome metal statues from the Third Intermediate Period that are large in scale and ambitious in decoration. Owing to the torsion in the body, an implicit shift in weight from one leg to the other, and the animating effect of the surface decoration, even this mere fragment communicates a sense of movement, a stylistic peculiarity expressed in similar ways by other more or less contemporary striding metal figures, including those of Takushit (cat. no. 27; pp. 98–103), Karomama (fig. 19), and Bepeshes (Musée du Louvre, Paris, E 7695).[2]

Consideration of the use of iron and iron tools is germane to an evaluation of this work and may, ultimately, provide one means of distinguishing between uninscribed late New Kingdom and Third Intermediate Period cupreous statuary. Ferrous metallurgy, in widespread use in western Asia and other regions around the Mediterranean in the late second millennium B.C., came relatively late to Egypt, with the earliest iron or steel tools—the latter an alloy of iron and carbon with superior cutting ability—dating well into the first millennium, generally after 600 B.C.[3] Iron smelting is first attested in Egypt in the sixth century B.C.[4] Exactly when during the first millennium iron core supports and iron armatures, which also served to steady the core inside the investment during casting, first came into use in Egypt is uncertain, but the Pedubaste torso is perhaps the earliest inscribed work on which they appear. Armatures, which have been observed inside Third Intermediate Period statuary from Samos[5]

and Karnak (cat. no. 25; pp. 95–97),[6] seem to have been used more frequently earlier in the first millennium B.C., while rectangular-section iron core supports are seen consistently through the Late and Ptolemaic Periods.

Iron tools were also used on bronze surfaces, but apparently for repairs or alterations and not initial manufacture; surface decoration executed in the wax model using incising or chasing tools can be observed on most statuary, and occasionally punches were used (cat. nos. 23 [pp. 92–94], 50 [fig. 86]).[7] Channels for inlay on the back of a kneeling figure (cat. no. 47; fig. 55), which spell out the name of the Twenty-sixth Dynasty king Amasis, were likewise cut in the wax, whereas a second inscription naming the same ruler but added at a later time was cut into the metal surface, by necessity using a steel tool. Similarly, a steel tool must have been used to cut a stepped rectilinear opening on the back of the Pedubaste figure, where a large casting flaw demanded the introduction of a metal patch. Perhaps in part because of the scarcity of suitable iron tools, this type of repair appears only occasionally on Egyptian cupreous statuary (cat. no. 26; see fig. 90), although patches are plentiful on statuary cast in silver (cat. no. 40; pp. 130–33), a softer metal that can be cut with bronze tools. In comparison, cast-in and cast-on repairs—which involve adding molten metal to repair or complete an object that is already cast—though laborious, do not require special tools and are more common, but they, too, are relatively infrequent.[8] Whether Egyptian founders recycled flawed works because they were unable or unwilling to repair them, or if they were able to consistently produce casts that required little improvement, remains an open question. D S

1. The torso of Pedubaste was examined and radiographed in the Sherman Fairchild Center for Objects Conservation in December 1999; at that time, samples of the figure itself and various inlays were removed for later analysis using EDS/SEM. For further details of the technical analysis, see Hill and Schorsch 2005, pp. 168–78. The color of the red gold is a result of the presence of a substantial amount of copper in the alloy.

2. See the essay "The Manufacture of Metal Statuary" in this volume. See also Hill and Schorsch 2005, pp. 185–86.

3. For the first systematic use of iron in Egypt, a subject seldom discussed, see Ogden 2000, pp. 166–68.

4. Petrie 1886, p. 39.

5. See, for example, several statues in the Archaeological Museum, Vathy, Samos (B 204, B 879, B 1312 [cat. no. 38], B 1364, and B 1525), based on visual examination by the author in 1989; illustrated in Jantzen 1972, pls. 1, 2, 4, 6, 7.

6. Taylor et al. 1998, p. 12; see also Raven 1993, pp. 130–31, for the examination of a female figure in the Rijksmuseum van Oudheden, Leiden (E 752).

7. In comparison, linear decoration was executed directly on the metal surface of the gold figure of Amun (cat. no. 19).

8. A small cast-in repair on the head of a striding priest figure (cat. no. 32) can be seen in radiographs; see also Raven 1993, pp. 131–32.

Kushite King

Third Intermediate Period, 25th Dynasty (ca. 747–664 B.C.)
Copper alloy, solid cast; formerly clad in precious-metal leaf; regalia intentionally removed
in antiquity
H. 38.7 cm (15 ¼ in.), W. 15.1 cm (6 in.), D. 19 cm (7 ½ in.)
National Archaeological Museum, Athens (624)
[cat. no. 23]

Provenance: unknown; acquired by Ioannis Demetriou in Alexandria; donated with his collection in 1880[1]

Selected References: Postolakas 1881, no. 166, p. 4; H. W. Müller 1955a, p. 62, n. 3; Tzachou-Alexandri 1995, p. 145; Málek 1999, no. 800–895–048; Hill 2004, pp. 60–62, 168–69

This statuette represents a king of the Kushite dynasty, yet it is inscribed with the cartouche of a later monarch. The king is shown kneeling with his right arm outstretched and flexed. The missing left forearm and hand would have mirrored the right; his palms thus faced inward and were parallel to one another. The shoulders are broad, the chest athletic: a powerful build that conveys an impression of physical strength but not brutality. His round head rests on a distinctively Kushite heavy neck. The face has broad cheeks, and the eyes are almond-shaped, with rounded eyeballs whose outlines are deeply incised. The nose is long and sharp. The lips are small but full, with two depressions at the corners of the mouth. The philtrum on the upper lip, so typical of Egyptian art, is not indicated. The chin is defined by a horizontal groove at the top, beneath which it narrows at its peak. The underlying hyoid bone in the neck protrudes markedly. The surviving right ear is represented in some detail; most of the left ear is missing, as is the base. Small raised disks indicate the nipples and navel.

Below the toes and between the knees are three tangs that once held the figure to its base; they appear more greenish in color than the statue itself. The king wears a pleated *shendyt* kilt, which is deeply grooved and finely executed. There are traces of gilding on the back and along the junction of the kilt and feet. On the head is a close-fitting cap decorated with stamped ringlets (see p. 94), which some scholars have interpreted as a stylized rendering of natural hair. The vertical groove that bisects the torso from the sternal notch to the navel is characteristic of the period from the

Fig. 49. *Ram Head Amulet (Probably from a Kushite Royal Necklace)* (cat. no. 36)

Twenty-fifth Dynasty (ca. 747–664 B.C.) until the reign of Psamtik II (595–589 B.C.) in the Twenty-sixth Dynasty.

There is a diadem, or headband, on the king's forehead, from which two streamers descend at the back. Originally the front of the diadem would have been decorated with the upraised heads of

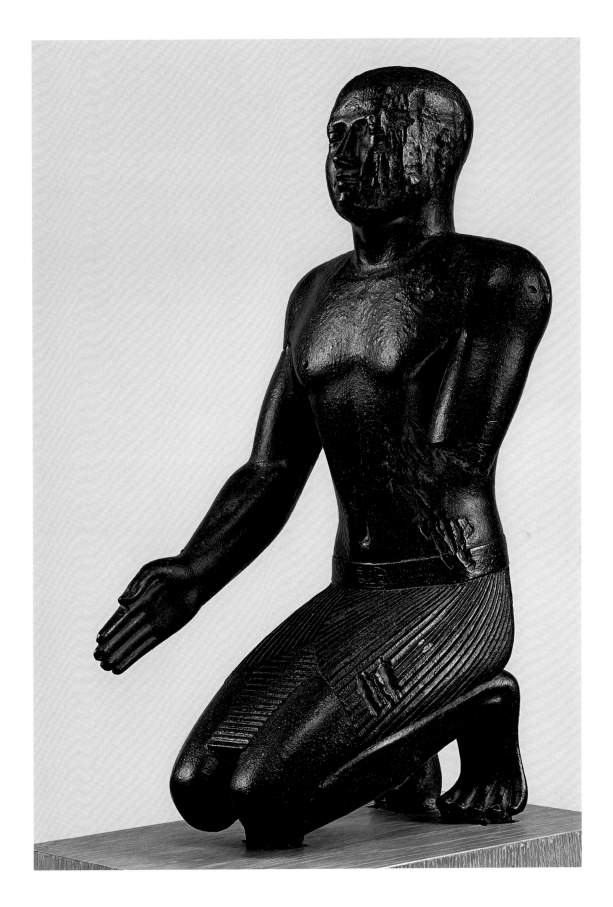

Details of back of head and torso
(left) *and top of head* (right)

two royal cobras (uraei)—their bodies twining back over the top of the head and their tails hanging down in the rear—that may have represented the Kushites' rulership over Upper and Lower Egypt. The traces of these emblems are more noticeable on the back of the statue (see above left). Around the neck there are faint impressions from what was originally a Kushite-type necklace or neck cord, which had three pendant ram heads resting on the middle and both sides of the chest (see cat. no. 36; fig. 49). The ram, a divine animal and symbol of Amun, was the dominant and protective deity of the Kushite dynasty.

The Kushites conquered Egypt in the mid-eighth century B.C. Driven back by the Assyrians in 664 B.C., by 656 B.C. they had withdrawn completely. A truce of some sort seems to have existed between the Kushites and the Egyptians for most of the first half of the Twenty-sixth Dynasty—that is, during the reigns of Psamtik I (664–610 B.C.) and Necho II (610–595 B.C.). When Psamtik II came to power, he organized a campaign against the Kushites and invaded Nubia. Subsequently, during his reign most Kushite representations were "corrected" to show only one uraeus; Kushite neck cords were similarly removed and, particularly in reliefs,

Kushite royal names were erased and sometimes replaced by his own. On this statuette, the Kushite regalia were skillfully and deliberately erased in antiquity, and the belt bears the cartouche of "Psamtik." Given this political context, the cartouche is almost certainly that of Psamtik II.

The size of the statue is nearly twice that of other examples of royal Kushite metal statuary; in fact, it is the largest preserved metal kneeling king from any period of Egyptian history. Along with its other stylistic particularities, this testifies to some unique circumstance of production. The kneeling pose and the position of the hands suggest that the figure was originally holding or stretching out toward a now-missing element, perhaps a baldachin sheltering a divine statue or some other cult object or symbol. It is possible the statuette was a votive offering, but, judging from its size, it was more likely a piece of the essential liturgical equipment of a sanctuary.

ET

1. The statuette arrived with the first shipments of the Demetriou collection in May 1880. Beginning in 1881 it was exhibited at the Polytechnic School in Athens, next to the future site of the National Archaeological Museum, where it remained on view for ten years.

Statue of a Woman (Probably a God's Wife of Amun)

Third Intermediate Period, 22nd–25th Dynasty, 9th–8th century B.C.
Leaded bronze, hollow cast with iron armatures; separate (?) solid-cast arms and wig;
gold leaf over gesso ground; eye sockets inlaid with limestone (?), lapis lazuli, and obsidian
H. 68.5 cm (27 in.), W. 23.5 cm (9 ¼ in.), D. 27 cm (10 ⅝ in.)
The Trustees of the British Museum, London (EA 43373)
[cat. no. 25]

Provenance: unrecorded, presumably Thebes; acquired from the collection of Giovanni d'Anastasi in 1839

Selected References: Budge 1922, p. 25 (cited erroneously as one of 43370–2); Roeder 1956, §400d, fig. 408; Oddy et al. 1988, p. 36, figs. 1, 2; Raven 1993, p. 133; Delange et al. 1998, pp. 72–73, fig. 12; Taylor et al. 1998, pp. 9–14, figs. 1, 7; Málek 1999, no. 801-715-752

This statue represents a woman clad in a long, tight-fitting dress with wide sleeves. Her short round wig or coiffure is composed of overlapping locks of hair. The figure is one of a group of fine metal sculptures representing high-status women from the Twenty-second to the Twenty-sixth Dynasty.[1] Of these, the best preserved and most beautiful is the statue of the God's Wife of Amun Karomama, of the Twenty-second Dynasty, now in the Musée du Louvre, Paris (fig. 19); another such statue, in the Ägyptisches Museum und Papyrussammlung, Berlin (52321), is inscribed for a songstress of Amun. No inscription survives on the present example that would identify the person represented, but iconographic features strongly suggest that the statue depicts one of the God's Wives of Amun. The position of the arms indicates that she was engaged in making an offering that originally was positioned on the open palm of her outstretched left hand. This object is now lost, but descriptions of the statue made at the time it entered the British Museum in 1839 indicate that it was a small seated figure of a goddess. Although identified as Isis in the early descriptions, the offering is much more likely to have been a figure of Maat, the personification of cosmic order, right, and truth. Offering Maat to a deity was a ritual role usually reserved for the king; the only women who are depicted performing this act in a temple context are the God's Wives.[2] That this lady is participating in a ritual is also suggested by the position of her feet, whose pose, with the left leg advanced, is otherwise unusual for a female figure.

The other statues in the group show women wearing similar costumes and hairstyles and, like this figure, several of them were originally depicted holding ritual objects that are now missing. Since the actions they perform presuppose a recipient, it is likely that the statues would have been placed in the immediate vicinity of the cult image of a deity.[3] Some of them were probably mounted on processional barques; these often carried royal figures attending on the cult image of the deity, which occupied the cabin. This role is strongly indicated for the statue of Karomama by an inscription on the base, which refers to her as the god's "pilot."[4] The provenance of most of the statues in the group is not recorded, but there is evidence that some were found in the northern part of Karnak, not far from the Osiris chapels erected there during the Third Intermediate Period. The statues may have been dedicated at these chapels and may have been formally buried in the area after their use life was past.[5]

The group to which this figure belongs is important in the history of the technology of metal statuary in the ancient Mediterranean. Together with two similar statues in the British Museum (EA 43371, 43372), it has been subject to recent cleaning and scientific investigation, which have thrown light on the manufacture of these works.[6] The head, torso, and feet of this example were cast in a single piece using the direct lost-wax process. It is possible that both the wig and the arms were made separately, but further technical examination is necessary to elucidate these parts of the statue. Attachment

of the arms by means of pegged tangs (a method clearly attested on EA 43371 and 43372) is, in this statue, unsubstantiated by radiography. The body metal is a heavily leaded bronze. Samples taken from the thigh and the foot showed a substantial variation in the lead component—12.8 and 26.4 percent, respectively—a difference that suggests the metal cooled slowly, allowing the lead to sink to the lower parts of the statue through gravity. Radiography shows armatures inside both legs. On other statues in the group, rectangular chaplets are visible, but these could not be definitively identified on this specimen, perhaps owing to the thickness of the corroded metal. The statue was probably fitted to a base by means of metal tangs attached to the feet, but damage and loss to these areas, and the presence of modern footplates, prevent an accurate appraisal.

Stylistic features suggest that this statue and its companions date to the ninth to eighth century B.C., making them among the earliest large, hollow-cast figural bronzes from the ancient Mediterranean identified thus far. Judging from numerous other features it seems that the production of such substantial hollow-cast statues posed a challenge to the skills of the artisans. The casting was made with very thick walls and is relatively simple in shape, presumably to minimize the risk of the molten metal solidifying before it had been completely poured. The inclusion of an unusually high lead content may have been a deliberate choice to maximize the fluidity of the metal during the casting process, and the gravity segregation mentioned above points to the casting having been permitted to cool slowly, perhaps as a further precaution against mishaps. From these observations, which apply to other statues of the type, it would appear the craftsmen still lacked confidence in the production of large-scale pieces of this kind. In spite of these precautions, casting flaws are visible on this statue and on others in the group.

The treatment of the surface of the three statues in the British Museum and others from this stylistic group varies. On some, gold leaf was applied directly to the metal or onto a substrate of carved gesso, while on others costume details, inscriptions, and figural scenes were rendered using metal inlays of gold, silver, or electrum hammered into grooves. The surface of the present statue is now a complex series of layers comprising original body metal, gesso, and corrosion products. The most conspicuous element is the regular pattern of small nodules that covers the surface of the figure where the gesso has flaked away. It was once thought that this pattern had been achieved by wrapping the wax model in cloth that was consumed during the firing process, leaving a roughened surface suitable for the application of gesso. The pattern's resemblance to the weave of a textile is superficial, however; a more probable scenario is that a tool was rolled over the surface of the wax model, creating indentations that were subsequently transformed by corrosion into the raised pimples visible today.[7] The indentations appearing on the bronze casting would have acted as a key for the gesso. Small traces of gold leaf adhering to the remaining gesso indicate that the surface was gilded, at least in part. The eyes were inlaid with a white material, probably limestone; the area of the pupil and iris on one of the eyes retains a thin overlay, apparently of obsidian. The eye borders are of lapis lazuli, a material probably also used for the eyebrows, though these are now lost.

J H T

1. For the most complete listing of these figures, see Delange et al. 1998.
2. Teeter 1997, pp. 13, 82, 115–15. The pose of the arms of this statue, with the right hand raised in protection of the image, is peculiarly appropriate to the presentation of Maat; ibid., p. 22.
3. Ibid., p. 31.
4. Jacquet-Gordon 1967, pp. 89–90.
5. Delange et al. 1998, pp. 73–74.
6. Taylor et al. 1998.
7. Ibid., p. 12, fig. 7.

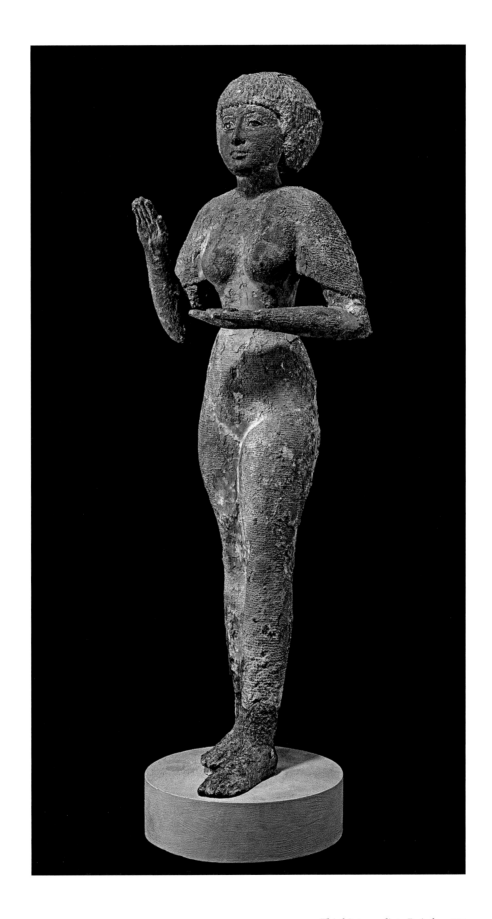

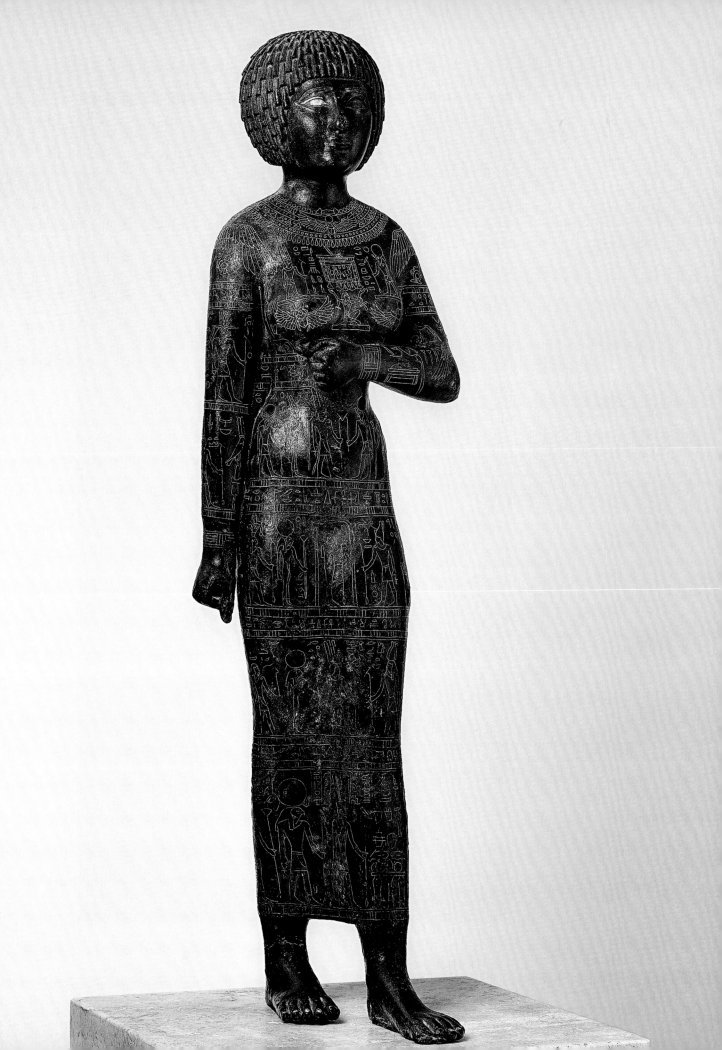

Takushit

Third Intermediate Period, end of 25th Dynasty (ca. 670 B.C.)
Copper alloy, hollow cast; precious-metal inlay; ivory inlays in eye sockets (left eye lost);
eyebrows formerly inlaid
H. 69 cm (27 ⅛ in.), W. 20.5 cm (8 ½ in.), D. 21.5 cm (8 ⅛ in.); max. H. of tangs 5.8 cm
(2 ¼ in.)
National Archaeological Museum, Athens (110)
[cat. no. 27]

Provenance: reportedly found east of Lake Mareotis, on Kom Kourougka or Kom
Tourougka, close to Chos village;[1] purchased by Ioannis Demetriou in Alexandria;
donated with his collection in 1880[2]

Selected References: Maspero 1900; Yoyotte 1961, pp. 159–61; Boufides 1981;
Tzachou-Alexandri 1995, pp. 158–59; Cladaki-Manoli et al. 2002, pp. 37–38, no. II.15;
Perdu 2004; Hill and Schorsch 2005, pp. 180–81, 184

Takushit is depicted as wearing a full-length, long-sleeved fitted dress that is embellished over its entire surface with figural decorations made of inlaid, thin precious-metal strips. Even her toenails are inlaid with precious metal, although here there are some losses. The ivory inlay of the left eyeball and the eyebrow inlays are also missing, as is the original base. Takushit wears a *wesekh* collar around her neck and wide bracelets on her wrists. The left arm is bent, with the fisted hand tucked beneath the right breast; the right arm hangs down straight and is attached to the torso. Similar statues suggest that the left hand originally held a fly-whisk scepter, the essential emblem of royal women who occupied supreme religious office. The right hand would have held a *menit* necklace, which also served as a ceremonial musical instrument. Her left foot advances in stride so that the figure's weight is proportionally distributed on both feet. This pose reflects the artist's intention to enliven the statue with energy and movement, necessary elements for the statue's performance in religious ceremonies.

The form of Takushit's body, as revealed by the dress, is quite sensuous. The inlaid decoration is divided into five zones: the upper body, and four wide, horizontal bands. The zones are defined by four narrower bands in between, which encircle the waist, hips, thighs, and knees. The narrow bands bear hieroglyphic inscriptions that read outward in each direction from the center, except for the lowest band, which reads left around the figure; these include the funerary formula (*hetep-di-nesut*). The offering inscription is made on behalf of the princess and *waab* priestess Takushit, daughter of Akanosh, great chief of the Ma, to certain deities named; the offering table on her advanced leg indicates that this offering extends to all of the deities depicted. No actual interaction between these gods and Takushit is represented, however. Study of the images and texts on the statue reveals an emphasis on deities—including Onuris, Mehyt, Osiris-Anedjty, Isis, and Harendotes—who were worshipped at religious centers in the Sebennytos region and elsewhere in the northeastern part of the Delta. Osiris-Anedjty, Isis, and Harendotes, who were worshipped together at Hebyt (modern Behbeit el-Hagar), are each represented twice, more than any of the other gods; the last line of the inscription refers to an offering on behalf of Osiris-Anedjty of Hebyt. All of these associations are strongly suggestive of the statue's provenance as well as Takushit's own origins. Future studies may refine our understanding of the religious topography represented by these gods, and perhaps they will also offer clues to the religio-political agenda of Takushit's father.

Other divine symbols on the statue are of a funerary rather than a ceremonial character, such as the enormous *djed* pillar on Takushit's backbone. The inscriptions refer to Takushit as an "Osiris" or as "justified," meaning one of the honored deceased.

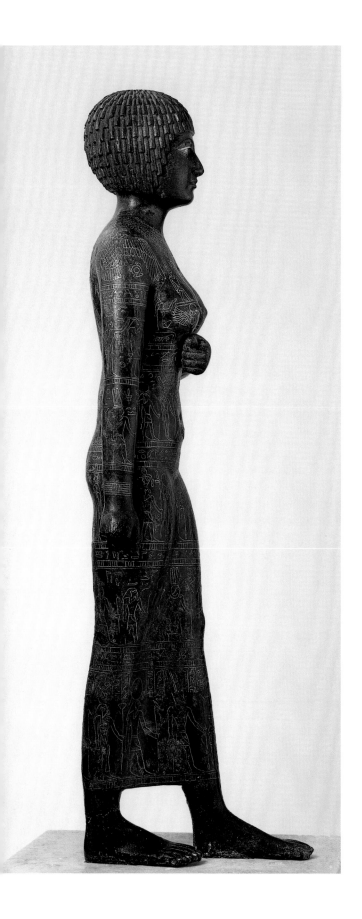
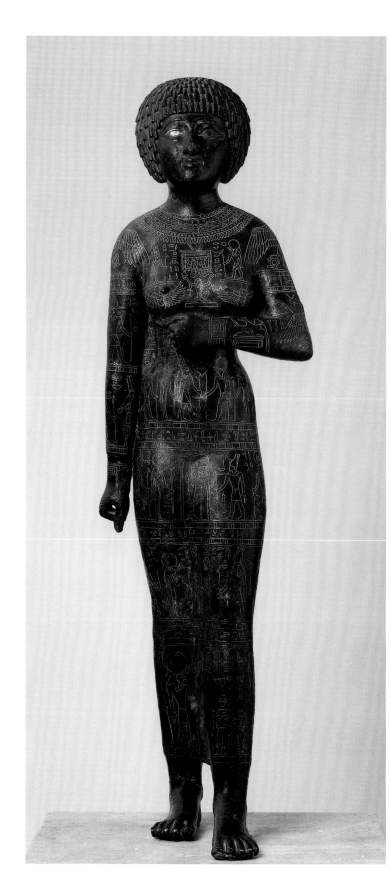

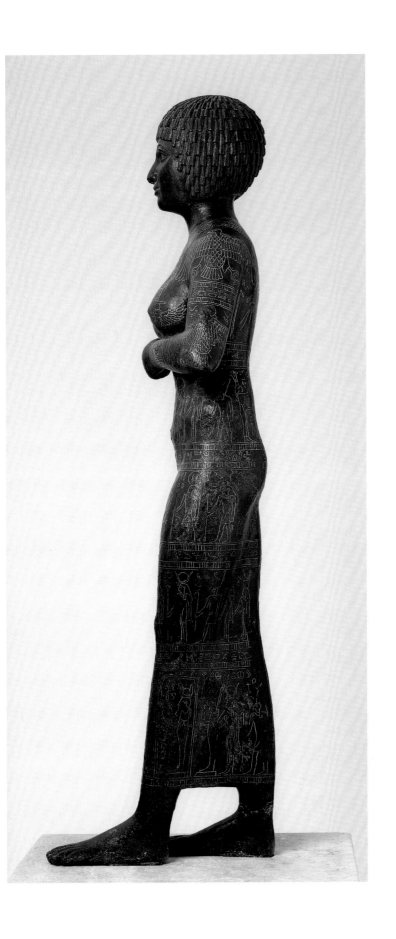

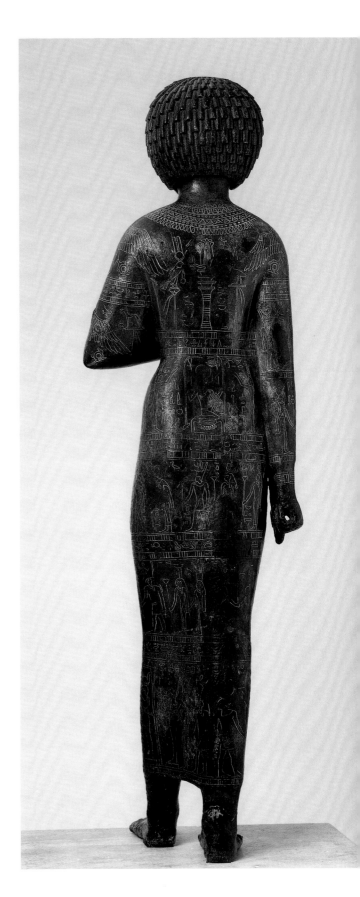

This fact reinforces the hypothesis that the statue had two uses: a ceremonial one, as a piece of sanctuary equipment while Takushit was alive, and a funerary one, as equipment for her cult within the temple after her death.

According to a recent study by Olivier Perdu, Takushit's father can likely be identified as Akanosh "B," a great chief of the Ma in the Sebennytos region and prophet of Isis of Hebyt. Akanosh B is recorded on a stela that includes a date to the second year of the northern dynast Necho I (r. ca. 672–664 B.C.), to whom, judging from that dating choice, Akanosh evidently felt some allegiance. That date coincides with year twenty of the reign of the Twenty-fifth Dynasty king Taharqo (r. ca. 690–664 B.C.). The name "Takushit," which translates as "the Ethiopian," suggests the subject was connected by either birth or marriage to the Kushite dynasty.

ET

1. Reported by Nikolaos Boufides, a former curator at the National Archaeological Museum, Athens, but without reference to a source. This information most likely derives from a Demetriou manuscript, but one that has yet to be located.
2. The statue arrived with the last shipments of the Demetriou collection. This information derives from a letter (dated May 24, 1880) written by Demetriou from "Rampli," a suburb of Alexandria where he was one of the first to build, to Markos Dragoumis, consul general of Greece in Alexandria, who was responsible for shipment of the collection to Athens. Demetriou reports the dispatch of the forty-fourth container of antiquities, some of which, acquired recently, had no stands. He thus commissions the construction of stands at his own expense and reiterates the need to construct a stand for the statue of Takushit (inv. no. 1). He also urges that the statue be favorably positioned at the center of the exhibition space. Beginning in 1881 Takushit was exhibited at the Polytechnic School in Athens, next to the future site of the National Archaeological Museum (Postolakas 1881, pp. 6–7).

Gods and Texts on the Statue

The offering texts and labels accompanying the images on the statue of Takushit are translated below by James P. Allen, based on digital photomontages of each section or register. Restorations, particularly on the back of the statue, are based on Maspero 1900 and Boufides 1981. It has not been possible to collate the readings against the original. Placement is indicated in *italics*; Egyptian inscriptions are placed in quotation marks; and descriptions or identifications based solely on iconography appear without quotation marks.

Chest
necklace with winged scarab
pectoral with (*from center*): *to the left*: Osiris and Isis; *to the right*: Horus
beneath pectoral: kneeling Shu with raised supporting arms
left of pectoral: "Amun-Re, lord of the throne of the Two Lands, foremost of Karnak"
beneath Amun-Re: winged scarab; kneeling goddess Meryt
inscription band beneath Meryt: "Recitation by Meryt of the North, lady of the sky"
right of pectoral: "Re-Harakhti, lord of the sky"
beneath Re-Harakhti: winged scarab

Back
djed pillar
left of pillar: "Horus on his papyrus stem, who rescued his father in Hebyt"
right of pillar: "Thoth [the great, lord of] all the Hermopolitans, the great god"
flanking the scene: *was* scepters

Inscription band beneath scene on back, from center to the left: "A royal offering of Isis the great, the god's mother"
to the right: "A royal offering of Nephthys, the god's sister, mistress of the gods"

Left arm, crossed over chest
on shoulder: image of Nekhbet
inscription band beneath Nekhbet: "Nekhbet, the white one, the one of Nekhen, with outstretched arms, lady of Faqet, lady of the southern palace"
on forearm and lower part of upper arm: image of Anubis; two images of "Wepwawet" on either side of an image of combined Nekhbet and Wadjet (vulture with spread wings), preceded by the legend "Double Wadjet"

Right arm
on shoulder: image of Nekhbet
inscription band beneath Nekhbet: "Nekhbet, the white one, the one of Nekhen, with outstretched arms, lady of Faqet, lady of the palace"
upper register: "the Ram of Mendes"; "Hatmehyt in Djedet"; child–god in double crown holding crook and flail scepters, labeled "Re–Harakhti"
lower register: Eastern Horus; "Onuris (*sic*), lord of the East," but the god depicted has the iconography of Sopdu; "Khensit"

First register below crossed arm, from center
to the left: "Amun–Re, king of the gods"; "Mut, eye of Re"; "Khonsu in Thebes"
to the right: falcon–headed god crowned with disk and uraeus; goddess crowned with disk on which a scarab can be seen; child–god in double crown holding crook and flail scepters
back: Heh holding branches flanked by "Meryt of the north" (*right*) and "Meryt of the south" (*left*), each saying, "come and bring, come and bring in perfect peace"

Inscription band below first register, on either side of ankh–*sign*
to the left: "A royal offering of Isis the great, the god's mother, eye of Re, lady of the sky"
to the right: "A royal offering of Nephthys, who makes food-offerings functional, giving pure offerings and sustenance, the work she has, every day (for) the Osiris Takasha (Takushit)"

Second register, from center
to the left: "Ptah"; "Sakhmet the great, lady of the sky"; "Nefertem–Re, protector of the Two Lands"
to the right: "Atum, lord of the land, the Heliopolitan"; "Khepri, the great god who came into being on his own"; "Shu, lord of the gods, lord of the sky"; "Tefnut, eye of Re, lady of the sky"; "Geb, elite one of the

Gods"; "Nut, who gave birth to the Gods"; "Nephthys, the god's sister, lady of the sky"; *was* scepter

Inscription band below second register, on either side of ankh–*sign*
to the left: "A royal offering of Ptah–Sokar–Osiris, lord of the sky"
to the right: "A royal offering of Atum–Khepri, the great god who came into being on his own, giving joining the Sun as he moves in his sunlight, appear-ing [...to Osiris Taka]sha (Takushit), justified, forever"

Third register, from center
to the left: "Onuris, son of Re"; "Mehyt"; "Hu, upon his mound"; "Sia, the great god"; traces of a figure and "[...] in the midst of the temple"
to the right: "Osiris Anedjty, foremost of Hebyt"; "Isis, lady of Hebyt"; "Harendotes"; "Nephthys, the god['s sister]"; "Wadjet"

Inscription band below third register
to the left, encircling figure: "A royal offering of Osiris–Anedjty, foremost of Hebyt, the great god, ruler of eternity, giving receiving what is pure on earth, in the sky, and in the netherworld, (to) the priestess Takasha (Takushit), daughter of the Great Chief of the Ma Akanosh"

Fourth register
center: "Osiris Takasha (Takushit)"; *below the name*: offering table
to the left: "Amun–Re, lord of the throne of the Two Lands, foremost of Karnak"; "Recitation by Re–Harakhti, the great god, lord of the Great Enclosure (temple of Heliopolis)"; "Recitation by Mut the great, lady of Isheru"; "Khonsu in Thebes"
to the right: "Ptah, beautiful of face, the Sun's deputy"; "Osiris–Anedjty, foremost of Hebyt"; "Isis, lady of Hebyt"; "Harendotes of Hebyt"

Roundel with Offering Scene
(Fragment from the *Menit* of Harsiese)

Third Intermediate Period–Late Period, 8th–6th century B.C.
Leaded bronze, solid cast; precious-metal and copper-alloy inlay
H. 7.7 cm (3 in.), W. 9.7 cm (3⅞ in.), D. 0.4 cm (⅛ in.)
Ägyptisches Museum und Papyrussammlung, Staatliche Museen zu Berlin (23733)
[cat. no. 33]

Provenance: unknown, reportedly from Thebes; Reinhardt collection; von Bissing collection; acquired in 1934

Selected References: Roeder 1956, §634e, pl. 64e, with reference to von Bissing 1939; Hill and Schorsch 2005, pp. 176, 185–86, 195

The *menit*, a type of bead necklace with a counter-weight, was associated with ideas of birth and rebirth, power, and rejuvenation.[1] *Menits* were also connected to the pacification of potentially dangerous goddesses, especially those who could appear in leonine form (seen here in the seated goddess, labeled Mut-Sekhmet-Bastet) and who were associated with the eye of the sun god, Re.[2] The other figure on this *menit* is a child-god, crowned with a uraeus, who proffers a sistrum to the goddess and holds a *menit* as a symbol of appeasement. The inscription before him mentions a "prophet, overseer of the city, and vizier, Harsiese." Unfortunately, the original owner cannot be identified with certainty, except that he was one of the viziers "Harsiese" known between the Twenty-second and the Twenty-sixth Dynasty.[3]

The two central figures are surrounded by political symbols, including the plants of Upper and Lower Egypt, each topped with its respective goddess. Written below them is "Uniting the Two Lands," flanked by lapwings atop baskets and stars, meaning "all the common people adore." The scene is surrounded by an ornamental band with alternating rosettes (solar motifs) and wedge- or spear-shaped forms. Parallels (of a sort) for this type of decorative band can be found, for example, on the statue of Karomama in the Louvre (fig. 19) and on a bronze base in the Egyptian Museum, Cairo (JE 25572).[4] A *menit* with extremely similar decoration, but with a somewhat confused inscription and without the framing seen here, has been published (in a drawing) as a discrete piece,[5] but in fact it is the same work. It is possible the differences reflect stages of cleaning of the roundel.

R F

1. For references to "mammisiac religion" and a "veritable theology of birth," and what these mean in terms of *menits* and other monuments, see Fazzini 1988, pp. 8–14; Fazzini 2001.
2. See, for example, Desroches-Noblecourt 1995, fig. on p. 114.
3. Payraudeau 2003, p. 205.

4. For two views of the base of JE 25572, see Yoyotte 1961, pl. II, 2 and 5. See also Hill 2004, pp. 29, 159 (no. 18).
5. Roeder 1956, §640e, with fig. 720 (noted as von Bissing Sammlung B47 on p. 555); Roeder saw it in The Hague in 1928 and, when he subsequently saw it in Berlin, evidently did not realize it was the same piece.

Sphinx Standard

Third Intermediate Period, 22nd–24th Dynasty (ca. 945–712 B.C.)
Leaded bronze, hollow cast with iron core supports; restored tail; precious-metal leaf and gold inlay
H. of figure 12.8 cm (5 in.); base: D. 12.3 cm (4⅞ in.), W. 3.7 cm (1½ in.)
Brooklyn Museum, New York; Charles Edwin Wilbour Fund (61.20)
[cat. no. 34]

Provenance: unknown; acquired in 1961

Selected References: Van Dijk 2003, p. 77, fig. 28; Kaper 2003, pp. 196–97, 198, n. 45

The sphinx stands erect, with straight forelegs, slightly extended hind legs, and tail curled up over its back. It wears a long beard of a type normally worn by gods and a lappet wig, and its body is adorned with wings. Flanking it on the standard are two uraei. Judging from other representations, this is a *sib*-sphinx, made as an apotropaic attachment for a sacred barque. The cavity in its headdress once held a *ịni* ("elevated") headdress, with ram horns, a sun disk, ostrich plumes, and, often, two uraei.[1] Some precious-metal leaf remains on the chest, face, and one part of the feather pattern of the wings. If the blackened surface of the sphinx was an intentional effect, it was done using a method not yet understood.

In the past this sphinx has been attributed on stylistic grounds to the Nineteenth Dynasty, but some scholars have recently proposed that it actu-ally dates to the Third Intermediate Period,[2] an era whose distinctive style was influenced both by Thutmoside art and by sculpture from the Nineteenth Dynasty that was influenced by the Thutmoside style. Variations on this style occur at sites throughout Egypt until the end of Libyan rule, in the late eighth century B.C.; it even survives, to a certain extent, in some reliefs of the Twenty-fifth Dynasty (ca. 747–664 B.C.).[3] The sphinx's facial features suggest a date in the later Twenty-second (ca. 945–712 B.C.) or Twenty-third Dynasty (ca. 818–712 B.C.). Technical examination of the sphinx by Deborah Schorsch has revealed several factors that likewise point to a Third Intermediate Period date, including the presence of iron core supports, the conformal nature of the inner cavity, and the composition of the leaded bronze itself

R F

1. For the term "*sib*" and the *ịni*-headdress, see Kaper 2003, pp. 196–97, 198, n. 45; and Van Dijk 2003, p. 77, fig. 28, with reference to Hodjash and Berlev 1982, p. 113, n. m.

2. See, for example, Vassilika 1997, esp. p. 294 and n. 49.
3. Fazzini 1996.

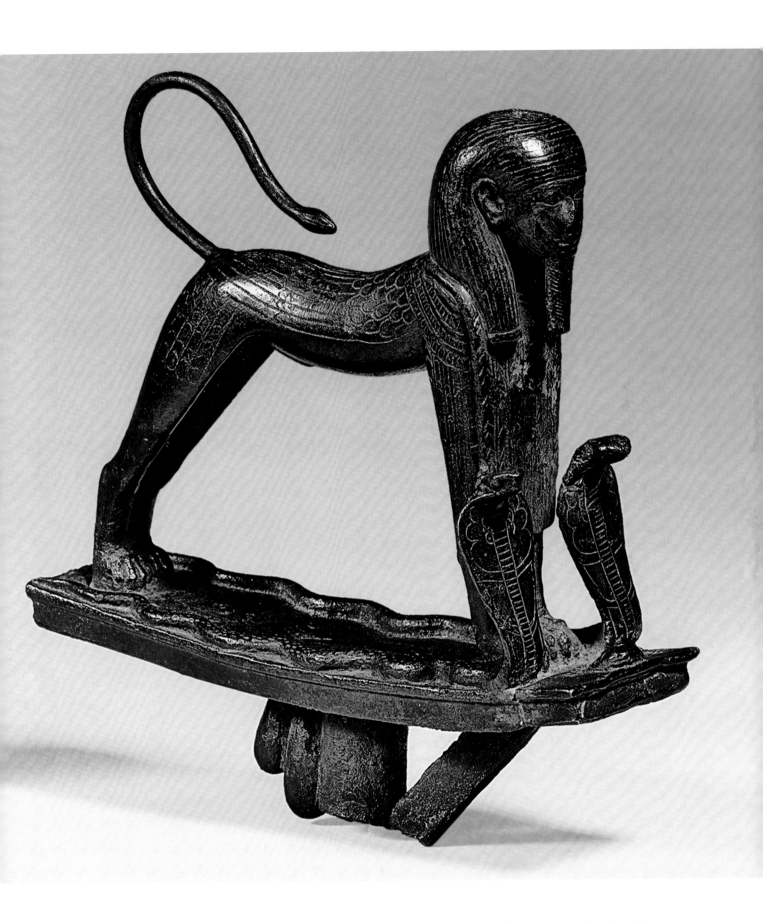

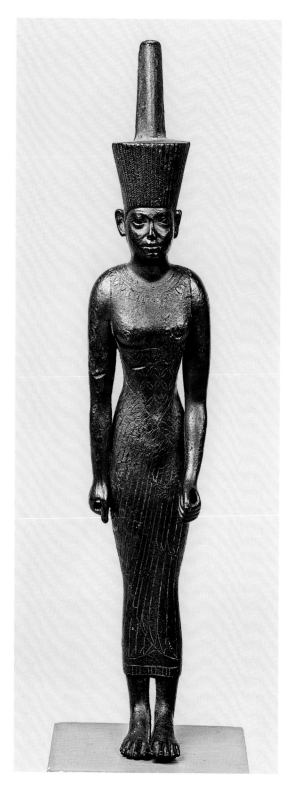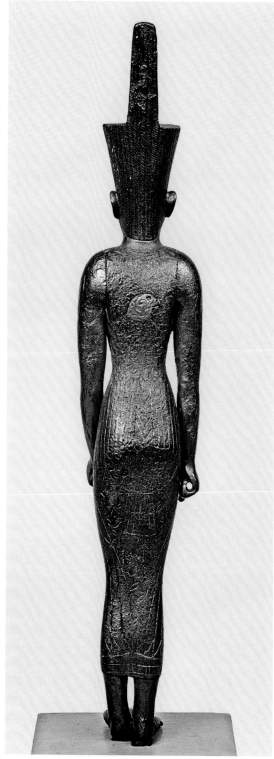

Neith

Third Intermediate Period, 25th Dynasty (ca. 747–664 B.C.)
Copper alloy, solid cast, with separate solid-cast arms; precious-metal and copper-alloy inlay
H. 22.5 cm (8⅞ in.)
Archaeological Museum, Vathy, Samos, Greece (B 354)
[cat. no. 37]

Provenance: excavated at the Heraion, Samos, 1934 (N/14)

Selected References: Jantzen 1972, pp. 23, 27, pls. 27, 28; Kyrieleis 1990, p. 25; Nikolaos Chr. Stampolidēs in Karetsou and Andreadakē-Vlazakē 2000, p. 165; Maria Viglaki-Sofianou in Beck et al. 2005, pp. 511–12

This statuette of the goddess Neith was brought in antiquity from Egypt to the island of Samos, off the Anatolian coast, where it was given as an offering in the archaic sanctuary of Hera, the Greek mother goddess. That renowned shrine, called the Heraion, attracted worshippers from throughout the eastern Mediterranean, who brought many types of offerings, including Egyptian works such as this statue. Neith is posed with her left leg slightly advanced. Her face is remarkable for its lines, fleshy ridges, and broad, unsmiling mouth, which together point to a date from the late Third Intermediate Period into the early Saite Period. This statue is thus one of the early bronze representations of the goddess, whose popularity was closely linked to the rise of the powerful dynasty in Sais, her cult city, which ruled Egypt from 664 to 525 B.C. as the Saite (or Twenty-sixth) Dynasty.

As is typical of representations of Neith, the goddess is wearing the "red crown," which served as the royal crown of Lower Egypt; here it is finely detailed with vertical hatched units. Her thin dress is barely discernible at the breasts and on the back of the legs; over this is a beaded net garment, which is covered, along with the rest of her body, by a feather garment, both of which were the prerogative of divine or semidivine women (see the essay "Heights of Artistry" in this volume). The falcon's head is still bright gold; it appears on the back of the statue along with the body of the bird, while the wings extend around the sides and cross in the front. The outline of the falcon, the nipples, and the necklace are heightened with cupreous-metal inlays. Two tangs under the feet allowed the statue to be fitted into a base; the arms were cast as separate elements and then attached.

MV–S

Statue of a Man with a Kilt Panel and Leopard Skin

Third Intermediate Period–Late Period, 25th–early 26th Dynasty (ca. 747–640 B.C.)
(see commentary below)
Copper alloy, hollow cast with iron armature; lead "core" in head (see n. 1); separate hollow-cast arms; precious-metal leaf
H. of torso fragment 26.6 cm (10 ½ in.); estimated original H. 66–68 cm (26–27 in.)
Archaeological Museum, Vathy, Samos, Greece (B 1312 [torso], B 160, B 126, B 1525, B 1690 [A 864, A 863, A 865])
[cat. no. 38]

Provenance: the Heraion, Samos (B 1312 [torso] in 1961, N/15; B 160 in 1928, south of the pillar room next to the canal; B 126 in 1927, beneath the Rhoikos altar; B 1525 in 1963, in the Heraion; B 1690 in 1965, Q/R2)

Selected References: Jantzen 1972, pp. 7, 9–12, pls. 1–4; Maria Viglaki-Sofianou in Beck et al. 2005, pp. 515–16, no. 74

Assembled from several hollow-cast components, in a typically Egyptian fashion, this statue survives in five large fragments: the head, torso, arms (the left is bent, the right is straight), and right leg (see p. 112). The arms have now been reattached to the torso. Like the statuette of Neith (cat. no. 37; pp. 108–9), the figure was excavated at the sanctuary of Hera (the Heraion) on the island of Samos, although the parts were found at various times over the course of several decades of work and in different locations. The hollow-cast head—at a later time the inner cavity was filled with lead, as is visible at the neck break[1]—no longer fits directly to the torso, but its size, casting technique, and state of preservation all testify to the fact that it belongs to this figure.

The individual represented in the statue wears a leopard skin on his back, which hangs down to his calves and is tied over the front at the left shoulder. His left hand is clenched into a fist that is hollow at the center; originally it could have held a staff. The right arm hangs to the side. Despite extensive damage to the head, and the statue's overall fragmentary condition notwithstanding, this example is the most important of the Egyptian metal works found at the Heraion, and it reflects their generally high quality. The traces of precious-metal leaf on the left wrist are faint, but they testify to the similarity between this statue and other great Egyptian copper-alloy works, such as Karomama (fig. 19), Takushit (cat. no. 27; pp. 98–103), the woman decorated with an image of the Sokar barque (cat. no. 26; figs. 40–44), and Padiamun (cat. no. 31; fig. 33). Compared to Greek statues of the period, this Egyptian example is remarkably large. Indeed, certain particularly large Greek bronze statues discovered on Samos may have been created under the influence of such Egyptian models, even though they are different in terms of the treatment of details and overall conception.

M V – S

1. Deborah Schorsch notes that lead and associated archaeological corrosion products are sometimes found in core cavities of cupreous statuary. Casting cores typically are refractory mixtures of sand and clay, and they cannot be substituted for with a low-melting metal such as lead. See Schorsch 1988b, p. 46.

Proposal for a Date and Attribution

This torso depicts a slender but manly young person with well-muscled shoulders and youthful, high-set pectorals. His long, narrow trunk is bifurcated by a shallow groove that descends to a depression in which the navel is set. His hips are narrow, and even his buttocks, as seen in profile, are notably spare. The arms and the preserved lower legs are, like the torso, well muscled. The ears and a cap of short-cropped hair are intact on the head, but the face has been destroyed.

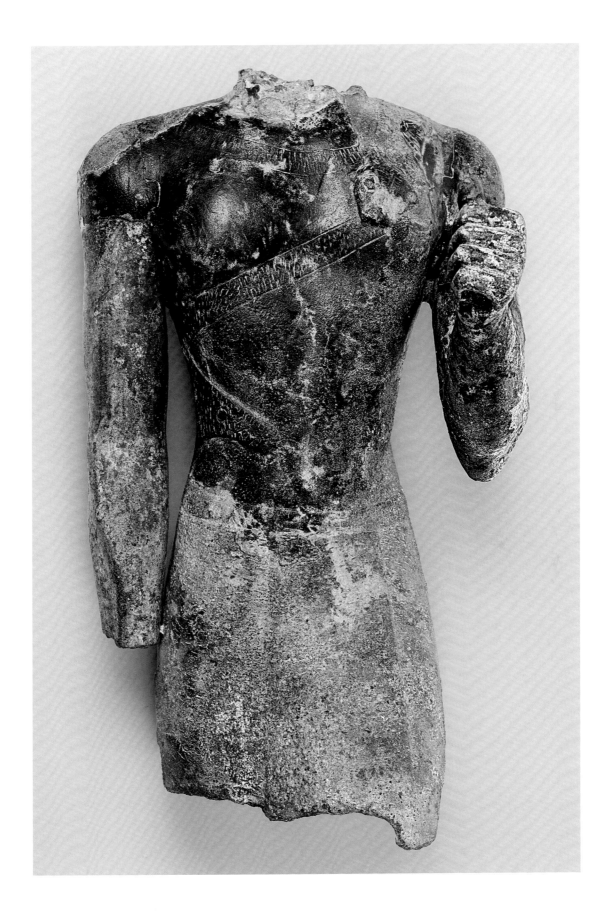

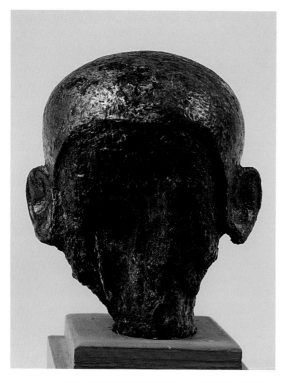

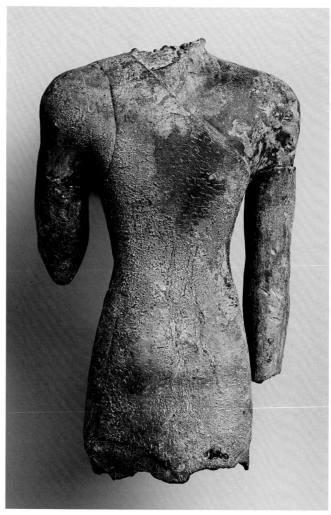

*Clockwise, from top left: fragment of head
from Statue of a Man (cat. no. 38);
view of back; right leg*

The figure wears a kilt with a belt, knotted at the front, from which a narrow flap or panel hangs. These elements of his clothing would have hung down over his thighs but, since they do not appear on his surviving leg, they must have ended at or above his knees. The combination of a short kilt with a front panel is unusual in this period,[1] making it difficult to suggest what the significance of the costume is, or what its original decoration may have been. Traces of leaf on the surviving right wrist suggest that the subject's bracelets and other jewelry may have been depicted in precious metal; if so, other details of his costume may have been indicated in a like manner.

Most of the man's back is covered by a leopard skin, the tail of which originally extended down the back of his right leg to reach the broadest part of his calf on the surviving part of the leg.[2] Egyptian priests were often represented wearing leopard-skin vestments. Unlike most such depictions, in this version the vestment is barely visible from the front;[3] only the animal's head, which hangs down over the wearer's left shoulder, and its forepaws, which extend around the sides toward the navel, are visible from that vantage. Two straps (or, possibly, strips of the hide) are also represented; one of these apparently connects the animal's head

with its body above the forward right leg, while the other may have been designed to hold its head and neck in place at the top of the wearer's chest.[4] The straps are covered with rows of short incised lines; the pelt proper, including the end of the tail, has similar lines, which are interspersed with circles to suggest the animal's distinctive markings.[5]

Although we cannot tell exactly for whom the statue was made, it does offer clues to its origins. The manly figure, with its high-set pectorals and muscular shoulders, derives from an ideal established for royal figures in the Old Kingdom as early as the Fourth Dynasty (ca. 2575–2465 B.C.). This ideal was revived by the Kushite kings of the Twenty-fifth Dynasty (ca. 747–664 B.C.) and adopted by their relatives and followers. Increasingly, however, and into the first decades of the succeeding Twenty-sixth Dynasty, a slightly more slender version of the figure type, as seen here, came to be preferred. It is interesting that one of the male figures most similar in form to this example is a stone statuette representing a prince of the Kushite royal family who was serving as high priest of Amun.[6] Thus it is not impossible that this figure represents another member of the Kushite royal family who held high office as either a priest or a government official.[7] E R R

1. The panel was normally worn in front of, or as part of, a long kilt, as on the roughly contemporary bronze figure of Khonsuirdis (British Museum, London, EA 14466), who also wears a panther skin; Russmann 2001, pp. 258–39, no. 130.
2. The end of the tail is visible in Jantzen 1972, pl. 4, and in Beck et al. 2005, pl. 13.74.
3. For the larger, more usual form of a leopard skin, see the bronze figure of Khonsuirdis in the British Museum (see n. 1).
4. I know of no parallels for these strips, which resemble neither a necklace nor the inscribed sash often worn over, and perhaps attached to, a leopard skin, as on the figure of Khonsuirdis (see nn. 1, 3).
5. These features, considered along with the small size of the

leopard skin, do not suggest a real pelt but, rather, an imitation. Such things certainly existed; see, for example, the gilded wood leopard head found in the tomb of Tutankhamun; *Tutankhamun* 1976, pp. 104–5, no. 4, color pl. 3.
6. The prince's name is Haremakhet (Egyptian Museum, Cairo, CG 42204); Russmann 1989, no. 89, pp. 175–77, 220–21.
7. As in the New Kingdom and the Third Intermediate Period, the leopard skin was often worn simply as a mark of priestly rank or duties. That its appearance here identifies its wearer as a member of the royal family, presumably the heir to the throne acting as a *sem*-priest in the funerary rites of his predecessor, is not supported by the available evidence.

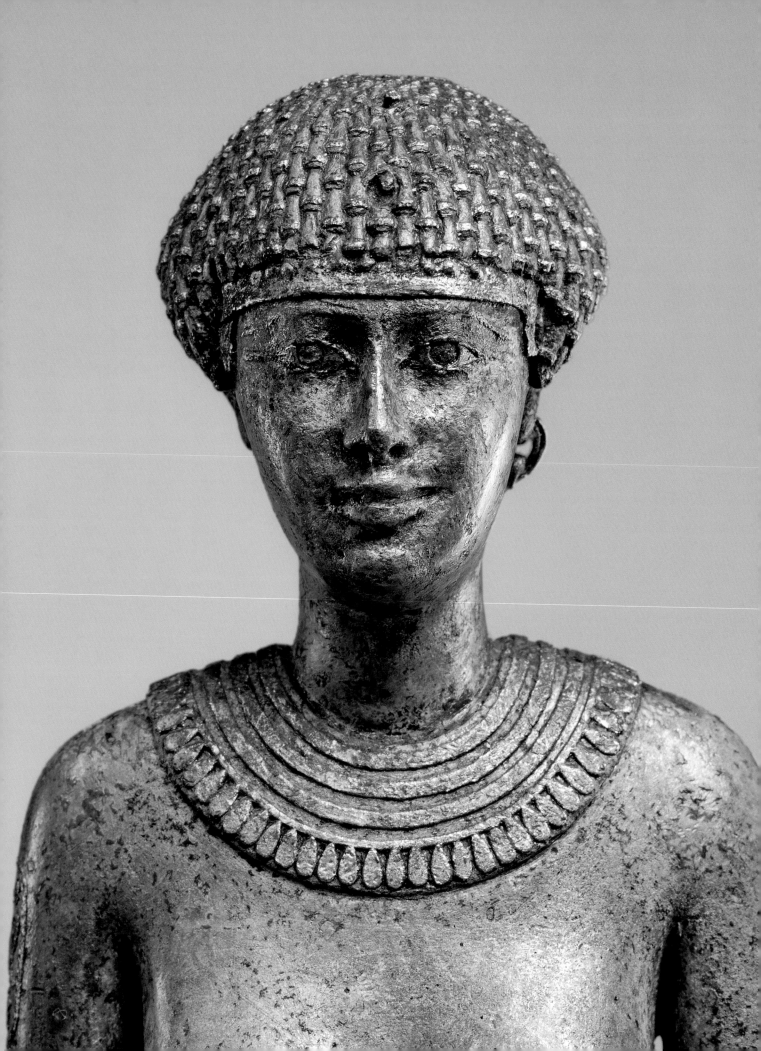

CASTING ABOUT: THE LATE PERIOD (664–332 B.C.) AND THE MACEDONIAN-PTOLEMAIC PERIOD (332–30 B.C.)

Marsha Hill

The Assyrian invasion of Egypt in 664 B.C. brought an end to the period of Kushite rule, though in Thebes the Kushite pharaohs retained ostensible control until 656 B.C. At the same time, it established the powerful dynasts in the Delta city of Sais as the pharaohs of the Twenty-sixth Dynasty (664–525 B.C.). The reassertion of central, royal power that had begun in the Kushite Period continued under the Saite kings, with the nominal unification of the country gradually becoming a true integration. A potent mythology had evolved that strongly identified the king with the divine child of some of the great gods, thus reinforcing the primacy of his role, but in reality the king's temporal power and influence were considerably limited. Moreover, during the second half of the millennium the rulership of Egypt fell to foreign powers: the Achaemenid Persians (525–404, 343–332 B.C.) and, following the invasion of Alexander the Great in 332 B.C., the Macedonian Greeks, who in 306 B.C. founded the Ptolemaic Dynasty and ruled as kings of Egypt until 30 B.C., when the country fell under Roman rule. Several aspects of Egyptian society acquired new visibility at this time; in addition to the king, high nobles, and lesser officials, temples emerged as relatively independent entities at the centers of cities and towns, and they themselves become important factors in our study of the influences on works of art.[1] Metal statuary, as a major artistic product of the era, presents us with a particularly rich portrait of this complex phase of Egyptian history.

Among preserved statues from this period are a number that reach impressive size, such as the statue of Osiris (cat. no. 39; pp. 128–29), or that meet an exceptional standard of quality, as does the silver female figure from the reign of Necho II (cat. no. 40; fig. 50). Others reveal a range of notable characteristics; the statuette of a man from Sais (cat. no. 41; pp. 134–36), for example, possesses remarkably realistic facial features. The subject is depicted in a running-kneel pose—his hands upraised in a gesture of respect tinged with awe—that succinctly conveys the immediacy and urgency of an actual temple address.[2] Stylistic details suggest the statue dates to about the first half of the Twenty-sixth Dynasty. The signs for the owner's name could be read as "Ḥr/nḫt/ḥb," so it is tempting to identify

Fig. 50. Detail of *Standing Woman* (cat. no. 40; see pp. 130–33)

the statuette as that of Nakhthorheb, a great official of Psamtik II (r. 595–589 B.C.) in Sais who had priestly titles such as director of the domains of Neith and chief ritualist.[3] Unfortunately, the order of the name signs presents an obstacle to this identification.[4]

At least two other strikingly individualistic, nonroyal metal statuettes of individuals can be firmly dated to the early years of the sixth century B.C. A large, sere figure of Ihat, a priest of Amun at Karnak (Ephesus Museum, Selçuk, Turkey, 1965), dates to late in the reign of Necho II or early in the reign of Psamtik II.[5] A small figure of Harira, overseer of the antechamber and holder of other high offices during several reigns (Musée du Louvre, Paris, AF 1670), is part of a group with Amun; the offerer is shown kneeling before the god and is represented with a high, shaved cranium, a long face, and a heavy lower lip.[6] Although Harira wears a large figure of the goddess Neith at his neck, the group itself is donated to Amun of Karnak on behalf of Harira's daughter, who served in the temple college, and can be dated by inscription to 589–585 B.C. There are no strong similarities between these two statuettes; nor is the face of either comparable to the face of the man from Sais (cat. no. 41), who, unlike the other two, has a distinctively aged body. There are also no compelling relationships to be noted among these works and the rather different types of realism that can be seen in stone sculpture dating to either the beginning or end of the Twenty-sixth Dynasty. Yet these temple statuettes are germane to ongoing discussions about the sources for such realism, as well as the question of its continuity over the

Fig. 51. *Ram*
(cat. no. 42)

course of the dynasty.[7] Indeed, all of these pieces testify to the fact that the Saite Period, more than is often realized, inherited the sophisticated metal-working traditions of the Third Intermediate Period.[8] One exquisite reflection of the beauty of the metal statuary that filled sanctuaries at this time is a stone ram (cat. no. 42; fig. 51) whose rare "chocolate" coloration, satiny surface, completely undercut horns (now missing), and lack of an integral base all mimic the characteristics of metal statuary.

Metal statues of kings, because of their profusion as well as their centrality to religious concerns, sensitively register the sociopolitical situation of the first millennium B.C. A study of these works has shown that during the first millennium there was a considerably wider stylistic range among this statuary than in contemporary royal stone statuary, pointing to the fact that most metal kings were not closely coordinated with a defined royal image, as generally seems to have been the case with royal stone statuary. In addition, metal statuary often incorporated features that were drawn from the relief repertoire rather than from stone statuary.[9] Occasionally, metal kings exhibit novel features that presumably reflect local proclivities, such as those of a particular cult. These characteristics indicate that the corpus of metal kings was manufactured across an extended network of temples that, while no doubt influenced by some unitary, central entity, also remained relatively independent, absorbing influences from their respective locales. This interplay of influences would have fluctuated with the character of a given temple or production installation, and patterns reflecting this would no doubt emerge if we could identify specific locations of production. Likewise, centralizing influences would have varied in conjunction with broader political and social changes; it appears the Saite kings, for example, maintained a different tenor in their relationship to temples than did the Ptolemaic kings. This picture is surprising only in that it underscores how the production of at least one category of *royal* image was considerably decentralized. Yet it offers a useful platform for understanding the negotiation of influences inherent in metal temple statuary and, in the absence of reliable provenances for most of these works (and poor evidence from ancient sources), it can provisionally characterize the general context for the production of metal statuary in these periods: a relatively independent, temple-based production that was closely linked to the activities that took place in the temples.[10] In this light, it is not surprising that concordances between metal statuary and stone statuary, particularly hard stone statuary, appear to be sporadic and not very stable.

Two impressive copper-alloy statuettes inscribed for "Necho" (cat. nos. 43, 44; figs. 52, 53), almost certainly depictions of Necho II (r. 610–595 B.C.), vary widely in terms of style. Catalogue number 44 is related somewhat to the Saite style that emerged in relief and stone statuary during the reign of Psamtik I (664–610 B.C.) and which strengthened thereafter; note the triangular face, slanted eyes, and curved smile. Catalogue number 43 does not reveal much of that style, or at least not in an obvious way. Other details

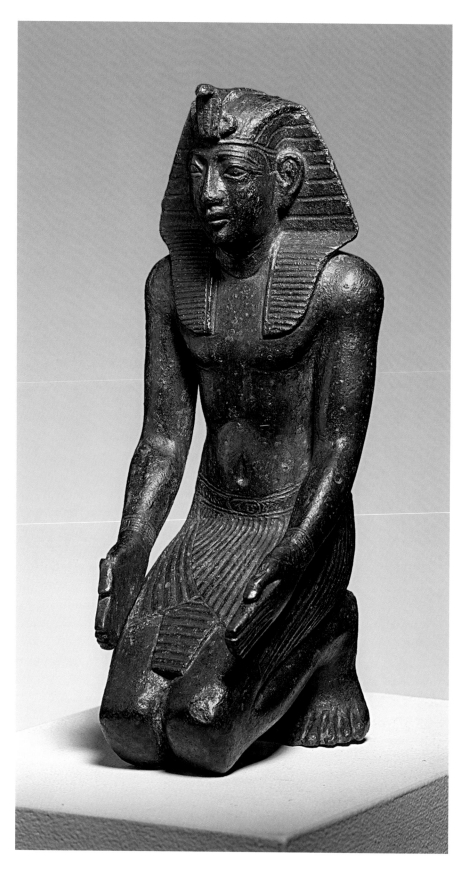

Fig. 52. *King Necho*
(cat. no. 43)

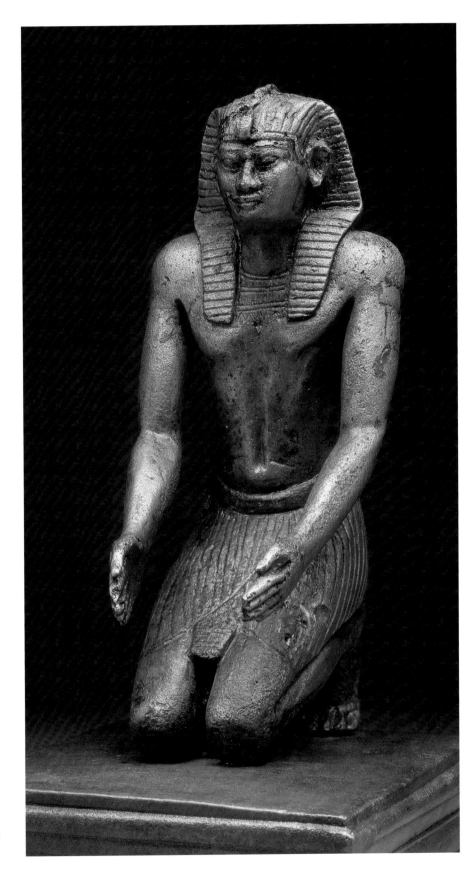

Fig. 53. *King Necho*
(cat. no. 44)

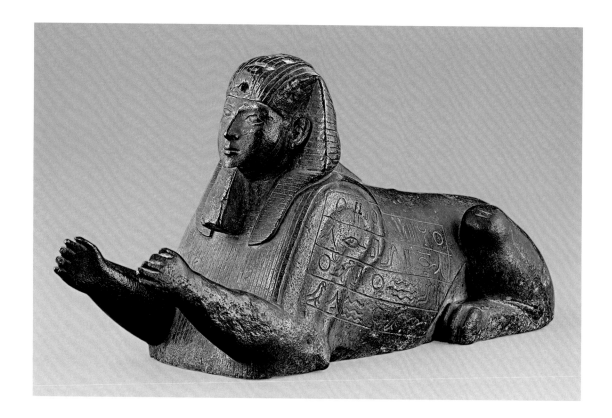

Fig. 54. *King Apries as a Sphinx* (cat. no. 45)

of the statues seem to reflect the complex interaction of influences that acted upon the production of bronzes, as discussed above. In catalogue number 44, we see a right–over–left kilt fold that, generally speaking, is quite unusual. The mode was somewhat popular among Saite metal statuary for reasons that are unclear; it is possible an Old Kingdom convention for statues of nonroyal males wearing kilts was misunderstood and employed as an intentional archaism. Catalogue number 43 has two delicate lines beneath the throat, a feature that seems to have gone out of vogue in stone statuary with Kushite rule but that continued to appear intermittently in reliefs and metal statuary before eventually being revived more broadly for statuary and relief at the end of the Twenty–sixth Dynasty.[11] A number of statues have facial features that follow the general Saite style described above, which presumably became widespread with the country's reintegration. One example is the sphinx of Apries (r. 589–570 B.C.; cat. no. 45; fig. 54), which is inscribed with pseudo–hieroglyphs that the comte de Caylus recognized as a superaddition in the mid–eighteenth century. Two rather different styles are again observable in catalogue numbers 46 and 47, both of which represent the pharaoh Amasis (r. 570–526 B.C.). His long reign might be considered a factor in their obvious differences, except that in neither case do these differences map well onto what is known of his stone statuary. The childlike appearance of the kneeling statuette (cat. no. 47; fig. 55)— with its large head, beautiful features, plump body, and short legs—and the delicate, youthful face of the aegis (cat. no. 46; pp. 137–39) are characteristic

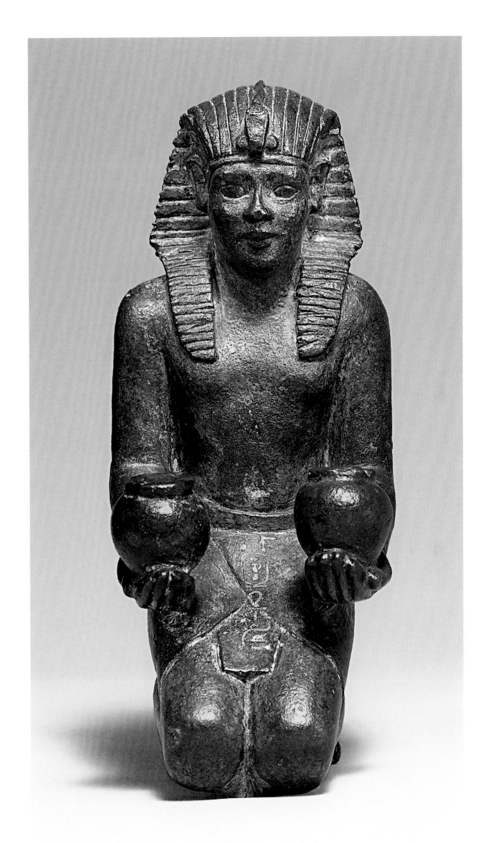

Fig. 55. *King Amasis*
(cat. no. 47)

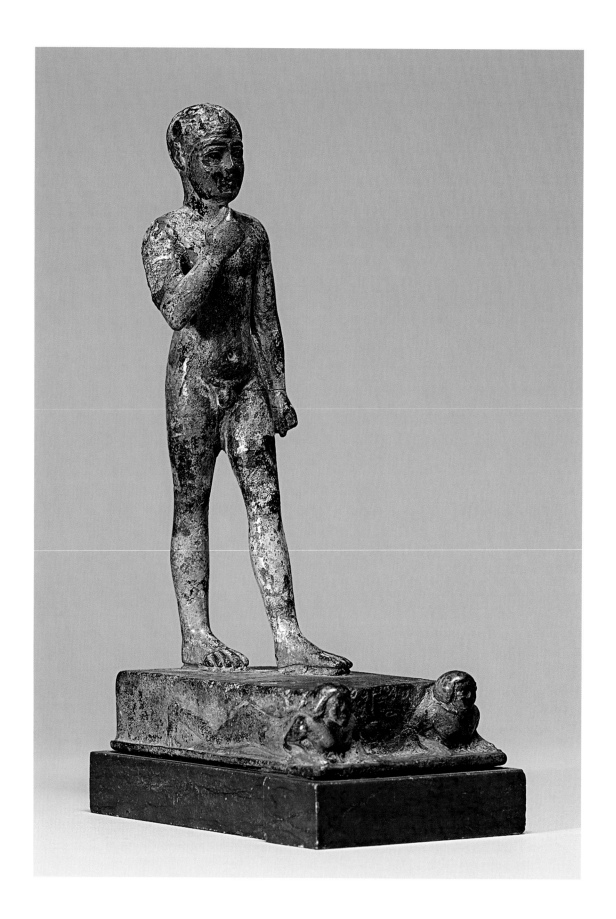

of a mode for some royal metal works that was certainly an extension of the contemporary association of the king with juvenile gods such as Horus, son of Isis. Like stone statuary from this period, these works testify to the high level of artistry attained during Amasis's reign.[12]

Impressive metal statuary continued to be made in the pharaonic style through the fifth and fourth centuries B.C. and in the Ptolemaic Period. The large head of a pharaoh (cat. no. 48; pp. 140–42) probably dates to the early fourth century B.C.; a statuette of Harpokrates on prostrate prisoners (cat. no. 49; fig. 56), which is bedecked with an elaborate collar and armlets that were formerly inlaid, should be dated to the late fourth or early third

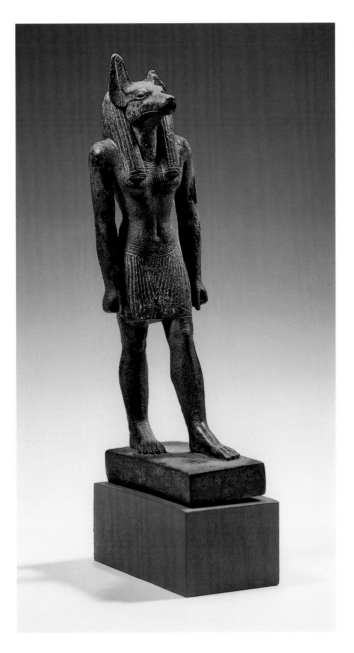

Fig. 57. *Anubis* (cat. no. 59)

Opposite:
Fig. 56. *Harpokrates* (cat. no. 49)

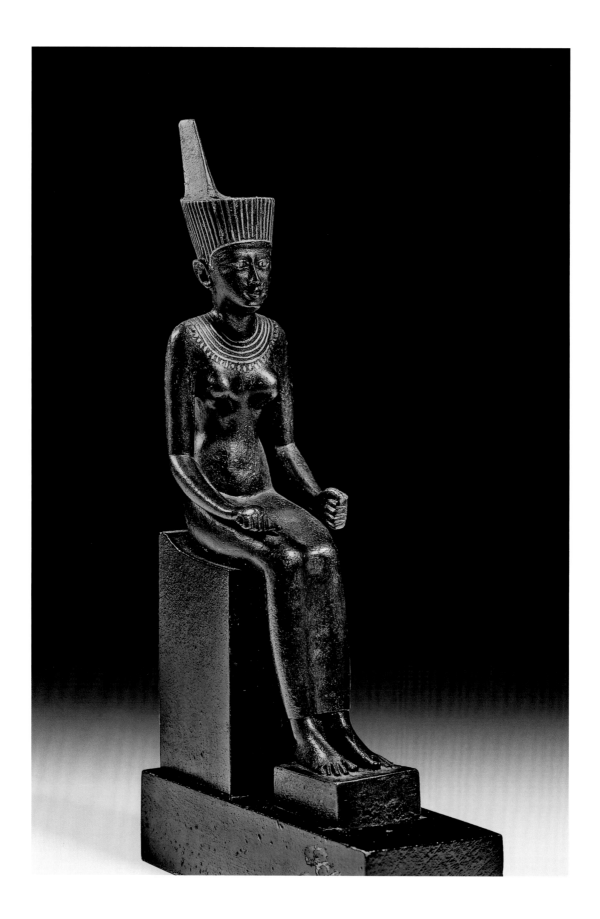

century B.C. (The latter was possibly donated by a son of Harsiese, vizier of Nectanebo II [r. 360–343 B.C.].) The inlaid Bes-image[13] of Horus-Ashakhet (cat. no. 50; fig. 86) was offered by an individual who probably lived in the fourth to second century B.C., while the large silver statuette of Nefertem (cat. no. 51; pp. 143–46) likely dates to the Ptolemaic Period. For the most part, it seems as though traditional pharaonic temples continued to produce traditional pharaonic types of statues during the Ptolemaic Period, although it may be that there were progressively fewer temple offerings made of this fairly costly type.[14]

Looking again to statues of kings as a guide, some of these works adhere to the idealizing style of the fourth century B.C., which remained influential throughout the Ptolemaic Period (cat. nos. 52–55; figs. 82–85); others show scant relationship to any of the style groups proposed for royal stone statuary and can probably be attributed to production in temple circles that were increasingly insulated from royal interactions.[15] "Mixed" images— those reflecting an obvious interpenetration of Egyptian and Greco-Roman styles and iconographies—are numerous neither among metal divine statuettes (beyond some of Isis and Harpokrates, whose cults enjoyed considerable growth around the Mediterranean during this period) nor among royal ritual statuettes. One royal figure that does reflect this convergence is a statuette of a king or a god (cat. no. 56; pp. 146–48) that, accordingly, must have been made in very unusual circumstances.

Before the first millennium B.C., the only identified donors of temple statuary were kings, although there is evidence that some nonroyal support for religious offerings emerged during the late New Kingdom.[16] This seeming restriction on donations accords with our current view that access to official religion was, generally speaking, rather limited. With the advent of the first millennium B.C., particularly after the beginning of the seventh century, the growth and diversification of offering practices constitute a remarkable phenomenon. After that time, a broad range of individuals submitted many kinds of offerings, including metal statuary, to temples; in most cases this probably happened through the mediation of temple personnel.[17] The dedication of catalogue number 50 to Horus-Ashakhet, an obscure god, possibly reflects a personal attachment to that deity on the part of the dedicator. In a similar vein, some dedications might reflect the Egyptians' deep personal connection to "hometown" gods, as expressed perhaps most eloquently in the stela of the high official Sematawitefnakht, who lived through the tumultuous Second Persian Period (343–332 B.C.). In the inscription he ascribes his favor first with the Egyptian kings and then with the conquering Persians to the protection of the god Herishef of his hometown Herakleopolis, in Middle Egypt. Here he attributes his narrow escape from the wars with the Greeks and his safe arrival home to that local patron:

You protected me in the combat of the Greeks [the armies of Alexander the Great], when you repulsed those of Asia [the Persians]. They slew a million at

*my sides, and no one raised his arm against me. Thereafter I saw you in my
sleep, your majesty [Herishef] saying to me: "Hurry to Hnes [Herakleopolis],
I will protect you!" I crossed the countries all alone, I sailed the sea unfearing,
knowing I had not neglected your word, I reached Hnes, my head not robbed of
a hair. As my beginning was good through you, so have you made my end com-
plete. You gave me a long lifetime in gladness.*[18]

By far, however, most dedicated statuettes are those of gods whose cults
were widespread and who had influence over universal religious concerns;
of the works presented here from the Late Period, these include statues of
Osiris (cat. no. 39; pp. 128–29), Isis (cat. no. 57; pp. 149–51), and juvenile gods
such as Harpokrates (cat. nos. 49, 58; figs. 56, 78) and Nefertem (cat. no. 51;
pp. 143–46).[19]

Some of these statuettes can be dated, whether by inscription, archae-
ological context, recognizable stylistic features, or combinations thereof (cat.
nos. 57 [pp. 149–51], 58, 59 [figs. 78, 57]); others belong to groups of similar
works whose links to political shifts, such as images of the goddess Neith
(cat. nos. 37 [pp. 108–9], 60 [fig. 58]), or to cultic evolutions (cat. no. 49; fig. 56)
may offer platforms for analysis. Certainly these gifts demonstrate the donors'
belief in the efficacy of such statuettes vis-à-vis the gods, just as the phe-
nomenon itself testifies to the unprecedented degree to which individuals
in this period were integrated into official cultic and religious practices.

1. Kemp 2006, pp. 336–85.

2. Regarding this pose, which is extremely rare in metal works, either royal or private, see H. W. Müller 1955b.

3. De Meulenaere 1998 summarizes the titles.

4. The statuette of Thutmose III (cat. no. 8) is an example of an atypical order of signs (the divine element in the king's name, the sun disk, is written in a central position) that may reflect the ritual context of the figure appearing opposite a divine image; Hill and Schorsch 1997, p. 10.

5. The height of the figure is 38 cm (15 in.); Winter 1971. Shubert (1989) would like to date the statue of Ihat to the time of Psamtik I (664–610 B.C.) and relate it, along with a metal figure of another man (British Museum, London, EA 49243), to the strain of realism typical of the early Twenty-sixth Dynasty. Ihat does not relate well in this respect, however; I have not studied the second work closely.

6. The height of the figure is 9.4 cm (3¾ in.); see Monnet 1955 (esp. p. 42) for a description; the statuette is viewable only on the Louvre's online Atlas database (http://cartelen.louvre.fr/). For a recent discussion of Harira, see Gozzoli 2000, pp. 73, 78, and references.

7. Russmann 2001, pp. 32–39, 241–44. For a recent evaluation of the "Heliopolis" reliefs and the individualistic royal images on them, see Yoyotte 2003. For a theory of portrait sources, see Josephson et al. 2005, esp. pp. 238–41.

8. Hill 2002, p. 549, with references.

9. Hill 2004, pp. 109–12, 145–46.

10. Roeder (1956, §§222–30, and as repeated and developed in other writings) found what he considered to be significant correlations among findspot, hand position, and a few other features of copper-alloy statues of Osiris; on the basis of these, he identified general Upper, Middle, and Lower Egyptian regional styles that he then applied to works of unknown provenance. While statues of Osiris, by virtue of their sheer numbers, are a promising type for study—and accepting that there is certainly something to be gained from these observations—Roeder's work now seems problematic. His concept of region follows strong preconceptions, and observations of materials and chronological distinctions (admittedly an immense problem for metal researchers in general) that might have considerably altered the resulting picture were effectively not pursued. A subtler handling of the evidence might result in a much less schematic view; however, given Roeder's massive accumulation of observations, much of it missing photographs and other documentation, it is extremely difficult to either check or otherwise reconstruct his work.

11. Hill 2002; see also the discussion of catalogue number 46, pp. 137–39.

12. Josephson 1988.

13. The visual form familiar from depictions of the god Bes was, in fact, adopted for numerous other gods, as it was here. Romano (1980, pp. 39–40) advocates use of the term "Bes-image" for these works, or for works in which the name of the god is not known.

14. Davies and Smith 1997, pp. 120–21.

15. Hill 2004, pp. 109, 112.

16. Helck 1980; Grandet 1994–99, vol. 2, pp. 55–57.

17. Spencer (2006, p. 51) discusses the related topic of agency in temple construction.

18. Lichtheim 1980, pp. 42–43.

19. Baines 2000, pp. 44–47.

Osiris

Late Period, 26th Dynasty (664–525 B.C.)
Copper alloy, hollow cast with iron armature, with separate atef *feathers;*
precious-metal leaf over gesso ground; eye sockets and beard inlaid
H. 106 cm (41¾ in.), W. 24.5 cm (9⅝ in.), D. 25.5 cm (10 in.)
Rijksmuseum van Oudheden, Leiden (AB 161)
[cat. no. 39]

Provenance: unknown, possibly Thebes; acquired with the Giovanni d'Anastasi collection in 1829

Selected References: Leemans 1840, p. 11, no. A 534; Boeser 1907, p. 139, no. E.XVIII.25; Maarten J. Raven in Akkermans et al. 1992, pp. 20–22, no. 3; Schneider and Raven 1997, p. 118, no. 184

Osiris is represented here with the crown and scepters befitting his position as king of the netherworld. His *atef* crown consists of a central miter flanked by two separately cast ostrich feathers, each fixed in two slots cut at the sides of the miter. The recessed striations of the feathers are inlaid with colored paste (green, with brown in the tips). There is a uraeus serpent above the brow, its body extending upward to the tip of the miter. The god's face is rounded, with well-modeled lips, nose, and ears. The recessed eyes are provided with inlays of light and dark stone. The long cosmetic lines, rims, and brows and the straps and plaited pattern of his false beard are likewise inlaid with strips of stone (now discolored, these were possibly gray, brown, or blue). The sturdy neck is set upon a body that was given few details and which is rather flat in profile. The lower arms lie crossed over the chest; the fists, with their modeled fingers, hold the crook and flail scepters, which cross yet again and have plain handles that protrude a little from underneath the fists. The pendants of the flail have a rather coarsely executed bead pattern. The figure's calves and knees have been indicated, but not the shins nor the separation of the feet. There is no plinth under the feet, just a hollow square protrusion about 12 centimeters long. A transverse pin through this tenon helped to secure the statue onto a base.

The statue's elaborate casting features were revealed during restoration in 1990. Hollow cast in order not to waste valuable metal, it originally had a clay core, which was removed during restoration. On that occasion, a square iron armature was detected running from head to feet that was acting as a support. Iron cross-supports were evidently used to help anchor the core to the casting mold. These are visible (their ends protruding through the bronze wall) on the central axis above the insteps, on the belly, and under the fists; on the chest to either side of the fists and above the scepters; and laterally at the left hip and at both shoulders. The tenon under the feet was partly miscast and repaired in plaster, presumably in modern times. The entire metal surface was covered in white gesso and then overlaid in gold leaf. As a result of corrosion, large patches of the outer skin had fallen off; these areas have been restored. The tip of the crown, the uraeus protome, the right feather, and the tip of the left feather were likewise reconstructed during the 1990 restoration.

Unfortunately, the original provenance of the statue is unknown. The crossed position of the hands seems to suggest an Upper Egyptian origin. Similar large Osiris figures have been discovered at Medinet Habu, and some of these seem to date to the Twenty-sixth Dynasty. Such a date would accord with this Osiris, whose elegant proportions do not resemble the squatter anatomy of statues made during the previous period of Sudanese rule.

M R

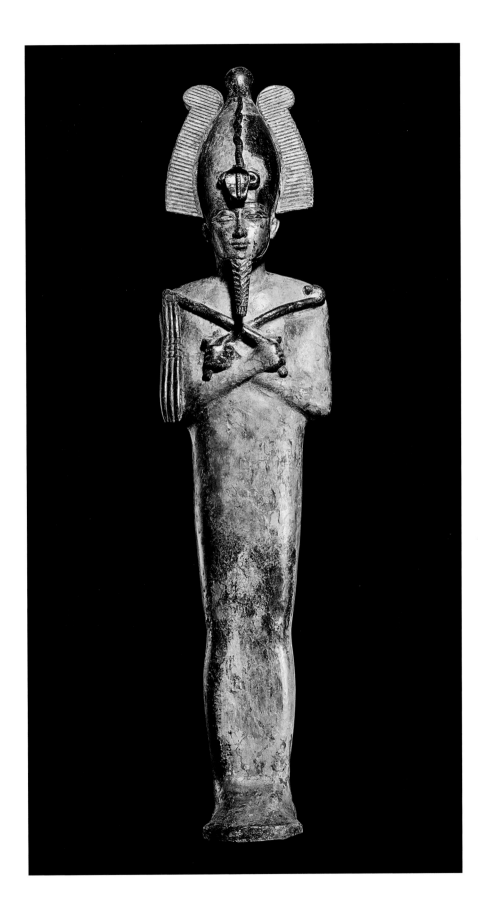

Standing Woman with the Cartouches of King Necho II on Her Arms

Late Period, 26th Dynasty, reign of Necho II (610–595 B.C.)
Silver, solid cast, with separate wig and jewelry
H. 24 cm (9 ½ in.), W. 5.6 cm (2 ¼ in.), D. 5.4 cm (2 ⅛ in.)
The Metropolitan Museum of Art, New York; Theodore M. Davis Collection,
Bequest of Theodore M. Davis, 1915 (30.8.93)
[cat. no. 40]

Provenance: unknown; acquired by Theodore Davis in Luxor, Egypt, 1905; bequeathed in 1915

Selected References: Becker et al. 1994; Málek 1999, no. 801-775-900; Hill 2004, pp. 80–81, no. LPPt-B, pl. 51

Acquired by Theodore Davis in 1905 from an antiquities dealer in Egypt,[1] this handsome figure was bequeathed to the Metropolitan Museum along with the rest of Davis's important collection of Egyptian art. The statuette embodies the ideal of feminine beauty current during the latter part of the Twenty-sixth Dynasty. She has a relatively long face with narrow, slightly slanted, elegantly outlined eyes and smiling lips (see fig. 50).[2] She is slender, but her breasts are heavier and more pendulous than in any previous period of Egyptian art, and her buttocks, seen from the side, are rather protuberant. Although fleshier than the style in vogue in many earlier periods, this figural type was nevertheless more slender than that favored during the Third Intermediate Period and into the early Twenty-sixth Dynasty.[3]

On each of the figure's upper arms is a cartouche encircling one of the two main names of Necho II: "Nikau," on her proper left arm, and "Wehem-ib-Re" on her proper right arm.[4] She is nude; her nipples are not indicated, but her pubic hair is shown as rows of punched dots,[5] and there is space between her legs just above the knees.[6] Despite being unclothed, she is richly bejeweled, with earrings, bracelets, anklets, and a broad collar necklace. All of these elements were made separately and attached to the figure,[7] as was the headdress, which, with its forehead band and thickness above the ears, somewhat resembles a helmet of short, rectangular curls.[8]

Short "bobs" covered with curls—which, as seen here, were typically shown as rows of rectangles—are attested in Egypt at least as early as the Old Kingdom. At that time, this hairdo was usually, but not exclusively, worn by elite men.[9] By the New Kingdom, when both men and women were represented wearing much more elaborate wigs,[10] this type of bob had nearly disappeared. During the Third Intermediate Period it appeared on women with religious functions,[11] and in the Twenty-sixth Dynasty a short, round bob with rectangular curls began to be represented on both royal and private women.[12] The distinctively shaped and banded style worn by this figure, however, appears to have been unique to her and to a group of female heads carved in limestone between the late Twenty-sixth Dynasty and the early Ptolemaic Period.[13] They were part of a large group of sculptures and reliefs that today are known as "sculptors' models," although the exact purpose and function of these works remain unclear.[14] As to the purpose and function of this statuette, a number of details point toward some general conclusions. This woman's nudity, for example, indicates that she was not a member of the royal family or the nobility.[15] Necho's names on her arms strongly suggest that she was his servant, or even his property.[16] Indeed, the fact that she is nude, together with the richness of her jewelry, may indicate that her primary function was to serve the king's sexual needs after his death.

The provision of concubine figures for postmortem pleasure, a practice that poses difficult questions,[17] is possibly attested during this period in at least two nonroyal tombs by nude female figures found in them or associated with them. One, a wood figure from the tomb of Tadja at

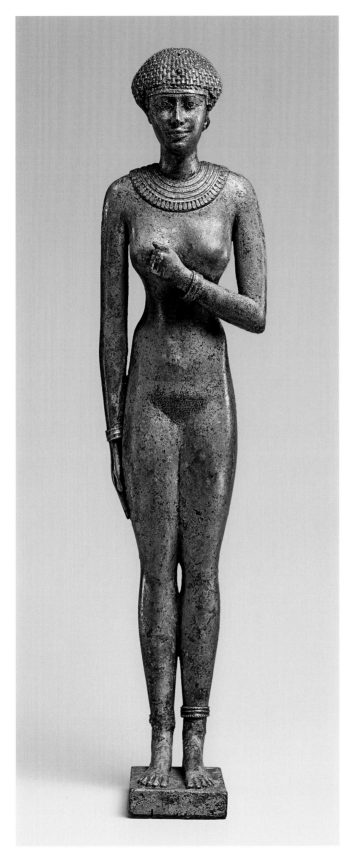
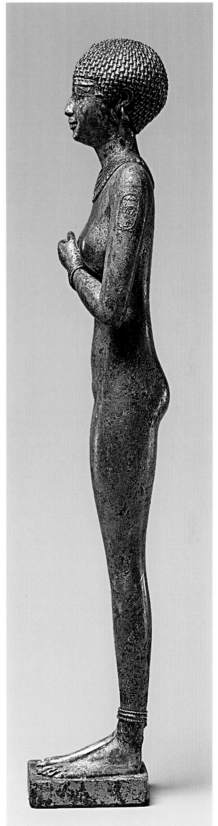

Abusir el-Malaq (Ägyptisches Museum und Papyrussammlung, Berlin, 16999), stands in exactly the same pose as this silver figure, with her left arm bent in front of her breast, the right arm hanging at her side, and both feet together on a small base. She is slightly more plump than the silver figure, and her hair is depicted in the curled, round bob typical for women of this period.[18] A number of figures very similar to this one lack provenance; some or all of them may also come from men's burials.[19] The other nude female figure known to come from a man's tomb has the same pose and a similar cropped, textured hairdo. She is carved in limestone, however, with black paint on her hair, eyes, and pubic area. The carving is very clumsy, so much so that the excavator suggested that her face was "perhaps intended for a European."[20] The tomb, though, as well as contemporary tombs in the area, belonged to people with Egyptian names. If the practice of providing statuettes of concubines was indeed indulged in during the Twenty-sixth Dynasty, as these few examples suggest, it might well have originated with the kings.

It should be noted that the tomb of Necho II, for which this figure would presumably have been intended, is believed to have been situated within the temple enclosure at his family home of Sais, in the Delta.[21] Yet Davis purchased it from an antiquities dealer in Luxor, many miles to the south. It is possible that the figure was produced at Thebes (modern Luxor), where silver sculpture is known to have been made during the Twenty-sixth Dynasty,[22] and was found there in modern times. It also seems possible, however, that it had been found among the objects from Necho's tomb, whence it was shipped to the main antiquities markets: first, perhaps, to Cairo, and then south to Luxor, where wealthy travelers like Davis spent much time.

ERR

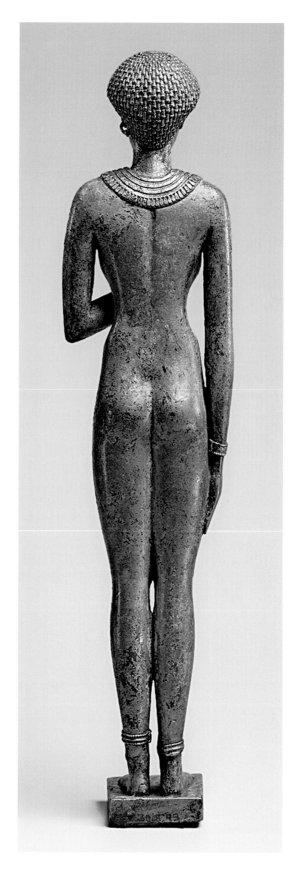

1. A description of the figure by a traveling companion of Davis is quoted in Becker et al. 1994, p. 37. Apart from this important article and an accompanying paper by Lisa Pilosi, "A Silver Statuette of the Saite Period (NY, MMA 30.8.93)" (Master's thesis, Institute of Fine Arts, New York University, 1988), the figure has barely been mentioned; in addition to the selected references above, see N. Scott 1946, p. 34, fig. 35.

2. These features can be seen on many heads of Saite kings, such as one found at Sais and often ascribed to Amasis (Ägyptisches Museum und Papyrussammlung, Berlin, 11864; see Priese 1991, pp. 172–73, no. 103), and on figures of private men and women, including the wood tomb statuettes of a woman, her husband, and son, also in Berlin (8813, 8812, 8814); see Ägyptisches Museum Berlin 1967, pp. 94–95, nos. 943–45, with pl.

3. See, e.g., the fleshy statue of the Divine Consort Ankhnesneferibre in the Egyptian Museum, Cairo (CG 42205); Russmann 1989, no. 85, pp. 182–85, 221. The figure type lasted well into the Ptolemaic Period; see, e.g., the headless, anonymous female figure in the Graeco-Roman Museum, Alexandria (1552; Bothmer 1960, pp. 119–21, no. 95, pls. 88–89).

4. See, e.g., Becker et al. 1994, p. 41, figs. 9–11.

5. Ibid., pp. 38, 49, figs. 1–2, 26.

6. Jack Ogden has suggested that the skin of her body was artificially blackened to set off the silver of the cartouches (Ogden 2000, p. 171); however, according to Deborah Schorsch and Lawrence Becker, two of the Metropolitan Museum conservators who examined and cleaned the piece, this is unlikely (e-mail from Deborah Schorsch, August 29, 2006). It is all the more improbable because the only known sculptures comparable to this example—the female heads of the so-called sculptors' models (see n. 14 below)—are made of unpainted limestone, whose white color was considered comparable to silver.

7. For a description of these ornaments, see Becker et al. 1994, p. 41, including figs. The earrings, bracelets, and anklets were fashioned from small silver strips; the proper right earring is lost, as is part of the proper right anklet. The necklace may have been cast in two pieces; ibid., p. 50, figs. 28, 29.

8. I cannot explain the holes that are in the front of the wig and slightly left of center, discussed in Becker et al. 1994 (p. 50 and visible in fig. 8). They resemble the holes used to attach a uraeus cobra, but, as noted in Becker, one would not expect to see a uraeus on a nude female figure. A funerary ornament, such as a lotus flower, is possible, but since this figure is apparently unique, there are no parallels for comparison.

9. Vandier 1958, p. 102; cf. p. 106.

10. Ibid., pp. 481–93.

11. Small copper-alloy figures of nude, fat women were made, apparently, throughout the Third Intermediate Period. They have short, round hairdos, with the texture indicated in various ways, and they usually wear crowns and, often, jewelry. They seem to have served some religious function, but what this was, or even whether they represented real women, is not known. The most complete discussion of this type of figure is still Riefstahl 1943–44. A large bronze statue of the Libyan Divine Consort Karomama (fig. 19) shows her wearing an elegant dress and a helmetlike headdress of rectangular curls, which somewhat resembles that on the silver figure.

12. It is worn by the Divine Consort Ankhnesneferibre (see n. 3) and on private figures such as the wood statuette in Berlin (8813; see n. 2) and the figure of Takushit (cat. no. 27).

13. See, e.g., the limestone head in the Staatliches Museum Ägyptischer Kunst München (ÄS 4879; Staatliche Sammlung 1972, p. 113, no. 101, pl. 68). This was apparently the only type of three-dimensional female image in the group of "sculptors' models." All of the examples known to me appear to be later in date than the figure discussed here.

14. For sculptors' models, see Liepsner 1980. I have not yet had access to Tomoum 2005.

15. In this period, women of high or royal rank were not represented nude.

16. Male officials of this period often had the names of their king written on their bodies, most often on the upper arms; see, e.g., Bothmer 1960, pls. 30, 44–45, 48. I know of no parallels, however, for cartouches being depicted on the bodies of women, either clothed or nude.

17. See, e.g., the comments on Middle Kingdom nude figures in Bourriau 1988, pp. 125–26.

18. See Ägyptisches Museum Berlin 1967, p. 96, no. 951, not illustrated. For an illustration, see Fechheimer 1922, p. 108.

19. See, e.g., a statuette in the Egyptian Museum, Cairo (CG 234), which differs only in that she is wearing jewelry and that her right arm, rather than her left, is held to her breast; Borchardt 1911–36, vol. 1, p. 153, pl. 49; Málek 1999, no. 801-775-540 (provides no additional information).

20. Quibell 1912, pp. 33 (as having been found in the shaft of the tomb of Nesdjehuty; H. ca. 20 cm), 142; the remark on her appearance is cited in the text, pl. 61, 1. See also Porter and Moss 1978, part 2, fasc. 2, pp. 669–70. Neither publication gives the current location of the statuette.

21. The evidence is sparse, however; see Porter and Moss 1934, pp. 46–49.

22. See, e.g., Graefe 1994, esp. p. 91, l. 21, which speaks of Ibi's gift of silver statues of Psamtik I and of women, presumably images of the Divine Consort Nitocris.

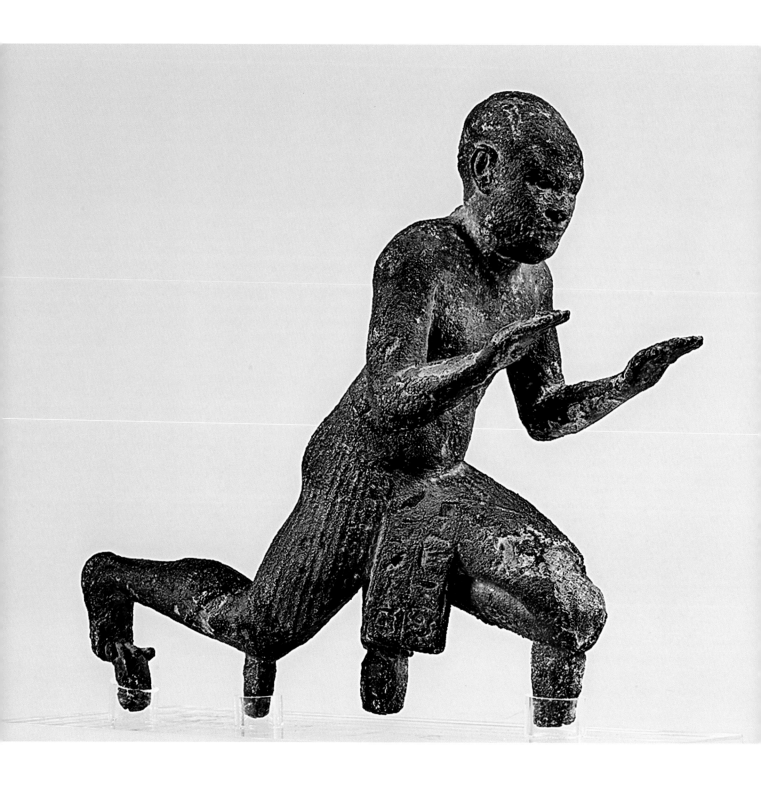

Figure of a Man from Sais

Late Period, 26th Dynasty (664–525 B.C.), possibly early 6th century B.C.
Copper alloy, solid cast; precious-metal inlay; eye sockets formerly inlaid
H. 15 cm (5⅞ in.), W. 6.7 cm (2⅝ in.), D. 17.5 cm (6⅞ in.)
National Archaeological Museum, Athens (640)
[cat. no. 41]

Provenance: unknown, probably from Sais; acquired by Ioannis Demetriou in Alexandria, by 1882; donated with his collection[1]

Selected References: H. W. Müller 1955b; Málek 1999, no. 801–758–010; Hill 2002

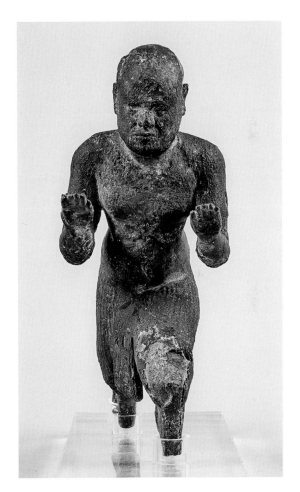

The "running-kneel" gesture of this figure—in which the subject is depicted placing his weight onto his left knee and foot while his right leg is bent and stretched backward—indicates a respectful urgency toward a god. The upper part of the body bends forward, while the hands are raised up and parallel to each other with the palms facing down. Judging from the individualistic facial features and the fleshiness of the body, it is apparent that the subject was an affluent, middle-aged man.

The man's skull is elongated and strikingly bony, especially on the right and left sides of the forehead and in the back. A fleshy protuberance can be observed on the middle of the forehead. As a result of extensive corrosion, it is unclear whether the head is bald or fully shaved, or if there are traces of hair below the pate. Like the skull, the face is elongated, with small, deeply set eyes (now missing inlays), a broad nose with strong, curved furrows running from the wings to the corners of the mouth, and wide, full lips that are turned downward. The ears, elongated and with generous lobes, exhibit a remarkable attention to detail, including precise indications of the antihelix, tragus, and outer rim. A double chin is strongly marked, as are two distinctive carved lines below it.[2]

The man has broad shoulders and fleshy breasts; below them, and above the plump belly, are two rolls of fat. On his back are two folds at the base of the neck that also represent a wide roll of fat. Beneath them is a conical protuberance created by the seventh cervical vertebra, and beneath that is a shallow groove indicating the spine. The buttocks are staggered slightly, the right one higher than the left, a naturalistic expression of the posture. Underneath the feet and knees are four tangs that helped hold the statuette onto a base, which is now missing. Traces of charred corrosion on the surface of the figure suggest that it may have been burned at some point.

The man wears an inscribed trapezoidal panel hanging from the belt of a short, pleated *shendyt* kilt. The inscription on the panel (right) is divided into two vertical columns of hieroglyphic signs, which are inlaid with what could be, according to microscopic examination, metal alloys of different colors. The inscription is in poor condition, and only the first column is comprehensible; it reads "honored before Neith, Mistress of Sais." The second column includes the man's name, but only frag-mentary hieroglyphic signs are distinguishable,

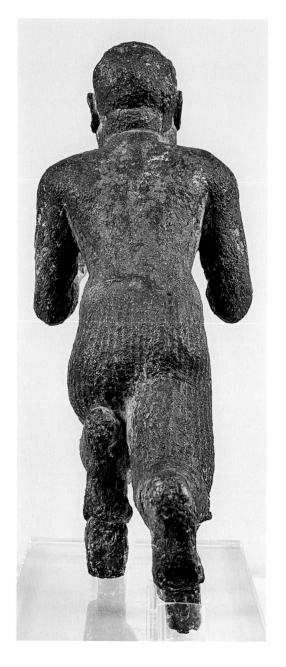

leaving the exact interpretation open to discus-sion. The proposed reading of the man's name as "Haremhab" is incorrect, but the alternative, "Nakhthorheb," is also problematic given the order of the signs. What can be said with certainty is that the statuette represents an official of the Twenty-sixth Dynasty. Based on the inscription, it is believed that the statuette was produced in a temple workshop closely connected to Sais, the dynastic capital. ET

1. The statuette was acquired by Demetriou between 1842, when he arrived in Egypt, and 1882. In 1880 Demetriou donated his entire collection to date—including any works he might acquire until his death (in 1892)—to the National Archaeological Museum, Athens. The Sais man was sent to Athens in June 1882 as part of the second shipment of his collection; Archive of Archaeologiki Etaireia.
2. The same feature is visible on some Saite Period copper-alloy statuettes (see cat. nos. 43 [fig. 52], 46 [pp. 137–39]).

Aegis of King Amasis

Late Period, 26th Dynasty, reign of Amasis (570–526 B.C.)
Copper alloy, hollow cast with open cavity
H 10.7 cm (4 ¼ in.), W. 9.1 cm (3 ⅝ in.), D. 8.7 cm (3 ⅜ in.)
Egyptian Museum, Cairo (T.R. 20/5/26/1 [M696])
[cat. no. 46]

Provenance: from Auguste Mariette's excavations at the Serapeum, Saqqara, 1850–64

Selected References: Porter and Moss 1978, p. 820; Hill 2002; Hill 2004, pp. 84–85, 164–65, no. 28, pl. 61

Amasis's head rises out of a broad collar that is elaborately decorated with ten rows of floral elements. Approximately circular, the collar curves smoothly backward to form a roughly perpendicular semicircle behind the neck, thus concealing a short, wide tube attached to the rear of the vertically oriented portion of the collar. On the breast of the aegis is a rectangular panel formed by a sky sign supported by two verticals;[1] within the panel, the king's cartouche names flank a central column where he is described as "beloved of Nut the Great who gave birth to the gods." Nut, as "mother of the gods," was related to a range of goddesses, from Isis to Ipet. Her own cult is poorly documented, but she may have been worshipped in connection with the *mammisi*, or birth temples. The aegis was most likely used in some Saite temple in the area of the Serapeum (or Sarapieion)—a precinct devoted to the Apis bull (an incarnation of Ptah)—which was at the center of the sacred animal installations at Saqqara (see fig. 74). It is also possible, however, that it comes from some place farther afield, since material potentially from the nearby Memphite temples has been found among the bronzes deposited in the area of the sacred animal installations at North Saqqara.[2] An aegis with a royal head is sometimes seen in representations of royal barques and on standards, but almost nothing is known about the fittings of such elements. Similar pieces are also sometimes described by scholars as terminals for the wood carrying poles of a piece of processional equipment.

The collar is oversize in relation to the king's head; this disproportion emphasizes the composite nature of the object as well as the delicacy of the small head rising out of its slightly undulating

form. The brow line, which lies close to the frontlet of the *nemes* headdress, and the narrow chin both bear some relation to the considerably more marked versions of those features that characterize stone statuary images identified as depictions of Amasis. More to the point, the countenance of the aegis is particularly youthful, a manner of representation that constitutes a motif among royal ritual statues from the first millennium B.C., a period

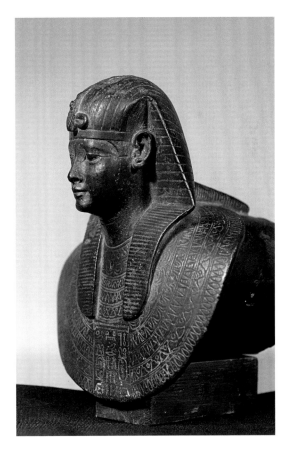

when the king was closely identified with the divine child of great gods (see, for example, cat. no. 47; fig. 55). The king's brows are neither indicated in relief nor outlined, whereas the finely contoured eyes are supplemented by long cosmetic lines, rendered in shallow relief, that extend from the outer corners of the eyes: a striking stylization familiar from certain stone statues from the Saqqara area that date to the time of Amasis.[3]

On the neck are two fine lines, and on each delicate ear is an earring hole. Both the holes and the lines beneath the throat are representational conventions normally associated with a period beginning in the New Kingdom about the reigns of Amenhotep III (ca. 1390–1352 B.C.) and Akhenaten (ca. 1352–1336 B.C.), and continuing in statuary and relief with some frequency throughout the remainder of the New Kingdom and also into the Third Intermediate Period. These features largely disappeared with the Kushite Period; they

remained in sporadic use in the Saite Period in temple and tomb reliefs and in metal statuary (see cat. nos. 41 [pp. 134–36], 43 [fig. 52]), but not in stone statuary, which during this period was made almost exclusively from hard stone.

In the late Twenty-sixth Dynasty both earring holes and lines under the throat experienced renewed popularity; throat lines, in particular, appear widely in reliefs and even in some hard stone statuary. That the features retained currency for metal works and temple and tomb reliefs during the interval when they were out of favor for hard stone statuary is surely a factor of how production of these respective media was organized. The manufacture of metal statuary and of reliefs probably was organized mainly out of the temples, whereas the network of workshops making hard stone statuary, even if they sometimes overlapped or intersected with metal statuary and relief production, was largely separate.

MH

1. The verticals derive from *was* scepters; the arrangement was an age-old device for symbolizing the world.
2. H. Smith 1984, cols. 425–26.
3. A graywacke head of Isis in the Museo Archeologico,

Florence (513), bears Amasis's name, and other hard stone statues with this combination of features are datable to his reign; see Bothmer 1987, pp. 56–59.

Bust of a King

Late Period, probably 29th Dynasty (399–380 B.C.)
Leaded bronze, hollow cast; precious-metal inlay; eye sockets inlaid
H. 39.5 cm (15 ½ in.), W. 25 cm (9 ⅞ in.), D. 24.5 cm (9 ⅝ in.)
Roemer- und Pelizaeus-Museum, Hildesheim, Germany (0384)
[cat. no. 48]

Provenance: unknown;[1] acquired by Wilhelm Pelizaeus in Egypt, 1907–11

Selected References: Roeder 1937, §§161–165, pls. 22–26; Eggebrecht 1993, pp. 90–91

Various dates have been proposed for this bust, usually to artistically complex eras such as the Third Intermediate Period or the Ptolemaic Period. As our understanding of these periods has improved, however, it seems the most plausible milieu is actually the early part of the fourth century B.C., when native dynasties resumed control of Egypt after more than a century of Persian rule and began to create an artistic definition of their reign.[2]

The rectangular structure of the king's face—the relatively wide-open eyes, the strong depressions between the cheeks and nose, and the wide, flat mouth—finds its best parallels in the faces of sphinxes inscribed for the kings Nepherites (r. 399–393 B.C.) and Achoris (r. 393–380 B.C.);[3] there is also some basis for comparison to the face of a small metal statue (Nelson-Atkins Museum of Art, Kansas City, 53.13) that has been assigned, probably correctly, to Achoris.[4] The construction of the king's blue crown, which has a dome that ends behind the top of the head and side seams that form pronounced ledges rather far back from the face, differs from the elegant, upward-sweeping form of the crown that became popular, if not exclusive, among royal sculptures that have been dated later in the fourth century B.C.[5] Some parallels for this crown form can be observed in the modest blue crown on the small copper-alloy statue of Achoris in Kansas City (noted above), in reliefs at Mendes that depict Nepherites, and in reliefs at Karnak that depict either Psammuthis or Achoris, all of which are modeled on Saite Period blue crowns.[6] Still, these are not precise parallels, and this evidence is admittedly meager.

The general picture that has been established of production in metal workshops at this time—specifically, the close relations between metal production and temple reliefs—has a bearing on our understanding of this piece and on the degree to which it can be firmly dated.[7] For example, beards, such as the one seen on this statue, are exceptional in stone statuary from the Late Period, and traditionally they did not occur in conjunction with the blue crown either in statuary or reliefs. The conjunction of beard and blue crown is, however, occasionally found in reliefs dating to the Late Period through the Ptolemaic Period.[8]

If we test the proposed dating of this bust against what we know about metal statuary from the Late Period, the fact that there are no compelling similarities to the royal figures assignable to the Twenty-sixth Dynasty (664–525 B.C.) provides a firm upper date limit.[9] The periods on either side of the Twenty-ninth Dynasty pose problems, however; the fifth century B.C. (which included the Persian Period, or the Twenty-seventh Dynasty, and the intermittent native rulers that collectively have been termed the Twenty-eighth Dynasty) is virtually unknown artistically, and exclusive differentiation between the Twenty-ninth and Thirtieth Dynasties is a difficult undertaking given the present state of our knowledge and the somewhat independent practices of metal workshops. A few copper-alloy statuettes that have typological similarities to the statuette of Achoris referred to above, and which present some of the same stylistic problems as both that piece and the present bust, cannot be precisely dated.[10] Some of these works may well date to the last native dynasties ruling in the fourth century B.C., but the dating of others to that era is made by default, since our knowledge of the art of the Persian Period is extremely limited. Even if knowledge of fifth-century stone or bronze figural styles remains

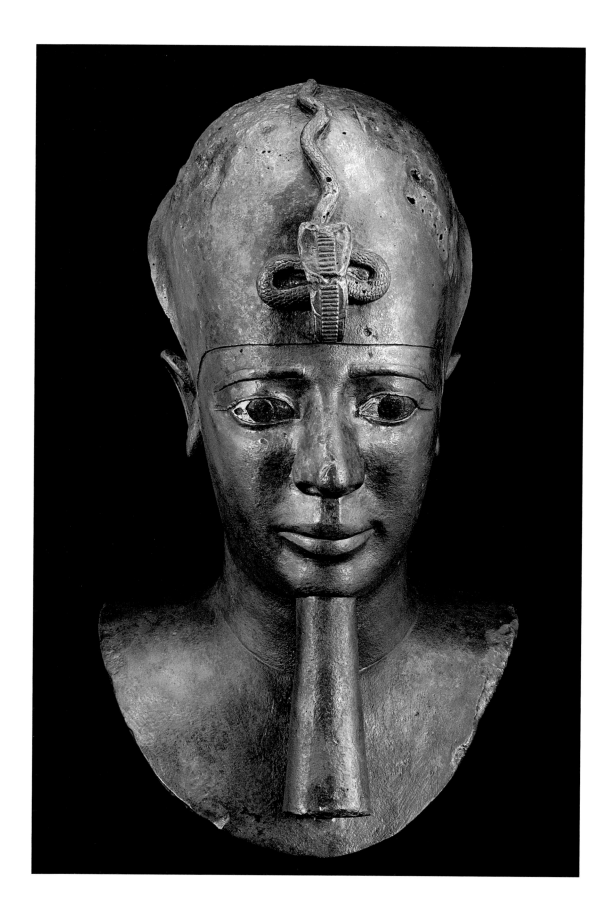

elusive, we know that temple workshops continued to produce large metal temple furnishings and divine statuary and, almost certainly, small ritual figures of kings.[11]

The formation of the bust's head and neck as a coherent unit with a surrounding area, which has the form of a *wesekh* collar, is characteristic of precious-metal funerary masks as well as small royal copper-alloy aegises made to be attached to other objects (cat. no. 46; pp. 137–39). Both the size

of the bust and its construction do not accord with either of those object types, however, nor does the bust resemble the head-and-collar forms that were found at the prows of certain barques (known only from relief depictions).[12] The bust is also atypical of preserved large copper-alloy anthropomorphic statuary. A few smaller, bustlike elements that constituted parts of some unknown original composites are known, but none is a close match to this unusual work.[13]

M H

1. The Tell Horbeit provenance provided by the dealer was also given to Ramesside stelae purchased at the same time, which have been shown to be from Qantir; thus the provenance is not reliable.
2. Traunecker 1979.
3. Both sphinxes are in the Louvre (N26 and N17); their noses have been restored. See Josephson 1997, pl. 1c, d.
4. Hill 2004, pp. 92–94, 166–67.
5. See, e.g., Josephson 1997, pls. 7b, 10a–c.
6. Redford 2004, pp. 49, 82, no. 201; Traunecker et al. 1981, vol. 2, Documents p. 37 G. For Saite Period crowns, see, e.g., two heads probably depicting Apries in the Louvre (E 3433) and the Museo Civico Archeologico di Bologna (1801).
7. See the essay "Casting About" in this volume.
8. In a very partial survey, a few reliefs showing a beard with a blue crown can be noted: two possible examples can be found in reliefs dated to Psamtik II at Hibis (*Temple of Hibis* 1953, pl. 2/IV right, after early drawings; pl. 12, register over doorway [beard seems visible in photograph K3-752]);

beards are clearly visible in reliefs datable to Philip Arrhidaeus at Karnak (Bothmer 1952, p. L.23); the so-called sculptors' models (Tomoum 2005, pl. 48c; MacGregor sale, Sotheby's London, June 26, 1922, no. 1644); and reliefs dated to Ptolemy VIII at Philae (Vassilika 1989, pl. 31 B).
9. Hill 2004, pp. 78–89. For a large work from the time of Amasis, see Delange et al. 1998, p. 68/4.
10. Hill 2004, pp. 96–97, n. 81.
11. Aston 1999 (pp. 17–18, nn. 13, 15) references a number of Persian Period objects; for a copper-alloy statue of Osiris dated to year 34 of Darius (Rijksmuseum van Oudheden, Leiden, L.VI.67), see Raven 1992, p. 530. The latter is visible in Schneider and Raven 1981 (pp. 132–33) on a base that does not belong to it.
12. Traunecker et al. 1981, vol. 2, pp. 82–85.
13. Roeder 1956 (§550c) notes two smaller copper-alloy busts—one in the Louvre (E 2522) and the other in the Ägyptisches Museum (8681)—that were attachments. The respective heights of the two busts are 17.5 and 13 centimeters.

Nefertem

Macedonian–Ptolemaic Period (332–30 B.C.)
Silver, solid cast; reassembled from fragments; left calf restored
H. of figure above base 26.1 cm (10 ¼ in.); base: D. 7.6 cm (3 in.), W. 3.2 cm (1 ¼ in.),
H. 0.6 cm (¼ in.)
Ägyptisches Museum und Papyrussammlung, Staatliche Museen zu Berlin (E 11001)
[cat. no. 51]

Provenance: unknown; Menascé collection, before 1891;[1] donated by Ludwig Jakoby in 1892

Selected References: Georg Möller in Schäfer 1910, p. 39, pl. 10, no. 46; Roeder 1956, §§22, 601b, pl. 3f; Priese 1991, p. 227; Vleeming 2001, p. 51, pl. II

Nefertem, the god represented by this statuette, is easily recognized by his distinctive crown in the form of an opening lotus blossom, signifying his oldest and most important association as "the lotus blossom at the nose of Re."[2] A partially preserved inscription running around the edge of the figure's shallow, rectangular base reinforces the iconographic identification; it reads "Nefertem gives life to . . . Bastet, Hor . . . , son of Djeho, the prophet of Savior, before Bastet, [the great goddess(?)]."[3] Originally two *menit*s, the counterpoises belonging to a necklace sacred to Hathor, were attached on either side of the crown, but they are now lost. Made of solid-cast silver, the piece is finer and more elegantly detailed than many others that depict this deity.[4] Indeed, that the statuette is so impressive is a result not only of the precious metal used to make it, but also of the crisp detailing on Nefertem's kilt, beard, tripartite wig, crown, and even his fingernails. The statuette's size, material, and quality of manufacture argue that it was created to be a significant gift to a temple.

The paleography of the inscription is a significant factor in the assignment to the statuette of a date in the Ptolemaic Period. A number of the sculpture's attributes, such as Nefertem's sizable ears, slight smile, and the tripartite division of his body into broad shoulders, a narrow waist, and a rounded stomach, support such a date. The preserved portion of the text identifies the god by name along with his mother, Bastet. The remainder of the inscription suggests that this statuette was a gift to Nefertem from a man whose name is not entirely readable.[5] A second lacuna prevents a clear understanding of the donor's ancestry, and

whether he or a relative was the named priest in a cult of Bastet.[6]

Nefertem is consistently associated with a lotus flower, almost certainly the blue lotus, which has a strong scent and whose flower begins to open at daybreak.[7] Through his association with the sun god, Re, Nefertem was a solar deity from his earliest known appearance and was thus also connected to creation mythology, though he is never identified as a creator god.[8] The Egyptians used the sweet smell of the lotus blossom to imbue ointments and perfumes with fragrance, and, accordingly, Nefertem is depicted in rituals receiving these items.[9] Nefertem's mother is identified as Sekhmet in the Coffin Texts (Middle Kingdom funerary spells), and by the New Kingdom the god had been integrated into a triad as the offspring of this goddess and her consort, Ptah. Nefertem is also mentioned in the company of other lion goddesses and gods, such as Tefnut, Mahes, and, as on this statuette, Bastet. This association with lion-headed goddesses may account for a seemingly contradictory aspect of Nefertem's nature: that of aggression or warlike behavior. When found on a cippus, a stela with magical curative texts, the lotus of Nefertem was a symbol of healing.[10]

Although the *menit*s suspended on either side of Nefertem's crown are always acknowledged in descriptions, their meaning is never addressed in discussions of the god's role. *Menit*s, like sistra and the *menit* necklace, were sacred to the goddess Hathor.[11] One possible explanation for the presence of *menit*s on figures of Nefertem could be what was, during the Third Intermediate Period,

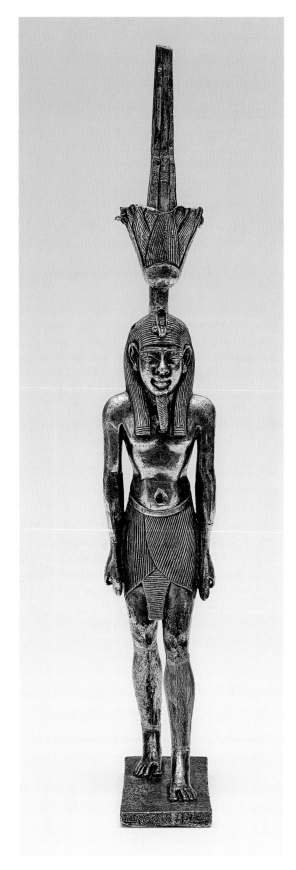
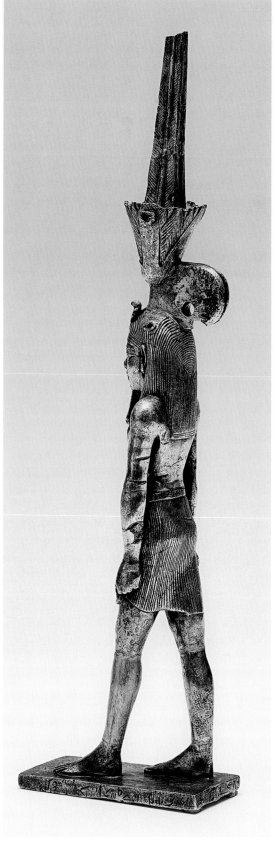

an increasing emphasis on "mammisiac religion,"[12] and with it the increased significance of family triads. The three junior members of the best-known triads, all of whom are closely affiliated with the sun god, carry symbols of Hathor: Nefertem displays a pair of *menits*; Khonsu wears the *menit* necklace; and Ihy shakes a sistrum. There may also be a connection between Hathor and the frequent use of silver for statues of Nefertem, wherein the metal represented Hathor's nocturnal aspect.[13]

Although Nefertem's inclusion in the pantheon of deities dates back to at least the late Old Kingdom, the earliest known three-dimensional depiction of him is from the Third Intermediate Period. These pieces are clearly amulets, of which the best known are six examples from the cemetery at Matmar in Middle Egypt.[14] Representations of the god are found in most museum collections, but few have any known provenance. The overall lack of documentation suggests that most examples came from accumulations of ritual pieces buried within the sacred precinct of a temple. In the late nineteenth and early twentieth century, *sebbakhiin*—farmers digging ancient temple sites for the rich dirt needed for fertilizer—most likely uncovered many of these deposits. Quickly separated from their context, these pieces often found their way into museum collections during the first quarter of the twentieth century.

Votive statues of Nefertem, most often of copper alloy, are well represented among works from the Late Period, although they are not as common as statues of other deities, such as Osiris, Harpokrates, or Amun-Re. One puzzling attribute of this silver Nefertem statuette is the loop behind the stem of the lotus. The size of this statuette would no doubt preclude its use as an amulet, the function traditionally used to explain the presence of a loop. Thus the loop is likely explained by one of two scenarios: either it was integral to the statue's function or housing, or it is a vestigial element from some earlier function that this type of statue no longer had at the time it was made.[15]

From a functional point of view, the loop might have been used to suspend the Nefertem statuette from the wall or from a pole within a temple's interior.[16] Given the quantity of surviving votive statuettes of deities, one can easily imagine how crowded with gifts offering tables and even the floor of temple courtyards must have become; suspending some of the pieces would have alleviated congestion. This statue, however, seems rather large to have been hung in that manner. Rarely, representations illustrate loops that were used to hang a statue from a priest during a ceremony when the god had to be transported to another location.[17] The loop on this statuette is oversize for that purpose, though, and its perforation is both small and asymmetrically located; as a result, it does not seem to have been designed to accommodate the type of cords depicted in such representations. (More functional loops are found on some other statues of Nefertem.)

Whether a statue has a loop or not appears to be more closely related to the particular deity depicted than to the piece's size or function. Statues of Nefertem seem to bear loops consistently, as do many of Harpokrates and Osiris, but in general standing or striding gods and goddesses not of amulet proportions do not consistently have loops. With this in mind, another possible consideration in understanding the rationale for the existence of a loop on a metal sculpture is the representational history of the god. Before the Third Intermediate Period, there are very few examples of true human forms being used as amulets other than those depicting a small number of anthropomorphic deities, such as the Horus-child, the Bes-image, or Taweret. Amulets of these deities were pierced through the head, from one side to the other, in order to string them for suspension. Loops, before the Third Intermediate Period, were thus exceptional and were almost always located on the top of the head.[18] With the sudden appearance of large numbers of anthropomorphic deities being represented on amulets in the late New Kingdom and, especially, the Third Intermediate Period, these figures were given loops behind the head unless a back pillar was present, in which case the pillar was pierced instead. If a deity in human form had first appeared as an amulet and then was made in a larger statuette size for votive use shortly thereafter, perhaps the loop was retained as a vestigial element. Considering the range of possibilities, it seems unlikely that there is a single explanation for the presence of a loop on every type of metal statuette that is not an amulet.

DCP

1. The statuette was part of the Menascé collection, Paris, and subsequently was sold at auction by Drouot, Paris, on February 23–24, 1891 (no. 299, pl. 7). The piece suffered serious damage during a theft in 1894, when the *menits*, the uraeus, a piece of the loop, the right arm, and the left calf sustained significant mutilation; those parts have undergone some reconstruction (Schäfer 1910, p. 39, pl. 10, no. 46). See also Roeder 1956, pl. 3f.

2. Schlögl 1980, col. 378.

3. After Vleeming 2001, p. 51, pl. II.

4. Silver was never a common material for statuettes. Nefertem was made in this metal more often than any other deity, but the reason is unknown; see Becker et al. 1994, esp. n. 46. Egyptian texts indicate that silver is associated with the moon and, by association, the night. Thus, the ancient Egyptians may have chosen silver for Nefertem because the god bears the lotus on his head, so that he appears to serve as the primeval mound in the dark void at the beginning of the creation process.

5. The illegible fragment is "Hor [. . .]."

6. Although Georg Möller originally published the statuette, Vleeming recorded the inscription and translated the text (see n. 3 above); it is his translation on which the above discussion is based.

7. Manniche 1999, pp. 97–98.

8. Schlögl 1980. The association with the sun god is also reinforced by the emblem Nefertem may carry in his right hand. Although it has generally been described as a "scimitar" or "scimitarlike," it is actually a short fan made from a single, curved ostrich plume that is set in either a lily- or papyrus-shaped handle. The fan is often capped with the head of a falcon wearing a sun disk, which probably represents Re-Harakhti. This form of fan appeared in the mid-Eighteenth Dynasty as a symbol of rank, but by the Ramesside period the fan had become a protective symbol. For the basic form of the fan, see Graham 2001, pp. 164–65; for the history of the form, see Fischer 1977, cols. 82–83; for examples of the emblem, see Roeder 1956, p. 25, fig. 35, pls. 3c, 3d, 4a, 4e.

9. Manniche 1999, pp. 22, 106.

10. Fazzini 1988, p. 10.

11. Vischak 2001, p. 85.

12. Fazzini 1988, p. 9.

13. Aufrère 1991, vol. 2, p. 411. See n. 4 above.

14. Brunton 1948, pl. 58. Berman (1999, no. 442) argues that Nefertem is an ideal subject for a funerary amulet, but the absence of such amulets in tombs suggests that he was rarely chosen to accompany a burial.

15. See also the discussion of loops with respect to the statuette of Amun (cat. no. 19), pp. 87–88.

16. See Perdu 2003.

17. For a few examples, see G. Scott 1992, no. 30; Chassinat et al. 1934–2001, vol. 8, pl. 677.

18. The picture becomes more complex when the question of which materials were used for the amulets is considered. Stone, faience, and bone amulets were pierced through the form of the amulet itself, but metal amulets were always suspended in a different manner. As early as the First Dynasty, loops were attached to the back of metal amulets, whose thin, flat forms offered no suitable place to drill a hole. Amulets made of a nonmetal core covered in gold foil were, however, pierced through in the same manner as most nonmetal amulets.

Standing King or God

Probably Roman Period, 1st–4th century A.D.
Leaded bronze, solid cast
H. 31 cm (12 ¼ in.), W. 8.4 cm (3 ¼ in.), D. 12.7 cm (5 in.); H. of tenon 3.7 cm (1 ½ in.)
Brooklyn Museum, New York; Gift of Mrs. Helena Simkhovitch in memory of her father,
Vladimir G. Simkhovitch (72.129)
[cat. no. 56]

Provenance: unknown; Gorringe collection, formed before 1885; donated in 1972

Selected References: Mercer 1916, pp. 51, 95–96; Bevan 1927, p. 343; Capart 1937–38, pp. 21–22; Málek 1999, no. 800-893-120; Hill 2004, pp. 100, 182, no. 73, pl. 75¹

This striking statuette was first collected in Egypt during the late nineteenth century and subsequently belonged to several distinguished collectors. Among them was Henry Gorringe,² a naval officer who in 1878 superintended the transport of an Egyptian obelisk from Alexandria to its present location in New York City's Central Park, directly behind the Metropolitan Museum.³ The figure is clearly derived from Egyptian images of kings, but, apart from the positions of its arms and legs, it

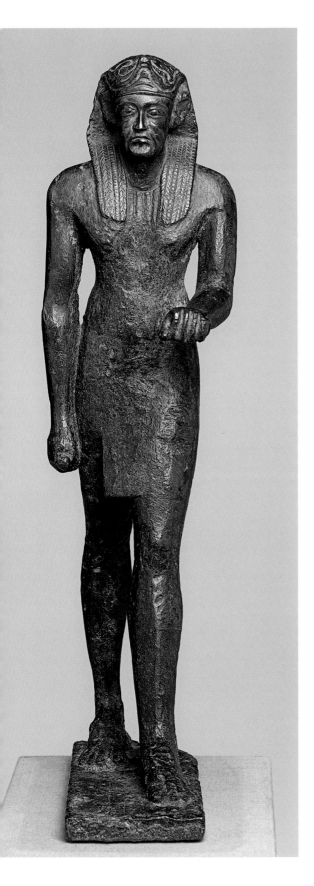
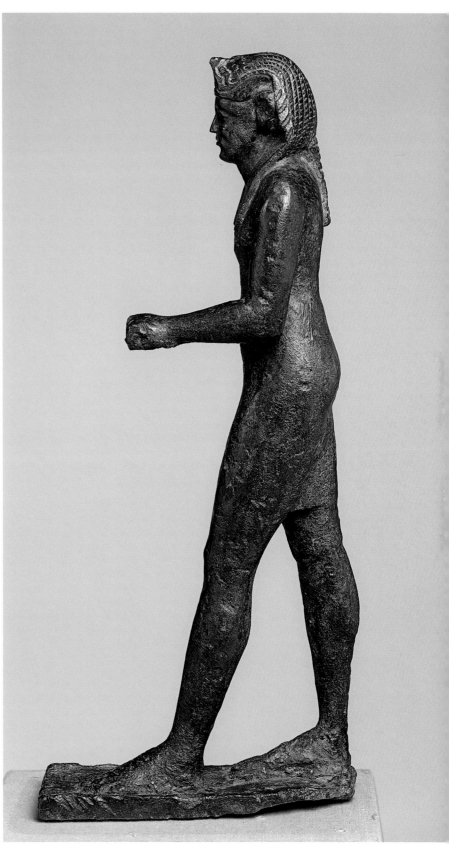

differs from orthodox royal representations in almost every detail. The body is longer in the legs and shorter in the waist and arms than traditional Egyptian royal figures. The fisted left hand is held, unusually, with the fingers at the bottom. The kilt resembles a royal kilt with a front flap, but it is longer than normal and, unlike most orthodox examples, it apparently lacks both pleats and a belt.[4] The four vertical bars between the lappets of the headdress, just below the neck, resemble neither the strands of the necklaces worn by Egyptian kings nor the neckline of the tunics they were occasionally shown wearing.[5]

The most unusual features, however, are the man's face and headdress. His long face is marked by two pairs of diagonal folds: a puffy-looking upper set that descends outward from below the inner corners of the eyes to cover (or define) the cheekbones, and a longer pair that extends down from behind the nostrils and outward to below the corners of the mouth. The mouth itself has a slight downward curve and appears to be barely open. Vertical striations on the upper lip and the front of the chin are apparently meant to indicate a small mustache and beard. Shorter striations on the right eyebrow and upper eyelid may also be intended to indicate the texture of brow and eyelashes, but these features are not, or are no longer, visible on the left side. The eyes themselves, large and heavy lidded, are separated from the lower face by a rather long, narrow nose. The ears are large, even by Egyptian standards. The face bears

no resemblance to any known Egyptian king, including several who were represented with facial furrows and other signs of age.[6]

The headdress is clearly based on the Egyptian royal *nemes*, but it departs from this model in almost every respect. The stripes formed by vertical incisions on the lappets and on the back of the head are covered with short incisions, which on the lappets appear to be arranged in pairs of slanted lines to form a herringbone pattern, each pair being separated by a stripe covered with horizontal lines. I know of no parallels for such a design on this type of Egyptian headdress. Also unprecedented is the curving pattern at the front and top of the headdress, which rises at the center to a "neck" that is slightly higher than the crown of the man's head. If a "head" surmounted this image, it has been lost.[7]

The figure's unorthodox headdress, unusual facial features, and slenderness argue that it does not represent a king of Egypt, either from the Roman Period or earlier; nor do these features appear on any Egyptian gods. Several Near Eastern gods were depicted wearing elements of Egyptian royal costume, but none, to my knowledge, resembles this figure. Considering all of these oddities, the authenticity of this figure might seem doubtful, but examination of the statuette by conservators at the Brooklyn Museum and the Metropolitan Museum has left little doubt of its antiquity.[8] The statuette thus continues to await either identification or elucidation.

ERR

1. Dated in Hill 2004 (p. 100 and n. 92) as late Ptolemaic Period (late second century B.C. or later) or possibly Roman.
2. Mercer 1916, cover ill., pp. 51, 95–96; Capart 1937–38, p. 22, fig. 9. See also selected references, noted above.
3. For his own account of this feat, see Gorringe 1882; for a recent description, see Brier 2002.
4. Such details might have been obliterated by overzealous cleaning, but considering the amount of detail preserved in the region of the head and neck that seems unlikely.
5. Hill 2004 (p. 182) mentions both as possibilities.
6. For the most extreme indications of royal age—on Senwosret III and Amenemhat III of the Middle Kingdom— see Wildung 1984, pp. 198–212. The indication of the texture

of hair in eyebrows or natural beards was extremely rare on statues of Egyptian kings or gods.
7. The suggestions in Hill 2004 (pp. 100, 182) that an eagle, elephant, or lion head surmounted the image are interesting, but no such traces are visible. Given the resemblance of the headcovering to a traditional royal *nemes*, I also doubt her suggestion that a cap crown might have been worn beneath it.
8. The results of examinations by Ellen Pearlstein, formerly of the Brooklyn Museum, and by Deborah Schorsch of the Metropolitan Museum are summarized in a letter in the files of the Brooklyn Museum, written by Schorsch and dated October 18, 1999.

Seated Isis Nursing Horus

Late Period, 26th Dynasty, ca. 611–594 B.C.[1]
*Bronze, solid cast; separate hollow-cast, leaded-bronze throne (ancient, but possibly not original
to figure) with iron core supports; electrum inlay; gilded-silver inlaid bands around sun disk on
obverse and reverse; sun disk formerly gilded; upper third of both horns rejoined; left forearm is
modern replacement*
H. 39.3 cm (15 ½ in.), W. 12.3 cm (4 ⅞ in.), D. 18.8 cm (7 ⅜ in.)
The Metropolitan Museum of Art, New York; Gift of David Dows, 1945 (45.4.3)
[cat. no. 57]

Provenance: unknown; Jane S. Dows collection; donated by her son in 1945

Selected References: unpublished

This exceptionally large and impressive figure of
Isis shows the goddess in the pose most charac-
teristic for three-dimensional representations of
her during the Late Period: seated and nursing
her infant son, the god Horus. Of the child, who
was seated on her lap, only the lower legs and
feet have survived.[2] The goddess's face has the
slightly slanted eyes and upturned lips charac-
teristic of the Twenty-sixth Dynasty;[3] with the
extended brows and eyelines suitable to a divinity,
the breadth of face, and the strong, aquiline nose,
these traits combine to make the face one of the
noblest physiognomies surviving from the period.

Isis wears a traditional tripartite wig with verti-
cal tresses beneath a cap in the shape of a vulture,
whose legs and tail can be seen at the back of her
head and whose wings extend down behind her
ears and beside her face. Instead of the bird's head,
however, the head and neck of a royal uraeus
cobra rear above her forehead.[4] More cobra heads
ring a small crown that supports a pair of cow
horns and a solar disk.[5] The goddess wears a neck-
lace, visible as a series of incised lines between the
front lappets of her hair, and a dress, which is
indicated only by the hem at midcalf.[6]

The small base under her feet bears an inscrip-
tion, which begins on the proper left side, contin-
ues onto the front, and ends on the right (fig. 59).
It contains the promise of an offering by "great Isis"
of life, prosperity, and health—as well as a long
and goodly old age—to the "Chamberlain of the
Divine Consort, Hor (or Horus), son of the Prince,
Count, Overseer of Upper Egypt,[7] Overseer of the
Great House of the Divine Consort, Padiharresnet."
Thus the statue was commissioned and dedicated
by a man named Horus whose father, Padiharresnet,
held the titles of the highest official of the Divine
Consort (high priestess) of Amun: at that time the
royal princess Nitocris. Padiharresnet was one of
the most important men of Thebes in his day; he
built a huge tomb there, which has been excavated
and studied.[8] The tomb of his son, who was a lesser
official of the Divine Consort, has not been found.[9]

Before the Late Period, almost all images of
Isis showed her with her husband, Osiris,[10] or in
tombs and on coffins mourning the deceased,
who was in some sense identified with the dead
Osiris.[11] Although these roles did not disappear in
the Late Period, Isis was now worshipped chiefly
as the mother of the child-god, whom she had

Fig. 59. Inscription on *Seated Isis Nursing Horus* (cat. no. 57). Drawing by Will Schenck

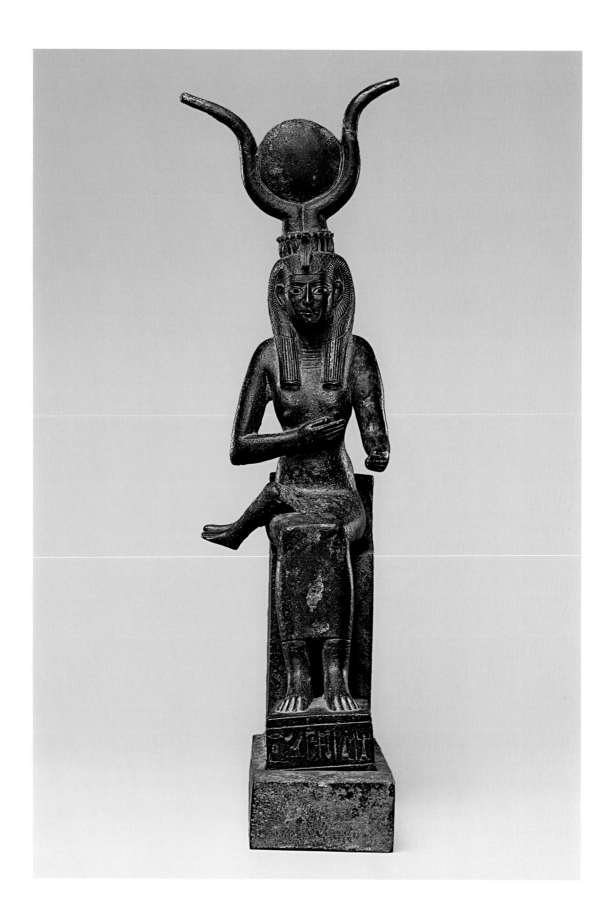

managed to conceive upon her dead husband, and, especially, as the child's protector—chiefly against his murderous uncle, Seth, but also against animal and spiritual dangers that might threaten human children and their mothers as well. In this role Isis was depicted in the seated and nursing pose, which had been used for representations of queen mothers from at least as early as the Old Kingdom.[12] Similar poses were later employed for nurses and male caretakers of royal children,[13] but the revival of the original version for representations of Isis that were even later in date shows that the pose's royal, and thus divine, connotations remained strong.

ERR

1. Graefe 1981 (vol. 1, p. 80) provides these dates for the term in office of the dedicator's father, discussed below.

2. The goddess's left forearm, which was also broken off, presumably at the same time, has been restored. This information comes from Metropolitan Museum conservator Deborah Schorsch, who has also informed me that the metal overlay on the whites of the goddess's eyes is electrum (e-mail, August 29, 2006).

3. Compare, for example, the eyes and mouth of catalogue number 40 (pp. 130–33), a silver figure of a mortal woman made about the same time.

4. The vulture cap, which was worn by the queen mother from the Old Kingdom on, aligned this most important of all royal women with the several tutelary goddesses who could appear as a vulture or cobra. When shown on a goddess, the cap emphasized her maternal role.

5. The solar disk flanked by cow horns originated as the headdress of Hathor, a deity who was sometimes represented as a cow. Divine headdresses were interchangeable to some extent, but the use of Hathor's insignia by Isis in the Late Period also marks the succession of Isis to the earlier preeminence of Hathor. According to Deborah Schorsch, the upper third of the horns on this example have been rejoined (e-mail, August 29, 2006).

6. She is presumably wearing the traditional dress with shoulder straps, which could easily have been lowered for nursing. Both nipples are indicated, as they often are on nursing statues of Isis; it is likely that her maternal gesture was considered more important than mundane details of costume.

7. The drawing shows this title as "Overseer of the City (Thebes)," which, while not impossible, seems to be otherwise unattested for this man.

8. Graefe 2003. It seems that the name of this son, who was one among several, was not preserved among the inscriptions found in the tomb.

9. Nor can he be identified with certainty elsewhere in the record. It is possible that his full name was a longer compound based on the name of the god Horus; we do know, however, that he did not succeed to his father's high office.

10. Often she was accompanied by their son, Horus, shown as an adult man with the head of a falcon, as on a gold and lapis lazuli amulet with the name of Osorkon II, where the pair flank a squatting Osiris (Musée du Louvre, Paris, E 6204); see *Tanis* 1987, pp. 172–75, no. 46.

11. As a mourner, she was usually paired with her sister, Nephthys; see, e.g., Taylor 2001, pp. 25–28.

12. See, e.g., the Sixth Dynasty king Pepy II seated on the lap of his mother, Ankhnesmeryre II (Brooklyn Museum, 39.119), published most recently in Do. Arnold et al. 1999, pp. 437–39. The only later royal example known to me is an arsenical-copper statuette of a nursing royal princess, who is seated on the ground (cat. no. 2; fig. 6). See also the probable Isis and Horus in Berlin (cat. no. 3; fig. 7); both works are discussed on pp. 12–13.

13. There are plentiful examples from the New Kingdom, in two and three dimensions, of nurses (and tutors) with their royal charges; see Roehrig 1990, pp. 271–307. See also Hema 2005, which notes two very unusual examples of this pose: a nurse with one seated child and three standing children on her lap (no. 11) and a nonroyal woman with her granddaughter, a princess (no. 35).

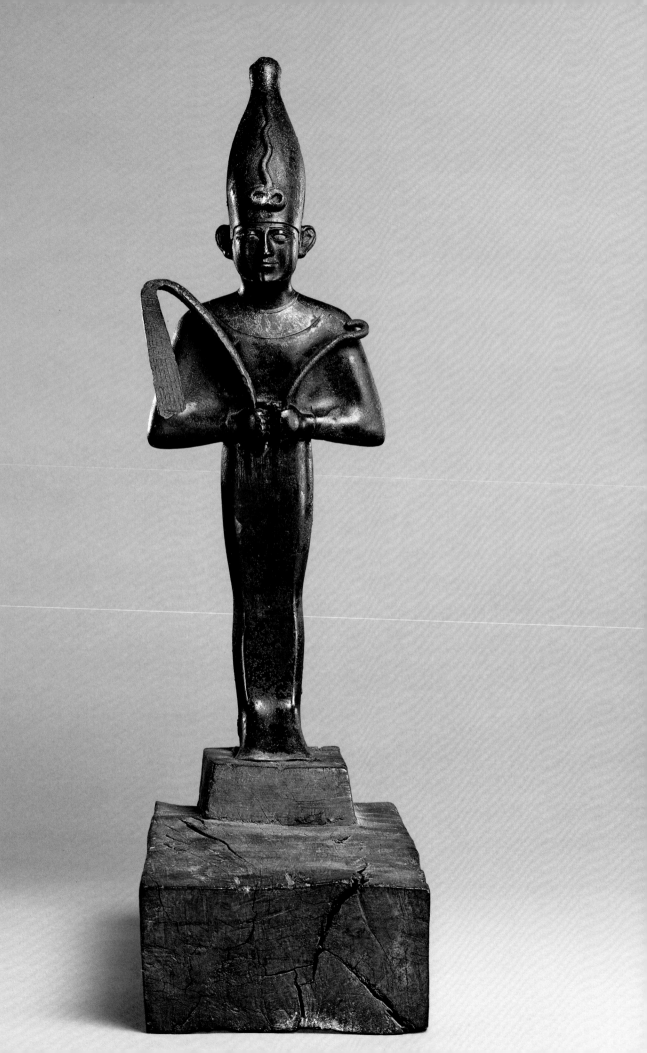

LIVES OF THE STATUARY

Marsha Hill

With the closing of the last temples in A.D. 392, cultural and personal connections to ancient Egyptian ritual practices lapsed, and the details and texture of the beliefs in which temple statuary was embedded were lost. Although ancient texts offer important insights into these practices and beliefs, the information they yield is partial and, generally, focused either on the ritual relations of officiants to a lone cult image or on royal largesse. Egyptologists have tended to absorb this focus on a lone cult image, but, finding almost no preserved statues that match the rare descriptions of such an image, they have had difficulty interpreting the role of the ubiquitous small temple statuary from the first millennium B.C. (fig. 60). These statues and statuettes are usually termed "votives," a designation that is problematic to the extent that it presupposes a purpose and a viewpoint. Studies have elucidated the social and economic structures surrounding presentations of so-called votive statuary during the Late Period. It appears that individuals funded statues that were then officially installed and maintained by temple personnel, with divine benefit accruing to the individual dedicator.[1] Judging from inscriptions (including prayers or wishes) that have occasionally been found in association with other types of offerings, it is possible that particular occasions, or rather specific objectives, underlay the otherwise formulaic requests for eternal life that appear on temple bronzes.[2] Yet the question of how donors envisioned that their statuary offerings would bring them benefit—that is, why, and in what capacity, they believed their donations were acceptable to the temple or gods—warrants further investigation.[3]

Toward a Demographics of Divine Images
In formal terms, the extant examples of statuettes of gods accord with what we know (from relief depictions and other sources) of the actual statuary employed within the temples. Likewise, the use of copper alloys together with precious metals has a history in temple statuary dating back to the

Fig. 60. *Osiris*
(cat. no. 18)

• 153

 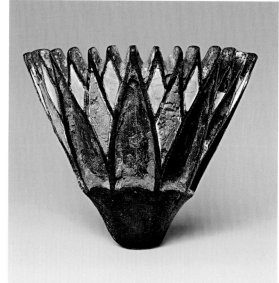

Figs. 61, 62. *Armlet for a Divine Statue* (cat. no. 63); *Lotus* (cat. no. 65)

earliest periods of Egyptian art. Along with indications provided by certain kinds of inscriptions (as noted above),[4] it becomes clear that the donors of these statuettes fully expected that their donations were to be used by a divinity. The careful treatment of the metal sculptures in deposits associated with the Sacred Animal Necropolis temples at North Saqqara (see the essay by Sue Davies in this volume) argues that this statuary was viewed by the temple personnel as more than simply accrued divine wealth. Remarkable corroboration of this understanding is provided by a find in the temple of Osiris–*iu* at ʿAyn Manâwir in the Kharga Oasis, where, adjacent to the sanctuary, a chapel was discovered crammed with about four hundred statuettes of Osiris (almost all of them bronze) and a few other figures left in positions that had been undisturbed since the temple's abandonment in the early fourth century B.C. (The excavation team working at ʿAyn Manâwir discusses this exciting find and its implications in their essay in this volume.) Clearly the placement of so many statuettes, many of unremarkable quality, deep within the temple itself is striking evidence that all small divine images from the first millennium—regardless of whether they were made of precious metal or copper alloy, or of fine or poor quality, and, probably, irrespective of who donated them—were regarded as loci for a divine presence.

Such archaeological evidence is in some ways difficult to comprehend given the focus of ancient texts on a single cult statue as the particular locus for the manifestation of a god.[5] In fact, there is probably no clear and fast distinction that can be made between a central cult image and the numerous statuettes that are actually preserved, and our notions about what Egyptian main cult statuary might have looked like need to be broadened.[6] No doubt a statue that was intended to serve as a cult focus was, in ideal

circumstances, made of valuable and symbolic materials representative of the god's importance (see, e.g., cat. no. 61; pp. 160–64). In addition, however, images that were possibly relicts of obscure events or of a distant past, and in which the god seemed immanent, might also have been revered.[7] The economic status of a temple, moreover, was surely reflected in its cult statuary. Central cult images made of less valuable materials, such as bronze, might have served for less prosperous temples; perhaps the auras of these images were then intensified by gilding, traces of which are frequently observed on preserved statuettes. Furthermore, extensive evidence—mainly from two-dimensional representations on temple walls and naoi dating to the first millennium B.C.—demonstrates that divine representations in Egyptian temples actually varied widely in purpose beyond our somewhat simplistic notion of a single cult focus.[8] Not all of these representations will have corresponded to embodiments in statue forms; nonetheless, aware-ness of this diversity of purpose should help to advance our appreciation for all preserved statuettes. It might also provide gradations and differenti-ations that could aid scholars in plotting the growth and course of the phe-nomenon of the widespread donation of divine images.

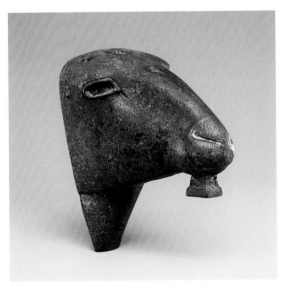

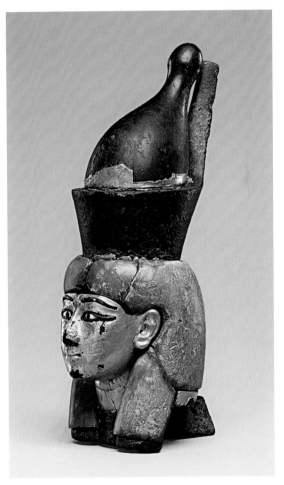

Figs. 63, 64. *Ram Head* (cat. no. 64); *Attachment Head of the Goddess Mut (?)* (cat. no. 66)

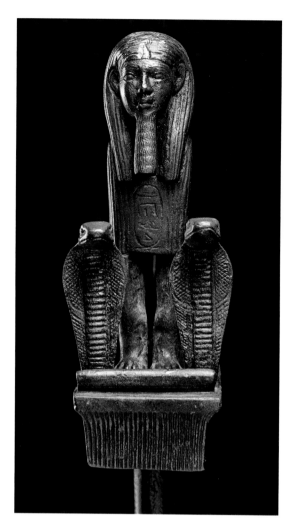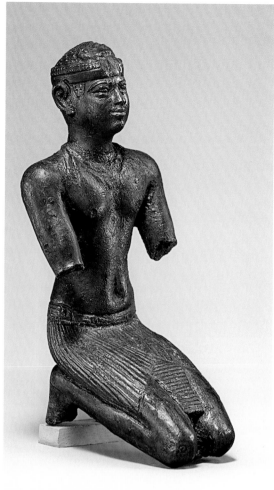

Claude Traunecker has explored the spectrum of status and role in divine representations: from the image that commingled with the essence of the being it represented (i.e., a "cult statue") to the image that was a simple transmitter of information. Within that spectrum, Traunecker identifies several classes of representation that are potentially relevant to the small temple statuary discussed here.[9] The category of "action images," for example, includes statues that served what he calls the "manifest" and "latent" cult. Among statues that were objects of the manifest cult are the various permanent and specialized cult images of the principal resident divinity of a temple as well as the associated resident divinities. "Latent" cult applies to images of principal divinities (or divinities with specialized functions) that were kept in discrete places, such as crypts, where their mere presence fulfilled their function: to generate a sort of "reservoir of power" supporting the temple. Both categories point to ways in which statuary that might seem to us only obliquely related to a cult focus could have been accommodated within the temple cult. The concept of latent cult images, moreover, suggests one possible scenario to explain the acceptance within temple rooms

Figs. 65, 66. *Sphinx Standard of King Taharqo* (cat. no. 35); *Kushite King with Altered Regalia* (cat. no. 24)

of multitudes of essentially similar statues, as seems to have been the case at 'Ayn Manâwir. Traunecker's category of "substitution images," comprising works that allowed cults normally practiced elsewhere to be integrated within a given temple, is also relevant to the discussion of possible contexts for small divine statuary, as is the practice he terms "reappropriation," in which worshippers employed sacred images or temple spaces for new ends. These categories and concepts are potentially applicable to some of the significant questions that exist about cults and statuary offerings in first-millennium temples. Osiris cults, in particular, experienced dramatic new growth at that time and were unquestionably one of the main benefactors of statue offerings. The formulation of our understanding of cults and statuary offerings during this period will no doubt be greatly enhanced as new evidence related to Osiris cults comes to light and as new studies of them are undertaken, especially in relation to their structure, ritual usages, and symbiotic relationships with the places of worship of other divinities.[10] In general, advances in our understanding are also dependent on the establishment of patterns of statuary offerings, a difficult proposition given that most divinity statues were buried in deposits after a long use life. Archaeological information such as that provided by the Sacred Animal Necropolis deposits at North Saqqara (see pp. 174–87) is extremely important in this respect.

Ritual Traces

Miniature jewelry (cat. nos. 62 [pp. 165–66], 63 [fig. 61]) and metal fittings for processional barques (cat. nos. 34 [pp. 106–7], 35 [fig. 65], 64–66 [figs. 62–64]) serve as potent reminders and traces of ritual activity. In some ways, absences, too, can evoke ancient ritual performances. Although depictions of the quintessential ritual groupings of a god or an emblem with either offering or protective royal statuary may be found on temple walls, valid examples of preserved groupings are exceedingly rare. This strongly implies that groupings containing the god and king were permanently dismantled at the end of their service, so that the ritual force flowing within the group was deactivated (see cat. no. 24; fig. 66).[11] In almost all of the surviving groups that *do* contain a king and a god, the king makes a sort of pious gesture toward a sacred animal. Possibly these groups remained intact because the gestures they depict—which do not include the great offerings or the protective gesture—may have had a less crucial significance, or perhaps the sacred animals performed a somewhat distinct function. Catalogue number 67 (fig. 67), for example, shows a king holding what may be a vestigial *shen-ring* toward an oversize otter. Two statuettes of kings and one each of the goddesses Isis and Nephthys (cat. nos. 52–55; figs. 82–85), all from two early collections drawn from some of the same finds, are so close in terms of style and size that they may represent constituent elements of a dismantled ancient ritual set.[12]

The final "decommissioning" of statuary was probably accompanied by certain rites and activities, after which the statues were buried in caches

within the sacred structures where they had lived. A vestige of such rites may be recognizable in the linen sometimes found wrapped about the statuettes, much as cult statues were covered with a skin or cloth in preparation for spending the night within the darkness of the temple.[13] Faint as they may be, these traces remind us that in gazing at metal statuary we are glimpsing the vestiges of ancient religious performance and belief.

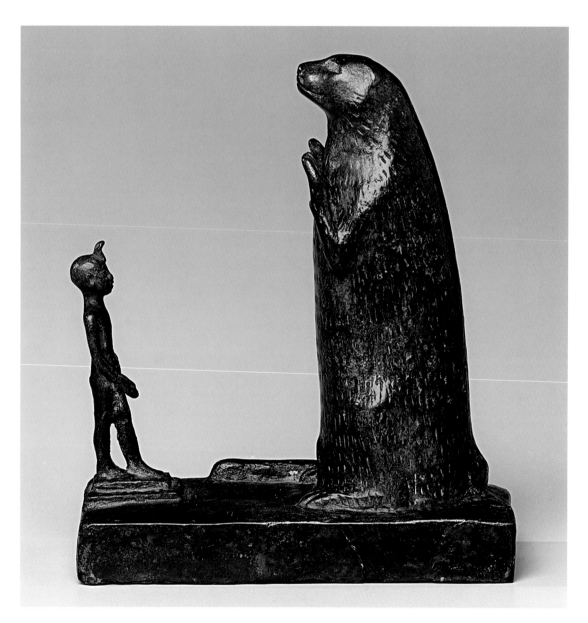

Fig. 67. *Group with King Holding a Shen-ring (?) before an Otter* (cat. no. 67)

1. De Meulenaere 1990; Colin 1998, pp. 546–50. See also the essay on ʿAyn Manâwir in this volume.

2. For North Saqqara, see Davies and Smith 1997, pp. 123–31, esp. p. 123; see also the essay on the Sacred Animal Necropolis in this volume.

3. For problems regarding the study of dedication practices and the problematic preconceptions involved in the various terms used, see Osborne 2004. Schulz (2004) remarks on many of the problems relevant to the discussion of Egyptian practices.

4. De Meulenaere 1990; Colin 1998. See also Perdu 2003, which discusses other inscriptions significant in this regard.

5. Lorton 1999 and Robins 2005 are valuable examinations of the Egyptian cult statue.

6. Robins (2005) establishes a somewhat wider framework of consideration.

7. Possible examples of this include an early wood falcon (see discussion of this work on pp. 8–9); catalogue number 3 (fig. 7), which might be (or mirror) a nonformal cult image; *benben* stones; the totemlike form used to represent the god Min-Kamutef; and the archaic wood statues at Dendera (see Cauville 1987, pp. 111–12).

8. Traunecker 1991. Spencer (2006, pp. 31–38) points out the many possible meanings of imagery on naoi. He refers to the difficulty of identifying representations of statuary in the absence of cues such as back pillars; this hardly constitutes an omission of specification, however, since back pillars do not exist on the wood and metal statuary commonly used in temple contexts.

9. Traunecker 1991.

10. Baines (2000, pp. 43–46) remarks on the seeming ubiquity of Osiris as an offering as well as on other patterns of offering that do not appear to fit a particular temple's overt identifications. Inquiries into the ways in which funerary religion and its imagery entered into and cohabited with the repertoire of nonfunerary temple concerns, like that initiated by John H. Taylor in his essay in this volume, are difficult undertakings, but they provide important perspectives on the convergence of religious concerns in the first millennium B.C.

11. Hill 2004, pp. 130–36. Apparently ancient groups with "priests" (or at any rate nonroyal individuals) exist (Mendoza 2006, p. 294), although the validity of the groups would need to be reviewed.

12. Identification of this possible set began with Élisabeth Delange's astute observation of common features of corrosion that suggested the Louvre king and the statuette of Isis (also in the Louvre) were associated in their burial environment.

13. Lorton 1999, pp. 136, 158. Egyptologists sometimes liken this treatment of statuettes to the wrappings given to the dead; see the essay by Sue Davies in this volume, which illustrates a wrapped statue (fig. 77).

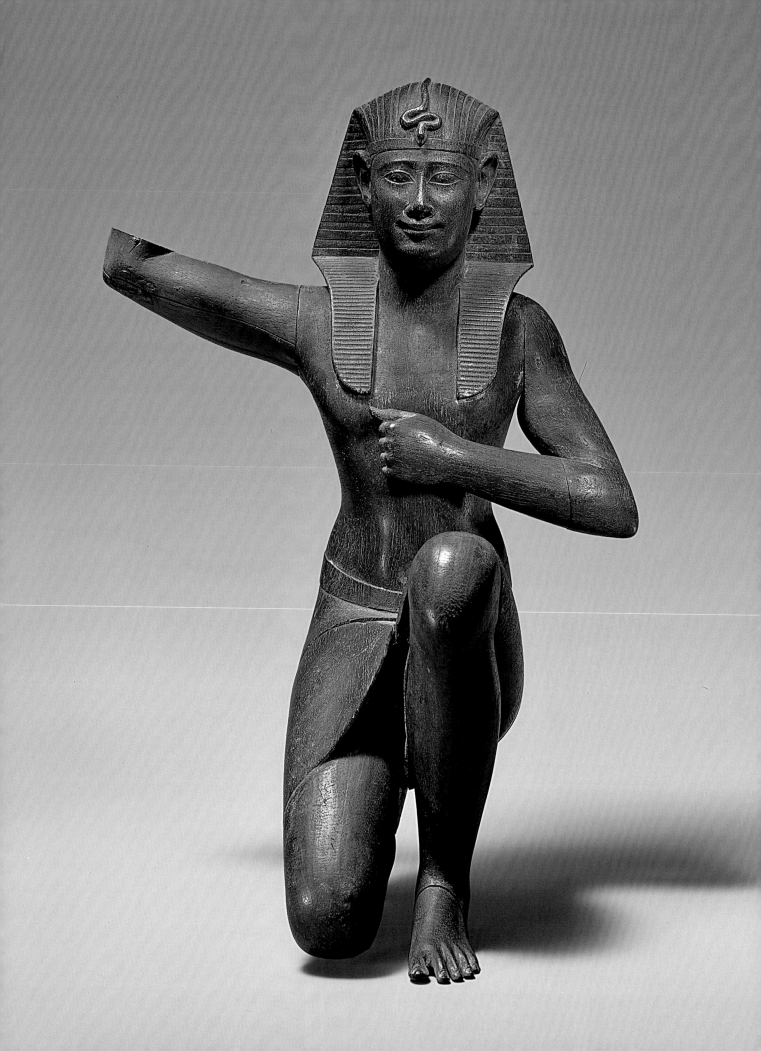

Statuette for a Royal Cult (?)

4th century B.C.–early Ptolemaic Period (380–246 B.C.)
Wood, assembled from eight components with carbon-based ink guidelines; formerly
clad with lead sheet
H. 21 cm (8¼ in.), W. 14.3 cm (5⅝ in.), D. 11 cm (4⅜ in.)
The Metropolitan Museum of Art, New York; Purchase, Anne and John V. Hansen Egyptian
Purchase Fund, and Magda Saleh and Jack Josephson Gift, 2003 (2003.154)
[cat. no. 61]

Provenance: unknown; Peytel collection, Paris, by 1922; Béhague collection;
Josephson collection; acquired in 2003

Selected References: Josephson 1997, pp. 31–32, 33–39; Málek 1999, no. 800-867-900;
Do. Arnold 2003, p. 6; Heywood forthcoming

The specific symbolic choices represented by
this royal wood statuette, along with the figure's
high artistry, elaborate construction, and select
materials—including, originally, a cladding of lead
sheet (fig. 68)[1]—suggest that it was likely a focal
image charged with meaning. Although the stat-
uette has been studied in detail and attributed to

Fig. 68. *Statuette for a Royal Cult* (cat. no. 61) with
lead cladding still in place. Photograph: from the
Exposition Champollion at the Musée du Louvre,
Paris, 1922

the reign of either Nectanebo I or II (380–362 B.C.,
360–343 B.C., respectively), the assignment of a
precise date to this unique piece is a particularly
difficult task. Until the work is better understood,
a date as late as the early third century B.C., in the
reigns of the earliest Ptolemies, should for now
remain under consideration.[2]

The king bends one knee and strikes his chest
in the *henu*, or acclamation, gesture. Both the pose
and the gesture are associated with jackal- and
falcon-headed figures representing the *bas*, or
souls, of the ancestral kings of Pe and Nekhen,
who accompanied the king in various ways during
his life, and whom he joined at his death; they
also have a role as attendants of solar gods, such
as Re and Amun-Re.[3] Threesomes of human-
headed royal figures are sometimes seen along-
side the composite figures, indicating that in
such cases the human-headed figures were
another way of representing the ancestral kings.
Interpretation of a single human-headed figure
of this type is more difficult. Such a figure was
regularly included alongside many types of royal
or royal-divine figures in scenes connected with
the transport of the barque of Amun; there the
figure leads similarly posed threesomes of jackal-
and falcon-headed figures in groupings on or
around the barque or its stand.[4] In this context,
the human-headed figure's exact status—whether
it represents the king himself, a personification
or deification of some other aspect of the king,
or an ancestral king—becomes difficult to
discern.[5]

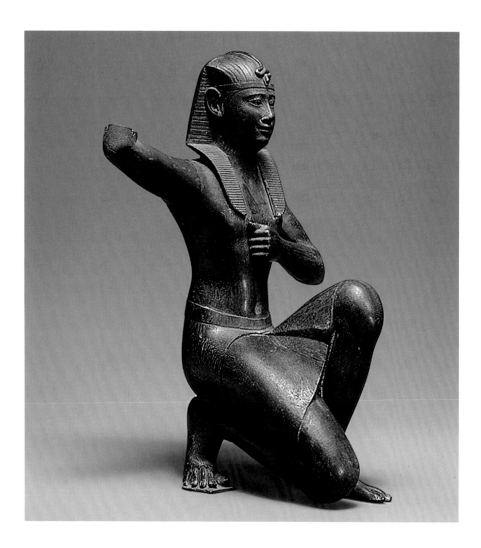

Over his brow the king wears a snake that is not the uraeus cobra, whose upper body and head are always raised to strike; rather, this snake's body and head hang down over the king's forehead, a feature that implies some unusual, presumably religious, significance.[6] The small limestone royal heads that have been termed "sculptors' models" (on account of their intentional partialness or incompleteness) sometimes display this pendant snake;[7] in fact, they seem to be virtually the only other sculptural form that does.[8] On those works, the snake sometimes appears alone,[9] or in some cases in tandem with the lower part of a head-dress comprising two ram horns topped by two feathers and a sun disk (fig. 69).[10] More rarely, the lower part of the feathers, horn, and disk head-dress appears on the king's head with no snake,[11] or with a uraeus snake.[12] This is a remarkable conjunction of unusual features, for the pendant snake does not appear on large three-dimensional sculptures of kings, nor is the headdress with tall feathers something that would be carved as an integral element[13] of the large statuary for which the limestone heads were the putative models. This conjunction, then, particularly in light of the highly wrought nature of the image presented by the wood king, is strong evidence that the small "sculptors' models" with these features probably had some religious import.[14] In return, the small heads exhibit a set of supplementary features that might, with study, lead to a more precise under-standing of any religious significance that they (and, by extension, this wood king) possessed.[15]

The statuette remains enigmatic, nevertheless; in addition to the debatable significance of the unusual snake over the forehead, we do not understand the meaning of royal figures posed in this manner, the symbolism of the lead cladding,[16]

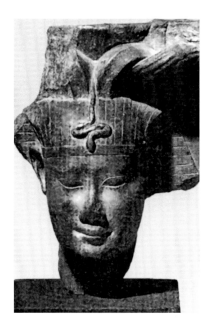

Fig. 69. *Sculptor's Model*, 4th–3rd century B.C. Limestone, H. 11 cm. Muzeum Narodowe, Warsaw (149801)

or the rationale behind the elaborate construction. As for the snake attribute, there are numerous possible explanations that involve a wide range of considerations, including the fact that various gods—Atum is perhaps the best known and the one with the greatest range of associations[17]—are strongly linked to snakes. More generally, a snake, beginning in the Middle Kingdom, was sometimes used as the determinative for the word "divinity."[18] Even more striking, the important religious text "The Book of the Heavenly Cow," best known from the Ramesside period, refers to the fact that the *ba*s of the gods appear in snakes;[19] also, various snake signs in Greco-Roman texts have the phonetic value "*ba*."[20] Thus it is appealing to interpret this snake, on some level, as a reiteration of the word or concept "*ba*," as is implicit in the overall figure.

M H

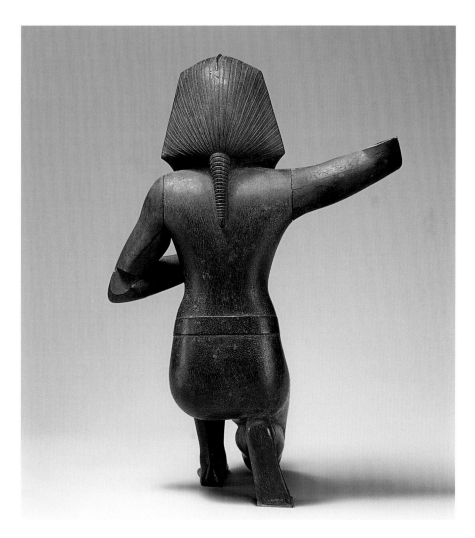

1. Ancient Egyptians generally painted or otherwise covered wood statuary surfaces even when, as in this case, the wood is particularly beautiful; here the covering concealed a separation in the kilt where the pieces abutted. Although the cladding material is unusual, there is no reason to doubt that it is contemporary with the creation of the figure. For the most recent investigations of the statue's manufacture, see Heywood forthcoming.

2. Josephson 1997, pp. 31–32, 33–39; see p. 35 n. 248.

3. On this topic, Žabkar 1968 remains useful; for ancestral kings, see pp. 15–36; for royal *bas*, see pp. 51–73. Karlshausen 1997 (pp. 242–44) considers the functions of the *bas* in relation to solar gods and their barques.

4. See, e.g., the reliefs of the barque station of Achoris at Karnak; Traunecker et al. 1981, vol. 2, pp. 83–84, pls. D, E/2.

5. On related questions, see Baines 1985, pp. 252–75.

6. Josephson 1992; Josephson 1997, pp. 31–32.

7. Josephson 1997, pp. 31–32. For a basic review of the opinions and study of the difficult objects termed "sculptors' models," see Tomoum 2005.

8. Josephson (1997, p. 31) argues that two larger heads (Musée du Louvre, Paris, E 22761; Los Angeles County Museum of Art, AC 1992.152.64) that have holes for the insertion of now-missing snakes must have originally had pendant snakes because the snake tail carved integrally with the head shows the Z-bend associated with the pendant snake. These tails are no different in appearance from the normal coils of a uraeus cobra, however; in this instance they are simply exposed by the absence of the uraeus body and head. For a kneeling leaded-bronze precursor to figures with downward-hanging snakes, dated to the reign of Apries (589–570 B.C.), see Hill 2004, pp. 163–64.

9. I count eighteen examples in a quick, incomplete survey: see Tomoum 2005, nos. 9, 16, 17, 25, 93; Steindorff 1946, pl. 47, no. 294, pl. 48, nos. 304, 305 (wood); one in the Metropolitan Museum (47.13.2); Josephson 1992, objects mentioned in nn. 10, 13, 14, 33, and fig. 6; one in the Musées Royaux d'Art et d'Histoire, Brussels (4063); two in the British Museum, London (EA 21916, EA 48665); and Redford 2004, pl. 32, whose archaeological context indicates it predates Ptolemy II (r. 284–246 B.C.).

10. In addition to figure 69 (noted in Josephson 1992, fig. 3), five examples of the latter include: Tomoum 2005, nos. 7, 36, 37; Steindorff 1946, pl. 47, no. 299; and one in the Metropolitan Museum, which has a base for horns (07.228.6). The slope of the contours of the feathers could suggest they are falcon rather than ostrich feathers, although the profile given to ostrich feathers in representations seems to vary.

11. See, e.g., Tomoum 2005, no. 33.

12. See, e.g., ibid., no. 39. See also an example in the Museum of Fine Arts, Boston (00.608), although there the attribute is damaged; visual inspection, which has not yet been possible, is required to determine which snake type (upright or pendant) was intended. See also Stanwick 2002 (p. 91, fig. 211, p. 220) for a relief showing a bust with this headdress and traditional forehead attributes being used as a standard.

13. Bothmer (1987, p. 92) notes holes or tangs on the heads of a few large statues that could, theoretically, have accommodated separate headdresses of this form. Stanwick (2002, pl. 202) captions a sculpture of Ptolemy XII as wearing a *hemhem* crown, although only the root of the horns is visible in the photo, so there is the possibility that this headdress was integrally carved. Absent the decisive conjunction of the headdress with the pendant snake, it might still be argued that heads with the lower parts of this headdress were simply "sculptors' studies"—that is, not strict guides, but pieces that served other instructional purposes. Tomoum (2005, p. 168) advances this explanation, noting the important fact that many of the so-called sculptors' models have features that do not relate directly to those of stone statuary or relief. Given the religious connotations of the pieces with the snake, it could be theorized that these types of objects, as a class, were "tokens" associated with some type of cult related to the great building projects of the period. Remarks in Ashton 2004 (pp. 195–98), Tomoum 2005 (pp. 203–5), and Spencer 2006 (p. 14, with comments in n. 26, pp. 17–18) tend toward associating the models rather specifically with the building program; certainly Spencer (esp. p. 51, and his other work cited there) sees the building program itself as a very complex phenomenon involving some kind of broader agency.

14. This is in contrast to the final appraisal of Tomoum 2005, pp. 202–5.

15. Aspects that could prove fruitful in terms of our evolving understanding of these works include: crown type; the close stylistic ties between the heads and the great temple and statuary programs of the fourth and third centuries B.C. and characteristic patterns of disjunctions in their respective formats; and archaeological provenance. Volokhine (2000, pp. 93–95, 97–101) discusses frontality and the bust format as modes for conveying religious manifestation. Indeed, a few busts on late Ptolemaic stelae (reproduced in Stanwick 2002, p. 220, and noted by Tomoum [2005, p. 53] as sculptors' model–type busts) are without question actually depictions of the god Pnepheros (Volokhine 2000, pp. 100–101). Regarding the stylistic similarities and format disjunctions among these objects, see n. 13 above.

16. The use of lead is attested throughout Egyptian history, but symbolic associations of the metal are only explicit in considerably later texts and usages; there could, however, be intimations of alchemical symbolism in the "Instructions of Amenemopet," which seems to have originated in the Ramesside period (Aufrère 1991, pp. 182–83, 453–57). A number of Egyptologists, such as John Darnell, Terence DuQuesne, Edmund Meltzer, and Jorge Roberto Ogdon, are pursuing studies related to the history of Egyptian ideas of material transformation and alchemy, which ultimately may prove illuminating in this regard.

17. Myśliwiec 1978–79, vol. 1, pp. 95–124.

18. Störk 1984, col. 649.

19. Žabkar 1968, p. 13; Hornung 1982, line 284, pp. 27, 47.

20. Daumas 1988, vol. 1, p. 355, no. 7, p. 366, no. 235, p. 371, no. 323, p. 372, no. 339.

Miniature Broad Collar

Macedonian–early Ptolemaic Period (ca. 332–246 B.C.)
Gold, soldered hammered sheet; cloisonné inlay with turquoise, lapis lazuli, and carnelian
H. 8.6 cm (3⅜ in.), W. 10.3 cm (4⅛ in.)
The Metropolitan Museum of Art, New York; Harris Brisbane Dick Fund, 1949 (49.121.1)
[cat. no. 62]

Provenance: unknown, thought to be from Tukh el-Qaramus; McKee Cook collection, by 1920; acquired in 1949

Selected References: Clark 1951; N. Scott 1964, p. 227; Aldred 1971, pp. 241–42, pl. 146

This semicircular broad (or *wesekh*) collar is decorated with floral motifs arranged in six curving bands, each with a different design articulated with small cells defined by gold cloisons and inlaid with semiprecious stones.[1] Judging from its modest size, the piece was probably intended to adorn a statuette of a deity. Many of the carnelian, turquoise, and lapis lazuli inlays are miss-ing, but enough remain to enable recognition of the original pattern and appreciation of the exqui-site workmanship.

Moving from the outermost to the innermost bands, the six strands of the necklace comprise, respectively: 1) turquoise drop beads with alternat-ing lapis triangles; 2) hanging lapis and turquoise lotuses with gold stems that alternate with long

gold buds (the interstices are filled with carnelian); 3) turquoise rosettes with gold centers separated by bands of lapis; 4) hanging lapis and turquoise papyrus flowers with gold stems (between each flower are round gold objects that may represent mandrake fruit;[2] the spaces in between are filled with carnelian); 5) turquoise and lapis triangular forms alternating with solid turquoise triangles (the inlay pattern suggests hanging flowers); and 6) hanging turquoise lilies separated by long gold leaves (between the leaves and flowers are alternating inlays of lapis and carnelian). On each side of the collar, the top is finished with inlaid lapis and turquoise block borders separated by thick gold cloisons. Hinged to the tops of the block borders are lotus-flower terminals with some remaining lapis and turquoise inlays. Closing the collar are short chains with single loops that interlock with double loops at the tops of the lotuses; bent gold pins secure the juncture.

In 1905 a miniature collar quite similar in size, style, and workmanship to this example was found deposited along with other sacred objects at Tukh el-Qaramus, a village in the Egyptian Delta located about 12½ miles northeast of Bubastis.[3] That collar has six cloisonné bands that generally have less complex patterns than the Metropolitan Museum example, including drop beads, vertical bars, hanging triangular flowers similar to those seen here, *wedjat* eyes, triangular flowers, and vertical bars. The terminals are in the shape of Horus heads crowned by sun disks.[4] Coins dated to Ptolemy I and II (r. 306–282 B.C., 284–246 B.C.,

respectively) were discovered in the area; another deposit contained a plaque inscribed for their predecessor, Philippus Arrhidaeus (r. 323–316 B.C.).[5] The similarity of the two collars suggests that the Metropolitan Museum piece may also originate from Tukh el-Qaramus, and the inscribed evidence points to a date in the early Ptolemaic Period.

Several factors make it difficult to ascertain how these miniature collars were used. Depictions of Egyptian pharaohs presenting broad collars and other items of jewelry to deities are often found on temple walls. In the New Kingdom, these representations feature collars that tend to be nearly circular and, sometimes, to have a counterpoise hanging from the back.[6] Similar scenes in Ptolemaic temples tend to show semicircular collars that have long strings or chains at the back, but no counterpoise,[7] an arrangement that resembles that of the two miniature collars discussed here. Since the tops of the collars are tightly curved and the gold base plates slope outward from bottom to top, one would expect that they were intended to lie across the upper chest. Difficulties would have arisen, however, when the semicircular collars were placed around the necks of statuettes; the long chains and the lack of counterpoises would have left them hanging low across the torsos.[8] The possibility that such collars were simply offerings placed in front of statues cannot be excluded,[9] although the intricate method of hinging the terminals suggests that they were intended to be placed around an object.

A O

1. For floral and plant-form collars, see Boyce 1995, pp. 337–42, 367–70, with further references. Although the word "cloison," a French term for a partition, has often been used to refer to these inlaid cells, it more precisely describes the metal rods or strips dividing them.

2. See Boyce 1995, pp. 346, 348, nos. C12, C12A, C12B, C56.

3. The piece is now in the Egyptian Museum, Cairo (CG 53669; Vernier 1907–27, pp. 480–81, pl. XCIX). See C. C. Edgar in Maspero 1907, pp. 57–62; Pfrommer 1987, pp. 142–59, 272, pl. 28d; Pfrommer 1999, pp. 39–40, fig. 58, with further references; Stanwick 2002, pp. 23, 99. In addition to Egyptian-style objects such as the collar, pieces showing clear Greek and Persian influence were also discovered.

4. For other Ptolemaic inlaid collars, see Gänsicke 1994, p. 27, with further references.

5. Naville 1890, p. 29, pls. VIIIb, XVII, no. 8; Griffith 1890, p. 55.

6. Examples include Luxor Temple (see Brunner 1977, pls. 6, 11, 91, 171) and the mortuary temple of Ramesses III at Medinet Habu (see *Medinet Habu* 1957, pt. 1, pls. 326, 331). In the latter, the collars are shown without counterpoises. The temple of Sety I at Abydos includes depictions of circular and semicircular collars; for examples, see Gardiner et al. 1933, pls. 13, 16, 33; Gardiner et al. 1935, pls. 12, 19, 27.

7. For example, at Dendera (see Chassinat et al. 1934–2001, vol. 9/2, pl. DCCCC, vol. 11/2, pls. 8, 30) and at Edfu (see Chassinat 1892–1934, vol. 10/1, pls. LXXXVIII, LXXXIX, CVII, vol. 11, pl. CCXXXIX). The significance of the king offering broad (*wesekh*) collars to deities is discussed in Beaud 1990.

8. Another type of broad (*wesekh*) collar was sometimes placed across the knees on Greco-Roman Period coffins; see Riggs 2001.

9. Semicircular collars with floral designs could also be hung from the prows and sterns of boats (Cauville 1998, pls. V, XVIII) and used as ritual implements (Chassinat et al. 1934–2001, vol. 5/2, pl. CCCCXXVIII; Cauville 2004, vol. 1, pp. 14–15). See also Gardiner et al. 1959, pls. 8, 39.

AN ASSEMBLAGE OF BRONZE STATUETTES IN A CULT CONTEXT: THE TEMPLE OF 'AYN MANÂWIR

Michel Wuttmann, Laurent Coulon, and Florence Gombert

In 1993, excavations by the Institut Français d'Archéologie Orientale (IFAO) at the site of 'Ayn Manâwir—located in the basin of present-day Baris, in the southern part of Kharga Oasis (about 150 miles from the Nile Valley in Upper Egypt)—uncovered the remains of an unbaked-brick temple at the center of a settlement of small houses.[1] The excavations there, in addition to abundant demotic ostraca recording contracts and receipts, afford valuable information about the organization of this rural community and the stages of its development from its beginnings about 470 B.C., under the First Persian Domination (or Twenty-seventh Dynasty, 525–404 B.C.), until its decline in about 370 B.C.

Although inhabited throughout prehistory, the region in which 'Ayn Manâwir is located preserves no trace of human activity between the end of the Old Kingdom (ca. 2200–2100 B.C.) and the first decades of the fifth century B.C., when systematic and planned exploitation of water resources in geological levels deep beneath the hills was undertaken by means of a system of man-made underground draining channels called *qanats*. The resulting water supply enabled the growth of a network of small hamlets surrounded by fields and gardens, including 'Ayn Manâwir, Tell Dush, and 'Ayn Ziyâda. The temple of 'Ayn Manâwir (fig. 70), consecrated to Osiris-*iu* ("Osiris-has-come"), measures about 60 meters east to west and is organized in a traditional manner, with a dromos leading to several courts, followed by a hypostyle hall (G) and a bipartite sanctuary (A, B) surrounded by chapels. Against the south side of the temple lies a service building that was used in part to prepare and store administrative documents. The chapels north of the sanctuary (E, F) held at the time the temple was abandoned a sizable group of cult objects, including a fragment of a wood naos containing the base of a statue of Osiris (fig. 72), a stuccoed covering, animal skeletons (one cat and one turtle), and nearly four hundred bronze statuettes and objects. A second deposit consisting of seven statuettes of

Fig. 70. Aerial view of the temple of Osiris–*iu*, showing the
bipartite sanctuary (A, B), the south chapel (C), corridor (D),
north chapels (E, F), and the hypostyle hall (G)

Osiris and one statuette of a nursing Isis was found beneath the floor of
the corridor along the south facade of the temple, and several additional
statuettes of Osiris were discovered that had been scattered about by pil–
lagers subsequent to the abandonment of the village.

The assemblage of bronzes comprises some 370 statuettes of Osiris
(fig. 73); about ten pieces representing other figures or divine attributes
(e.g., a nursing Isis, Anubis, Apis, an offering bearer, an orant, animals, and
Hathoric crowns); isolated objects such as a situla, a bracelet, and a frag–
ment of a cup; and some unidentifiable fragments. From a technical point
of view, the metal employed in these works is a leaded bronze containing
about 7 percent tin and up to 25 percent lead. The metal was cast in two
types of molds; most were monovalve, but in a few cases a bivalve mold
was used. Additionally, the lost–wax technique was employed for the largest
and most elaborate sculptures. Examination of certain pieces suggests that
separately fashioned elements, particularly scepters or parts of the crown,
were added to a wax model. There is little trace of any cold–working after
casting. Sizes vary considerably; the largest statuette measures 29 centime-
ters in height and a few are smaller than 5 centimeters, but the majority

can be grouped according to average heights of 7, 9, or 11 centimeters. The statuettes made in mono- or bivalve molds were apparently subjected to bending at the base of the legs to form the feet. At the point of torsion, a tang, perhaps created with the aid of a mold, was added. Nearly all the figures have tangs, which allowed them to be fixed in a wood base; only three bases are preserved, one of which served to support four identical figures of Osiris placed side-by-side. Three small figures were provided with both a tang and a loop on the back at neck level. In three cases, groups of Osiris figures were cast side-by-side as one piece: two groups of three Osirises are attached at the bottom, which was provided with a single tang, and one group of two Osirises was given a loop. In several cases the god's *atef* crown is surmounted by a solar disk; in others it has a set of ram horns. Although it is possible to establish subgroups of the Osiris sculptures based on elements they have in common—such as the type of *atef* crown, the positions of the god's hands, or even the length and orientation of his scepter—it must be emphasized that within any given subgroup the statuettes differ in other details. Some of these differences would certainly take on significance as possible indicators of different production sites if it were possible to determine where the works were produced. The only testament

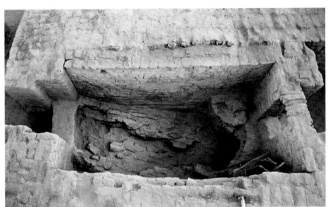

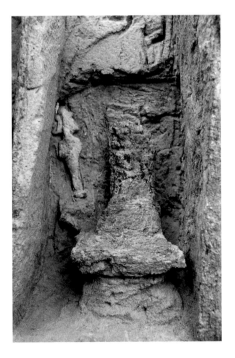

Fig. 71. View onto the outermost north chapel (F), showing the shaft leading to the underground space (visible at left) and the naos (visible in the northwest corner)

Fig. 72. Remains of the large cult statue in its naos, with a bronze statue of Osiris alongside it

to metalworking at 'Ayn Manâwir is very modest and, at the current stage of the excavations, does not confirm that the statuettes were produced there. In terms of style, execution, and iconography, the statuettes are quite similar to those discovered in the environs of the temple of Amun at ancient Hibis (modern Kharga), located in the north part of Kharga Oasis about 100 kilometers to the north of 'Ayn Manâwir. The find there lay about 15 meters east of what the excavators called the "south building," beneath the floors of houses dating to the fourth century A.D.[2] That discovery comprised a number of works, most of them small figures of Osiris (85 in total); there were also plumes and beards from eight large statues of the god, which originally must have reached a height of 130 centimeters, and a statuette of

Harpokrates. The group clearly constitutes a deposit that originated in the temple, where the statuettes no doubt had been previously consecrated.

The north chapels of 'Ayn Manâwir were discovered in much the same state as they must have been in when they were abandoned, except for slight disturbances caused by the collapse of the roof. The arrangement of the material in them can, therefore, be interpreted in relation to the function of these rooms. Located at the heart of the temple, the chapels constitute three spaces that were accessed from the hypostyle hall. The first two (F) are situated one above the other: a lower vaulted space, reached from a small shaft opening into the floor of the hypostyle hall, and a rectangular upper room, also vaulted. From the upper room, the third room (E) was reached through a low doorway. The collapse of the underground room while the temple was still in use necessitated significant repairs; the room was cleared, the floor of the upper space was redone, and the vault of the upper room was reconstructed. Owing to this circumstance, it is difficult to separate the original functions of the underground space and the space above it. In the final stage of use, the finds were organized around the naos containing the cult statue, in the northwest corner of the first upper room (fig. 71). In proximity to this naos were grouped a great number of statuettes, including the largest. In the third room (E), which was unaffected by the collapse, the arrangement is more uniform but is nevertheless denser along the side walls. Judging from this distribution of finds, it seems improbable that the sculptures were deposited at a single time; rather, the arrangement seems to reflect successive additions of statuettes and regular traffic through the two upper rooms.[3] The absence of any vestiges of provisions for closing off the spaces reinforces this analysis.

What interpretation can be proposed regarding the rituals represented by this ensemble of votive bronzes? Unfortunately, clues that might allow us to explain the working of the deposits are scarce, and the decoration of the temple has almost entirely disappeared. Very slight traces of painted plaster survive; on the lintel of the doorway giving access to the outermost room of the central sanctuary (B), it is possible to discern the two falcon-headed divinities Re–Harakhti and Khonsu, and on a few other fragments, three gods with human heads can be recognized. The demotic documentation, which furnishes some indications about the organization of the cult, occasionally mentions the title of the chief of the temple administration (the *lesonis*) or, more often, the names of principal officiants, such as Harsiese and his son Wenamunemhab, who evidently were particularly active under Darius II (r. 424–404 B.C.). Contracts record that these two men regularly leased a monthly portion of their liturgical duties to other individuals, who thus obtained the responsibility for carrying out the "festivals of the temple of the Domain-of-Osiris-*iu*."[4] A few women, such as the daughter of Harsiese, likewise exercised liturgical functions in the sanctuary.[5] That the cult enjoyed close ties to the temple of Isis at Dush, where a temple of Osiris-*iu* was later constructed in the Roman era, is evident from the temple archive

documents, as is the dependency of the 'Ayn Manâwir sanctuary on that of Amun at Hibis, whose decoration shows the name of Darius I (r. 521–486 B.C.). Yet the temple archive documents reveal more about the economic network of the sanctuary and its functionaries than they do about details of the rituals practiced there.

Among the other significant elements of the furnishings found in the temple were some one hundred clay pellets, most bearing one or more stamped impressions. Found in bulk in the hypostyle hall (G) and in the south chapel (C), which had been converted into a sort of clearance room, they are almost certainly not sealings, judging from their often perfectly spherical form. It is tempting to think that, given the Osirian context of the temple, the pellets were used in the enactment of the "rite of the 4 balls," in which balls were thrown in the four cardinal directions as part of a ceremony to invoke protection for Osiris from his enemies. This hypothesis would seem all the more reasonable since the decoration of the Osirian chapels of the temple of Amun at Hibis includes a part of the associated liturgy.[6] Yet the variety of the stamp motifs and their similarity to seal impressions differentiate them from accepted archaeological evidence of this ceremony, in which the ritual notations on the balls relate to the cardinal points and their protecting deities.[7]

Given the current state of our knowledge, the consecration at 'Ayn Manâwir of bronze figures of Osiris cannot be directly linked to a particular ceremony. Some scholars have interpreted the figures as being the Osirises "raised"[8] at the Osirian Festival performed every year during the month of Khoiak, in association with the fabrication of corn mummies of the god. Yet the diversity of the sizes of the 'Ayn Manâwir figures, the accumulation of them around a cult statue (rather than an annual replacement of them, as is the case with the divine figures produced in connection with the Khoiak Festival), and the specific dedications that some statues from other sites bear suggest, instead, that they were votives consecrated to benefit individuals, a scenario that does not exclude their having been involved in certain ceremonies in a secondary manner. The consecration of such figures in the Saite Period is well understood, since the dedication formulas on divine figures explicitly mention that a temple clergy subordinate is being entrusted with the maintenance of the monument before the local god in order that the person who made the donation to the temple would receive, in return, divine protection.[9] Given the modest scale of the sanctuary at 'Ayn Manâwir, one can imagine that the priests responsible for the cult played a role comparable to the temple personnel mentioned on the Saite donation figures. (Contributions toward maintenance given by a visitor or worshipper to the clergy on behalf of one of these propitiatory statuettes would doubtless have been included among the revenues generated by liturgical services, which are so often the subject of the transactions discussed in the contracts.) The size of a statuette would almost certainly be a function of the size of the donation, and the groupings could correspond

to consecrations made in groups; without textual evidence, however, it is difficult to make more specific proposals.

It is also not easy to identify which local factors might have played a role in the foundation of this particular cult at 'Ayn Manâwir, especially given the lack of comparable archaeological evidence for the period. Judging from the modest furnishings of the houses adjoining the temple, most of which seem to have been made locally, it would appear that this community, located at the borders of the Persian Empire, was largely self-sufficient. At the same time, the presence of containers that originated in the Nile Valley, Palestinian jars, and even Attic lekythoi testify to relations with the outside world.[10] Moreover, the Osirian rites practiced in the temple of Hibis, which must have served as models for those practiced in the rest of the oasis, were imported from Thebes or Abydos. Thus, while the collection of bronzes from 'Ayn Manâwir constitutes one of the rare instances of a group discovered in its regular context of use in the temple—preserved because of the exceptional environmental conditions in the oasis for the preservation of unbaked-brick buildings, and also as a result of the brief history of the site—the picture that the site provides of temple rooms and practices is probably representative.

1. Wuttmann et al. 1996, 1998.
2. *Temple of Hibis* 1941, p. 42, pl. XXVII. Almost all the crowns of the statuettes discovered at Hibis, however, seem to lack ram horns.
3. Although the composition of the 'Ayn Manâwir furnishings (the naos and the statuary), certain characteristics of their disposition, and the dating of the find relate to that of the deposit at Gate D of the Sacred Animal Necropolis (SAN) at North Saqqara (H. Smith et al. 2006, pp. 60–61, pl. XI; see also the essay by Sue Davies in this volume, fig. 76), the latter was a closed pit, so its configuration (unlike that of 'Ayn Manâwir) did not permit regular access. The disposition of the SAN Gate D deposit, which is perfectly organized, reflects a deposit that was constituted at one moment.
4. Chauveau 1996, pp. 39–40; Chauveau 1998, p. 24.
5. Michel Chauveau in Wuttmann et al. 1998, p. 444.
6. Goyon 1975; Goyon 1999, pp. 63–73.
7. See, for example, Ziegler 1979. See also the balls found in the Oxyrhynkhos Osireion, such as those discussed by Philippe Collombert in Mathieu 2002, p. 565. It should be noted, however, that the stamped impressions on some of the 'Ayn Manâwir pellets do repeat. For pellets with seal impressions similar to those found in 'Ayn Manâwir that were used in apotropaic rituals, see Arnst 2006.
8. Koemoth 1993, pp. 165–74.
9. De Meulenaere 1990; Colin 1998.
10. Marchand forthcoming, section 4.1.

BRONZES FROM THE SACRED ANIMAL NECROPOLIS AT NORTH SAQQARA

Sue Davies

This essay is dedicated to the memory of Mr. Hasaballah el-Taiyib

About thirty kilometers south of Cairo, on the west bank of the Nile, lie the ruins of the ancient city of Memphis, for much of its history the first city of pharaonic Egypt. West of the city, on the edge of the desert, lay its great necropolis, Saqqara. This essay discusses a number of bronzes recovered from a site at Saqqara known as the Sacred Animal Necropolis (SAN). Sacred animals had always been an important feature of ancient Egyptian religion, but beginning about the Twenty-sixth Dynasty (664–525 B.C.) the phenomenon of sacred animal cults burgeoned in terms of both patronage and popularity. In some temples a single sacred animal acted as the living incarnation of a god; for example, the Apis bull, the emanation of the creator god, Ptah, passed his life in the precinct of the great Ptah temple at Memphis and upon death was buried in the vast subterranean vaults of the Sarapieion at Saqqara. In other temples living species were kept within the precincts; in the temple of Ptah-under-his-moringa-tree at Memphis lived the baboons sacred to the god Thoth, who upon their deaths were buried in a catacomb at the SAN site. There were also temples and sanctuaries attached to the burial places of sacred animals; the site discussed here falls into that category.

The Sacred Animal Necropolis lies on the west side of the bluff of North Saqqara, which forms the east scarp of a desert valley running from Abusir up to the Sarapieion (fig. 74).[1] Here, cut into the escarpment, lie the catacombs that housed the burials of the Mother of Apis cows, falcons, baboons, and ibis, and in front of them were once ranged the shrines attached to their respective cults (fig. 75).[2] A description and chronology of the structures attached to the cults of the Mother of Apis cow, baboon, and falcon is apposite, for this was the area from which most of the bronzes came. The site history that follows is given in the form of phases of development; the structures referred to are shown in figure 75 unless otherwise noted.

Fig. 74. Map of North Saqqara, showing the Sacred Animal Necropolis (SAN) in relation to other structures discussed in this essay

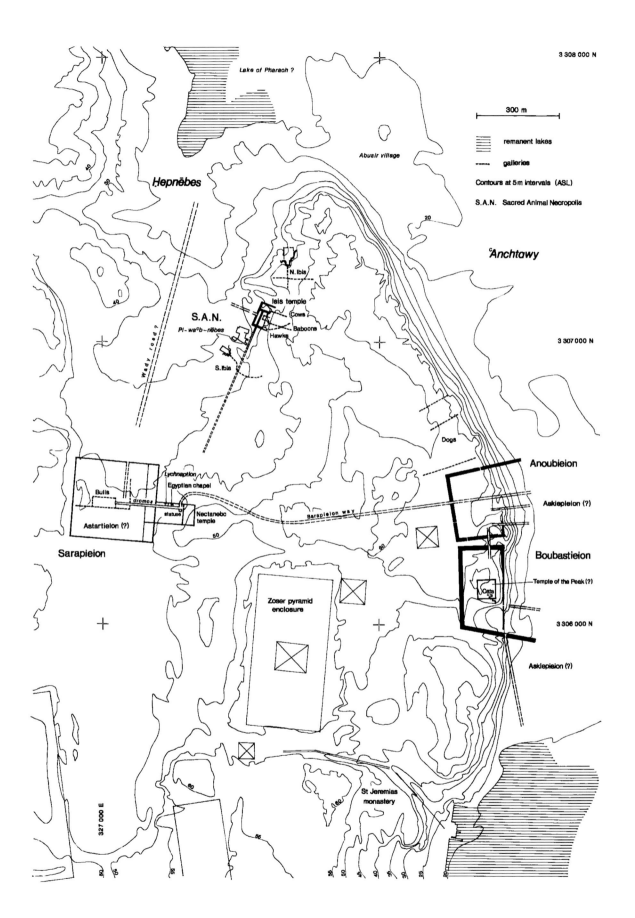

Sector 8

Sector 1

Northern Enclosure

Sector 5

buttress

buttress

Mother of
Apis Gate

Mother of Apis Dromos

Mother of Apis Catacomb

Sector 2

FROM ABUSIR VALLEY ROAD

Main Access Ramp

Main Enclosure Wall

Stair

3 307 100 mN

Precinct D

W Gate

Causeway D

Gate D

Sector 4

Sector 3

Causeway A

Sanctuary A

Vault D complex

Central
Temple Enclosure

Courtyard
A

Vault A complex

Causeway B

Gate B

Sector 6

Causeway C

Baboon
Chapel

Vault B complex

Sanctuary B

Gate C

Baboon
Dromos

Falcon
Precinct

Baboon Catacomb

Falcon
Sanctuary

Baboon
Precinct

S Gate

3 307 050 mN

Falcon
Courtyard

GRID
NORTH

Pillared
Wall

Sector 9

Sector 7

Boundary
Wall

NORTH SAQQARA
THE SACRED ANIMAL NECROPOLIS

Falcon

Catacomb

Rock-cut feature

Stair

Brick feature

Line of escarpment

30 m

Grid references are to UTM Square 36 R UU

Fig. 75. Plan of the Sacred Animal Necropolis (SAN)

Phase I comprises the Twenty-sixth through the Twenty-seventh Dynasty, when sacred animals were being buried in preexisting tomb chambers in the escarpment.[3] The surface structures consisted of Sanctuary A, with Gate D and Precinct D adjoining it to the north, and Gate B and Precinct B (the Baboon Precinct) to the south. The sanctuary and precincts fronted Vaults A–D in the escarpment, where the earliest cow and baboon burials were made. South of Precinct B lay tomb chambers housing falcon burials.

Phase II comprises the first half of the fourth century B.C., when construction began on the Mother of Apis, Baboon, and Falcon Catacombs.[4] To accommodate expansion of the surface structures, a terrace was built against the escarpment. A mud-brick retaining wall was constructed with an entrance left in its west side. This wall (the Main Enclosure Wall) surrounded the Central Temple Enclosure, which continued to be filled throughout Phase II proceeding from east to west, with the buildings following as level surface became available. Sanctuary A was restored, and Courtyard A was added to it on the west. Sanctuary B was built against the south side of Sanctuary A, to the east of Gate B. Gates D and B were rebuilt, and causeways and stairways were constructed in front of them along the north and south flanks of Courtyard A. To the south of Causeway and Gate B, Causeway and Gate C were introduced to provide access to the Baboon Catacomb, and between Gates B and C the Baboon Chapel was built into the thickness of the east Main Enclosure Wall. From Causeway C, the Falcon Causeway ran south to the Falcon Sanctuary, which was constructed in the southeast corner of the Central Temple Enclosure over the entrance to the Falcon Catacomb. A new route was introduced to the site from the south via a causeway that almost certainly led north from the Sarapieion Way; this north-to-south Sacred Way ran across the Central Temple Enclosure to the top of a ramp (not indicated on fig. 75) leading down to the Mother of Apis Catacomb. There is no structural or inscriptional evidence for the end of Phase II, but the defeat of Nectanebo II (r. 360–343 B.C.) by the Persian king Artaxerxes III Ochos in 343 B.C. may have been the historical context for the end of the phase.

Phase III comprises the Macedonian and Ptolemaic periods (332–30 B.C.).[5] This phase witnessed the completion of the filling of the Central Temple Enclosure and its conversion into a single temple terrace, which could be approached from the south via the north-to-south Sacred Way and from the west on a ramp linking the site to the desert valley. A decision was subsequently made to extend the terrace northward; this extension is termed the Northern Enclosure. Few extant structures can be assigned to Phase III, but if the correlation between the end of Phase II and the defeat of Nectanebo II is correct, then it lasted more than three hundred years— from 343 B.C. to at least the end of the Ptolemaic Period in 30 B.C.—during which time, as we know from inscriptional evidence, sacred animals continued to be buried at the site and their cults maintained.[6] The completion of the filling of the Central Temple Enclosure and the construction and

filling of the Northern Enclosure were enormous projects that would not have been undertaken without serious purpose. Given this fact, it appears unlikely that the Ptolemies would have erected no monuments; indeed, if evidence concerning the nature of the fill of the Northern Enclosure has been interpreted correctly (see below), a structure of considerable size may well have once stood there.

Excavations at the SAN from 1964 to 1976[7] recovered more than 1,800 bronzes, comprising 874 statuettes representing anthropomorphic and animal-headed deities, 267 statuettes of sacred animals, 7 statuettes of kings, 12 statuettes of nonroyal offerers, elements from the bodies of statuettes and composite statues, elements from crowns, statuette bases, aegises, offering tables, counterpoises, plaques, staff heads and finials, sistra, and other ritual equipment, including altars, stands, censers, tongs, razors, ladles, skillets, strainers, ewers, jars, basins, dishes, and situlae. Of the deities, there are 486 statuettes of Osiris, 8 Osirian groups, 157 Isis and Harpokrates groups, 88 statuettes of Harpokrates (some from Isis and Harpokrates groups), 24 statuettes of Ptah, 13 each of Anubis and Nefertem, 8 each of Bastet and Amun, 7 of Isis, 6 of Sekhmet, 5 of Min, 3 of composite deities, 3 each of Horus, Thoth, Neith, and Imhotep, 2 each of Khnum, Onuris, Khonsu, Hathor, and a snake-headed god, 1 each of Maat, Bes, Pataikos, and a cow-headed goddess, and 22 others, some of doubtful identity. The animal statuettes comprise 79 Apis and bovid bronzes, 78 shrews, 30 falcons, 30 cats, 21 ibis, 9 lizards or crocodiles, 8 snakes, 3 lions, 3 baboons, 3 dogs or jackals, 2 ichneumons, and 1 monkey. Some of these bronzes have been published, but most have not.[8]

What makes the bronzes so interesting is the fact that most of them were discovered in situ. About 75 percent of the pieces were recovered from caches ranging in size from five to more than two hundred objects.[9] The caches did not always consist of bronzes alone; objects in other materials, usually stone, wood, and faience, were often included. The cached material was, however, almost all votive in character. Most of the caches contained a predominance of one category of object (e.g., statuettes, situlae, or temple equipment), but it is too soon in the study of these works to say whether any correlations can be established between categories of caches and their findspots. The objects were not always in pristine condition, and the presence within the caches of such items as detached elements from crowns and parts of broken statuary shows that damaged objects were deliberately included. Although a full list of the caches cannot be given in this brief discussion, the following observations can be noted.

A number of caches were found inside and outside of the Central Temple Enclosure near the base of the north, west, and south arms of the Main Enclosure Wall.[10] These could have been deposited as early as the beginning of Phase II, when the wall was built. Several caches were discovered in an area of clean sand fill in the Northern Enclosure, which seems likely to have been the foundation of a sanctuary.[11] These must have been

deposited in Phase III. Other caches buried in a fill apparently intended as a foundation for a building came from the area of mastaba 3518, immediately east of the site.[12]

In terms of bronzes, the caches discussed thus far were small compared with some recovered from the east side of the terrace. Of these, the most spectacular came from a pit immediately east of Gate D (fig. 76).[13] This cache, which contained more than one hundred pieces of statuary, the majority of them bronzes, was exceptional in that the contents were packed into wood naoi and appear to have been undamaged when cached. Many of the bronzes were in pristine condition, with their linen wrappings still intact (fig. 77). They were probably cached when Gate D was reconstructed at the beginning of Phase II. It is unclear whether the linen wrappings functioned simply to protect the bronzes or if they were also intended to symbolize mummy bandages. Four other caches came from the vicinity of Precinct D; two, consisting of ritual equipment, were found within the precinct,[14] while one, comprising some two hundred bronzes, appears to

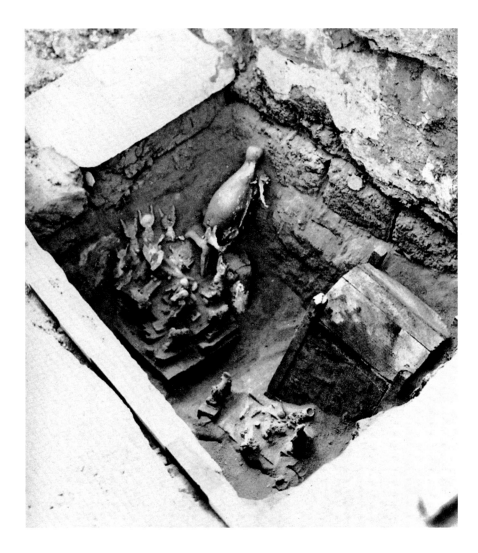

Fig. 76. View of cache found east of Gate D, showing a large wood figure of Osiris, wrapped bronzes, and wood naoi containing other bronzes

Fig. 77. *Isis with Harpokrates* in wrappings, as found in the cache east of Gate D

have been related to the precinct's west wall. These caches may have been deposited at the beginning of Phase II, although they could also date back to Phase I. In Sanctuary A, a cache of some thirty bronzes found beneath the floor of the southeast room was clearly deposited at the beginning of Phase II, when the sanctuary was restored.[15] Two caches came from the vicinity of Gate B; one of them, as indicated by archaeological context, was linked to its reconstruction at the beginning of Phase II.[16] The other cache, comprising more than 130 items, mainly bronzes, was found between the walls of Courtyard A and Stairway B and must have been deposited during Phase II, when the stairway was built.[17] Several caches recovered from the Falcon Precinct[18] appear to have been associated with the Falcon Causeway. In 1995–96, while sand was being cleared from this area for photographic purposes, a huge cache of bronzes was found under the east Main Enclosure Wall. This cache, the largest found at the site to date, comprised some six hundred items, which are currently undergoing restoration and are not included in the totals of bronzes given above.[19]

Large numbers of bronzes, including nearly all the falcon, shrew, lizard, snake, and ichneumon images, were recovered from the Falcon Catacomb, the main concentrations coming from Chambers 4/1 and 4/2 and Galleries 3, 5, 16, 19, and 20 (fig. 78).[20] The material from Chambers 4/1 and 4/2 was

probably deposited near the beginning of Phase II, when the entrance was reconstructed,[21] while the cache of temple equipment from Gallery 16 may have been deposited at the end of the Ptolemaic Period in connection with the termination of the cult.[22] No caches were found in the Mother of Apis and Baboon Catacombs, but this is not surprising, for these were pillaged in antiquity.[23]

Regarding these findings, two basic questions become apparent: why were the caches buried where they were, and why were they deposited at all? Although analyses of findspots and contents cannot reveal the thought processes of those responsible for depositing the caches, some observations emerge that serve to narrow the range of speculation.

First, most of the caches were placed at the level of foundations of buildings, in close proximity to them, or in terrace fills, either immediately before or during construction. They have been interpreted by some scholars as foundation deposits, and, though they do not correspond to the norm for such deposits, it is probable that a portion of the material should be viewed as directly linked to the refurbishment of the cults. The number of pristine bronzes recovered from the pit east of Gate D, for example, suggests that this cache comprised new material buried at a foundation or dedicatory ceremony. A bronze protome from a composite statue of Nectanebo II as a falcon was recovered from Gallery 3 of the Falcon Catacomb,[24] and the bronze falcons, shrews, lizards, and snakes from Chambers 4/1 and 4/2 and Galleries 3 and 5, many of which contained mummified fauna, may have been deposited in connection with the cults of the Nectanebos as falcons.[25] If a political stratum overlay the cult stratum, then consideration of the interplay between the two raises many questions. For example, did the political stratum vary in strength from reign to reign, and did this have a fluctuating effect on the use of bronze as a prestigious medium? Was there a proliferation of those entitled to, desirous of, or able to dedicate bronzes? If so, from which levels of society did they come, and was there an onus on certain groups to contribute such gifts?

Second, in addition to the political stratum, the phenomenon of private votives must be considered. There is ample evidence from the SAN that, beyond the state element, the sacred animal cults were a focus for popular belief across the full spectrum of society, down to its humblest levels.[26] Thus the number of private votives arriving at the site may have been high. Given this fact, the deposition of much of the cached material could be viewed as being dictated by practicalities; the shrines had to be kept clear. The placement of the deposits in foundations and fills may also have been dictated by practical considerations; these areas may have been chosen to safeguard against the caches being subsequently exposed.

Third, there is also evidence suggesting that there were intervals of disruption in the cults, perhaps accompanied by looting and destruction, between the developmental phases.[27] Since the archaeological contexts of certain caches indicate that they may have been deposited either at the very

Fig. 78. *Harpokrates*
(cat. no. 58),
found in the
Falcon Catacomb

end or the very beginning of one of these phases, it is worth bearing in
mind that at least some depositions may have been prompted by necessity.

The presence of damaged bronzes within most of the caches indicates
that these pieces had been dedicated earlier in their history, had fulfilled
their votive purposes, and thus had been discarded when deposited. It
remains to consider what this earlier history may have been. The expertise
needed to manufacture bronzes, together with the costly inlays present on
some works, implies that there was an authorized sphere of production,
either royal or temple workshops. Although the bronzes could have been
manufactured farther afield, it seems more likely that they were made locally.
The means by which they arrived at the SAN probably varied. Visitors may

have carried their votives to the shrines personally, or the offerings may have been taken there by cult personnel direct from the point of purchase. Some bronzes may have reached the site as part of the paraphernalia of festival or funerary processions. Staffs, sistra, and ritual vessels were undoubtedly used on such occasions. Some of the aegises may have come from the prows of sacred barques. A portion of the statuettes may likewise have been mounted on barques, thereby protecting the cult images or mummified animals by establishing a charged, sacred space around them.[28] In this respect, it is interesting to note that, in addition to tangs (see below), at least fifty of the statuettes were equipped with rings or loops placed behind the head and/or on one side of the base.[29] If these bronzes were destined only to stand inside the sanctuaries, it is hard to visualize circumstances in which such attachments would have been useful. If, however, they were mounted on barques, additional means of support would presumably have been necessary to safeguard against accident. A rope or rod passed through the rings would have fulfilled such a purpose admirably.

Once at the site, the statuettes were clearly intended to be mounted for display and/or storage, as the majority were equipped with tangs for insertion into bases.[30] At least eleven bronze bases were registered in the course of excavations,[31] and one limestone base was found preserved with a pair of bronze feet still attached.[32] In more than eighty cases, wood bases, thrones, and sleds were preserved intact with their statuettes.[33] In what manner, where, and for how long the bronzes remained on display or in use is unknown, but there are indications that at least some of the pieces had a long life (see below). The extant shrines at the SAN are of modest dimensions; the internal measurements of the main chamber and southeast room of Sanctuary A are 6.1 x 3.8 and 1.9 x 2.05 meters, respectively, while those of Sanctuary B, the Baboon Chapel, and the Falcon Sanctuary are 3.8 x 6.3, 1.3 x 1.4, and 5.5 x 4.9 meters, respectively. The statuettes themselves are not large; the majority range in height from 3 to 30 centimeters, with just a few pieces between 30 and 45 centimeters. Even so, space must have been at a premium. It is possible that prior or subsequent to being displayed, and pending burial, the items were stored elsewhere, although no extant structures at the SAN point to such a usage. All of the material from any given cache presumably was buried at the same time, but it is impossible to know whether it all came from one sanctuary or whether it represents an accumulation of the contents of several.

A statuette of a king from the cache associated with the west wall of Precinct D can be dated on stylistic grounds to the Kushite Period,[34] and two royal bronzes recovered from Gallery 19 of the Falcon Catacomb can be dated to the Third Intermediate Period.[35] These statuettes thus had a long life prior to being cached. A situla recovered from a cache near the base of the west Main Enclosure Wall can be dated from its inscription to the fortieth year or later of the reign of Psamtik I (664–610 B.C.).[36] If the cache was deposited when the wall was built, at the beginning of Phase II, then this

situla was originally dedicated about 220 years prior to being buried there; moreover, if the dates suggested by Christine Insley Green for two of the other situlae from the same deposit are accepted,[37] it is not unique in this respect. Whether all the bronzes had similarly long lives is unknown. If the total number of bronzes registered between 1964 and 1976 (say 1,800) and the six hundred bronzes from the 1995–96 cache are divided by the number of years that the site is known to have flourished (about six hundred), then about four bronzes were dedicated on average per annum. If they all remained on display or in use for another two hundred or so years, then at any given time some eight hundred bronzes would have been housed in the sanctuaries. Overall, it seems more likely that such long periods of usage were the exception rather than the rule.

Inscriptional clues provide evidence for both the range in social status and the intentions of the donors of the bronzes. It should be remembered that many of these works have never been cleaned, and that most of those in museums have not yet been reexamined. Discussion here is confined to pieces that have been published to date; full publication will certainly swell the numbers of inscribed items and may change the picture.

The Falcon Catacomb yielded twenty-eight inscribed bronzes, including the protome of Nectanebo II,[38] eleven statuettes and bases and one scepter bearing private dedicatory hieroglyphic inscriptions,[39] and fifteen other items of ritual equipment with similar demotic inscriptions.[40] All of these inscriptions, as far as can be ascertained, appear to be of standard types (recitation by X for Y, may X give life to Y, etc.). Only once are titles certainly given; the scepter (FCO-374) is inscribed for a "*wab*-priest of the great souls, scribe of the divine book of the ibis, sacristan of the baboon." Thirty-two inscribed bronzes are recorded as coming from other parts of the SAN; a censer is inscribed in hieroglyphs for the pharaoh Amasis (r. 570–526 B.C.);[41] the other thirty-one pieces comprise a statuette base,[42] an offering-tray,[43] and twenty-nine situlae,[44] all bearing private dedicatory hieroglyphic inscriptions of standard types. Again, only once are titles certainly given; a situla (Insley Green no. 163) is inscribed for a "Chief Royal(?) Steward" and "agent(?)." A wood base that once supported a bronze statuette bears a private dedicatory demotic inscription, again of standard type and with no titles given.[45]

The salient point about the pieces bearing private inscriptions is that in only two cases are titles certainly given, and only one of these titles can be classified as a prestigious office. Thus the idea that such offerings were made principally by highly placed persons to demonstrate their loyalty to the royal cult[46] does not appear to be borne out by the available evidence. Four of the pieces of ritual equipment from the Falcon Catacomb (FCO-336, 359, 371, and 373) were dedicated by women. Of these, two were offered on festive occasions; FCO-336 (an offering or incense stand) was presented by women engaged "in the feast of the writings(?) (of) Taonnofri," and FCO-371 (a skillet) was given by a woman named Tarow "(on) her festival."

It is quite possible that a far greater proportion of the material than has been identified was similarly dedicated in connection with public or private celebrations.

It is unclear whether the bronzes bearing royal inscriptions were given by the king/temple or whether they were offered as private votives. At least some bronzes, presumably, were provided by the authorities, and distinctions must be made between these and private offerings in terms of both the intentions of the dedicators and the purposes the bronzes were intended to fulfill. Royal images would have served as substitutes for the pharaoh in ritual interactions between king and gods. Such interactions were inherently right and natural: a necessary part of the upholding of *maat*, with no overtones of demand or entreaty. The private bronzes, on the other hand, certainly embraced the latter aspects. The inscriptions on them indicate that private offerers sought, through their gifts, access to the gods for the presentation of prayers and wishes. The mechanisms of how the cults operated are obscure, but examples of pleas, complaints, and oracle questions to deities were found among the papyri and ostraca from the site,[47] and it may be that an accompanying votive gift was required.

The question of which types of temple activities the bronzes might have been used for or in is relatively easy to answer with regard to ritual equipment, but less so for statuary. As noted above, the royal statuettes would have acted as substitutes for the king and were clearly understood to possess ritual force. It is probable that private bronzes, having been dedicated at the sanctuaries, were likewise believed to possess such force. This being so, it is worth considering the possibility that this force was seen as something potentially dangerous that had to be managed or channeled. Maybe the pieces had to be buried in order to stop their spiritual charge flowing. Alternatively, as sanctified objects, they may have been regarded as possessing protective or prophylactic properties, two aspects that in the minds of ancient Egyptians may not necessarily have been mutually exclusive.

Although some of the bronzes exhibit magnificent craftsmanship, most were clearly mass-produced. Such art-historical aspects have not been discussed here because the prime importance of these finds, as stressed above, is their archaeological context. The vast majority of bronzes in Egyptian collections have no known findspots, and the SAN bronzes suggest a reason for this. If, in most cases, bronzes were deposited at low levels around and under mud-brick temple sanctuaries and enclosure walls, then they will usually have been unearthed by *sebbakhiin*. More important, the SAN finds confirm the religious, votive, and ritual spheres within which most categories of bronzes played a role, and, once fully published, should provide a sound basis for future interpretation of these fascinating and in some cases beautiful objects.

[*Technical editor's note:* With few exceptions (e.g., cat. no. 58; fig. 78), the cast figures excavated at the Sacred Animal Necropolis at Saqqara have not been subjected to elemental analyses. In this essay, which discusses an extensive corpus of mostly Saite Period or later cupreous-metal statuary found in specific ritual contexts, the term "bronze" has been retained and does not reflect the alloy composition; see the essay "The Manufacture of Metal Statuary" in this volume for terminology and a chronology of the successive introduction of different cupreous metals in Egypt.]

1. I should like to express my thanks to the Committee of the Egypt Exploration Society, London, for allowing me to utilize the material presented in this essay. Thanks are also owed to Dr. D. J. Thompson, Girton College, Cambridge University, for permission to reproduce figure 74.

2. For the archaeological reports on the Main Temple Complex, the Falcon Complex and Catacomb, and the Mother of Apis and Baboon Catacombs, see, respectively, H. Smith et al. 2006, Davies and Smith 2005, and Davies 2006. For the report on the southern part of the site, including the South Ibis Complex and Catacomb, see Martin 1981. The report on the North Ibis Complex and Catacomb will be included in a volume on the bird pots and faunal material currently being prepared by Dr. Paul T. Nicholson and others.

3. For Phase I, see H. Smith et al. 2006, sections 2.2.i, 3; Davies and Smith 2005, section 2.2.i; Davies 2006, section 2.2.i.

4. For Phase II, see H. Smith et al. 2006, sections 2.2.ii, 5–7; Davies and Smith 2005, section 2.2.ii; Davies 2006, section 2.2.ii.

5. For Phase III, see H. Smith et al. 2006, sections 2.2.iii, 8; Davies 2006, section 2.2.iii.

6. The evidence comes from the stelae and graffiti of the priests who authorized the interments of the Mother of Apis cows and the masons who cut the vaults in the catacomb and introduced the burials. The volume devoted to these inscriptions (H. Smith et al. forthcoming) is nearing completion; for a preliminary account of the material, see H. Smith 1992.

7. For the preliminary reports on work conducted at the site from 1964 to 1976, see Emery 1965, 1966, 1967, 1969, 1970, 1971; Martin 1973, 1974; H. Smith 1976; H. Smith and Jeffreys 1977.

8. The bronze objects (excluding coins) recovered from the southern part of the site are published in Martin 1981, p. 18, no. 38, p. 22, no. 66, p. 24, nos. 145–49 and 170–71, p. 25, nos. 188–90 and 217–22, p. 28, nos. 293–96, p. 33, nos. 333–35 and 337–38, p. 40, nos. 354–55, pp. 42–43, nos. 377–81, p. 44, nos. 392–93, p. 45, nos. 437–39, p. 47, no. 442, p. 49, nos. 475–76 and 481, p. 52, no. 494, p. 54, no. 503, p. 55, nos. 532 and 548–49, pp. 59–60, nos. 620–21, p. 64, nos. 754, 757, and 761–64, p. 67, no. 862, p. 74, no. 901, p. 93, nos. 1112–17, p. 94, nos. 1135–47, p. 106, nos. 1489–1502. For the temple furniture and ritual equipment found at the site, see Insley Green 1987. The bronzes recovered from the Falcon Catacomb are published in Davies and Smith 2005, section 6.2, and the few recovered from the Mother of Apis and Baboon Catacombs in Davies 2006, sections 5.2 and 5.3, respectively. For royal statuettes (including three on censer shafts), see Hill 2004, p. 165, no. 29, pp. 167–68, no. 33, pp. 188–89, nos. 98–100, pp. 189–90, no. 105, pp. 193–94, no. 121, pp. 212–13, nos. 195–96. A volume devoted to the statuettes is projected.

9. It is intended that an in-depth study of the caches should be included in the projected catalogue of bronzes (see n. 8).

10. Emery 1969, pp. 31–32, pls. VI.1, 3, 5, 7, VII.1–4; H. Smith and Jeffreys 1977, p. 25.

11. H. Smith et al. 2006, sections 8.5.iii, 8.6.iii, 8.7; see also Emery 1967, p. 143.

12. Martin 1974, p. 25.

13. Cache 2, 1968–69 season; H. Smith et al. 2006, section 5.3.ii; see also Emery 1970, p. 6, pls. IV–IX (though not all the bronzes shown on these plates necessarily came from this cache, despite Emery's statements).

14. Emery 1970, p. 7; Emery 1971, p. 9.

15. Cache 2, 1974–75 season; H. Smith et al. 2006, section 3.1 with n. 9, 4.4.iii; see also H. Smith 1976, pp. 16–17, pls. V.4, VI.1–2.

16. Cache 1, 1974–75 season; H. Smith et al. 2006, sections 4.4.ii, 5.4.ii; see also H. Smith 1976, p. 16, pl. V.2.

17. Cache 1, 1968–69 season; H. Smith et al. 2006, sections 4.4.i, 6.2.

18. Emery 1971, p. 4.

19. For the preliminary report on this find, see Nicholson and Smith 1996a, pp. 9, 11, pl. I.1–2; see also Nicholson and Smith 1996b; Nicholson 2004.

20. See n. 8 above for the publication of the bronzes recovered from the Falcon

Catacomb; see also Emery 1971, pp. 5–8, figs. 1, 2, pls. V.3, VII–X.

21. Davies and Smith 2005, sections 3.1.i, 3.2.i.

22. Cache 9, 1969–70 season; Davies and Smith 2005, sections 3.1.iii, 3.2.iv; see also Emery 1971, p. 6, figs. 1, 2, pls. V.3, VII.1.

23. See n. 8 above for the publication of the few bronzes recovered from the Mother of Apis and Baboon Catacombs.

24. Davies and Smith 2005, section 6.2, FCO-170; Hill 2004, pp. 167–68, no. 33.

25. For the cults of Nectanebo I and Nectanebo II as falcons, see De Meulenaere 1960. For the bronzes containing faunal material, see Davies and Smith 2005, section 4.3.

26. Davies and Smith 1997, pp. 122–24.

27. H. Smith et al. 2006, sections 4, 8.7.

28. For a brief discussion of this, see Hill 2004, p. 139.

29. For examples, see Davies and Smith 2005, section 6.2, FCO-52, 111, 113, 117, 184, 208, 217, 254, 271, 277, 282, 442, 444, 452(?), 465, 467, 476.

30. For examples, see Davies and Smith 2005, section 6.2, FCO-17, 50, 52–54, 56, 85–86, 89, 90, 93, 96, 104, 105, 108, 110–16, 144, 169, 171–75, 178–79, 185, 213–15, 217–20, 230, 243, 258, 261–62, 264–67, 269–74, 276, 278–80, 284–85, 288, 290–91, 293, 296, 307, 308, 318, 323, 423, 430, 441, 443, 445, 447–48, 450, 454, 456, 458, 461, 463–64, 466–68, 470, 490–91, 514, 543.

31. Three examples came from the Falcon Catacomb; Davies and Smith 2005, section 6.2, FCO-313, 427, 474. See also Martin 1981, p. 25, no. 217.

32. H5-1590 [3419] (unpublished).

33. None of these intact assemblages came from the Falcon Catacomb; see, however, Emery 1969, pl. VIII.5, 6; Emery 1970,

pls. VIII.2, 4, IX.3. For examples of wood bases and thrones that once supported bronze statuettes, see Hastings 1997, pp. 57–59 (Section F).

34. Hill 2004, pp. 193–94, no. 121.

35. Davies and Smith 2005, section 6.2, FCO-258, 318 (Hill 2004, pp. 188–89, nos. 99, 98, respectively).

36. Insley Green 1987, p. 69, no. 165, figs. 100–101.

37. Ibid., pp. 69–70, no. 166, fig. 102 (dated tentatively to the sixth century B.C.), p. 71, no. 168, fig. 103 (dated to the sixth century B.C.).

38. See n. 24 above.

39. Davies and Smith 2005, section 6.2, FCO-99, 146–47, 164–65, 261, 278, 443, 462 (statuettes); FCO-313, 474 (bases); FCO-374 (scepter).

40. Davies and Smith 2005, section 6.2, FCO-336–37, 354, 359–61, 365, 368–73, 394, 400. Professor J. D. Ray's edition of these inscriptions is forthcoming, and the translations given in Davies and Smith 2005 are those proposed by Ray.

41. Insley Green 1987, p. 38, no. 82, figs. 57, 58; see also Emery 1971, pl. X.4.

42. Martin 1981, p. 25, no. 217.

43. Insley Green 1987, p. 117, no. 452.

44. Ibid., pp. 66–74, nos. 163–69, 172, 174, with figs. 99–103, 105; pp. 76–80, nos. 178, 180–81, 183, with figs. 107–10; pp. 85–87, nos. 188–89, 192–94, with figs. 113–16; pp. 88–90, nos. 198, 202, with fig. 118; pp. 95–97, nos. 234, 245, with fig. 124; pp. 101–3, nos. 273–79.

45. Hastings 1997, p. 58, no. 206. The translation of the inscription given there is incorrect, but the argument is unaffected.

46. Kessler 1989, pp. 143–49, 299–303.

47. For a preliminary account of these, see H. Smith 2002.

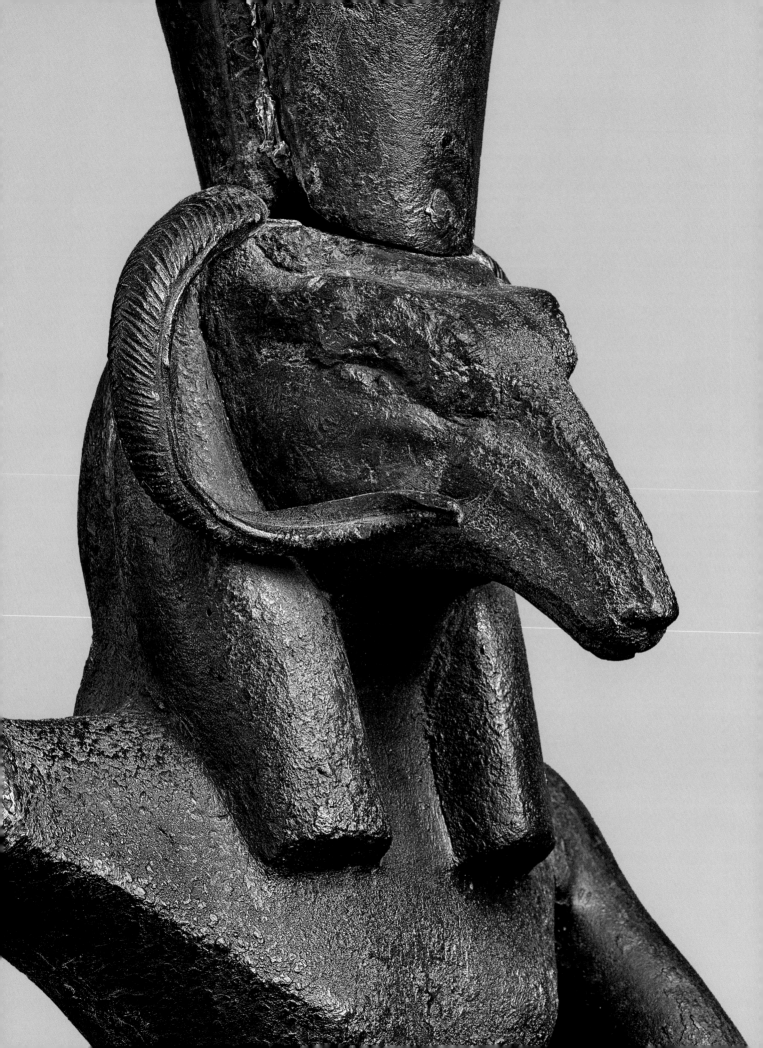

THE MANUFACTURE OF METAL STATUARY: "SEEING THE WORKSHOPS OF THE TEMPLE"[1]

Deborah Schorsch

Each of the individual works populating the corpus of ancient Egyptian metal statuary calls attention to its material nature, to peculiarities of its manufacture, and to its physical history. Technical examination informs our understanding of each statue and statuette as a unique entity, created in a medium chosen with forethought, requiring for its manufacture and embellishment a complex sequence of processes involving multiple steps, all necessitating decisions on the part of the maker. Also evident in the physical record are signs of how these meticulously produced works have been altered intentionally, by chance, or systematically as a result of environmental conditions. These insights complement and sometimes contextualize observations and judgments concerning style, date, iconography, and function.

In the following essay, the relatively uncommon term "cupreous metal" has generally been used to refer collectively to unalloyed copper and to copper alloys, while in the catalogue texts and the checklist that follow, individual works of unknown composition are described as "copper alloy," even though they may, in fact, be unalloyed copper that contains only small amounts of natural impurities. "Precious metal" is used to describe all gold, silver, or electrum inlays and cladding that have not been analyzed.[2] As with all designations concerning composition and manufacture, the goal here is to avoid ambiguities by clearly distinguishing information that has been obtained by informed examination and analyses from assumptions or approximations that may appear in museum records and publications.

With the notable exception of a Sixth Dynasty group of unalloyed copper figures from Hierakonpolis, comprising two large striding kings and a falcon with a gold head (see fig. 3),[3] virtually all surviving metal figural statuary from ancient Egypt was produced by casting. The lost-wax process was used to create both solid and hollow statuary, and most hollow figures

Fig. 79. Detail of *Seth* (cat. no. 13; see pp. 34–37)

also have solid components, either integrally cast or joined mechanically (fig. 80). The ability of metals, when molten, to take any form, and, when solidified, to seemingly defy gravity, afforded certain freedoms—such as opening up negative spaces and allowing limbs to extend unsupported—that were readily exploited by ancient metalworkers. In this regard, sculptors working in stone and even wood were far more limited.

Cupreous Metals

Among the metals employed in ancient Egypt to serve utilitarian and ritual needs, the most important were copper, tin, and lead, and the precious metals, gold and silver. Although elemental analyses of copper-based metalwork date back well into the nineteenth century, and much data for statuary has been collected more recently,[4] methodologies for integrating analytical results with the insights of art-historical, archaeological, and other scholarly disciplines remain undeveloped.[5] Still, compositional data, usually in conjunction with other forms of technical analysis, can elucidate ancient metalworking practices by identifying alloys that were chosen either for their superior working properties or to satisfy ritual or aesthetic requirements. For example, compositional analysis can be useful in reconstructing coloristic schemes by establishing the inherent colors of different metals and alloys and by confirming the use of artificially patinated surfaces. In addition, by suggesting what is an intentional rather than an unintentional alloying or recycling of metal, compositional data provide further indices as to the level of sophistication, or lack thereof, attained by the workshop. These determinations are not independent of notions of dating and provenience, which can be expanded as more analytical programs are directed toward securely dated and/or excavated works.

By the same token, the possibility of establishing correlations among statuary type, quality, manufacture, and composition deserves consideration in the future. Furthermore, composition often plays a role in identifying modern forgeries and pastiches[6] and in helping scholars to recognize common or disparate origins for traditionally associated elements (see cat. no. 13; pp. 34–37; see also fig. 79) or works.

A succession of cupreous metals, beginning with unalloyed copper and progressing to arsenical copper, bronze (copper-tin alloys), and leaded bronze, were introduced in ancient Egypt over a period of several millennia.[7] The more or less occasional use of unalloyed copper and earlier alloys

Fig. 80. X-ray radiograph of *King Osorkon I* (cat. no. 17), showing hollow cavity (a) and solid-cast arms attached mechanically using mortise-and-tenon joins (b)

that continued for centuries after new alloying systems had been adopted, as well as the paucity of works securely attributed to earlier periods, makes it difficult to establish a strict chronology for these developments. Unalloyed copper, employed during the Old Kingdom for the hammered-sheet royal figures and the associated falcon body from Hierakonpolis,[8] was in frequent use in the Middle Kingdom[9] and occasionally for New Kingdom works, such as the milling shawabti of Siese (cat. no. 11; figs. 15, 16) and the figure of Seth dated to the Ramesside period (cat. no. 13).[10] Utilitarian objects made from arsenical copper—an alloy containing more than 1 percent arsenic[11] derived from either arsenic-copper ores or the co-smelting of copper and arsenic ores—and even bronze had already appeared in Egypt during the Old Kingdom,[12] with greater and lesser frequency, respectively, and were produced in yet greater numbers in the First Intermediate to Middle Kingdom periods.[13] Arsenical copper was probably used for statuary in the later Old Kingdom or First Intermediate Period (cat. no. 4; fig. 8) and certainly in the Middle Kingdom (cat. nos. 2, 3; figs. 2, 6, 7), but it can also be cited for the New Kingdom.[14] Bronze statuary appears no later than the late Middle Kingdom[15] and predominated by the New Kingdom (cat. nos. 8, 9; figs. 1, 12). A handful of leaded-bronze alloys can be dated to the Middle and New Kingdoms.[16] In the Third Intermediate Period, leaded-bronze statuary (cat. nos. 18 [fig. 60], 34 [pp. 106–7]) appears with greater frequency and, over the course of the first millennium B.C., with increasingly significant amounts of lead.[17] The kneeling figure of King Pami (cat. no. 22; figs. 28, 29), which contains about 25 percent lead, is dated to the first half of the eighth century B.C. and can be cited as a precocious example; other unusual formulations, such as a heavily leaded arsenical copper used for a statue dating to the Twenty-second Dynasty (cat. no. 29; fig. 31), fall outside currently defined patterns of production. As noted earlier, far too little securely dated statuary has been analyzed, and future research may well show that composition correlates more readily to statuary type, style of manufacture, or origin than has been recognized to date.

Cupreous alloys of a type known as "black copper" or, more commonly, "black bronze"—*ḥmty km* in ancient Egyptian[18]—which by virtue of an intentional addition of several percent gold can be treated chemically to produce a lustrous black surface (cat. nos. 8, 16; figs. 1, 11, 20), first appeared in Egypt in the late Middle Kingdom. Characterization of the alloy and a probable mechanism for the artificial patination process have been made possible, in part, by technical studies of *shakudo*, an analogous Japanese material. *Shakudo* is one of several copper-based formulations treated using traditional chemical processes, collectively known as *nikomi-chakushoku*, to produce artificial patination layers in a nuanced range of colors.[19] The Egyptians probably produced other patinated metals with compositions and surface colorations analogous to some of these other artificially patinated Japanese alloys.[20] Yet many ancient cupreous-metal artifacts, regardless of their original appearance, now have black surfaces resulting from

Fig. 81. X-ray radiograph of *Sphinx Standard* (cat. no. 34), showing hollow cavity (a) and locations of rectangular-section iron core supports (b)

cleaning and/or repatination procedures (cat. no. 18; fig. 60) or subsequent exposure to specific environmental conditions, underscoring the role of careful visual examination, scrutiny of early documentation, and, not least, elemental analyses in the characterization of manufacturing processes.

Casting Technologies

Old Kingdom cupreous-metal statuary, either cast or made from hammered sheet, is quite rare. The earliest surviving cast figures, which as a rule are solid, are representations of nonroyal males that can be attributed to the late Old Kingdom or the First Intermediate Period. The earliest datable hollow examples appeared only in the late Middle Kingdom and tend to be larger. Although hollow casting was a technical refinement that produced casts more economically, works later in date and of substantial size often are solid (cat. no. 23; pp. 92–94), while relatively small figures, surprisingly, may be hollow (cat. nos. 32, 34; figs. 34, 81). Irrespective of date, whether a piece of statuary is hollow or solid is not necessarily clear from its size or heft. The trained eye can discern much information relating to manufacture during an optical examination, but radiography, which allows the investigator to peer inside a statue, is certainly the most important technique employed in the study of ancient casting technology. If a figure does prove to be hollow, there are many features to be considered. It is possible, for example, to see the size and shape of the core cavity and to recognize multiple cavities; to gauge the thickness and relative evenness of the metal walls; and to note the location and shape of core supports or internal armatures. On both solid and hollow figures, separately cast elements such as

limbs and attributes as well as the type of joins used to attach them can be detected in radiographic images. Internal porosity (cat. nos. 13 [pp. 34–37], 15 [fig. 25]; see also fig. 88) and other casting flaws reflect some combination of factors that may include elemental composition, the preparation of core and investment, and general casting practices.

The presence of iron core supports and armatures serves as a tool for dating uninscribed statuary, as iron was not used for these purposes prior to the Third Intermediate Period. Rectangular iron core supports that have been detected in the walls of a sphinx standard (cat. no. 34; fig. 81) and two representations of priests (cat. nos. 28, 32; figs. 30, 34) are a significant factor, along with composition, in the current assignment of post–New Kingdom dates to these works. An indicator for an earlier date is irregularity in the shape and size of tangs on the underside of the figures (cat. nos. 8, 14; figs. 1, 17),[21] which took on a canonical form—rectangular in section, with a flat end— sometime after the New Kingdom.[22]

Taken as a whole, the technological features revealed during radiographic examination also contribute to our current understanding of the individualized nature of Egyptian castings. Although Günther Roeder brought years of careful observation to his pioneering articles and volumes on Egyptian bronzes, his views regarding the use of plaster molds to produce wax models of figural components in order to cast replicas, much influenced by contemporary theories of classical bronze casting, are questionable.[23] Limited to surface examination, Roeder was free to interpret features to suit his theories; recognizing in some instances that channels cut into the sides of various figures were designed to anchor precious-metal sheet, he insisted that in other cases they represent mold lines,[24] a feature that would establish the use of an indirect casting method and the potential to produce replicas.[25] Thus far, when cast-metal "identical siblings" purported to be of ancient Egyptian manufacture have been subjected to close scrutiny, one or both have proved to be fakes.[26] Furthermore, no reliable technical evidence identifying any solid or hollow statuary as the product of an indirect process has been found,[27] although visual cues indicate that replicas or versions may have been cast in Egypt under the rule of the Greek Ptolemies. Technical examination, and in particular radiography, of two seemingly identical Ptolemaic royal figures and their accompanying goddesses (cat. nos. 52–55; figs. 82–85) could provide insight into possible changes in local foundry practices introduced through the influence of Greek craftsmen, which might include the indirect lost-wax method.

Precious Metals
Most of the gold that was available to ancient metalworkers naturally contains greater or lesser amounts of silver, whereas the copper that has been detected in individual works was, as a rule, added intentionally.[28] When gold appears pale or silvery, it is often called electrum.[29] Jewelry made from a copper-rich gold alloy with a distinctive red color appears occasionally

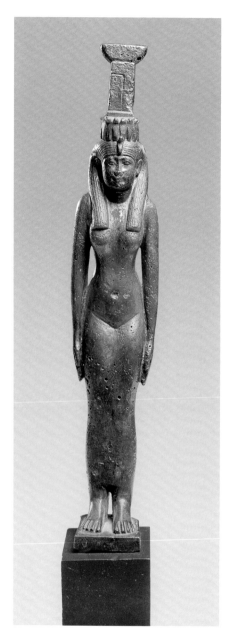
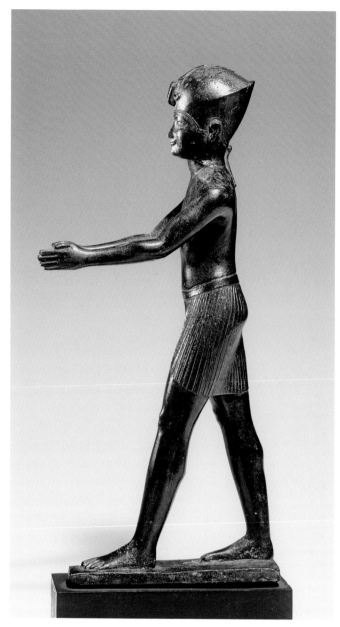

during the reign of Akhenaten (ca. 1352–1336 B.C.)[30] and later as an inlay in cupreous statuary (cat. no. 21; pp. 90–91).[31] Much Egyptian silver predating the New Kingdom contains varying amounts of gold and copper; the latter is an intentional addition, while the origin of the gold is unclear.[32] By convention, these alloys are labeled "silver," as are the silver-copper alloys made using silver smelted from imported argentiferous galena that were more common in later times; however, the term "auriferous silver" appears in the checklist below to describe silver that is particularly rich in gold (cat. nos. 16, 50 [figs. 11, 20, 86]).

Figs. 82, 83. *Nephthys* (cat. no. 52); *King* (cat. no. 53)

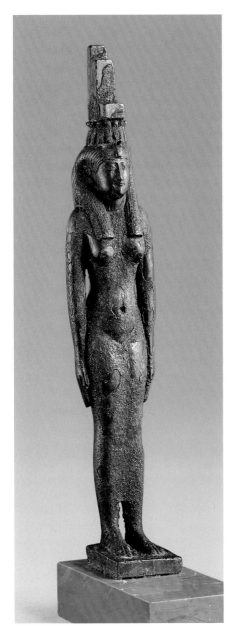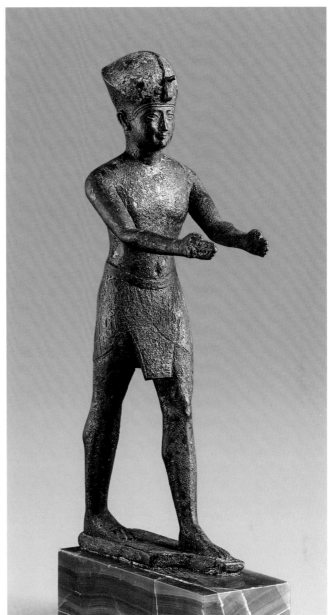

Figs. 84, 85. *Isis*
(cat. no. 54); *King*
(cat. no. 55)

Surface Decoration

Within the last few years, scholars have increasingly come to realize that metal polychromy was an important medium for decorative, symbolic, and naturalistic ends in various ancient Old World contexts, including Egypt.[33] For example, the decorative scheme on a Bes–image (cat. no. 50; fig. 86), noteworthy for details of its dress and an unusual inscription, incorporates at least seven distinct metallic hues derived from the use of a wide variety of metals: gold and electrum (?), including an auriferous silver containing approximately 34 percent gold, and unleaded and leaded cupreous alloys with tin contents ranging from approximately 2 to more than 25 percent.

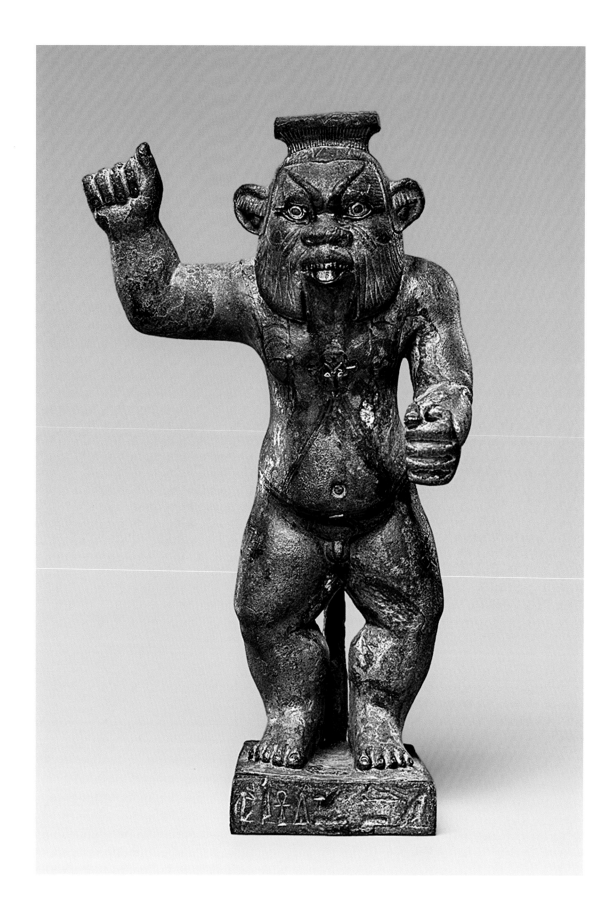

The missing crown ornament may have contributed yet another color. Finishing and surface articulation contribute significantly to the visual impact of metal statuary, on which embellishment was often applied with jewel-like refinement and a miniaturist's attention to detail. In addition to polishing and burnishing carried out to produce lustrous and reflective surfaces, formal details and variations in texture were introduced by scoring and punching executed in the wax model (cat. no. 23; pp. 92–94)—or, in the case of precious metals, on the surface itself (cat. no. 19; pp. 84–89)—and by selectively applying gold, silver, and electrum leaf, sheet, and foil, as well as inlays of various metals, semiprecious and other types of stone, faience, glass (cat. no. 65; fig. 62), and ivory. The use of color in the patterning of the apron on the torso fragment of King Pedubaste (cat. no. 21; pp. 90–91)—where differences in the size and number of chevrons on either side of the garment and the lack of alignment in the alternating blocks of yellow and copper-rich red gold evoke the sensation of movement—contributes to the dynamism of the figure's pose, which is expressed formally by the slight twist of the body and an implicit shift in weight as it strides forward. In a similar but more explicit way, color animates the surface of the *menit* roundel of Harsiese (cat. no. 33; pp. 104–5), on which wedge-shaped inlays of gold, silver, and probably copper circle in alternation with gold rosettes, straining centripetally against the rim.[34]

Alterations and Damage

Ancient alterations, intentional and accidental damage, and subsequent repairs sometimes provide information relating to how a specific work, or statuary in general, functioned in its ritual environment, both initially and over time. The impetus for alteration was often political. Just as the Seth figure (cat. no. 13) was modified probably after the end of the Ramesside dynasty as that god fell from grace, exclusively Kushite regalia on many royal figures that were reused by later kings (cat. nos. 23 [pp. 92–94], 24 [fig. 66]) were intentionally altered or erased. Furthermore, characteristic damages to the forearms and tangs of many royal figures (cat. nos. 24, 47; figs. 66, 55) give evidence of their having been removed from their bases in ancient times using brute force. Although occasionally the work of ancient thieving hands can be recognized,[35] in other cases losses can be attributed to modern greed. On the gold statuette of Amun (cat. no. 19; pp. 84–89), for example, the feather crown and sun disk, loop, and base were cut or wrenched off and then probably melted down to be sold separately, leaving the figure in an impoverished but nonetheless salable condition.

Opposite:
Fig. 86. *Bes-image of the God Horus-Ashakhet* (cat. no. 50)

1. This mention of the royal workshops in the temple of Amun at Karnak, from the tomb chapel of Mery, a high priest of Amun during the reign of Amenhotep III, appears in Giumlia-Mair and Quirke 1997, p. 104.

2. Three of the five "precious-metal" objects (cat. nos. 51, 62, 63) are of unknown composition and are described as silver or gold on the basis of their visual appearance.

3. Eckmann and Shafik 2005, pp. 29–32, 61–65. See discussion in "Charting Metal Statuary" in this volume, esp. pp. 8–9.

4. Riederer 1978, 1982, 1983, 1984, 1988.

5. This is true even when practical issues related to the acquisition of valid data are temporarily disregarded.

6. Schorsch 1988a, 1988b.

7. Examples of ancient Egyptian cast brass statuary are not reported, but such work may have been produced after the Roman conquest in 30 B.C.

8. Rehren 2005, pp. 72–73.

9. Schoske 1988, n. 17; Schoske 1992.

10. Old analyses (see Clayton 1972, p. 174) that identify shawabtis of the scribe Ani (British Museum, London, 32692) and Ramesses II (Ägyptisches Museum und Papyrussammlung, Berlin, 2502) as unalloyed copper certainly warrant revisiting; see n. 16.

11. Cowell 1987, pp. 97–98. This threshold for evaluating accidental versus intentional arsenical-copper alloys was established by Craddock (1976, p. 98) with respect to Greek Bronze Age metalwork. The data derive primarily from utilitarian artifacts, but 1 percent also seems appropriate for statuary, for which deoxidization of the melt is of more significance than the hardness of the final product. See, for example, Schorsch 1994, p. 114, for a group of what must be considered unalloyed-copper statuettes from Lebanon with arsenic contents clustered within a range from 0.3 to 1.0 percent.

12. The presence of at least 4 percent tin is suggested by Cowell (1987, pp. 98–99) as indicative of an intentional addition, with smaller amounts, particularly in combination with arsenic, also having an effect on working properties of the melt. Again (see n. 11 above), the hardness of an alloy is less significant when it is used for statuary. A number of Third Intermediate Period statues with alloys containing less than 4 percent tin can be cited (cat. nos. 17, 18, 21), although these do not consistently contain

intentional additions of arsenic; see also Ogden 2000, pp. 153–54.

13. Cowell 1987, p. 99.

14. For example, a figure of Baal/Reshef in the Roemer- und Pelizaeus-Museum, Hildesheim (RPM 46); see also discussion of the statue of the god Seth (cat. no. 13), pp. 34–37, esp. n. 9.

15. The known compositions of various late Middle Kingdom figures said to be from the Fayum are diverse; for example, the two figures cited above in n. 9 are unalloyed copper, while the vizier in the Louvre (E 27155) is bronze (Delange 1987, pp. 211–13) and the crocodile in the Staatliches Museum Ägyptischer Kunst München (ÄS 6080) and one of the royal figures in the Ortiz collection are both "black bronzes" (Giumlia-Mair 1996).

16. There is a leaded-bronze cylinder seal of the early Middle Kingdom king Mentuhotep II in the Louvre (Vandier 1968, p. 105, n. 28); the attribution of a leaded-bronze seated female figure, also in the Louvre (Delange 1987, pp. 176–77), to the Second Intermediate Period has been questioned (Vassilika 1997, p. 297, n. 11; Hill 2004, p. 11, n. 18). See Craddock 1985 (table I1, 33938) for an analysis of a New Kingdom leaded-bronze shawabti in the British Museum, superseding data published by Clayton (1972, p. 174), as well as several pre–Third Intermediate Period bronze tools that contain varying amounts of lead (tables H1 and I1). According to Craddock (1985, pp. 61–62), up to 2 percent lead significantly improves the mobility of molten copper, so that even a relatively small amount of lead might be an intentional addition. Craddock adds that increasing the lead content will lower the melting point of an alloy and increase the ease with which a finished cast can be cold-worked. Using lead will also reduce the costs of raw materials and fuel.

17. For example, Riederer (1983, p. 11; 1984, p. 9) reports lead percentages up to 32–33 percent, which falls just short of the miscibility limit of lead in molten copper (ca. 36 percent). Most of the nearly one thousand Egyptian cupreous-metal statues Riederer analyzed have not been rigorously studied in terms of either style or manufacture, but a large portion probably can be attributed to the Late or Ptolemaic Periods.

18. Giumlia-Mair and Craddock 1993. When analyzed, most of these alloys have proved

to be bronze (e.g., cat. nos. 8, 9), although exceptions can be cited (cat. no. 15). For a philological point of view, see Giumlia-Mair and Quirke 1997.

19. Murakami 1993.

20. La Niece et al. 2002; see also the essay by Élisabeth Delange in this volume.

21. Hill and Schorsch 1997, fig. 11.

22. The majority of the figures illustrated in this catalogue have such canonical tangs that are hidden from view by their bases; typical tangs of the later type can be seen, for example, on several statues of Amun in Roeder 1956, pls. 7, 8.

23. For example, Roeder 1937, §§591–93, and Roeder 1956, §704.

24. Roeder 1937, §588a.

25. Useful definitions of "replica," "version," and "copy" can be found on the Getty Research Institute's *Art and Architecture Thesaurus® Online*.

26. Schorsch 1988b, figs. 1, 2; Schorsch and Frantz 1997–98, p. 19.

27. Taylor et al. 1998.

28. Stós-Fertner and Gale 1979, p. 306; Gale and Stós-Gale 1981, p. 107.

29. Use of this term varies with point of view. The designation of electrum as a naturally occurring gold alloy containing more than 20 percent silver, proposed by Pliny and adhered to by Lucas (1962, p. 34), serves for the purposes of this catalogue, including the technical descriptions for all works of art. See, however, the essay by Élisabeth Delange in this volume, n. 5.

30. Schorsch 2001, p. 68.

31. However, most cases of red coloration observed on Egyptian gold are superficial and unintentional; see Frantz and Schorsch 1990.

32. Whether or not such mixtures, and also particularly silver-rich electrums, reflect natural or intentional alloys remains unresolved. It has been argued—most recently from a geological point of view in Rehren et al. 1996—that auriferous-silver alloys must be the result of recycling; see also Mishara and Meyers 1974 and Gale and Stós-Gale 1981, pp. 108–9 (using the term "aurian silver").

33. For Egypt, see Delange 1998; Griffin 2000; Schorsch 2001; La Niece et al. 2002.

34. Hill and Schorsch 2005, pp. 183–86; in fact, the composition of these metal inlays is not known. The *menit* itself was analyzed nearly thirty years ago (Riederer 1978, no. 105), at a time when one did not routinely look for gold in ancient cupreous metals because the connection between gold content and "black bronze" had not yet been established; it is not known whether or not the *menit* was artificially patinated in antiquity.

35. On the back of the seated silver figure of a falcon-headed god now in the Miho Museum, Shigaraki, Japan (see Catharine H. Roehrig, "Cult Figure of a Falcon-Headed Deity," in *Shumei Family Collection* 1996, pp. 4–7, no. 2), a blunt instrument was used presumably to determine whether or not the figure was made of solid gold. Disappointed on this score, the ancient thieves removed the thick gold sheet that originally clad the figure.

WORKS IN THE EXHIBITION

Works marked with an asterisk (*) are discussed in separate catalogue entries. Dimensions are abbreviated as follows: height (H.), width (W.), depth (D.), length (L.), diameter (Diam.), and thickness (Th.). Height measurements of statues do not include tangs; tang measurements are provided only when they relate to chronological issues discussed in the text. Heights of bases are given separately. Inscriptions are given in full only if they are not discussed in the text or referred to in cited publications. For works in the collection of The Metropolitan Museum of Art, unpublished inscriptions are recorded in hieroglyphic transcriptions or drawings.

Standards for technological descriptions are discussed in an essay by Deborah Schorsch in this volume (pp. 188–99). The year in which unpublished analyses or other instrumental examinations were undertaken is given in parentheses. Superscript letters refer to the analytical procedure used and to the institution where it was performed; a complete list of these is provided at the end of the checklist.

1. Censer Lid with Prostrate King Senwosret [I]

Middle Kingdom, 12th Dynasty, reign of Senwosret I (ca. 1961–1917 B.C.)
Copper alloy, solid cast figure with separate base
Overall L. 7.3 cm (2⅞ in.); figure: L. 6.3 cm (2½ in.), H. 1.9 cm (¾ in.), W. 4.2 cm (1⅝ in.)
Egyptian Museum, Cairo (JE 35687)

Provenance: Deir el–Ballas
Selected References: Fischer 1956; Lacovara 1981, p. 120; Hill 2004, pp. 15, 187, no. 95

2. Princess Sobeknakht Nursing Her Son

Middle Kingdom, mid- to late 13th Dynasty (ca. 1750–1650 B.C.)
Arsenical copper (2006[a]), solid cast (2005[b])

H. 10.2 cm (4 in.), W. 7 cm (2¾ in.), D. 8.3 cm (3¼ in.)
Brooklyn Museum, New York; Charles Edwin Wilbour Fund (43.137)

Provenance: unknown; Borelli Bey (?) and Alphonse Kann collections, before 1927; acquired in 1943
Selected References: Romano 1992; James Romano in Capel and Markoe 1996, pp. 60–61, no. 9; Málek 1999, no. 801–495–070

3. Isis Nursing Horus (?)

Middle Kingdom, late 12th–13th Dynasty (ca. 1878–1650 B.C.)
Arsenical copper (1978[c]), solid cast, with separate, partially hollow–cast Horus figure and separate base (1989[d])
H. of female figure 12.2 cm (4¾ in.); base: D. 13.2 cm (5¼ in.), W. 8.2 cm (3¼ in.)
Ägyptisches Museum und Papyrussammlung, Staatliche Museen zu Berlin (14078)

Provenance: unknown; acquired in 1897
Selected References: Romano 1992, pp. 138–42, pl. 30/2; Málek 1999, no. 801–495–049

4. Striding Man

Old Kingdom, 6th Dynasty, reign of Pepi II–early 12th Dynasty (ca. 2246–1917 B.C.)
Arsenical copper (2007[a]), solid cast (1999[f])
H. 15 cm (5⅞ in.), W. 4.5 cm (1¾ in.), D. 6.2 cm (2½ in.)
The Walters Art Museum, Baltimore (54.407)

Provenance: unknown, said to have been found "at the pyramids"; acquired in 1924
Selected Reference: Steindorff 1946, p. 39, no. 99, pl. 16

5. Treasurer Nakht

Middle Kingdom, second half of 12th Dynasty
(ca. 1887–1802 B.C.)
Copper alloy, solid cast
H. above base 10 cm (4 in.), W. 3.2 cm (1¼ in.),
D. 4.4 cm (1¾ in.)
Egyptian Museum, Cairo (CG 433)

Provenance: Meir
Selected References: Borchardt 1911–36, vol. 2,
p. 39, pl. 71; von Bissing 1913, p. 244, pl. XI/2;
Porter and Moss 1934, p. 257; Grajetzki 2001, p. 79

6. Amenemhab with Lotus, Offered by His Father, Djehuti

New Kingdom, early 18th Dynasty
(ca. 1550–1479 B.C.)
Bronze (1990[a]), solid cast (2007[b]); separate silver
lotus (1990[a]); wood base with pigmented inlays
H. 13 cm (5⅛ in.); base: H. 2.5 cm (1 in.),
W. 4.9 cm (1⅞ in.), D. 9 cm (3½ in.)
The Metropolitan Museum of Art, New York; Pur-
chase, Edward S. Harkness Gift, 1926 (26.7.1413)

Provenance: Thebes, Lower Asasif; Carter-Carnarvon
excavations, 1910–11; Carnarvon collection;
acquired with Carnarvon collection in 1926
Selected References: Carnarvon and Carter 1912,
pp. 74–75, frontis., pl. 67; Porter and Moss 1964,
p. 616; Roehrig 2005, pp. 41–43, no. 19 (alloy
corrected above)

7. Hepu*

New Kingdom, early 18th Dynasty
(ca. 1550–1479 B.C.)
Copper alloy, solid cast, with hammered staff;
silver/electrum (?) attribute in right hand (see von
Bissing 1913, p. 241, n. 1); hammered copper-alloy
sheet over wood base
H. of statuette above base 14.5 cm (5¾ in.);
base: H. 3.8 cm (1½ in.), W. 6.7 cm (2⅝ in.),
D. 12.7 cm (5 in.)
National Archaeological Museum, Athens (3365)

For provenance, and selected references, see
catalogue entry (pp. 18–21).

8. King Thutmose III

New Kingdom, 18th Dynasty, reign of Thutmose III
(ca. 1479–1425 B.C.)
Black bronze[a] (Hill and Schorsch 1997, p. 12), solid
cast, with noncanonical tangs (see p. 193) and
separate solid-cast arms[b] (Hill and Schorsch 1997);
gold inlay (2006[j]); nu vessels formerly gilded (?);
eye sockets formerly inlaid
H. 13.1 cm (5⅛ in.), W. 6 cm (2⅜ in.),
D. 7.6 cm (3 in.); L. of tangs 3.1 cm (1¼ in.)
The Metropolitan Museum of Art, New York; Pur-
chase, Edith Perry Chapman Fund and Malcom
Hewitt Weiner Foundation Inc. Gift, 1995 (1995.21)

Provenance: unknown; British Rail Pension Fund
collection, from 1979; acquired in 1995
Selected References: Hill and Schorsch 1997; Málek
1999, no. 800-618-562; Hill 2004, pp. 17–21, 150,
no. 1, pl. 2

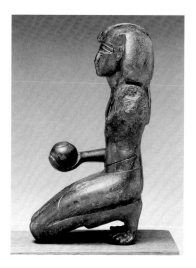

Fig. 87. Profile view of *King
Thutmose III* (cat. no. 8),
showing slanted belt line

9. Kneeling King (Probably Tutankhamun)

New Kingdom, 18th Dynasty, reign of
Tutankhamun (ca. 1336–1327 B.C.)
Black bronze[k] (Fishman and Fleming 1980, pp.
82–84; see also Hill and Schorsch 1997, p. 12, n. 39),
hollow cast with two core cavities[l] (Fishman and
Fleming 1980, pl. 4), with noncanonical tangs (see
p. 193) and separate arms and uraeus (arms and
uraeus now lost); precious-metal sheet and inlay;
copper-alloy inlay; eye sockets and eyebrows
formerly inlaid

H. 20.6 cm (8⅛ in.), W. 10.2 cm (4 in.),
D. 15.2 cm (6 in.)
University of Pennsylvania Museum of Archaeology and Anthropology, Philadelphia (E 14295)

Provenance: unknown; acquired in 1924
Selected References: Fishman and Fleming 1980; Silverman 1997, pp. 100–101; Málek 1999, no. 800-745-600; Hill 2004, pp. 17–21, 235–36, no. 284, pl. 5

10. Standing Amarna King

New Kingdom, 18th Dynasty, Amarna Period
(ca. 1349–1336 B.C.)
Bronze (2007ᶜ), solid cast; bronze base and modern brass socket (2006ᵉ·ᶠ); formerly gilded (?)
H. 10.4 cm (4⅛ in.), W. 2.8 cm (1⅛ in.),
D. 1.9 cm (¾ in.)
The Walters Art Museum, Baltimore (54.406)

Provenance: said to be from Medinet Gurab; acquired in 1927
Selected References: Borchardt 1911, p. 16, no. 5, fig. 16; Steindorff 1946, p. 47, no. 134, pl. 22; Hill 2004, pp. 17–21, 171, no. 43, pl. 4, right

11. Milling Shawabti of the King's Scribe, Siese, Son of Ahmose

New Kingdom, 18th Dynasty, reign of Thutmose IV–reign of Amenhotep III (ca. 1400–1352 B.C.)
Unalloyed copper (2006ᵃ), partially hollow cast (grinding platform only), with separate solid-cast arms and grindstone (2005ᵇ)
L. 10.2 cm (4 in.), H. 9.2 cm (3⅝ in.), W. 4 cm (1⅝ in.)
Brooklyn Museum, New York; Charles Edwin Wilbour Fund (37.125E)

Provenance: unknown, said to be from Saqqara; Abbott collection; acquired by the New-York Historical Society in 1860; acquired by the Brooklyn Museum in 1948
Selected References: De Meulenaere 1971, pp. 225–26; James 1974, p. 120, no. 271, pl. 70; Schneider 1977, vol. 1, pp. 217, 295

12. Fragment of a Wig*

New Kingdom, late 18th–19th Dynasty
(ca. 1350–1186 B.C.)
Copper alloy, hollow cast
H. 8 cm (3⅛ in.), W. 16 cm (6¼ in.),
Th. 0.7 cm (¼ in.)
Cyprus Museum, Nicosia (Enkomi Fr. Ex. Inv. No. 126, 1960)

For provenance and selected references, see catalogue entry (pp. 32–33).

13. Seth*

New Kingdom, 19th–20th Dynasty
(ca. 1295–1070 B.C.)
Unalloyed copper (2006ᵃ), solid cast, with separate right arm (2006ʳ); auriferous-silver and copper-alloy inlay; partially clad with gold sheet (2007ᵃ); altered in antiquity by removal of ears and addition of ram horns and crown with lituus; feet with lower legs, right horn, and reattachment of right arm are 19th-century restorations (2006ʳ, 2007ᵃ)
H. as restored 67.7 cm (26⅝ in.), W. 35 cm (13¾ in.),
D. 30 cm (11¾ in.)
Ny Carlsberg Glyptotek, Copenhagen (AEIN 614)

For provenance and selected references, see catalogue entry (pp. 34–37).

Fig. 88. Gamma radiograph of Seth (cat. no. 13), detail of crown, head, and torso, showing overall casting porosity, loose tenon joining crown to head (a), and join of left arm to body (b)

14. Kneeling Official

New Kingdom, late 19th–20th Dynasty
(ca. 1250–1070 B.C.)
Bronze (2006[m]), hollow cast with open cavity, with noncanonical tangs (see p. 193) and separate solid-cast arms (2005[b])
H. 7.3 cm (2⅞ in.), W. 4.5 cm (1¾ in.), D. 4.8 cm (1⅞ in.); H. of tangs 2.5 cm (1 in.)
The Metropolitan Museum of Art, New York; Rogers Fund, 1951 (51.173)

Provenance: unknown; acquired in 1951
Selected Reference: Hayes 1990, vol. 2, p. 382

15. Royal or Divine Child

New Kingdom, late 18th–early 19th Dynasty
(ca. 1336–1250 B.C.) or later
Black copper[g] (Mathis et al. 2007), solid cast, with partially hollow head (2005[h]); separate black bronze hairlock[i] (Mathis et al. 2007) and separate arms and uraeus (now lost); gold (in hairlock[g], Mathis et al. 2007) and precious-metal inlay; eye sockets formerly inlaid
H. 14.2 cm (5⅝ in.), W. 3 cm (1⅛ in.),
D. 7 cm (2¾ in.)
Musée du Louvre, Paris (E 7735)

Provenance: unknown; acquired from M. Allemant in 1884
Selected Reference: Deonna 1931, p. 74, fig. 12/9, pp. 83–84

16. Menit *Inscribed for Sobek-Re*

New Kingdom, mid-18th–20th Dynasty
(ca. 1425–1070 B.C.)
Black bronze[g] (Mathis et al. 2007), hollow cast (2005[h]); auriferous-silver teeth; electrum and gold inlay; gold leaf[g] (Mathis et al. 2007)
L. 18.7 (7⅜ in.)
Musée du Louvre, Paris (E 11520)

Provenance: unknown; Peytel collection; donated in 1918
Selected References: Boreux 1932, pp. 356–57, pl. 66; Seipel 2001, p. 122, no. 144

17. King Osorkon I*

Third Intermediate Period, 22nd Dynasty, reign of Osorkon I (ca. 924–889 B.C.)
Bronze (2004[j,m]), hollow cast, with separate solid-cast arms (2004[b]); precious-metal inlay and leaf
H. 14 cm (5½ in.), W. 3.8 cm (1½ in.),

D. 9.2 cm (3⅝ in.)
Brooklyn Museum, New York; Charles Edwin Wilbour Fund (57.92)

For provenance and selected references, see catalogue entry (pp. 82–83).

18. Osiris

Third Intermediate Period, 21st–24th Dynasty
(ca. 1070–712 B.C.)
Leaded bronze (2006[a]), solid cast (2006[b]), with separate attributes (bronze flail, 2006[j]); separate *atef* feathers, beard, and uraeus (all lost); precious-metal leaf; eyes inlaid, eyebrows and chinstrap formerly inlaid; modern black patina; ink or black paint inscription on wood base
Statue: H. 35 cm (13¾ in.), W. 12.2 cm (4¾ in.), D. 9 cm (3½ in.); base: H. 9.5 cm (3¾ in.), W. 13.4 cm (5¼ in.), D. 26.2 cm (10¼ in.)
Inscription: see fig. 89
The Metropolitan Museum of Art, New York; Gift of Egypt Exploration Fund, 1903 (03.4.11)

Provenance: el-Hiba, area described as chamber tombs beneath structure on east side of town wall; allotted to the Metropolitan Museum in distribution of finds, 1903
Selected References: Grenfell and Hunt 1902–3, pp. 2–3; Roeder 1956, §187a, pl. 76e

Fig. 89. Inscription on *Osiris* (cat. no. 18): "Osiris Wennefer, elder god, lord of Busiris, ruler of eternity, giving life, soundness, and health to the astronomer of the House of Amun, Ibeb, son of the astronomer of the House of Amun, Ankhpekhered, [justified], honored [. . .] forever"]

19. Amun*

Third Intermediate Period, early 8th century
(ca. 800–770 B.C.)
Gold (2002[a]), solid cast, with separate solid-cast arms
and beard (1999[s]); separate tripartite loop, attributes,
feather crown, and sun disk (loop, crown, and disk
mostly lost); separate precious-metal base (lost)
H. 17.5 cm (6⅞ in), W. 4.7 cm (1⅞ in.),
D. 5.8 cm (2¼ in.)
The Metropolitan Museum of Art, New York;
Purchase, Edward S. Harkness Gift, 1926 (26.7.1412)

For provenance and selected references, see
catalogue entry (pp. 84–89).

20. Nefertem with Headdress of Montu

Third Intermediate Period, 21st–24th Dynasty
(ca. 1070–712 B.C.)
Copper alloy, hollow cast, with separate arms,
beard, and uraeus (beard and uraeus lost); feather
headdress with sun disk substituted in antiquity
H. 36.5 cm (14⅜ in.), W. 7.4 cm (2⅞ in.),
D. 11.3 cm (4½ in.)
Rijksmuseum van Oudheden, Leiden (H.III.M...-2)

Provenance: unknown; acquired by Jean-Émile
Humbert in Livorno, Italy, 1826
Selected References: Leemans 1840, no. A2; Boeser
1907, no. E.XVIII.142; Roeder 1956, §23a, fig. 31,
§115a; Schneider and Raven 1997, pp. 28–29, no. 18

21. Torso of King Pedubaste*

Third Intermediate Period, 23rd Dynasty, reign of
Pedubaste (ca. 818–793 B.C.)
Bronze[a] (Hill and Schorsch 2005, pp. 175–76), hollow
cast with multiple cavities and iron armature and
core supports[b] (Hill and Schorsch 2005, pp. 170–71);
yellow- and red-gold inlay and gold leaf[a] (Hill
and Schorsch 2005, p. 177)
H. 27 cm (10⅝ in.), W. 14 (5½ in.), D. 17 cm (6¾ in.)
Museu Calouste Gulbenkian, Lisbon (52)

For provenance and selected references, see
catalogue entry (pp. 90–91).

22. King Pami Kneeling and Offering Nu Pots

Third Intermediate Period, 22nd Dynasty, reign of
Pami (ca. 773–767 B.C.)
Leaded copper[n] (Craddock 1985, table II, 32747),
hollow cast, with separate arms
H. 26 cm (10¼ in.), W. 9 cm (3½ in.),
D. 10.5 cm (4⅛ in.)
The Trustees of the British Museum, London (EA
32747)

Provenance: unknown; acquired from H. E. E. T.
Rogers in 1880
Selected References: Yoyotte 1988, pp. 158, 164–66,
pls. 4, 5; Málek 1999, no. 800-781-400; Russmann
2001, pp. 215–17, no. 114; Hill 2004, pp. 29, 44, 46,
156–57, no. 13, pl. 20; Hill and Schorsch 2005,
pp. 176, 182–83

23. Kushite King Later Inscribed for King Psamtik*

Third Intermediate Period, 25th Dynasty
(ca. 747–664 B.C.)
Copper alloy, solid cast; formerly clad in precious-
metal leaf; regalia intentionally removed in antiquity
H. 38.7 cm (15¼ in.), W. 15.1 cm (6 in.),
D. 19 cm (7½ in.)
National Archaeological Museum, Athens
(ANE 624)

For provenance and selected references, see
catalogue entry (pp. 92–94).

24. Kushite King with Altered Regalia

Third Intermediate Period, 25th Dynasty
(ca. 747–664 B.C.)
Bronze (2006[a]), solid cast (2006[b]); precious-metal
leaf; regalia altered and figure damaged when
removed from base in antiquity
H. 7.5 cm (3 in.), W. 3.2 cm (1¼ in.),
D. 3.6 cm (1⅜ in.)
The Metropolitan Museum of Art, New York;
Purchase, Lila Acheson Wallace Gift, and Anne
and John V. Hansen Egyptian Purchase Fund,
2002 (2002.8)

Provenance: unknown; Christos Bastis collection,
from 1975; acquired in 2002
Selected References: Bothmer 1987, pp. 39–41;
Málek 1999, no. 800-817-600; Hill 2004, pp. 56, 59,
73, 226, no. 243, pl. 35

25. Statue of a Woman (Probably a God's Wife of Amun)*

Third Intermediate Period, 22nd–25th Dynasty,
9th–8th century B.C.
Leaded bronze[n], hollow cast with iron armatures;
separate (?) solid-cast arms and wig[o] (Taylor et al.
1998, p. 11); gold leaf[p] (Taylor et al. 1998, p. 9, fig. 1)
over gesso ground; eye sockets inlaid with lime-
stone (?), lapis lazuli, and obsidian
H. 68.5 cm (27 in.), W. 23.5 cm (9¼ in.),
D. 27 cm (10⅝ in.)

The Trustees of the British Museum, London (EA 43373)

For provenance and selected references, see catalogue entry (pp. 95–97).

26. *Statue of a Woman with Sokar Barque, Fetish, and Figures of Osiris*

Third Intermediate Period, 25th Dynasty
(ca. 747–664 B.C.)
Copper alloy, hollow cast, with separate wig and arms (arms lost); surface of face, neck, and anklets textured to hold gesso; precious-metal leaf; eyes, eyebrows, and diadem formerly inlaid
H. 47 cm (18½ in.), W. 24 cm (9½ in.),
D. 11.6 cm (4⅝ in.)
Ägyptisches Museum und Papyrussammlung, Staatliche Museen zu Berlin (2309)

Provenance: unknown; acquired by Baron Minutoli in 1820–21
Selected References: Minutoli 1824, p. 416, pl. 31, no. 3; Roeder 1956, §599b–d, §708cb, pl. 47a–c; Reuterswärd 1958, p. 64; Maystre 1986, p. 55; Priese 1991, pp. 230–31, no. 139; Málek 1999, no. 801-715-520

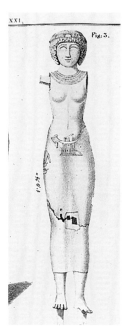

Fig. 90. Drawing of *Statue of a Woman* (cat. no. 26) from Minutoli 1824, showing evidence of ancient patches now concealed by modern restoration

27. *Takushit**

Third Intermediate Period, end of 25th Dynasty
(ca. 670 B.C.)
Copper alloy, hollow cast; precious-metal inlay; ivory inlays in eye sockets (left eye lost); eyebrows formerly inlaid
H. 69 cm (27⅛ in.), W. 20.5 cm (8½ in.), D. 21.5 cm (8⅛ in.); max. H. of tangs 5.8 cm (2¼ in.)
National Archaeological Museum, Athens (110)

For provenance and selected references, see catalogue entry (pp. 98–103).

28. *Priest*

Third Intermediate Period, 22nd–24th Dynasty
(ca. 945–712 B.C.)
Leaded bronze (2006[a]), hollow cast with iron core supports; separate solid-cast arms (2005[b]); gold leaf on censer and vessel (2006[a])
H. 11.7 cm (4⅝ in.), W. 3.4 cm (1⅜ in.),
D. 5.4 cm (2⅛ in.)
The Metropolitan Museum of Art, New York; Dodge Fund, 1947 (47.105.3)

Provenance: unknown; acquired in 1947
Selected References: unpublished

29. *Upper Part of a Man*

Third Intermediate Period, 22nd–24th Dynasty
(ca. 945–712 B.C.)
Leaded arsenical copper[n] (Taylor et al. 1998, pp. 12–13), hollow cast with iron armature and core supports; separate arms and wig[o] (Taylor et al. 1998, p. 11); precious-metal leaf; lower part of figure preserved (EA 71459) but with no direct join
H. 42 cm (16⅝ in.), W. 20 cm (7⅞ in.),
D. 11.5 cm (4½ in.)
The Trustees of the British Museum, London (EA 22784)

Provenance: unknown, said to be from Giza; donated by James Danford Baldry in 1889
Selected References: Taylor et al. 1998, pp. 9–14; Málek 1999, no. 801-711-700; Russmann 2001, pp. 219–21, no. 117

30. The God's Father of Khonsu, Khonsumeh (depicted on sides: God's Father of Atum Lord of the Populace, Pasherienese)

Third Intermediate Period, possibly 10th–9th century B.C.
Leaded bronze[c] (Riederer 1978, no. 156), hollow cast, with separate arms; precious-metal inlay
H. 29.1 cm (11½ in.), W. 8.2 cm (3¼ in.), D. 10.5 cm (4⅛ in.)
Ägyptisches Museum und Papyrussammlung, Staatliche Museen zu Berlin (23732)

Provenance: unknown; von Bissing collection, from 1910; acquired in 1935
Selected References: von Bissing 1928; Roeder 1956, §370a, figs. 385, 386, pls. 45a–e, 46b, f, g; Fay et al. 1990, pp. 114–15, no. 59; Málek 1999, no. 801-704-520

31. Padiamun

Third Intermediate Period, middle third of 8th century B.C. (?)
Copper alloy, hollow cast, with separate arms (left arm recently recovered and reattached; right arm lost); eye sockets inlaid
H. 58 cm (22⅞ in.), W. 16.3 cm (6⅜ in.), D. 20 cm (7⅞ in.)
Inscription on skirt panel: "Padiamun, honored before Osiris at home in Rosetau, son of Wedjahor; his son Haremakhbit . . . causes his name to live"
Musée du Louvre, Paris (E 10586)

Provenance: unknown, said to be from Memphis; acquired in 1891
Selected References: Révillout 1891–92; Ziegler 1996, p. 38; Málek 1999, no. 801-728-450

32. Statuette of a Man Holding a Document Case or Papyrus

Third Intermediate Period, 25th Dynasty (ca. 747–664 B.C.)
Leaded bronze (2006[m]), hollow cast with iron core supports; separate solid-cast arms (2006[b])
H. 8.6 cm (3⅜ in.), W. 3 cm (1⅛ in.), D. 3 cm (1⅛ in.)
Inscription: see fig. 91
The Metropolitan Museum of Art, New York; Purchase, Edward S. Harkness Gift, 1926 (26.7.1415)

Provenance: unknown; Carnarvon collection, from 1922; acquired with Carnarvon collection in 1926
Selected Reference: Roeder 1956, §367b

Fig. 91. Name and titles on banderole of *Statuette of a Man* (cat. no. 32), which are only partly legible (*front at left, back at right*): "God's Father, God's Beloved . . . Hat . . ."

33. Roundel with Offering Scene (Fragment from the Menit of Harsiese)*

Third Intermediate Period–Late Period, 8th–6th century B.C.
Leaded bronze[c] (Riederer 1978, no. 105; see also the essay "The Manufacture of Metal Statuary" in this volume, esp. n. 34), solid cast; precious-metal and copper-alloy inlay
H. 7.7 cm (3 in.), W. 9.7 cm (3⅞ in.), D. 0.4 cm (⅛ in.)
Ägyptisches Museum und Papyrussammlung, Staatliche Museen zu Berlin (23733)

For provenance and selected references, see catalogue entry (pp. 104–5).

34. Sphinx Standard*

Third Intermediate Period, 22nd–24th Dynasty (ca. 945–712 B.C.)
Leaded bronze (2004[a]), hollow cast (2004[b]) with iron core supports; restored tail (2004[a]); precious-metal leaf and gold inlay (2004[a])
H. of figure 12.8 cm (5 in.); base: D. 12.3 cm (4⅞ in.), W. 3.7 cm (1½ in.)
Brooklyn Museum, New York; Charles Edwin Wilbour Fund (61.20)

For provenance and selected references, see catalogue entry (pp. 106–7).

35. Sphinx Standard of King Taharqo

Third Intermediate Period, 25th Dynasty, reign of Taharqo (ca. 690–664 B.C.)
Leaded bronze (1981[q]), solid cast; eye sockets formerly inlaid
H. 16 cm (6¼ in.), L. 13.6 cm (5⅜ in.), W. 4.6 cm (1¾ in.); H. of figure 9.8 cm (3⅞ in.)
Musée du Louvre, Paris (E 3916)

Provenance: unknown; Delaporte collection; acquired in 1864
Selected Reference: Hill 2004, pp. 72, 161, no. 23, pl. 39

36. Ram Head Amulet (Probably from a Kushite Royal Necklace)

Third Intermediate Period, 25th Dynasty (ca. 747–664 B.C.), or, if from Nubia, possibly somewhat later
Gold, solid cast (2006[b])
H. 4.2 cm (1⅝ in.), W. 3.7 cm (1⁷/16 in.), D. 2 cm (¾ in.)
The Metropolitan Museum of Art, New York; Gift of Norbert Schimmel Trust, 1989 (1989.281.98)

Provenance: unknown; Tigrane Pacha collection, before 1911; Schimmel collection; donated in 1989
Selected References: Settgast 1978, no. 252; Roehrig 1992

37. Neith*

Third Intermediate Period, 25th Dynasty (ca. 747–664 B.C.)
Copper alloy, solid cast, with separate solid-cast arms; precious-metal and copper-alloy inlay
H. 22.5 cm (8⅞ in.)
Archaeological Museum, Vathy, Samos, Greece (B 354)

For provenance and selected references, see catalogue entry (pp. 108–9).

38. Statue of a Man with a Kilt Panel and Leopard Skin*

Third Intermediate Period–Late Period, 25th–early 26th Dynasty (ca. 747–640 B.C.) (see commentary in catalogue entry, pp. 110–13)
Copper alloy, hollow cast with iron armature; lead "core" in head (see catalogue entry, n. 1); separate hollow-cast arms; precious-metal leaf
H. of torso fragment 26.6 cm (10½ in.); estimated original H. 66–68 cm (26–27 in.)
Archaeological Museum, Vathy, Samos, Greece (B 1312 [torso], B 160, B 126, B 1525, B 1690 [A 864, A 863, A 865])

For provenance and selected references, see catalogue entry (pp. 110–13).

39. Osiris*

Late Period, 26th Dynasty (664–525 B.C.)
Copper alloy, hollow cast with iron armature, with separate atef feathers; precious-metal leaf over gesso ground; eye sockets and beard inlaid
H. 106 cm (41¾ in.), W. 24.5 cm (9⅝ in.), D. 25.5 cm (10 in.)
Rijksmuseum van Oudheden, Leiden (AB 161)

For provenance and selected references, see catalogue entry (pp. 128–29).

40. Standing Woman with the Cartouches of King Necho II on Her Arms*

Late Period, 26th Dynasty, reign of Necho II (610–595 B.C.)
Silver[a] (Becker et al. 1994, p. 47), solid cast, with separate wig and jewelry[b] (Becker et al. 1994, pp. 47–51)
H. 24 cm (9½ in.), W. 5.6 cm (2¼ in.), D. 5.4 cm (2⅛ in.)

The Metropolitan Museum of Art, New York; Theodore M. Davis Collection, Bequest of Theodore M. Davis, 1915 (30.8.93)

For provenance and selected references, see catalogue entry (pp. 130–33).

41. Figure of a Man from Sais*

Late Period, 26th Dynasty (664–525 B.C.), possibly early 6th century B.C.
Copper alloy, solid cast; precious-metal inlay; eye sockets formerly inlaid
H. 15 cm (5⅞ in.), W. 6.7 cm (2⅝ in.), L. 17.5 cm (6⅞ in.)
National Archaeological Museum, Athens (640)

For provenance and selected references, see catalogue entry (pp. 134–36).

42. Ram

Late Period, probably last third of 26th Dynasty–4th century B.C. (ca. 570–300 B.C.)
Meta-arenite (quartz-rich indurated sandstone) (2007¹); eyes formerly inlaid
L. 23 cm (9 in.), H. 16.3 cm (6⅜ in.), W. 6.4 cm (2½ in.)
The Metropolitan Museum of Art, New York; Purchase, Lila Acheson Wallace, Malcolm Hewitt Wiener Foundation Inc., and Vaughan Foundation Fund Gifts, 1998 (1998.77)

Provenance: unknown; art market, Rome, 1930s; [K. J. Hewett, London, 1963]; Brummer collection (?); acquired in 1998
Selected References: sale catalogue, K. J. Hewett, 1963, unnumbered p. 10; Christie's London, December 11, 1996, lot 33

43. King Necho [II]

Late Period, 26th Dynasty, reign of Necho II (610–595 B.C.)
Bronze (2006ᵃ), solid cast
H. 14 cm (5½ in.), W. 5.7 cm (2¼ in.), D. 7 cm (2¾ in.)
Brooklyn Museum, New York; Charles Edwin Wilbour Fund (71.11)

Provenance: unknown; Brummer collection, New York, before 1949; Kevorkian collection; acquired in 1971
Selected References: Málek 1999, no. 800-824-100; Hill 2002, p. 553; Hill 2004, pp. 81, 110, 117, 162–63, no. 25, pl. 53

44. King Necho [II]

Late Period, 26th Dynasty, reign of Necho II (610–595 B.C.)
Copper alloy, solid cast
H. 18.1 cm (7⅛ in.), W. 12.7 cm (5 in.), D. 15.2 cm (6 in.)
University of Pennsylvania Museum of Archaeology and Anthropology, Philadelphia (E 13004)

Provenance: unknown; Posno collection; acquired in 1914
Selected References: Silverman 1997, pp. 108–9; Málek 1999, no. 800-824-600; Hill 2004, pp. 81, 110, 117, 161–62, no. 24, pl. 52

45. King Apries as a Sphinx

Late Period, 26th Dynasty, reign of Apries (589–570 B.C.)
Leaded bronze (2006ᵍ), hollow cast with open cavity, with separate uraeus (now lost); formerly overlaid with precious-metal sheet
H. 19.5 cm (7⅝ in.), W. 12.8 cm (5 in.), L. 45 cm (17¾ in.)
Musée du Louvre, Paris (N 515)

Provenance: unknown; sent from Egypt to France in mid-18th century; Comte de Maurepas collection; Comte de Caylus collection (?); Comte de Cossé-Brissac collection; seized during the Revolution
Selected References: Caylus 1761, pp. 44–47, pls. 14, 15; Málek 1999, no. 800-829-600; Hill 2004, pp. 83, 164, no. 27, pl. 58

46. Aegis of King Amasis*

Late Period, 26th Dynasty, reign of Amasis (570–526 B.C.)
Copper alloy, hollow cast with open cavity
H. 10.7 cm (4¼ in.), W. 9.1 cm (5⅝ in.), D. 8.7 cm (3⅜ in.)
Egyptian Museum, Cairo (T.R. 20/5/26/1 [M696])

For provenance and selected references, see catalogue entry (pp. 137–39).

47. King Amasis with His Names on Front of Kilt and Back of Belt

Late Period, 26th Dynasty, reign of Amasis
(570–526 B.C.)
Bronze (2002[a]), solid cast (1997[b]); precious-metal inlay and leaf; damaged in antiquity when removed from base
H. 11 cm (4⅜ in.), W. 4.8 cm (1⅞ in.),
D. 6 cm (2⅜ in.)
The Metropolitan Museum of Art, New York; Gift of Edward S. Harkness, 1935 (35.9.3)

Provenance: unknown; donated in 1935
Selected References: Málek 1999, no. 800-852-500; Hill 2004, pp. 84–85, 116–17, 166, no. 31 (incorrectly as formerly in the Sabatier collection), pl. 60

48. Bust of a King*

Late Period, probably 29th Dynasty (399–380 B.C.)
Leaded bronze[c] (Riederer 1984, no. 66), hollow cast; precious-metal inlay; eye sockets inlaid
H. 39.5 cm (15½ in.), W. 25 cm (9⅞ in.),
D. 24.5 cm (9⅝ in.)
Roemer- und Pelizaeus-Museum, Hildesheim, Germany (0584)

For provenance and selected references, see catalogue entry (pp. 140–42).

49. Harpokrates, Lord of Hebyt, Offered by a Son of the Great One of Netjery, Harsiese

30th Dynasty–early Ptolemaic Period, probably second half of 4th century B.C.
Copper alloy, solid cast, with separate lock (lost) and separate hollow-cast base (2006[f])
H. 18.2 cm (7⅛ in.), W. 6.5 cm (2½ in.),
D. 10.7 cm (4¼ in.)
The Walters Art Museum, Baltimore (54.554)

Provenance: unknown; acquired in 1924
Selected References: Steindorff 1946, pp. 112–13, no. 431, pls. 75, 118; Favard-Meeks 1991, p. 393, n. 723, p. 394, n. 732

50. Bes-image of the God Horus-Ashakhet

30th Dynasty–mid-Ptolemaic Period,
4th–2nd century B.C.
Bronze (2006[a]), solid cast (2006[b]), with separate headdress (lost); gold, electrum (?), auriferous-silver, and copper-alloy inlay (2006[a,m])
H. 16.8 cm (6⅝ in.), W. 9.6 cm (3¾ in.),
D. 6.7 cm (2⅝ in.)

Inscription: see fig. 92
The Metropolitan Museum of Art, New York; Rogers Fund, 1929 (29.2.3)

Provenance: unknown; acquired in 1928
Selected Reference: Roeder 1956, §139a

Fig. 92. Inscription on *Bes-image* (cat. no. 50): "Horus-Ashakhet, who makes live Ibi, son of Padiastarte, born of Tadiese . . . "
[*Editor's note:* This reading was provided by Herman De Meulenaere, who also remarked: "I am unable to explain the group of signs following the mother's name. In view of the father's name, which refers to the goddess Astarte, it may well be an epithet of Semitic origin The dedicator and his father are also named on an offering tray . . . (Schoske and Wildung 1992, p. 210)" (letter to Marsha Hill, November 3, 2006). The date given for the piece in Schoske and Wildung 1992 is conjectural; more helpful is Teeter 1994 (p. 263), which provides a date for the object type as the 4th–2nd century B.C. For the reading of Ibi, see De Meulenaere 1981, p. 254.]

51. Nefertem*

Macedonian–Ptolemaic Period (332–30 B.C.)
Silver, solid cast; reassembled from fragments; left calf restored
H. of figure above base 26.1 cm (10¼ in.);
base: D. 7.6 cm (3 in.), W. 3.2 cm (1¼ in.), H. 0.6 cm (¼ in.)
Ägyptisches Museum und Papyrussammlung, Staatliche Museen zu Berlin (E 11001)

For provenance and selected references, see catalogue entry (pp. 143–46).

52. Nephthys

Macedonian–Ptolemaic Period (332–30 B.C.)
Copper alloy, solid cast
H. 28.8 cm (11 3/8 in.), W. 5.3 cm (2 1/8 in.),
D. 4.6 cm (1 3/4 in.)
Rijksmuseum van Oudheden, Leiden (L.VII.69)

Provenance: unknown; acquired with the
De Lescluze collection in 1826–27
Selected References: Leemans 1840, no. A832;
Boeser 1907, no. E.XVIII.58; Hill 2004,
pp. 101–2, 113, 202–3

53. King

Macedonian–Ptolemaic Period (332–30 B.C.)
Copper alloy, solid cast
H. 24.1 cm (9 1/2 in.), W. 6.3 cm (2 1/2 in.),
D. 10 cm (4 in.)
Rijksmuseum van Oudheden, Leiden (L.VII.70)

Provenance: unknown; acquired with the
De Lescluze collection in 1826–27
Selected References: Leemans 1840, no. D1; Boeser
1907, no. E.XVIII.319; Maarten J. Raven in Akker-
mans et al. 1992, p. 31, no. 8; Schneider and Raven
1997, p. 77, no. 105; Málek 1999, no. 800–893–300;
Hill 2004, pp. 101–2, 113, 202–3, no. 153

54. Isis

Macedonian–Ptolemaic Period (332–30 B.C.)
Copper alloy, solid cast; precious-metal leaf
H. including platform base 29.2 cm (11 1/2 in.);
base: D. 4.6 cm (1 3/4 in.), W. 4.1 cm (1 5/8 in.)
Musée du Louvre, Paris (N 3988)

Provenance: unknown; acquired with Salt collec-
tion in 1826
Selected Reference: Hill 2004, pp. 101–2, 113, 232

55. King

Macedonian–Ptolemaic Period (332–30 B.C.)
Copper alloy, solid cast; precious-metal leaf
H. 24.1 cm (9 1/2 in.), W. at base 3.3 cm (1 1/4 in.),
D. 9.1 cm (3 5/8 in.)
Musée du Louvre, Paris (N 506)
Provenance: unknown; acquired with Salt collec-
tion in 1826
Selected Reference: Hill 2004, pp. 101–2, 113, 232,
no. 268, pl. 77

56. Standing King or God*

Probably Roman Period, 1st–4th century A.D.
Leaded bronze (2006[a]), solid cast
H. 31 cm (12 1/4 in.), W. 8.4 cm (3 1/4 in.),
D. 12.7 cm (5 in.); H. of tenon 3.7 cm (1 1/2 in.)
Brooklyn Museum, New York; Gift of Mrs. Helena
Simkhovitch in memory of her father, Vladimir G.
Simkhovitch (72.129)

For provenance and selected references, see
catalogue entry (pp. 146–48).

57. Seated Isis Nursing Horus*

Late Period, 26th Dynasty, ca. 611–594 B.C.
(see catalogue entry, n. 1)
Bronze (2007[a]), solid cast (2006[b]); separate hollow-
cast, leaded-bronze throne (2007[a]), ancient but
possibly not original to figure, with iron core
supports; electrum inlay (sclerae, 2006[j]); gilded-
silver (2007[a]) inlaid bands around sun disk on
obverse and reverse; sun disk formerly gilded;
upper third of both horns rejoined; left forearm
is modern replacement
H. 39.3 cm (15 1/2 in.), W. 12.3 cm (4 7/8 in.),
D. 18.8 cm (7 3/8 in.)
The Metropolitan Museum of Art, New York;
Gift of David Dows, 1945 (45.4.3)

For inscription and provenance, see catalogue
entry (pp. 149–51).

58. Harpokrates with a Falcon on the Back of His Nemes Headdress

Ptolemaic Period, 1st century B.C.
Leaded bronze (2006[j]), solid cast (2006[b]); formerly
"gilded" (Davies and Smith 2005), but no traces of
precious metal currently visible
H. 16 cm (6 1/4 in.), W. 5.6 cm (2 1/4 in.),
D. 2.4 cm (1 in.)
The Metropolitan Museum of Art, New York; The
Adelaide Milton de Groot Fund, in memory of the
de Groot and Hawley families, 1976 (1976.63.2)

Provenance: Saqqara, Sacred Animal Necropolis
(Falcon Catacomb, gallery 6, niche 6a)
Selected Reference: Davies and Smith 2005,
pp. 124–25, pls. LIV, LV

59. Anubis

Late Third Intermediate Period–early 26th Dynasty
(ca. 800–600 B.C.)
Bronze[c] (Riederer 1978, no. 102), solid cast;
precious-metal leaf and inlay
H. of figure 13.8 cm (5⅜ in.); base: D. 6.1 cm (2⅜ in.),
W. 3 cm (1⅛ in.), H. 1 cm (⅜ in.)
Ägyptisches Museum und Papyrussammlung,
Staatliche Museen zu Berlin (2466)

Provenance: unknown; acquired in Dresden, 1869
Selected References: Roeder 1956, §83c, §84a–c, pl. 9h

60. Neith

Late Period, 26th–30th Dynasty (664–332 B.C.)
Copper alloy, solid cast; precious-metal inlay
H. 15.4 cm (6 in.), W. 3.5 cm (1⅜ in.),
D. 8.8 cm (3½ in.)
Ägyptisches Museum und Papyrussammlung,
Staatliche Museen zu Berlin (15446)

Provenance: unknown; Hebich collection, Kassel;
acquired in 1902
Selected References: Roeder 1956, §266c, e, §717q,
pl. 32a, b; Priese 1991, pp. 228–29, no. 137

61. Statuette for a Royal Cult (?)*

4th century B.C.–early Ptolemaic Period
(380–246 B.C.)
Wood, assembled from eight components with
carbon-based ink guidelines (2003[q]); formerly clad
with lead sheet (2007[a])
H. 21 cm (8¼ in.), W. 14.3 cm (5⅝ in.),
D. 11 cm (4⅜ in.)
The Metropolitan Museum of Art, New York;
Purchase, Anne and John V. Hansen Egyptian Pur-
chase Fund, and Magda Saleh and Jack Josephson
Gift, 2003 (2003.154)

For provenance and selected references, see
catalogue entry (pp. 160–64).

62. Miniature Broad Collar*

Macedonian–early Ptolemaic Period
(ca. 332–246 B.C.)
Gold, soldered hammered sheet (2006[b]); cloisonné
inlay with turquoise, lapis lazuli, and carnelian
H. 8.6 cm (3⅜ in.), W. 10.3 cm (4⅛ in.)
The Metropolitan Museum of Art, New York;
Harris Brisbane Dick Fund, 1949 (49.121.1)

For provenance and selected references, see
catalogue entry (pp. 165–66).

63. Armlet for a Divine Statue

Macedonian–Ptolemaic Period (332–30 B.C.)
Gold, soldered hammered sheet; cloisonné inlays
(inlays lost)
H. 2.1 cm (⅞ in.), outer Diam. 3.5 cm (1⅜ in.),
inner Diam. 3 cm (1⅛ in.)
Egyptian Museum, Cairo (JE 45210)

Provenance: Dendera temple area
Selected Reference: Abdalla 1995, p. 27

64. Ram Head (Possibly from a Barque Prow)

Third Intermediate Period (ca. 1070–664 B.C.)
or later
Leaded bronze (2006[a]), hollow cast with open cav-
ity, with separate solid-cast beard, ears (lost), and
horns (fragmentary remains, bronze [2006[a]]);
precious-metal leaf; copper-alloy inlay in eye
rims; eye sockets formerly inlaid
H. 15.8 cm (6¼ in.), W. 10.2 cm (4 in.),
D. 13.5 cm (5⅜ in.)
The Metropolitan Museum of Art, New York;
Rogers Fund, 1945 (45.2.9)

Provenance: unknown; Posno collection; Hoffmann
collection; acquired in 1945
Selected Reference: Legrain 1894, pp. vii, 134

65. Lotus (Possibly from a Baldachin)

Third Intermediate Period (ca. 1070–664 B.C.)
or later
Bronze (2006[a]), hollow cast with open cavity; gold
foil (2006[a]) over gesso ground; white, dark blue,
and light blue glass inlays over light blue and
dark blue grounds
H. 13.5 cm (5⅜ in.), W. 15.8 cm (6¼ in.),
D. 9.2 cm (3⅝ in.)
The Metropolitan Museum of Art, New York;
Theodore M. Davis Collection, Bequest of
Theodore M. Davis, 1915 (30.8.232a)

Provenance: unknown; bequeathed in 1915
Selected References: unpublished

66. Attachment Head of the Goddess Mut (?)

Third Intermediate Period (ca. 1070–664 B.C.)
Leaded bronze (2006[a]), hollow cast with open
cavity; separate crown hollow cast in two pieces
(2006[b]); gold and electrum sheet on crown (2006[a]);
gold sheet on face (probably restored); Egyptian
blue inlays and blue glass eye rims and cosmetic
lines (largely restored); eyes restored

H. 16.5 cm (6½ in.), W. 6 cm (2⅜ in.),
D. 8.6 cm (3⅜ in.)
The Metropolitan Museum of Art, New York; Purchase, Edward S. Harkness Gift, 1926 (26.7.1427)

Provenance: unknown; Dattari collection; Carnarvon collection; acquired with Carnarvon collection in 1926
Selected Reference: Burlington Fine Arts Club 1922, p. 76, no. 17

67. Group with King Holding a Shen-ring (?) before an Otter

Late Period–early Ptolemaic Period,
7th–3rd century B.C.
Copper alloy, hollow cast (otter and base) with open cavity, with solid-cast king
H. 12.7 cm (5 in.), W. 6.4 cm (2½ in.),
L. 11.4 cm (4½ in.)
Brooklyn Museum, New York; Charles Edwin Wilbour Fund (76.105.2)

Provenance: unknown; Levi-Benzion collection, Cairo, before 1947; acquired in 1976
Selected References: Benzion 1947, probably p. 59, no. 425; Hill 2004, pp. 63, 114, 130, 182, no. 74

a Energy-dispersive X-ray spectrometry (EDS/SEM) analysis of a subsurface sample, Sherman Fairchild Center for Objects Conservation/Department of Scientific Research, The Metropolitan Museum of Art, New York

b X-ray radiography, Sherman Fairchild Center for Objects Conservation, The Metropolitan Museum of Art, New York

c Atomic absorption analysis (AA), Rathgen-Forschungslabor, Staatliche Museen zu Berlin

d X-ray radiography, Bundesamt für Materialforschung und Prüfung, Berlin

e X-ray fluorescence spectrometry, surface analysis (XRF), Department of Conservation and Technical Research, The Walters Art Museum, Baltimore

f X-ray radiography, Department of Conservation and Technical Research, The Walters Art Museum, Baltimore

g Particle-induced X-ray emission spectroscopy (PIXE), Centre de Recherche et de Restauration des Musées de France, Paris

h X-ray radiography, Centre de Recherche et de Restauration des Musées de France, Paris

i Based on ion-beam analysis (IBA) of black patina, Centre de Recherche et de Restauration des Musées de France (former Laboratoire de Recherche des Musées de France), Paris

j X-ray fluorescence spectrometry, surface analysis (XRF), Sherman Fairchild Center for Objects Conservation/Department of Scientific Research, The Metropolitan Museum of Art, New York

k Particle-induced X-ray emission spectroscopy (PIXE), Museum Applied Science Center for Archaeology, University of Pennsylvania Museum of Archaeology and Anthropology, Philadelphia

l X-ray radiography, Museum Applied Science Center for Archaeology, University of Pennsylvania Museum of Archaeology and Anthropology, Philadelphia

m Energy-dispersive X-ray spectrometry, surface analysis (EDS/SEM), Sherman Fairchild Center for Objects Conservation/Department of Scientific Research, The Metropolitan Museum of Art, New York

n Inductively coupled plasma atomic emission spectrometry (ICP-AES), Department of Conservation, Documentation and Science (former Department of Scientific Research), British Museum, London

o X-ray radiography, Department of Conservation, Documentation and Science (former Department of Scientific Research), British Museum, London

p Energy-dispersive X-ray spectrometry (EDS/SEM), Department of Conservation, Documentation and Science (former Department of Scientific Research), British Museum, London

q Inductively coupled plasma atomic emission spectrometry (ICP-AES), Centre de Recherche et de Restauration, Musées de France (former Laboratoire de Recherche des Musées de France), Paris

r Gamma radiography, Force Technology, Brøndby, Denmark

s Gamma radiography, JANX, Piscataway, New Jersey

t X-ray diffraction (XRD), Sherman Fairchild Center for Objects Conservation/Department of Scientific Research, The Metropolitan Museum of Art

BIBLIOGRAPHY

Abbreviations used in the bibliography:

ASAE	*Annales du Service des Antiquités de l'Égypte*
BIFAO	*Bulletin de l'Institut Français d'Archéologie Orientale*
BSFE	*Bulletin de la Société Française d'Égyptologie*
JAS	*Journal of Archaeological Science*
JEA	*Journal of Egyptian Archaeology*
JSSEA	*Journal of the Society for the Study of Egyptian Antiquities*
MDAIA	*Mitteilungen des Deutschen Archäologischen Instituts, Athenische Abteilung*
MDAIK	*Mitteilungen des Deutschen Archäologischen Instituts, Abteilung Kairo*
RDAC	*Report of the Department of Antiquities, Cyprus*
ZÄS	*Zeitschrift für ägyptische Sprache und Altertumskunde*

Abdalla, Aly

1995 "Finds from the Sebbakh at Dendera." *Göttinger Miszellen* 145, pp. 19–28.

Ägyptisches Museum Berlin

1967 *Ägyptisches Museum Berlin: Östlicher Stülerbau am Schloss Charlottenburg.* Berlin: Staatliche Museen Preussischer Kulturbesitz.

Akkermans, Peter M. M. G., et al.

1992 Peter M. M. G. Akkermans, Maarten J. Raven, R. Halbersma, and M. Brouwer. *Brons uit de Oudheid: Rijksmuseum van Oudheden.* Amsterdam: De Bataafsche Leeuw.

Aldred, Cyril

1956 "The Carnarvon Statuette of Amūn." *JEA* 42, pp. 3–7.

1971 *Jewels of the Pharaohs: Egyptian Jewelry of the Dynastic Period.* New York: Praeger.

Allen, Thomas George

1974 Trans. *The Book of the Dead, or Going Forth by Day.* Chicago: University of Chicago Press.

Altenmüller, Hartwig, and Ahmed M. Moussa

1991 "Die inschrift Amenemhets II aus dem Ptah–Tempel von Memphis: Ein Vorbericht." *Studien zur altägyptischen Kultur* 18, pp. 1–48.

Andrews, Carol

1984 *Egyptian Mummies.* London: British Museum.

Araújo, Luís Manuel de

2006 *Egyptian Art: Calouste Gulbenkian Collection.* Lisbon: Museu Calouste Gulbenkian.

Arnold, Dieter

1992 *The Pyramid Complex of Senwosret I.* New York: Metropolitan Museum of Art.

1999 *Temples of the Last Pharaohs.* New York: Oxford University Press.

Arnold, Dorothea

1996 *The Royal Women of Amarna: Images of Beauty from Ancient Egypt.* Exh. cat. New York: Metropolitan Museum of Art.

2003 "Royal Ancestral Figure." *Metropolitan Museum of Art Bulletin* 61, no. 2, p. 6.

Forth- *The Imhotep Mastaba Complex at Lisht.*
coming New York.

Arnold, Dorothea, et al.

1999 *Egyptian Art in the Age of the Pyramids.* Exh. cat., Galeries Nationales du Grand Palais, Paris; The Metropolitan Museum of Art, New York; Royal Ontario Museum, Toronto. New York: Metropolitan Museum of Art.

Arnst, Caris–Beatrice

2006 "Nilschlammbälle mit Haaren: Zum Opfer des ersten Haarschnitts." *ZÄS* 133, pp. 10–19.

Aruz, Joan

2003 Ed. *Art of the First Cities: The Third Millennium B.C. from the Mediterranean to the Indus.* Exh. cat.,

The Metropolitan Museum of Art, New York.
New Haven: Yale University Press.

Ashton, Sally-Ann

2004 "Egyptian Sculptors' Models: Function and Fashion in the 18th Dynasty." In *Invention and Innovation: The Social Context of Technological Change. 2, Egypt, the Aegean and the Near East, 1650–1150 BC*, ed. Jannine Bourriau and Jacke Phillips, pp. 176–99. Oxford: Oxbow Books.

Aston, David A.

1999 "Dynasty 26, Dynasty 30, or Dynasty 27? In Search of the Funerary Archaeology of the Persian Period." In *Studies on Ancient Egypt in Honour of H. S. Smith*, ed. Anthony Leahy and John Tait, pp. 17–22. London: Egypt Exploration Society.

Aubert, Jacques F., and Liliane Aubert

2001 *Bronzes et or égyptiens*. Paris: Cybèle.

Aucouturier, Marc, et al.

2004 Marc Aucouturier, Élisabeth Delange, and Marie-Emmanuelle Meyohas. "Karomama, divine adoratrice d'Amon: Son histoire, sa restauration, l'étude en laboratoire." *Technè*, no. 19, pp. 7–16.

Aufrère, Sydney

1991 *L'univers minéral dans la pensée égyptienne*. 2 vols. Cairo: Institut Français d'Archéologie Orientale.

Baines, John

1985 *Fecundity Figures: Egyptian Personification and the Iconology of a Genre*. Chicago: Bolchazy-Carducci.

2000 "Egyptian Deities in Context: Multiplicity, Unity, and the Problem of Change." In *One God or Many? Concepts of Divinity in the Ancient World*, ed. Barbara Nevling Porter, pp. 9–78. Chebeague, Maine: Casco Bay Assyriological Institute.

2006 "Public Ceremonial Performance in Ancient Egypt: Exclusion and Integration." In *Archaeology of Performance: Theaters of Power, Community, and Politics*, ed. Takeshi Inomata and Lawrence S. Coben, pp. 261–302. Lanham, N.Y.: Altamira Press.

Bakry, H. S. K.

1971 "The Discovery of a Temple of Sobk in Upper Egypt." *MDAIK* 27, no. 2, pp. 131–46.

Barber, E. J. W.

1991 *Prehistoric Textiles: The Development of Cloth in the Neolithic and Bronze Ages with Special Reference to the Aegean*. Princeton: Princeton University Press.

Baud, Michel, and Vassil Dobrev

1995 "De nouvelles annales de l'ancien empire égyptien: Une 'Pierre de Palerme' pour la VIe dynastie." *BIFAO* 95, pp. 23–92.

Beaud, Richard

1990 "L'offrande du collier-*ousekh*." In *Studies in Egyptology Presented to Miriam Lichtheim*, ed. Sarah Israelit-Groll, pp. 46–62. Jerusalem: Magnes.

Beck, Herbert, et al.

2005 Herbert Beck, Peter C. Bol, and Maraike Bückling, eds. *Ägypten, Griechenland, Rom: Abwehr und Berührung*. Exh. cat. Frankfurt: Städelsches Kunstinstitut und Städtische Galerie.

Becker, Lawrence, et al.

1994 Lawrence Becker, Lisa Pilosi, and Deborah Schorsch. "An Egyptian Silver Statuette of the Saite Period: A Technical Study." *Metropolitan Museum Journal* 29, pp. 37–56.

Benzion, Moïse Levy de

1947 *Succession de feu M. Moïse Levy de Benzion*. Cairo.

Berman, Lawrence M.

1999 *Catalogue of Egyptian Art*. Cleveland: Cleveland Museum of Art.

Bevan, Edwyn

1927 *A History of Egypt under the Ptolemaic Dynasty*. London: Methuen.

1968 *The House of Ptolemy: A History of Egypt under the Ptolemaic Dynasty*. Rev. ed. Chicago: Argonaut.

Bianchi, Robert S.

1990 "Egyptian Metal Statuary of the Third Intermediate Period (Circa 1070–656 BC), from Its Egyptian Antecedents to Its Samian Examples." In *Small Bronze Sculpture from the Ancient World*, ed. Marion True and Jerry Podany, pp. 61–84. Malibu: Getty Museum.

Bissing, Friedrich Wilhelm von

1913 "Ägyptische bronze- und kupferfiguren des Mittleren Reiche." *MDAIA* 38, pp. 239–62.

1928 "Eine Priesterfigur aus der Bubastiden-Zeit." *Pantheon* 2, pp. 590–94.

1939 *Unterteil eines Menits des Stadtvorstehers und Veziers Harsiesis: Ein Beitrag zur Geschichte der Metallpolychromie*. Göttingen: Vandenhoeck & Ruprecht.

Boeser, P. A. A.

1907 *Catalogus van het Rijksmuseum van Oudheden te Leiden, Egyptische afdeeling*. The Hague: Ministerie van Binnenlandsche Zaken.

Bomann, Ann H.

1991 *The Private Chapel in Ancient Egypt: A Study of the*

Chapels in the Workmen's Village at El Amarna with Special Reference to Deir el Medina and Other Sites. London: Kegan Paul.

Borchardt, Ludwig

1899 "Der Zweite Papyrusfund von Kahun und die zeitliche Festlegung des mittleren Reiches der ägyptischen Geschichte." *ZÄS* 37, pp. 89–103.

1911 *Der Porträtkopf der Königin Teje im Besitz von Dr. James Simon in Berlin.* Leipzig: J. C. Hinrichs.

1911–36 *Statuen und Statuetten von Königen und Privatleuten im Museum von Kairo.* 5 vols. Berlin: Reichsdruckerei.

Boreux, Charles

1952 *Guide-catalogue sommaire [Musée du Louvre].* 2 vols. Paris: Musées Nationaux.

Bothmer, Bernard V.

1952 "Ptolemaic Reliefs I: A Granite Block of Philip Arrhidaeus." *Bulletin of the Museum of Fine Arts* 50, pp. 19–27.

1960 *Egyptian Sculpture of the Late Period: 700 B.C to A.D. 100.* Brooklyn: Brooklyn Museum.

1987 "Egyptian Antiquities." In *Antiquities from the Collection of Christos G. Bastis,* ed. E. S. Hall, pp. 1–106. Mainz am Rhein: Philipp von Zabern.

Boufides, Nikolaos

1981 "Takushit, the Daughter of the Great Chief of the Ma" (in Greek). *Archaiologikē Ephēmeris: Ekdidomenē tēs Archaiologikēs Hetaireias 1979: Archaiologika Chronika,* pp. 72–94.

Bourriau, Janine

1988 *Pharaohs and Mortals: Egyptian Art in the Middle Kingdom.* Exh. cat., Fitzwilliam Museum, Cambridge. Cambridge: Cambridge University Press.

Boyce, Andrew

1995 "Collar and Necklace Designs at Amarna: A Preliminary Study of Faience Pendants." In *Amarna Reports VI,* ed. Barry J. Kemp, pp. 336–71. London: Egypt Exploration Society.

Brier, Bob

2002 "Saga of Cleopatra's Needles." *Archaeology* 55 (November–December), pp. 48–54.

Brunner, Hellmut

1977 *Die südlichen Räume des Tempels von Luxor.* Mainz am Rhein: Philipp von Zabern.

Brunton, Guy

1948 *British Museum Expedition to Middle Egypt, 1929–1931: Matmar.* London: Quaritch.

Bucher, Paul

1928 "'Les hymnes à Sobek-Ra, seigneur de Smenou, papyri n° 2 et 7 de la Bibliothèque Nationale de Strasbourg." *Kêmi* 1, pp. 41–52, 147–66.

Budge, E. A. W.

1922 *A Guide to the Fourth, Fifth and Sixth Egyptian Rooms, and to the Coptic Room.* London: British Museum.

Burlington Fine Arts Club

1922 *Catalogue of an Exhibition of Ancient Egyptian Art.* London: Burlington Fine Arts Club.

Capart, Jean

1937–38 "Bronze Figurines of Egyptian Divinities from the Collection of H. H. Gorringe." *Worcester Art Museum Annual* 3, pp. 7–22.

Capel, Anne K., and Glenn E. Markoe

1996 Eds. *Mistress of the House, Mistress of Heaven: Women in Ancient Egypt.* New York: Hudson Hills Press.

Carnarvon, Earl of, and Howard Carter

1912 *Five Years' Explorations at Thebes: A Record of Work Done 1907–1911.* London: H. Frowde.

Cauville, Sylvie

1987 "Les statues cultuelles de Dendera d'après les inscriptions pariétals." *BIFAO* 87, pp. 73–117.

1998 *Dendara I: Traduction.* Leuven: Peeters.

2004 *Dendara V–VI: Les cryptes du temple d'Hathor.* 2 vols. Leuven: Peeters.

Caylus, Anne Claude Philippe, comte de

1761 *Recueil d'antiquités égyptiennes, étrusques, grecques et romaines.* New ed. Paris: Desaint et Saillant.

Cenival, Jean-Louis de

1986 "Fragment de perruque en bronze." In Karageorghis 1986, pp. 47–49.

Černý, Jaroslav

1962 "Egyptian Oracles." In *A Saite Oracle Papyrus from Thebes in the Brooklyn Museum,* ed. Richard A. Parker, pp. 35–48. Providence: Brown University Press.

Chassinat, Émile

1892–
1934 *Le temple d'Edfou.* 14 vols. Cairo: Institut Français d'Archéologie Orientale.

Chassinat, Émile, et al.

1934–
2001 Émile Chassinat, François Daumas, and Sylvie Cauville. *Le temple de Dendara.* 11 vols. Cairo: Institut Français d'Archéologie Orientale.

Chauveau, Michel

1996 "Les archives d'un temple des oasis au temps des Perses." *BSFE* 137, pp. 32–47.

1998 "Une oasis égyptienne au temps des Perses." *Égypte, Afrique et Orient* 9 (May), pp. 21–26.

Cladaki–Manoli, Eleni, et al.

2002 Eleni Cladaki-Manoli, Margarita Nicolakaki-Kentrou, and Eleni Tourna. "Egyptian Thesauri in the National Archaeological Museum of Athens." In *Ancient Egypt and Antique Europe: Two Parts of the Mediterranean World*, ed. Amanda-Alice Maravelia, pp. 31–56. Oxford: Archaeopress.

Clark, Charlotte R.

1951 "Egyptian Jewelry." *Metropolitan Museum of Art Bulletin* 10, no. 3 (November), pp. 110–12.

Clayton, Peter

1972 "Royal Bronze Shawabti Figures." *JEA* 58, pp. 167–75.

Colin, Frédéric

1998 "Les fondateurs du sanctuaire d'Amon à Siwa (Désert libyque): Autour d'un bronze de donation inédit." In *Egyptian Religion: The Last Thousand Years: Studies Dedicated to the Memory of Jan Quaegebeur*, ed. Willy Clarysse et al., pp. 329–55. Leuven: Peeters.

Cooney, John D.

1966 "On the Meaning of ⌑ ." *ZÄS* 93, pp. 43–48.

Cornelius, Izak

1994 *The Iconography of the Canaanite Gods Reshef and Ba'al: Late Bronze and Iron Age I Periods (c 1500–1000 BCE)*. Fribourg: University Press.

Courtois, Jacques–Claude

1984 *Alasia III: Les objets des niveaux stratifiés d'Enkomi (fouilles C.F.-A. Schaeffer 1947–1970)*. Paris: Éditions Recherche sur les Civilisations.

Courtois, Jacques–Claude, et al.

1986 Jacques-Claude Courtois, Jacques Lagarce, and Elisabeth Lagarce. *Enkomi et le bronze récent à Chypre*. Nicosia: Zavallis.

Cowell, R. Michael

1987 "Scientific Appendix 1: Chemical Analysis." In W. V. Davies et al., *Catalogue of Egyptian Antiquities in the British Museum*, vol. 7, *Tools and Weapons I: Axes*, pp. 96–118. London: British Museum.

Craddock, Paul T.

1976 "The Composition of Copper Alloys Used by the Greek, Etruscan and Roman Civilisations, 1: The Greeks before the Archaic Period." *JAS* 3, pp. 93–113.

1978 "The Composition of Copper Alloys Used by the Greek, Etruscan and Roman Civilizations, 3: The Origins and Early Use of Brass." *JAS* 5, pp. 1–16.

1985 "Three Thousand Years of Copper Alloys: From the Bronze Age to the Industrial Revolution." In *Application of Science in Examination of Works of Art*, ed. Pamela A. England and Lambertus van Zelst, pp. 59–67. Boston: Research Laboratory, Museum of Fine Arts.

Craddock, Paul T., and Alessandra Giumlia–Mair

1993 "Ḥsmn-km, Corinthian Bronze, Shakudo: Black-Patinated Bronze in the Ancient World." In *Metal Plating and Patination*, ed. Susan La Niece and Paul T. Craddock, pp. 101–27. Oxford: Butterworth-Heinemann.

Daumas, François

1988 *Valeurs phonétiques des signes hiéroglyphiques d'époque gréco-romaine*. Montpellier: Publications de la Recherche, Université de Montpellier.

D'Auria, Sue, et al.

1988 Sue D'Auria, Peter Lacovara, and Catharine H. Roehrig. *Mummies & Magic: The Funerary Arts of Ancient Egypt*. Exh. cat. Boston, Museum of Fine Arts.

Davies, Sue

2006 *The Sacred Animal Necropolis at North Saqqara: The Mother of Apis and Baboon Catacombs: The Archaeological Report*. London: Egypt Exploration Society.

Davies, Sue, and Harry S. Smith

1997 "Sacred Animal Temples at Saqqara." In *The Temple in Ancient Egypt: New Discoveries and Recent Research*, ed. Stephen Quirke, pp. 112–31. London: British Museum Press.

2005 *The Sacred Animal Necropolis at North Saqqara: The Falcon Complex and Catacomb: The Archaeological Report*. London: Egypt Exploration Society.

De Meulenaere, Herman

1960 "Les monuments du culte des rois Nectanébo." *Chronique d'Égypte* 35, pp. 92–107.

1971 "Le chefs de greniers du nom de Saésé au Nouvel Empire." *Chronique d'Égypte* 46, pp. 223–33.

1981 "Notes d'onomastique tardive (Quatrième série)." *Bibliotheca Orientalis* 38, pp. 253–58.

1990 "Bronzes égyptiens de donation." *Bulletin des Musées Royaux d'Art et d'Histoire* 61, pp. 63–81.

1998 "La statue d'un haut fonctionnaire saïte (Stockholm, MME 1986.1 + Vatican 22686)." *Bulletin of the Medelhavsmuseet* 31, pp. 13–21.

Del Francia, Pier Roberto

2000 "Di una statuetta dedicata ad Amon-Ra dal grande capo dei Ma Tefnakht nel Museo Egizio di Firenze." In *Atti del V Convegno Nazionale di Egittologia e Papirologia Firenze, 10–12 dicembre 1999*, ed. Simona Russo, pp. 63–112. Florence: Istituto Papirologico "G. Vitelli."

Delange, Élisabeth

1987 *Catalogue des statues égyptiennes du Moyen Empire: 2060–1560 avant J.-C.* Paris: Éditions de la Réunion des Musées Nationaux.

1998 "Couleur vraie." In *La couleur dans la peinture et l'émaillage de l'Égypte ancienne*, ed. Sylvie Colinart and Michel Menu, pp. 17–30. Bari: Edipuglia.

Delange, Élisabeth, et al.

1998 Élisabeth Delange, Angélique Di Mantova, and John H. Taylor. "Un bronze égyptien méconnu." *Revue du Louvre et des Musées de France*, no. 5 (December), pp. 67–75.

2005 Élisabeth Delange, Marie-Emmanuelle Meyohas, and Marc Aucouturier. "The Statue of Karomama: A Testimony of the Skill of Egyptian Metallurgists in Polychrome Bronze Statuary." *Journal of Cultural Heritage* 6, no. 2, pp. 99–113.

Deonna, Waldemar

1931 "L'attitude du repos dans la statuaire de la Grèce Archaïque et la loi de frontalité." *Revue Archéologique* 34, pp. 42–122.

Desroches-Noblecourt, Christiane

1967 *Toutankhamon et son temps.* Exh. cat., Musée du Petit Palais, Paris. Paris: Ministère d'État, Affaires Culturelles.

1995 *Amours et fureurs de La Lointaine: Clés pour la compréhension de symbols égyptiens.* Paris: Stock/Pernouds.

Dijk, Jacobus van

2003 "De Sfinx in de Oudheid: Van Egypte naar Griekenland en Terug." *Phoenix* 49, pp. 51–100.

Donadoni Roveri, Anna Maria

1989a Ed. *Dal Museo al Museo: Passato e futuro del Museo Egizio di Torino.* Exh. cat. Turin: Umberto Allemandi.

1989b Ed. *Egyptian Civilization: Monumental Art.* Turin: Istituto Bancario San Paolo.

Eckmann, Christian, and Saher Shafik

2005 *"Leben dem Horus Pepi": Restaurierung und technologische Untersuchung der Metallskulpturen des Pharao Pepi I. aus Hierakonpolis.* Mainz: Verlag des Römisch-Germanischen Zentralmuseums.

Eggebrecht, Arne

1993 Ed. *Pelizaeus-Museum Hildesheim: Die Ägyptische Sammlung.* Mainz am Rhein: Philipp von Zabern.

Eggler, Jürg

2006 "Baal." In *Iconography of Deities and Demons in the Ancient Near East: Electronic Pre-Publication*, at: http://www.religionswissenschaft.unizh.ch/idd/prepublications/e_idd_baal.pdf, pp. 1/8–8/8.

El-Toukhy, Adel

2005 "A Late Period Standing Statue of *Pꜣ-ḥr-Ḫnsw* in the Egyptian Museum JE 37860." *Bulletin of the Egyptian Museum* (Cairo) 2, pp. 61–64.

Emery, Walter B.

1965 "Preliminary Report on the Excavations at North Saqqâra 1964–65." *JEA* 51, pp. 3–8.

1966 "Preliminary Report on the Excavations at North Saqqâra 1965–66." *JEA* 52, pp. 3–8.

1967 "Preliminary Report on the Excavations at North Saqqâra 1966–67." *JEA* 53, pp. 141–45.

1969 "Preliminary Report on the Excavations at North Saqqâra 1968." *JEA* 55, pp. 31–35.

1970 "Preliminary Report on the Excavations at North Saqqâra 1968–69." *JEA* 56, pp. 5–11.

1971 "Preliminary Report on the Excavations at North Saqqâra 1969–70." *JEA* 57, pp. 3–13.

Englund, Gertie

1987 "Gifts to the Gods—A Necessity for the Preservation of Cosmos and Life: Theory and Praxis." In *Gifts to the Gods: Proceedings of the Uppsala Symposium 1985*, ed. Tullia Linders and Gullög Nordquist, pp. 57–66. Uppsala: Academia Ubsaliensis.

Favard-Meeks, Christine

1991 *Le temple de Behbeit el-Hagara: Essai de reconstitution et d'interpretation.* Hamburg: H. Buske.

Fay, Biri

2003 "L'art égyptien du Moyen Empire. Seconde partie." *Égypte Afrique et Orient* 31 (October), pp. 13–34.

Fay, Biri, et al.

1990 *Egyptian Museum Berlin.* 4th ed. Berlin: Ägyptisches Museum der Staatlichen Museen Preussischer Kulturbesitz.

Fazzini, Richard A.

1988 *Egypt Dynasty XXII–XXV.* Leiden: Brill.

1996 "Third Intermediate Period Sculpture." In *The Dictionary of Art*, ed. Jane Turner, vol. 9, p. 886. New York: Grove.

1997 "Several Objects, and Some Aspects of the Art of the Third Intermediate Period." In *Chief of Seers:*

Egyptian Studies in Memory of Cyril Aldred, ed. Elizabeth Goring et al., pp. 113–37. London: Kegan Paul.

2001 "Four Unpublished Ancient Egyptian Objects in Faience in the Brooklyn Museum of Art." *JSSEA* 28, pp. 55–66.

2002 "Some Reliefs of the Third Intermediate Period in the Egyptian Museum, Cairo." In *Egyptian Museum Collections around the World,* ed. Mamdouh Eldamaty and Mai Trad, vol. 1, pp. 351–62. Cairo: Supreme Council of Antiquities.

Fechheimer, Hedwig

1922 *Die Plastik der Ägypter.* Berlin: B. Cassirer.

Fischer, Henry G.

1956 "Prostrate Figures of Egyptian Kings." *University Museum Bulletin* 20, no. 1, pp. 27–42.

1977 "Fächer und Wedel." In *Lexikon der Ägyptologie,* vol. 2, cols. 81–85. Wiesbaden: Harrassowitz.

Fishman, Bernard, and Stewart J. Fleming

1980 "A Bronze Figure of Tutankhamun: Technical Studies." *Archaeometry* 22, no. 1, pp. 81–86.

Forty, A. J.

1979 "Corrosion Micromorphology of Noble Metal Alloys and Depletion Gilding." *Nature* 282, pp. 597–98.

Frantz, James H., and Deborah Schorsch

1990 "Egyptian Red Gold." *Archeomaterials* 4, pp. 133–52.

Freed, Rita E., et al.

1999 Rita E. Freed, Yvonne J. Markowitz, and Sue D'Auria, eds. *Pharaohs of the Sun: Akhenaten, Nefertiti, Tutankhamen.* Exh. cat., Museum of Fine Arts, Boston; Los Angeles County Museum of Art; Art Institute of Chicago; Rijksmuseum van Oudheden, Leiden. Boston: Bulfinch Press.

Gale, Noel H., and Zofia A. Stós-Gale

1981 "Ancient Egyptian Silver." *JEA* 67, pp. 103–15.

Gänsicke, Susanne

1994 "King Aspelta's Vessel Hoard from Nuri in the Sudan." *Journal of the Museum of Fine Arts, Boston* 6, pp. 14–40.

Gardiner, Alan H., et al.

1933 Alan H. Gardiner, Amice M. Calverley, and Myrtle F. Broome. *The Temple of King Sethos I at Abydos,* vol. 1, *The Chapels of Osiris, Isis, and Horus.* London: Egypt Exploration Society.

1935 Alan H. Gardiner, Amice M. Calverley, and Myrtle F. Broome. *The Temple of King Sethos I at Abydos,* vol. 2, *The Chapels of Amen-Rē, Rē-Harakhti,*

Ptah and King Sethos. London: Egypt Exploration Society.

1959 Alan H. Gardiner, Amice M. Calverley, and Myrtle F. Broome. *The Temple of King Sethos I at Abydos,* vol. 4, *The Great Hypostyle Hall.* London: Egypt Exploration Society.

Gasse, Annie

1996 *Les sarcophages de la Troisième Période Intermédiaire du Museo Gregoriano Egizio.* Vatican City: Monumenti, Musei e Gallerie Pontificie.

Giumlia-Mair, Alessandra R.

1996 "Das Krokodil und Amenemhat III aus el-Faiyum." *Antike Welt* 27, pp. 313–21.

1997 "Black Copper Is Not Niello." *Egyptian Archaeology* 11, pp. 35–36.

Giumlia-Mair, Alessandra R., and Paul T. Craddock

1993 "Corinthium aes: Das schwarze Gold der Alchimisten." *Antike Welt* 24, pp. 2–62.

Giumlia-Mair, Alessandra R., and Stephen Quirke

1997 "Black Copper in Bronze Age Egypt." *Revue d'Égyptologie* 48, pp. 95–108.

Gorringe, Henry H.

1882 *Egyptian Obelisks.* New York: Published by the author.

Goyon, Jean-Claude

1975 "Textes mythologiques II: 'Les révélations du mystère des quatre boules.'" *BIFAO* 75, pp. 349–99.

1999 *Le papyrus d'Imouthès, fils de Psintaès.* New York: Metropolitan Museum of Art.

Gozzoli, Roberto

2000 "The Statue British Museum EA 37891 and the Erasure of Necho II's Names." *JEA* 86, pp. 67–80.

Graefe, Erhart

1981 *Untersuchungen zur Verwaltung und Geschichte der Institution der Gottesgemahlin des Amun vom Beginn des Neuen Reiches bis zur Spätzeit.* 2 vols. Wiesbaden: Harrassowitz.

1994 "Der autobiographische Text des Ibi, Obervermögensverwalter der Gottesgemahlin Nitokris, auf Kairo JE 36158." *MDAIK* 50, pp. 85–99.

2003 *Das Grab des Padihorresnet: Obervermögensverwalter der Gottesgemahlin des Amun (Thebanisches Grab Nr. 196).* Turnhout: Brepols.

Graham, Geoffrey

2001 "Insignias." In *Oxford Encyclopedia of Ancient Egypt,* ed. Donald B. Redford, vol. 2, pp. 163–67. Oxford: Oxford University Press.

Grajetzki, Wolfram

2001 *Two Treasurers of the Late Middle Kingdom*. Oxford: Archaeopress.

Grandet, Pierre

1994–99 *Papyrus Harris I: BM9999*. 3 vols. Cairo: Institut Français d'Archéologie Orientale.

Grenfell, Bernard P., and Arthur S. Hunt

1902–3 "Report of the Graeco-Roman Branch." *Egypt Exploration Fund, Archaeological Report*, pp. 1–9.

Griffin, Patricia S.

2000 "The Selective Use of Gilding on Egyptian Polychromed Bronzes." In *Gilded Metals: History, Technology, and Conservation*, ed. Terry Drayman-Weisser, pp. 49–72. London: Archetype Publications.

Griffith, Francis Llewellyn

1890 *The Mound of the Jew and the City of Onias: Belbeis, Samanood, Abusir, Tukh El Karmus, 1887 [and] The Antiquities of Tell el Yahûdîyeh*. London: K. Paul, Trench, Trübner.

Guermeur, Ivan

2005 *Les cultes d'Amon hors de Thèbes: Recherches de géographie religieuse*. Turnhout: Brepols.

Harlé, Diane, and Jean Lefebvre

1993 Eds. *Sur le Nil avec Champollion: Lettres, journaux et dessins inédits de Nestor L'Hôte: Premier voyage en Égypte, 1828–1830*. Orléans-Caen: Éditions Paradigme.

Harvey, Julia Carol

2001 *Wooden Statues of the Old Kingdom: A Typological Study*. Leiden: Brill.

Hastings, Elizabeth Anne

1997 *The Sculpture from the Sacred Animal Necropolis at North Saqqâra, 1964–76*. London: Egypt Exploration Society.

Hayes, William C.

1990 *The Scepter of Egypt: A Background for the Study of the Egyptian Antiquities in The Metropolitan Museum of Art*. 2 vols. Rev. ed. New York: Metropolitan Museum of Art.

Helck, Wolfgang

1980 "Opferstiftung." In *Lexikon der Ägyptologie*, vol. 4, cols. 590–94. Wiesbaden: Harrassowitz.

Hema, Rehab Assem

2005 *Group Statues of Private Individuals in the New Kingdom*. 2 vols. Oxford: British Archaeological Reports.

Heywood, Ann

Forth-coming "An Unusual Ancient Surface Reconstructed." Paper presented at the conference "Decorated Surfaces on Ancient Egyptian Objects: Technology, Deterioration and Conservation," ICON Archaeology Group and the Fitzwilliam Museum, University of Cambridge, 6–9 September 2007.

Hill, Marsha

2002 "A Bronze Aegis of King Amasis in the Egyptian Museum: Bronzes, Unconventionality and Unexpected Connections." In *Egyptian Museum Collections around the World*, ed. Mamdouh Eldamaty and Mai Trad, vol. 1, pp. 545–56. Cairo: Supreme Council of Antiquities.

2004 *Royal Bronze Statuary from Ancient Egypt: With Special Attention to the Kneeling Pose*. Leiden: Brill.

Forth-coming (a) "Hepu's Hair: A Copper Alloy Statuette in the National Archaeological Museum in Athens." *Bulletin of the Egyptological Seminar*.

Forth-coming (b) *The Amherst Statuary from the Dump of the Great Temple of the Aten at Amarna*. New York.

Hill, Marsha, and Deborah Schorsch

1997 "A Bronze Statuette of Thutmose III." *Metropolitan Museum Journal* 32, pp. 5–18.

2005 "The Gulbenkian Torso of King Pedubaste: Investigations into Egyptian Large Bronze Statuary." *Metropolitan Museum Journal* 40, pp. 163–95.

Hirao, Yoshimitsu, et al.

1995 Yoshimitsu Hirao, Junko Enomoto, and Hideko Tachikawa. "Lead Isotope Ratios of Copper, Zinc, and Lead Minerals in Turkey, in Relation to the Provenance Study of Artefacts." In *Essays on Ancient Anatolia and Its Surrounding Civilizations*, ed. Prince Takahito Mikasa, pp. 89–114. Wiesbaden: Harrassowitz.

Hodjash, Svetlana, and Oleg Berlev

1982 *The Egyptian Reliefs and Stelae in the Pushkin Museum of Fine Arts, Moscow*. Leningrad: Aurora Art Publishers.

Hoffmann, Friedhelm

1996 *Der Kampf um den Panzer des Inaros: Studien zum P. Krall und seiner Stellung innerhalb des Inaros-Petubastis-Zyklus*. Vienna: Bruder Hollinek.

Hornung, Erik

1982 *Der ägyptische Mythos von der Himmelskuh: Eine Ätiologie des Unvollkommenen*. Göttingen: Vandenhoeck & Ruprecht.

Hornung, Erik, and Betsy M. Bryan

2002 Eds. *The Quest for Immortality: Treasures of Ancient Egypt*. Exh. cat. Washington, D.C.: National Gallery of Art.

In Pharaos Grab

2006 *In Pharaos Grab: Die verborgenen Stunden der Sonne.* Exh. cat. Basel: Antikenmuseum Basel und Sammlung Ludwig.

Insley, Christine

1979 "A Bronze Statuette of Unnufer, Choachyte of King Harsiese, in the Fitzwilliam Museum." *JEA* 65, pp. 167–69.

Insley Green, Christine

1987 *The Temple Furniture from the Sacred Animal Necropolis at North Saqqâra, 1964–1976.* London: Egypt Exploration Society.

Jacquet-Gordon, Helen

1964–65 "A Statue of a Son of Karoma." *Brooklyn Museum Annual* 6, pp. 43–49.

1967 "A Statuette of Ma'et and the Identity of the Divine Adoratress Karomama." *ZÄS* 94, pp. 86–93.

James, T. G. H.

1974 *Corpus of Hieroglyphic Inscriptions in the Brooklyn Museum.* Brooklyn: The Museum.

Jansen-Winkeln, Karl

1985 *Ägyptische Biographien der 22. und 23. Dynastie.* 2 vols. Wiesbaden: Harrassowitz.

1995 "Die Plünderung der Königsgräber des Neuen Reiches." *ZÄS* 122, pp. 62–78.

2001 *Biographische und religiöse Inschriften der Spätzeit aus dem Ägyptischen Museum Kairo.* 2 vols. Wiesbaden: Harrassowitz.

2004 "Zu einigen Inschriften der Dritten Zwischenzeit." *Revue d'Égyptologie* 55, pp. 45–79.

Jantzen, Ulf

1972 *Ägyptische und orientalische Bronzen aus dem Heraion von Samos.* Bonn: Deutsches Archäologisches Institut.

Jorgensen, Mogens

1998 *Catalogue, Egypt II (1550–1080 B.C.).* Copenhagen: Ny Carlsberg Glyptotek.

Josephson, Jack A.

1988 "An Altered Royal Head of the Twenty-Sixth Dynasty." *JEA* 74, pp. 232–35.

1992 "A Variant Type of Uraeus in the Late Period." *Journal of the American Research Center in Egypt* 29, pp. 123–30.

1997 *Egyptian Royal Sculpture of the Late Period, 400–246 B.C.* Mainz am Rhein: Philipp von Zabern.

Josephson, Jack A., et al.

2005 Jack Josephson, Paul O'Rourke, and Richard Fazzini. "The Doha Head: A Late Period Egyptian Portrait." *MDAIK* 61, pp. 219–41.

Kaper, Olaf E.

2003 *The Egyptian God Tutu: A Study of the Sphinx-God and Master of Demons with a Corpus of Monuments.* Leuven: Peeters.

Karageorghis, Vassos

1986 "Kypriaka IX." *RDAC*, pp. 46–54.

Karetsou, Alexandra, and Maria Andreadakē–Vlazakē

2000 Eds. *Krētē Aigyptos: Politismikoi desmoi triōn chilietiōn / Crete-Egypt: Three Thousand Years of Cultural Links.* Exh. cat., Archaiologikon Mouseion Hērakleiou. Herakleion: Hellenic Ministry of Culture.

Karlshausen, Christine

1997 "L'iconographie de la barque processionnelle divine en Égypte au Nouvel Empire." 2 vols. Ph.D. diss., Université Catholique de Louvain.

Kees, Hermann

1961 "'Gottesväter' als Priesterklasse." *ZÄS* 86, pp. 115–25.

Keimer, Louis

1948 *Remarques sur le tatouage dans l'Égypte ancienne.* Cairo: Institut Français d'Archéologie Orientale.

Kemp, Barry J.

1995 "How Religious Were the Ancient Egyptians?" *Cambridge Archaeological Journal* 5, no. 1, pp. 25–54.

2006 *Ancient Egypt: Anatomy of a Civilization.* 2d ed. London: Routledge.

Kessler, Dieter

1989 *Die heiligen Tiere und der König,* vol. 1, *Beiträge zu Organisation, Kult und Theologie der spätzeitlichen Tierfriedhöfe.* Wiesbaden: Harrassowitz.

Kitchen, Kenneth A.

1986 *The Third Intermediate Period in Egypt, 1100–650 B.C.* 2d ed. with suppl. Warminster: Aris & Phillips.

Koemoth, Pierre

1993 "Le rite de redresser Osiris." In *Ritual and Sacrifice in the Ancient Near East,* ed. Jan Quaegebeur, pp. 157–74. Leuven: Peeters.

Kozloff, Arielle P., et al.

1992 Arielle P. Kozloff, Betsy M. Bryan, Lawrence M. Berman, and Élisabeth Delange. *Egypt's Dazzling Sun: Amenhotep III and His World.* Exh. cat., Cleveland Museum of Art. Bloomington: Indiana University Press.

Kyrieleis, Helmut

1990 "Samos and Some Aspects of Archaic Greek Bronze Casting." In *Small Bronze Sculpture from the Ancient World*, ed. Marion True and Jerry Podany, pp. 15–30. Malibu: Getty Museum.

La Niece, Susan, et al.

2002 Susan La Niece, Fleur Shearman, John Taylor, and Antony Simpson. "Polychromy and Egyptian Bronze: New Evidence for Artificial Coloration." *Studies in Conservation* 47, pp. 95–108.

Laboury, Dimitri

1998 *La statuaire de Thoutmosis III: Essai d'interprétation d'un portrait royal dans son contexte historique*. Liège: C.I.P.L.

Lacovara, Peter

1981 "The Hearst Excavations at Deir el-Ballas: The Eighteenth Dynasty Town." In *Studies in Ancient Egypt, the Aegean, and the Sudan*, ed. William Kelly Simpson and Whitney M. Davis, pp. 120–24. Boston: Department of Egyptian and Ancient Near Eastern Art, Museum of Fine Arts.

Leclant, Jean

1961a "Un statuette d'Amon–Rê–Montou au nom de la adoratrice Chepenoupet." In *Mélanges Maspero*, vol. 1, *Orient ancien*, fasc. 4, pp. 73–98. Cairo: Institut Français d'Archéologie Orientale.

1961b "Sur un contrepoids de Menat au nom de Taharqa." In *Mélanges Mariette*, pp. 251–85. Cairo: Institut Français d'Archéologie Orientale.

Leemans, Conrad

1840 *Description raisonnée des monuments égyptiens du Musée d'antiquités des Pays-Bas*. Leiden: H. W. Hazenberg.

Legrain, Georges

1917 "Le logement et transport des barques sacrées et des statues des dieux dans quelques temples égyptiens." *BIFAO* 13, pp. 1–76.

Lichtheim, Miriam

1973 *Ancient Egyptian Literature*, vol. 1, *The Old and Middle Kingdoms*. Berkeley: University of California Press.

1980 *Ancient Egyptian Literature*, vol. 3, *The Late Period*. Berkeley: University of California Press.

Liepsner, Thomas F.

1980 "Modelle." In *Lexikon der Ägyptologie*, vol. 4, cols. 168–80. Wiesbaden: Harrassowitz.

Lilyquist, Christine

2007 "Reflections on Mirrors." In *The Archaeology and Art of Ancient Egypt: Essays in Honor of David B. O'Connor*, ed. Zahi Hawass and Janet Richards, pp. 95–110. Cairo: Supreme Council of Antiquities.

Lorton, David

1999 "The Theology of Cult Statues in Ancient Egypt." In *Born in Heaven, Made on Earth: The Making of the Cult Image in the Ancient Near East*, ed. Michael B. Dick, pp. 123–210. Winona Lake, Ind.: Eisenbrauns.

Lucas, Alfred

1962 *Ancient Egyptian Materials and Industries*. 4th ed., rev. and enl. by James R. Harris. London: E. Arnold.

Málek, Jaromír

1999 With Diana Magee and Elizabeth Miles. *Topographical Bibliography of Ancient Egyptian Hieroglyphic Texts, Statues, Reliefs, and Paintings*, vol. 8, *Objects of Provenance Not Known*, parts 1 and 2. Oxford: Griffith Institute, Ashmolean Museum.

Malinine, Michel, et al.

1968 Michel Malinine, Georges Posener, and Jean Vercoutter. *Catalogue des stèles du Sérapéum de Memphis*. 2 vols. Paris: Éditions des Musées Nationaux.

Manniche, Lise

1999 *Sacred Luxuries: Fragrance, Aromatherapy, and Cosmetics in Ancient Egypt*. Ithaca, N.Y.: Cornell University Press.

Marchand, Sylvie

Forth- "La céramique de la partie sud de l'oasis de
coming Kharga." In *The Oasis Papers 5: Proceedings of the Fifth International Conference of the Dakhleh Oasis Project*, *Cairo, 3–6 June 2006*.

Martin, Geoffrey T.

1973 "Excavations in the Sacred Animal Necropolis at North Saqqâra, 1971–72: Preliminary Report." *JEA* 59, pp. 5–15.

1974 "Excavations in the Sacred Animal Necropolis at North Saqqâra, 1972–73: Preliminary Report." *JEA* 60, pp. 15–29.

1981 *The Sacred Animal Necropolis at North Saqqâra: The Southern Dependencies of the Main Temple Complex*. London: Egypt Exploration Society.

Maspero, Gaston

1900 "Lettre à M. François Lenormant." *Bibliothèque Égyptologique* 8, pp. 259–66.

1907 Ed. *Le Musée Égyptien: Recueil de monuments et de notices sur les fouilles d'Égypte*. Vol. 2. Cairo: Institut Français d'Archéologie Orientale.

Mathieu, Bernard

2002 "Travaux de l'Institut Français d'Archéologie Orientale en 2001–2002." *BIFAO* 102, pp. 437–614.

Mathis, François

2005 "Croissance et propriétés photo-colorimétriques des couches d'oxydation et des patines à la surface d'alliages cuivreux d'intérêt archéologique ou artistique." Ph.D diss., Université Paris 11.

Mathis, François, et al.

2007 F. Mathis, J. Salomon, S. Pagès-Camagna, M. Dubus, D. Robcis, M. Aucouturier, S. Descamps, and É. Delange. "Corrosion Patina or Intentional Patina? Contribution of Non-destructive Analyses to the Surface Study of Copper Based Archaeological Objects." In *Corrosion of Metallic Heritage Artefacts*, ed. Philippe Dillmann et al. London: European Federation of Corrosion Publications.

Maystre, Charles

1986 *Tabo*, vol. 1, *Statue en bronze d'un roi méroïtique, Musée National de Khartoum, Inv. 24705*. Geneva: Georg.

Medinet Habu

1957 *Medinet Habu*, vol. 5, *The Temple Proper*. Chicago: University of Chicago Press.

Mendoza, Barbara

2004 "Private Cupreous Statuary from the Old to the Middle Kingdoms." *Journal of the Association of Graduates in Near Eastern Studies* 10, no. 1, pp. 23–61.

2006 "Everlasting Servants of the Gods: Bronze Priests of Ancient Egypt from the Middle Kingdom to the Greco-Roman Period." Ph.D. diss., University of California, Berkeley.

Mercer, Samuel A. B.

1916 "Note on the Gorringe Collection." *Ancient Egypt*, part 2, pp. 49–52, 95–96.

Minutoli, Heinrich

1824 *Reise zum Tempel des Jupiter Ammon in der libyschen Wüste und nach Oberägypten in den Jahren 1820 und 1821*. Berlin: A. Rucker.

Mishara, Joan, and Pieter Meyers

1974 "Ancient Egyptian Silver: A Review." In *Recent Advances in Science and Technology of Materials*, ed. Adli Bishay, vol. 3, pp. 29–45. New York: Plenum.

Monnet, Janine

1955 "Un monument de la corégence des divine adoratrices Nitocris et Ankhenesneferibré." *Revue d'Égyptologie* 10, pp. 37–47.

Montet, Pierre

1947 *Les constructions et le tombeau d'Osorkon II à Tanis*. Paris: Jourde et Allard.

1961 *Géographie de l'Égypte ancienne*, vol. 2, *To-chema, La Haute Égypte*. Paris: C. Klincksieck.

1966 *Le lac sacré de Tanis*. Paris: C. Klincksieck.

Moran, William L.

1992 Ed. and trans. *The Amarna Letters*. Baltimore: Johns Hopkins University Press.

Müller, Hans Wolfgang

1955a "Ein Königbildnis der 26. Dynastie mit der 'Blauen Krone' im Museo Civico zu Bologna." *ZÄS* 80, pp. 46–68.

1955b "Die Torso einer Königsstatue im Museo Archeologico zu Florenz: Ein Beitrag zur Plastik der Ägyptischen Spätzeit." In *Studi in Memoria di Ippolito Rosellini*, vol. 2, pp. 183–221. Pisa: V. Lischi.

Müller, Maya

1984–85 "Zwei Bildwerke aus der Dritten Zwischenzeit." *Bulletin de la Société d'Égyptologie de Genève* 9–10, pp. 199–222.

Murakami, Ryu

1993 "Japanese Traditional Alloys." In *Metal Plating and Patination*, ed. Susan La Niece and Paul T. Craddock, pp. 85–94. Oxford: Butterworth-Heinemann.

Murnane, William J.

1995 *Texts from the Amarna Period in Egypt*. Atlanta: Scholars Press.

Myśliwiec, Karol

1978–79 *Studien zum Gott Atum*. 2 vols. Hildesheim: Gerstenberg.

Naville, Édouard

1890 *The Mound of the Jew and the City of Onias: Belbeis, Samanood, Abusir, Tukh El Karmus, 1887 [and] The Antiquities of Tell el Yahûdîyeh*. London: K. Paul, Trench, Trübner.

Nicholson, Paul T.

2004 "Conserving Bronzes from North Saqqara." *Egyptian Archaeology* 25 (Autumn), pp. 7–9.

Nicholson, Paul T., and Harry S. Smith

1996a "Fieldwork, 1995–6: The Sacred Animal Necropolis at North Saqqara." *JEA* 82, pp. 8–11.

1996b "An Unexpected Cache of Bronzes." *Egyptian Archaeology* 9, p. 18.

Niwinski, Andrzej

1988 *21st Dynasty Coffins from Thebes: Chronological and Typological Studies*. Mainz am Rhein: Philipp von Zabern.

Oddy, Andrew, et al.

1988 Andrew Oddy, P. Pearce, and L. Green. "An Unusual Gilding Technique on Some Egyptian Bronzes." In *Conservation of Ancient Egyptian Materials*, ed. Sarah C. Watkins and Carol E. Brown, pp. 35–39. London: Institute of Archaeology Publications.

Ogden, Jack

2000 "Metals." In *Ancient Egyptian Materials and Technology*, ed. Paul T. Nicholson and Ian Shaw, pp. 148–76. Cambridge: Cambridge University Press.

Osborne, Robin

2004 "Hoards, Votives, Offerings: The Archaeology of the Dedicated Object." *World Archaeology* 36, pp. 1–10.

Parlasca, Klaus

1953 "Zwei ägyptische Bronzen aus dem Heraion von Samos." *MDAIA* 68, pp. 127–36.

Payraudeau, Frédéric

2003 "Harsiésis, un vizir oublié de l'époque libyenne." *JEA* 89, pp. 199–205.

Perdu, Olivier

2003 "Des pendentifs en guise d'ex-voto." *Revue d'Égyptologie* 54, pp. 155–66.

2004 "La chefferie de Sébennytos de Piankhi à Psammétique Ier." *Revue d'Égyptologie* 55, pp. 95–111.

Petrie, W. M. Flinders

1886 *Naukratis, Part I: 1884–5*. London: Trübner.

Petschel, Susanne, and Martin von Falck

2004 Eds. *Pharao siegt immer: Krieg und Frieden im alten Ägypten*. Exh. cat., Gustav-Lübcke-Museum, Hamm. Bönen: Kettler.

Pfrommer, Michael

1987 *Studien zu alexandrinischer und grossgriechischer Toreutik frühhellenistischer Zeit*. Berlin: Mann.

1999 *Alexandria: Im Schatten der Pyramiden*. Mainz am Rhein: Philipp von Zabern.

Pichot, Valérie, et al.

2006 Valérie Pichot, Philippe Fluzin, Michel Vallogia, and Michel Wuttmann. "Les chaînes opératoires métallurgiques en Égypte à l'époque gréco-romaine: Premiers résultats archéométriques et archéologiques." In *L'apport de l'Égypte à l'histoire des techniques*, ed. Bernard Mathieu et al., pp. 217–37. Cairo: Institut Français d'Archéologie Orientale.

Pinch, Geraldine

1994 *Magic in Ancient Egypt*. London: British Museum Press.

Porter, Bertha, and Rosalind L. B. Moss

1934 *Topographical Bibliography of Ancient Egyptian Hieroglyphic Texts, Reliefs, and Paintings*, vol. 4, *Lower and Middle Egypt*. Oxford: Clarendon.

1937 *Topographical Bibliography of Ancient Egyptian Hieroglyphic Texts, Reliefs, and Paintings*, vol. 5, *Upper Egypt*. Oxford: Griffith Institute, Ashmolean Museum.

1964 With Ethel W. Burney. *Topographical Bibliography of Ancient Egyptian Hieroglyphic Texts, Reliefs, and Paintings*, vol. 1, *The Theban Necropolis*, part 2, *Royal Tombs and Smaller Cemeteries*. 2d ed. Oxford: Clarendon Press.

1978 With Ethel W. Burney. *Topographical Bibliography of Ancient Egyptian Hieroglyphic Texts, Reliefs, and Paintings*, vol. 3, *Memphis*, parts 1 and 2. Oxford: Griffith Institute, Ashmolean Museum.

Posener-Kriéger, Paule

1976 *Les archives du temple funéraire de Néferirkarê-Kakaï (Les papyrus d'Abousir)*. Cairo: Institut Français d'Archéologie Orientale.

1997 "News from Abusir." In *The Temple in Ancient Egypt: New Discoveries and Recent Research*, ed. Stephen Quirke, pp. 17–23. London: British Museum Press.

Postolakas, Achilleus

1881 *Sammlung ägyptischer Altertümer der hellenischen Nation geschenkt von G. Di Demetrio*. Supplement to Arthur Milchhöfer, *Die Museen Athens*. Leipzig: K. Wilberg.

Priese, Karl-Heinz

1991 Ed. *Ägyptisches Museum: Museumsinsel Berlin*. Mainz am Rhein: Philipp von Zabern.

1993 *The Gold of Meroe*. Exh. cat. New York: Metropolitan Museum of Art.

Quibell, James E.

1912 *Excavations at Saqqara*, vol. 4, *1908–1909, 1909–1910*. Cairo: Institut Français d'Archéologie Orientale.

Quirke, Stephen

1997 "Gods in the Temple of the King: Anubis at Lahun." In *The Temple in Ancient Egypt: New Discoveries and Recent Research*, ed. Stephen Quirke, pp. 24–48. London: British Museum Press.

Radwan, Ali

2005 "The Sacred Ram-Head of the Sun-God." *ASAE* 79, pp. 211–24.

Raven, Maarten J.

1992 "A Catalogue Project of Bronzes in Leiden." In *Sesto Congresso internazionale di egittologia*, vol. 1,

pp. 529–34. Turin: International Association of Egyptologists.

1993 "The Lady of Leiden: A Monumental Bronze Figure and Its Restoration." In *Aegyptus museis rediviva: Miscellanea in honorem Hermanni De Meulenaere*, ed. Luc Limme and Jan Strybol, pp. 129–40. Bruxelles: Musées Royaux d'Art et d'Histoire.

Raven, Maarten J., et al.

1998 Maarten J. Raven, David A. Aston, John H. Taylor, Eugen Strouhal, Georges Bonani, and Willy Woelfli. "The Date of the Secondary Burials in the Tomb of Iurudef at Saqqara." *Oudheidkundige Mededeelingen van het Rijksmuseum van Oudheden te Leiden* 78, pp. 7–30.

Ray, John D.

Forth-coming *Texts from the Baboon and Falcon Galleries: Demotic, Hieroglyphic and Greek Inscriptions from the Sacred Animal Necropolis, North Saqqâra.* London: Egypt Exploration Society.

Redford, Donald B.

2004 *Excavations at Mendes.* Leiden: Brill.

Rehren, Thilo

2005 "Blech und Nägel: Das Material der Pepi-Statuen." In *"Leben dem Horus Pepi": Restaurierung und technologische Untersuchung der Metallskulpturen des Pharao Pepi I. aus Hierakonpolis*, Christian Eckmann and Saher Shafik, pp. 71–75. Mainz: Verlag des Römisch-Germanischen Zentralmuseums.

Rehren, Thilo, et al.

1996 Thilo Rehren, Karsten Hess, and Graham Philip. "Auriferous Silver in Western Asia: Ore or Alloy?" *Journal of the Historical Metallurgy Society* 30, pp. 1–9.

Reuterswärd, Patrik

1958 *Studien zur Polychromie der Plastik. 1, Aegypten.* Stockholm: Almqvist & Wiksell.

Révillout, Eugène

1891–92 "Nouvelle statue de Bronze au Musée Égyptien du Louvre." *Bulletin des Musées* 2, pp. 333–34, 443–45.

Riederer, Josef

1978 "Die naturwissenschaftliche Untersuchung der Bronzen des Ägyptischen Museums Preussischer Kulturbesitz in Berlin." *Berliner Beiträge zur Archäometrie* 3, pp. 5–42.

1982 "Die naturwissenschaftliche Untersuchung der Bronzen der Staatlichen Sammlung Ägyptischer Kunst in München." *Berliner Beiträge zur Archäometrie* 7, pp. 5–34.

1983 "Metallanalysen der ägyptischen Statuetten des Kestner-Museums, Hannover." *Berliner Beiträge zur Archäometrie* 8, pp. 5–17.

1984 "Die naturwissenschaftliche Untersuchung der ägyptischen Bronzen des Pelizaeus-Museums in Hildesheim." *Berliner Beiträge zur Archäometrie* 9, pp. 5–16.

1988 "Metallanalysen ägyptischer Bronzestatuetten aus Deutschen-Museen." *Berliner Beiträge zur Archäometrie* 10, pp. 5–20.

Riefstahl, Elizabeth

1945–44 "Doll, Queen, or Goddess?" *Brooklyn Museum Journal*, pp. 5–23.

1944 *Patterned Textiles in Pharaonic Egypt.* Brooklyn: Brooklyn Museum.

Riggs, Christina

2001 "Forms of the *Wesekh* Collar in Funerary Art of the Greco-Roman Period." *Chronique d'Égypte* 76, pp. 57–68.

Robins, Gay

1997 *The Art of Ancient Egypt.* London: British Museum Press.

2005 "Cult Statues in Ancient Egypt." In *Cult Image and Divine Representation in the Ancient Near East*, ed. Neal H. Walls, pp. 1–12. Boston: American Schools of Oriental Research.

Roccati, Alessandro

1982 *La littérature historique sous l'ancien empire égyptien.* Paris: Éditions du Cerf.

Roeder, Günther

1937 *Ägyptische Bronzewerke.* Glückstadt: J. J. Augustin.

1956 *Ägyptische Bronzefiguren.* Berlin: Staatliche Museen zu Berlin.

Roehrig, Catharine H.

1990 "The Eighteenth Dynasty Titles Royal Nurse (*mnˁt nswt*), Royal Tutor (*mnˁ nswt*), and Foster Brother/Sister of the Lord of the Two Lands (*sn/snt mnˁ n nb t3wy*)." Ph.D. diss., University of California, Berkeley.

1992 "Ram's-Head Amulet." *Metropolitan Museum of Art Bulletin* 49 (Spring), p. 34.

1996 "Woman's Work: Some Occupations of Nonroyal Women as Depicted in Ancient Egyptian Art." In *Mistress of the House, Mistress of Heaven: Women in Ancient Egypt*, ed. Anne K. Capel and Glenn E. Markoe, pp. 13–24. New York: Hudson Hills Press.

2002 *Life along the Nile: Three Egyptians of Ancient Thebes.* New York: Metropolitan Museum of Art.

2005 Ed., with Renée Dreyfus and Cathleen A. Keller. *Hatshepsut: From Queen to Pharaoh.* Exh. cat., M. H.

de Young Memorial Museum, San Francisco; The Metropolitan Museum of Art, New York; Kimbell Art Museum, Fort Worth. New Haven: Yale University Press.

Romano, James

1980 "The Origin of the Bes-Image." *Bulletin of the Egyptological Seminar* 2, pp. 39–56.

1992 "A Statuette of a Royal Mother and Child in the Brooklyn Museum." *MDAIK* 48, pp. 131–43.

Russmann, Edna R.

1989 *Egyptian Sculpture: Cairo and Luxor.* Austin: University of Texas Press.

2001 *Eternal Egypt: Masterworks of Ancient Art from the British Museum.* Exh. cat. New York: American Federation of Arts.

Sauneron, Serge

1968 "Quelques monuments de Soumenou au Musée de Brooklyn." *Kêmi* 8, pp. 57–78.

Sayre, Edward V., et al.

2001 Edward V. Sayre, Emile C. Joel, M. James Blackman, K. Aslahan Yener, and Hadi Özbal. "Stable Lead Isotope Studies of Black Sea Anatolian Ore Sources and Related Bronze Age and Phrygian Artefacts from Nearby Archaeological Sites. Appendix: New Central Taurus Ore Data." *Archaeometry* 43, pp. 77–115.

Schäfer, Heinrich

1910 Ed. *Ägyptische Goldschmiedearbeiten.* Berlin: K. Curtius.

Schlögl, Hermann A.

1980 "Nefertem." In *Lexikon der Ägyptologie*, vol. 4, cols. 378–80. Wiesbaden: Harrassowitz.

Schneider, Hans D.

1977 *Shabtis: An Introduction to the History of Ancient Egyptian Funerary Statuettes with a Catalogue of the Collection of Shabtis in the National Museum of Antiquities at Leiden.* 3 vols. Leiden: Rijksmuseum van Oudheden.

Schneider, Hans D., and Maarten J. Raven

1981 *De Egyptische oudheid: Een inleiding aan de hand van de Egyptische verzameling in het Rijksmuseum van Oudheden te Leiden.* 's-Gravenhage: Staatsuitgeverij.

1997 *Life and Death under the Pharaohs: Egyptian Art from the National Museum of Antiquities in Leiden, Netherlands.* Exh. cat. Perth: Western Australian Museum.

Schorsch, Deborah

1988a "An Egyptian Ibis Sarcophagus in the Virginia Museum of Fine Arts: A Technical Report." *Arts in Virginia* 28, pp. 48–59.

1988b "Technical Examinations of Ancient Egyptian Theriomorphic Hollow Cast Bronzes? Some Case Studies." In *Conservation of Ancient Egyptian Materials*, ed. Sarah C. Watkins and Carol E. Brown, pp. 41–50. London: Institute of Archaeology Publications.

1994 "Lebanese Mountain Figures: Eine technologische Betrachtung." In *Handwerk und Technologie im Alten Orient: Ein Beitrag zur Geschichte der Technik im Altertum*, ed. Ralf-B. Wartke, pp. 111–18. Mainz am Rhein: Philipp von Zabern.

2001 "Precious Metal Polychromy in Egypt in the Time of Tutankhamun." *JEA* 87, pp. 55–71.

Forth- "Seth, Figure of Mystery." *Meddelelser fra Ny*
coming *Carlsberg Glyptotek.* Copenhagen: Ny Carlsberg Glyptotek.

Schorsch, Deborah, and James H. Frantz

1997–98 "A Tale of Two Kitties." *Metropolitan Museum of Art Bulletin* 55 (Winter), pp. 16–29.

Schorsch, Deborah, and Elizabeth Hendrix

2003a "Ambition and Competence in Late Bronze Age Cyprus." *Report of the Antiquities Organization, Cyprus*, pp. 53–77.

2003b "The Production of Relief Ornament on Cypriot Bronze Castings of the Late Bronze Age." In *Archaeometallurgy in Europe*, vol. 2, pp. 47–56. Milan: Associazione Italiana di Metallurgia.

Schoske, Silvia

1988 "Statue Amenemhets III." *Münchner Jahrbuch der bildenden Kunst* 39, pp. 207–10.

1992 "Statue eines beliebten Mannes." *Münchner Jahrbuch der bildenden Kunst* 47, pp. 177–81.

Schoske, Silvia, and Dietrich Wildung

1992 *Gott und Götter im alten Ägypten.* Mainz am Rhein: Philipp von Zabern.

Schulman, Alan R.

1986 "Some Observations on the *Ꜣḫ iḳr n Rꜥ*-Stelae." *Bibliotheca Orientalis* 43, nos. 3–4, pp. 302–47.

Schulz, Regine

1992 *Die Entwicklung und Bedeutung des kuboiden Statuentypus: Eine Untersuchung zu den sogenannten "Würfelhockern."* 2 vols. Hildesheim: Gerstenberg.

2004 "Treasures of Bronze." *Bulletin of the Egyptian Museum* 1, pp. 61–66.

Scott, Gerry D.

1992 *Temple, Tomb, and Dwelling: Egyptian Antiquities from the Harer Family Trust Collection.* Exh. cat. San

Bernardino: University Art Gallery, California
State University.

Scott, Nora E.

1946 *Egyptian Statuettes.* New York: Metropolitan
Museum of Art.

1964 "Egyptian Jewelry." *Metropolitan Museum of Art Bul-
letin* 22, no. 7 (March), pp. 225–34.

Seipel, Wilfried

1989 *Ägypten: Götter, Gräber und die Kunst: 4000 Jahre Jen-
seitsglaube.* 2 vols. Exh. cat., Schlossmuseum Linz.
Linz: Oberösterreichisches Landesmuseum.

1992 *Gott, Mensch, Pharao: Viertausend Jahre Menschenbild in
der Skulptur des Alten Ägypten.* Exh. cat., Künstlerhaus
Wien. Vienna: Kunsthistorisches Museum.

2001 Ed. *Gold der Pharaonen.* Exh. cat., Kunsthistorisches
Museum Wien. Milan: Skira.

Sethe, Kurt

1914 "Hitherto Unnoticed Evidence Regarding Copper
Works of Art of the Oldest Period of Egyptian
History." *JEA* 1, pp. 233–36.

Settgast, Jürgen

1978 Ed. *Von Troja bis Amarna: The Norbert Schimmel Collec-
tion, New York.* Mainz am Rhein: Philipp von
Zabern.

Sherratt, Andrew, and Susan Sherratt

2001 "Technological Change in the East Mediterranean
Bronze Age: Capital, Resources and Marketing."
In *The Social Context of Technological Change: Egypt and
the Near East, 1650–1550 BC,* ed. Andrew J. Short-
land, pp. 15–38. Oxford: Oxbow Books.

Shubert, Steven Blake

1989 "Realistic Currents in Portrait Sculpture of the
Saite and Persian Periods in Egypt." *JSSEA* 19,
pp. 27–47.

Shumei Family Collection

1996 *Ancient Art from the Shumei Family Collection.* Exh.
cat., The Metropolitan Museum of Art, New York;
Los Angeles County Museum of Art. New York:
Metropolitan Museum of Art.

Silverman, David P.

1997 Ed. *Searching for Ancient Egypt: Art, Architecture, and
Artifacts from the University of Pennsylvania Museum of
Archaeology and Anthropology.* Exh. cat. Ithaca, N.Y.:
Cornell University Press.

Smith, Harry S.

1976 "Preliminary Report on Excavations in the
Sacred Animal Necropolis, Season 1974–1975."
JEA 62, pp. 14–17.

1984 "Saqqara, Nekropolen, SpZt." In *Lexikon der
Ägyptologie,* vol. 5. Wiesbaden: Harrassowitz.

1992 "The Death and Life of the Mother of Apis." In
*Studies in Pharaonic Religion and Society in Honour of
J. Gwyn Griffiths,* ed. Alan B. Lloyd, pp. 201–25.
London: Egypt Exploration Society.

2002 "The Saqqara Papyri: Oracle Questions, Pleas,
and Letters." In *Acts of the Seventh International Con-
ference of Demotic Studies, Copenhagen, 23–27 August
1999,* ed. Kim Ryholt, pp. 367–75. Copenhagen:
Museum Tusculanum Press.

Smith, Harry S., and David G. Jeffreys

1977 "The Sacred Animal Necropolis, North Saqqàra:
1975/6." *JEA* 63, pp. 20–28.

Smith, Harry S., et al.

2006 Harry S. Smith, Sue Davies, and Kenneth J.
Frazer, eds. *The Sacred Animal Necropolis at North
Saqqara: The Main Temple Complex: The Archaeological
Report.* London: Egypt Exploration Society.

Forth- Harry S. Smith, C. A. R. Andrews, and Sue
coming Davies. *The Sacred Animal Necropolis at North Saqqara:
The Mother of Apis Inscriptions.* London: Egypt
Exploration Society.

Smith, Stuart Tyson

1992 "Intact Tombs of the Seventeenth and Eighteenth
Dynasty from Thebes and the New Kingdom
Burial System." *MDAIK* 48, pp. 193–231.

Sourouzian, Hourig

2006 "Seth fils de Nout et Seth d'Avaris dans la
statuaire royale Ramesside." In *Timelines: Studies in
Honour of Manfred Bietak,* ed. Ernst Czerny et al.,
vol. 1, pp. 331–54. Leuven: Peeters.

South, Alison K., et al.

1989 Alison K. South, Pamela A. Russell, and
Priscilla Schuster Keswani. *Vasilikos Valley Project 3:
Kalavasos-Ayios Dhimitrios II: Ceramics, Objects,
Tombs, Specialist Studies.* Göteborg: P. Åströms
Förlag.

Spencer, Neal

2006 With Daniela Rosenow. *A Naos of Nekhthorheb
from Bubastis: Religious Iconography and Temple
Building in the 30th Dynasty.* London: British
Museum.

Staatliche Sammlung

1972 *Staatliche Sammlung Ägyptischer Kunst.* Munich:
Residenz Hofgartenstrasse.

Stanwick, Paul Edmund

2002 *Portraits of the Ptolemies: Greek Kings as Egyptian
Pharaohs.* Austin: University of Texas Press.

Steindorff, George

1946 *Catalogue of the Egyptian Collection in the Walters Art Gallery*. Baltimore: Trustees [of the Gallery].

Stern, Ludwig

1885 "Altertumskunde. Die ältesten Bronzen der Welt.—Die Posno'sche Sammlung Aegyptischer Alterthumer.—Versteigerung derselben.—Die Erwerbungen des Louvre und Berliner Museums." *Zeitschrift für die gebildete Welt über das gesammte Wissen unserer Zeit und über alle wichtigste Berufszweige* 3 (1885), pp. 285–88.

Stierlin, Henri, and Christiane Ziegler

1987 *Tanis: Trésors des pharaons*. Fribourg: Seuil.

Störk, Lothar

1984 "Schlange." In *Lexikon der Ägyptologie*, vol. 5, cols. 644–52. Wiesbaden: Harrassowitz.

Stós-Fertner, Zofia A., and Noel H. Gale

1979 "Chemical and Lead Isotope Analysis of Ancient Egyptian Gold, Silver, and Lead." In *Proceedings of the 18th International Symposium on Archaeometry and Archaeological Prospection*, pp. 299–314. Cologne: Rheinland-Verlag.

Stós-Gale, Zofia A.

2001 "Minoan Foreign Relations and Copper Metallurgy in MMIII–LMIII Crete." In *The Social Context of Technological Change: Egypt and the Near East, 1650–1550 BC*, ed. Andrew J. Shortland, pp. 195–210. Oxford: Oxbow Books.

Stós-Gale, Zofia A., and Noel H. Gale

1994 "The Origin of Metals Excavated on Cyprus." In *Provenience Studies and Bronze Age Cyprus: Production, Exchange and Politico-Economic Change*, ed. A. Bernard Knapp and John F. Cherry, pp. 92–122. Madison, Wis.: Prehistory Press.

Stós-Gale, Zofia A., et al.

1995 Zofia A. Stós-Gale, Noel H. Gale, and Judy Houghton. "The Origin of Copper Metal Excavated at Amarna." In *Egypt, the Aegean and the Levant: Interconnections in the Second Millennium BC*, ed. W. Vivian Davies and Louise Schofield, pp. 127–35. London: British Museum Press.

Straten, Folkert van

1992 "Votives and Votaries in Greek Sanctuaries." In *Le sanctuaire grec: Huit exposés suivis de discussions*, ed. Albert Schachter and Jean Bingen, pp. 247–84. Geneva: Fondation Hardt.

Tanis

1987 *Tanis: L'or des pharaons*. Exh. cat., Galeries Nationales du Grand Palais, Paris. Paris: Ministère des Affaires Étrangères.

Taylor, John H.

2001 *Death and the Afterlife in Ancient Egypt*. London: British Museum Press.

2003 "Theban Coffins from the Twenty-second to the Twenty-sixth Dynasty: Dating and Synthesis of Development." In *The Theban Necropolis: Past, Present and Future*, ed. Nigel Strudwick and John H. Taylor, pp. 95–121. London: British Museum Press.

Taylor, John H., et al.

1998 John H. Taylor, Paul T. Craddock, and Fleur Shearman. "Egyptian Hollow-Cast Bronze Statues of the Early First Millennium BC: The Development of a New Technology." *Apollo* 148 (July), pp. 9–14.

Teeter, Emily

1994 "Bronze Votive Offering Tables." In *For His Ka: Essays Offered in Memory of Klaus Baer*, ed. David P. Silverman, pp. 255–65. Chicago: Oriental Institute, University of Chicago.

1997 *The Presentation of Maat: Ritual and Legitimacy in Ancient Egypt*. Chicago: Oriental Institute, University of Chicago.

Tefnin, Roland

1979 *La statuaire d'Hatshepsout: Portrait royal et politique sous la 18e dynastie*. Brussels: Fondation Égyptologique Reine Élisabeth.

Temple of Hibis

1941 Herbert E. Winlock. *The Temple of Hibis in El Khārgeh Oasis, Part 1: The Excavations*. The Metropolitan Museum of Art Egyptian Expedition, vol. 13. New York: Plantin Press.

1953 Norman de Garis Davies. *The Temple of Hibis in El Khārgeh Oasis, Part 3: The Decoration*. The Metropolitan Museum of Art Egyptian Expedition, vol. 17. New York: Plantin Press.

Tomoum, Nadja Samir

2005 *The Sculptor's Models of the Late and Ptolemaic Periods: A Study of the Type and Function of a Group of Ancient Egyptian Artefacts*. Cairo: Supreme Council of Antiquities.

Török, László

1990 "The Costume of the Ruler in Meroe: Remarks on Its Origins and Significance." *Archéologie du Nil Moyen* 4, pp. 151–202.

Traunecker, Claude

1979 "Essai sur l'histoire de la XXIXe dynastie." *BIFAO* 79, pp. 395–436.

1991 "Observations sur le décor des temples égyptiens." In *L'image et la production du sacré: Actes du Colloque de Strasbourg, 20–21 janvier 1988*, ed. Françoise Dunand et al., pp. 77–101. Paris: Méridiens Klincksieck.

Traunecker, Claude, et al.

1981 Claude Traunecker, Françoise Le Saout, and Olivier Masson. *La Chapelle d'Achôris à Karnak.* 2 vols. Paris: Éditions A.D.P.F.

Tutankhamun

1976 *Treasures of Tutankhamun.* Exh. cat. New York: Metropolitan Museum of Art.

Tzachou-Alexandri, Olga

1995 Ed. *The World of Egypt in the National Archaeological Museum.* Athens: Greek Ministry of Culture.

Valbelle, Dominique, and Geneviève Husson

1998 "Les questions oraculaires d'Égypte: Historie de la recherché, nouveautés et perspectives." In *Egyptian Religion: The Last Thousand Years: Studies Dedicated to the Memory of Jan Quaegebeur*, ed. Willy Clarysse et al., pp. 1055–71. Leuven: Peeters.

Vandier, Jacques

1958 *Manuel d'archéologie égyptienne*, vol. 3, *Les grandes époques: La statuaire.* Paris: A. et J. Picard.

1968 "La vie des Musées: Nouvelles acquisitions, Musées du Louvre, Département des Antiquités Égyptiennes." *Revue du Louvre et des Musées de France* 18, pp. 95–108.

1969 "Le dieu Seth au Nouvel Empire: À propos d'une récente acquisition du Louvre." *MDAIK* 25, pp. 188–97.

Vassilika, Eleni

1989 *Ptolemaic Philae.* Leuven: Peeters.

1997 "Egyptian Bronze Sculpture before the Late Period." In *Chief of Seers: Egyptian Studies in Memory of Cyril Aldred*, ed. Elizabeth Goring et al., pp. 291–302. London: Kegan Paul.

Velde, Herman te

1977 *Seth, God of Confusion: A Study of His Role in Egyptian Mythology and Religion.* 2d ed. Leiden: Brill.

2001 "Seth." In *Oxford Encyclopedia of Ancient Egypt*, ed. Donald B. Redford, vol. 3, pp. 269–71. Oxford: Oxford University Press.

Vernier, Émile

1907–27 *Bijoux et orfèvreries.* 2 vols. Cairo: Institut Français d'Archéologie Orientale.

Vischak, Deborah

2001 "Hathor." In *Oxford Encyclopedia of Ancient Egypt*, ed. Donald B. Redford, vol. 2, pp. 82–85. Oxford: Oxford University Press.

Vleeming, Sven P.

2001 *Some Coins of Artaxerxes and Other Short Texts in the Demotic Script Found on Various Objects and Gathered from Many Publications.* Leuven: Peeters.

Volokhine, Youri

2000 *La frontalité dans l'iconographie de l'Égypte ancienne.* Geneva: Société d'Égyptologie.

Weitz, Katja

2005 "Ägyptische Bronzevotive in griechischen Heiligtümern." In *Ägypten, Griechenland, Rom: Abwehr und Berührung*, ed. Herbert Beck et al., pp. 133–37. Frankfurt: Städelsches Kunstinstitut und Städtische Galerie.

Wildung, Dietrich

1984 *Sesostris und Amenemhet: Ägypten im Mittleren Reich.* Munich: Hirmer Verlag.

1997 Ed. *Sudan: Ancient Kingdoms of the Nile.* Exh. cat., Kunsthalle der Hypo-Kulturstiftung, Munich. New York: Flammarion.

Winter, Erich

1971 "Eine ägyptische Bronze aus Ephesos." *ZÄS* 97, pp. 146–55.

Wuttmann, Michel, et al.

1996 "Premier rapport préliminaire des travaux sur le site de 'Ayn Manâwîr (Oasis de Kharga)." *BIFAO* 96, pp. 585–451.

1998 "'Ayn Manâwîr (Oasis de Kharga): Deuxième rapport préliminaire." *BIFAO* 98, pp. 367–462.

Yoyotte, Jean

1958 "Le dénommé Mousou." *BIFAO* 57, pp. 81–89.

1961 "Les principautés du Delta au temps de l'anarchie libyenne (Études d'histoire politique)." In *Mélanges Maspero*, vol. 1, *Orient ancien*, fasc. 4, pp. 121–81. Cairo: Institut Français d'Archéologie Orientale.

1988 "Des lions et des chats: Contribution à la prosopographie de l'époque libyenne." *Revue d'Égyptologie* 39, pp. 155–78.

2003 "Un nouveau souvenir de Sheshanq I et un muret Héliopolitain de plus." *Revue d'Égyptologie* 54, pp. 219–53.

Žabkar, Louis V.

1968 *A Study of the Ba Concept in Ancient Egyptian Texts.* Chicago: University of Chicago Press.

Ziegler, Christiane

1979 "À propos du rite des quatre boules." *BIFAO* 79, pp. 437–39.

1987 "Les arts du métal à la Troisième Période Inter-médiaire." In *Tanis: L'or des pharaons*, pp. 85–101. Paris: Ministère des Affaires Étrangères.

1993 "Champollion en Égypte: Inventaire des antiqui-tés rapportées au Musée du Louvre." In *Aegyptus museis rediviva: Miscellanea in honorem Hermanni De Meulenaere*, ed. Luc Limme and Jan Strybol, pp. 197–208. Bruxelles: Musées Royaux d'Art et d'Histoire.

1996 "Jalons pour une histoire de l'art égyptien: La statuaire du métal au Musée du Louvre." *Revue du Louvre et Musées de France* 46, no. 1, pp. 29–38.

Zivie–Coche, Christiane

1991 *Giza au premier millénaire: Autour du temple d'Isis, dame des pyramides*. Boston: Museum of Fine Arts.

2004 *Tanis: Travaux récents sur le tell Sân el-Hagar*, vol. 3, *Statues et autobiographies de dignitaires: Tanis à l'époque ptolémaïque*. Paris: Édition Cybèle.

INDEX

Page references in *italic* refer to illustrations.

20th, 29
> See also cat. nos. 13, 14, 16

21st, 44, 51, 81n.28
> See also cat. no. 20

22nd, 39–40, 51, 106, 191
>> coffins and cartonnage cases from, 70, 71, 72, 73, 81n.28
>> stone statues from, 70, 73
>> See also cat. nos. 17, 18, 20, 22, 25, 28, 29, 34

23rd, 51, 91, 106
> See also cat. nos. 18, 20, 21, 25, 28, 29, 34

24th, 51
> See also cat. nos. 18, 20, 25, 28, 29, 34

25th (Kushite Period), 35, 51, 55, 62, 73, 87, 92, 94, 102, 106, 113, 115, 120, 139, 183, 197
>> coffin iconography in, 71, 73, 79–80
>> figural surface decoration in, 73, 79
>> See also cat. nos. 23–27, 32, 35–58

26th (Saite Period), 55, 62, 70, 86, 92, 94, 109, 115–23, 128, 139, 140, 172, 174
>> childlike features in, 120–23, 137–39
>> coffin iconography in, 81n.28, 79–80
>> concubine figures from, 130–32
>> ideal of beauty in, 130, 133n.2
>> local influences in, 117
>> nonroyal metal statuettes from, 58, 115–17
>> realism in, 115, 116–17, 127n.5, 135
>> royal metal and stone statues from, 113, 117–23, 137–39
>> Sacred Animal Necropolis at North Saqqara in, 177
>> "Saite" facial features in, 117, 120, 130, 149
>> temple reliefs related to metal works in, 31n.14, 117, 120, 139
>> See also cat. nos. 38–47, 57, 59, 60

27th–30th, 140, 177
> See also cat. nos. 60

E

Egyptian blue, 155. See also cat. no. 66

electrum, 40, 42, 86, 189, 193, 195, 197, 199nn. 29, 32
> use of term, 48n. 5, 193, 199n. 29
> See also cat. nos. 50, 57, 66

Enkomi, 32, 33

F

facial features and styles, depictions of:
> childlike, in Late Period, 120–23, 137–39
> realistic, 115–16, 148
> in New Kingdom, 25, 26, 29, 30

in Macedonian–Ptolemaic Period, 125, 143

in Third Intermediate Period, 52, 58, 61, 62, 82, 106, 109

faience inlays. See inlays (nonmetallic)

Falcon Catacomb, at SAN, 174, 177, 180, 183, 184

falcon-headed deities, 35n.4, 36n.2, 72, 73, 82, 86, 161, 171

falcon imagery, 73, 109, 151n.10, 180, 181
> statuette from Hierakonpolis (fig. 5), 8, 8, 13, 189, 191

Fayum, 9–12, 16, 198n.15

feather garments, 40, 55–56, 63n.7, 109

figural surface decoration, 65–81
> as amuletic devices, 72, 80
> coffin iconography and, 67–68, 70, 71–72, 73, 79–80
> depiction of family members in, 75
> figures arranged in registers in, 65, 67, 78–80
> figures in formal groups in, 67, 75–78
> funerary dimension of, 67–68, 70–73, 79, 80
> isolated figures or emblems in, 66–67, 70–75
> positioning of divine images in, 73
> role of, 66–70, 80
> stone sculpture and, 66, 68–71, 73, 75
> temple ritual dimension of, 72, 78–79, 80
> wall decoration and, 79

Figure of a Man from Sais (cat. no. 41), 115–16, 134–36, 134–36

First Intermediate Period, 9, 15–16
> use of bronze in, 191, 192

foundation deposits, 181, 185,

Fragment of a Wig (cat. no. 12), 24, 32, 32–33

funerary masks, 142

funerary practices, 16, 24, 29, 56, 68
> Book of the Dead vignettes and, 67, 68
> concubine figures and, 130–32
> See also coffins; figural surface decoration; mummies; tomb statues

G

gamma radiography, 36n.1, 87n.2

gesso, as ground for gilding, 96, 128
> See also cat. nos. 25, 26, 65

gestures:
> henu, or acclamation, 161
> worshipping, 29
> See also poses

Giza, 66

gilding, 86, 96, 155
> See also gold; cat. nos. 16, 28, 57, 65

glass inlays. See inlays (nonmetallic)
> See also cat. no. 65

God's Father of Khonsu, Khonsumeh (cat. no. 30; figs. 32, 45–47), 51, 58, 59, 66, 72, 73–75, 76, 77, 78, 78

"God's Father" title, 58

"God's Father, Beloved of the God" title, 62

God's Wife of Amun Karomama (fig. 19), 38, 39–41, 51, 52, 55, 56, 91, 95, 104, 110, 133n.11

God's Wives:
> of Amun, as institution, 39, 51, 55, 95
> statues of, 79. See also cat. no. 25; fig. 19

gold, 41, 189, 190, 193–94, 199n.34
> availability of, 23
> composition of, in ancient Egypt, 193
> in black copper or black bronze, 39, 42, 44, 45, 48n.2, 191
> leaf, 40, 42, 72, 96
> polychromy and, 40, 42, 47, 195, 197
> red, 90, 91n.1, 193–94, 199n.31
> See also gilding; inlay (metalworking technique); cat. nos. 13, 19, 36, 62, 63

goldsmithing techniques, 84–86

Gorringe, Henry, 146

Greeks, 31n.7, 62, 110, 115, 125, 193
> See also Ptolemaic Period

Group with King Holding a Shen-ring (?) before an Otter (cat. no. 67; fig. 67), 157, 158

H

hairstyles:
> "natural," 16–17, 19–21
> sidelock worn by children, 47
> for women, 150, 133n.11
> See also wigs

hammering, as metalworking technique, 8, 21, 84, 192
> See also cat. nos. 62, 65

Harakhbit, stone statue of (Egyptian Museum, Cairo, CG 42214), 70

Haremakhbit, 62

Harendotes (god), 99

Harira, statue of (Musée du Louvre, Paris, AF 1670), 116

Harpokrates, Lord of Hebyt, Offered by a Son of the Great One of Netjery, Harsiese (cat. no. 49; fig. 56), 122, 123–25, 126

Harpokrates (god), statuettes of, 145, 171, 178
> from Falcon Catacomb at SAN (cat. no. 58; fig. 78), 126, 180, 182
> with Isis (fig. 77), 3, 179, 180
> on prostrate prisoners (cat. no. 49; fig. 56), 122, 123–25, 126

Harpokrates with a Falcon on the Back of His Nemes Headdress (cat. no. 58; fig. 78), 126, 180, 182

Harsiese:
> at 'Ayn Manâwir, 171
> fragment from menit of (cat. no. 33), 42, 104–5, 105, 197, 199n.34
> "Great One of Netjery," 125

PHOTOGRAPH AND REPRODUCTION CREDITS

Photographs were in most cases provided by the owners of the works of art and are published with their permission; their courtesy is gratefully acknowledged. Additional credits follow. Illustrations in catalogue entries are referenced by catalogue and page number; all other illustrations are referenced by figure number.

Dieter Arnold: fig. 12

(c) The Trustees of The British Museum, London: figs. 28, 29, 31, 36; cat. 25 (p. 97)

Cliché Archives Photographique/Collection MAP (c) CMN, Paris: fig. 68

Courtesy of the Egypt Exploration Society, London: fig. 75

Courtesy of the Egypt Exploration Society, London, and Dr. D. J. Thompson: fig. 74

Egyptian Museum, Cairo/photograph by Biri Fay: figs. 4, 5, 9, 61; cat. no. 46 (pp. 137, 138)

From Emery 1970, plate V/1, reproduced courtesy of the Egypt Exploration Society, London: fig. 77

(c) Hellenic Ministry of Culture/Archaeological Receipts Fund/photograph by G. Fafalis: fig. 26; cat. nos. 7 (pp. 18–21), 23 (pp. 93, 94), 27 (pp. 98, 100, 101), 37 (p. 108), 58 (pp. 111–12), 41 (pp. 134–56)

Reproduced by permission of the Institut Français d'Archéologie Orientale, Cairo: figs. 70–73

(c) 2007 Kunsthistorisches Museum, Vienna: fig. 39

The Photograph Studio, The Metropolitan Museum of Art, New York: fig. 87; photograph by Bruce Schwarz: fig. 10; photograph by Oi-Cheong Lee: figs. 1, 17, 30, 34, 50, 51, 55, 60, 62–64, 66, 78, 86; cat. nos. 19 (pp. 85, 86, 89), 36 (fig. 49), 40 (pp. 131, 132), 57 (p. 150), 61 (pp. 160, 162, 163) 62 (p. 165)

From Minutoli 1824, pl. 31, fig. 3/Asian and Middle Eastern Division, The New York Public Library, Astor, Lenox and Tilden Foundations: fig. 90

(c) Musée du Louvre, Paris: photograph by Christian Décamps: figs. 11, 20, 25; photograph by Georges Poncet: figs. 19, 21–24, 33, 35

Museu Calouste Gulbenkian, Lisbon/ photograph by Bill Barrette: cat. no. 21 (p. 90)

Muzeum Narodowe, Warsaw/photograph from the Corpus of Late Egyptian Sculpture, Brooklyn Museum, New York: fig. 69

(c) Réunion des Musées Nationaux/Art Resource, New York: fig. 84; photograph by Hervé Lewandowski: fig. 65; photograph

by Franck Raux: figs. 54, 85

(c) Rijksmuseum van Oudheden, Leiden: figs. 27, 82, 83; cat. no. 39 (p. 129)

(c) Roemer– und Pelizaeus–Museum, Hildesheim: cat. no. 48 (p. 141)

With permission of the Royal Ontario Museum, Toronto (c) ROM: fig. 58

Deborah Schorsch: figs. 80, 81, 88; cat. no. 19 (pp. 84, 88)

From Smith et al. 2006, plate XI/b, reproduced courtesy of the Egypt Exploration Society, London: fig. 76

(c) Staatliche Museen zu Berlin, Ägyptisches Museum und Papyrussammlung: photograph by Margaret Büsing: fig. 7; photograph by Jürgen Liepe: figs. 52, 40–47, 57, 58; cat. no. 33 (p. 105), 51 (p. 144); photograph by Dietrich Wildung: fig. 37

Bruce White: fig. 18

Drawings:
James P. Allen: figs. 89, 92
Julia Jarrett: fig. 91
J. Ribbeck/(c) Christian Eckmann, Römisch–Germanisches Zentralmuseum: fig. 3
Will Schenck: figs. 48, 59

Additional credit:
Fig. 18: Theodore M. Davis Collection, Bequest of Theodore M. Davis, 1915